1968

e Career of
homas Coady
he Hopkins
Hopkins

Honoring the Career of
Lieutenant
Brian Joseph Daly

In appreciation to
those who served
Catherine Grochowski

Collins

Rafael A. Garcia

Honoring the Career of
Sgt. Michael B Maloney
Past Pres CPSA
31 Years of Service

Honoring the Career of
Carl Suchocki CPD
Kevin Suchocki, USMC

nory
m

Robert
Margaret
Matthew
The Mizera Family

Honoring the Career of
Detective
David N. Sandlund

In Memory
Police O
Jimmie Lam

Tim
Kyle
Katie

e Cerven Family
Patti

The S

The
Gregory E. Sandlund
Family

The Wright Family
Paulette
John
Amanda

Honoring the
Deputy
John J.

Officer
Ann Staniec
#17408

The Madsen Family
Erik    Jamie
Taylor    Haylie

Honoring the Career
My Grandfather
Officer
Frank Kinnall

Stella
mily

American Title Realty
Fred Keto, CEO
JoAnn Keto, Realtor
Est. 1969

In Memory of
Officer
John Gillespie
34 Years of Service

Honoring the Career of
Officer
John-Paul Jean

In Memory of
Robert E. Shepard
With Our Love
The Shepard Family

The
Dave
Matthew

Cou

Kamien Family
Ken, Anna,
Kevin, Kristopher,
& Kenny

American
Motorcy
Chic

Ca

CHICAGO

MONUMENTAL

LARRY BROUTMAN

**B**

CHICAGO

PUBLISHED BY

**BROUTMAN PHOTOGRAPHY, LLC**
106 W. GERMANIA PLACE, SUITE 207
CHICAGO, ILLINOIS 60610

**Carol Haralson,** Sedona, Arizona: EDITING + DESIGN,
PRODUCTION + MANUFACTURING SUPERVISION
Design ©2016 by Carol Haralson

**John Rabias,** Chicago, Illinois: PHOTO DIGITAL EFFECTS

DISTRIBUTED BY

**LAKE CLAREMONT PRESS:**
A CHICAGO JOINT, AN IMPRINT
OF EVERYTHING GOES MEDIA, LLC
www.lakeclaremont.com
www.everythinggoesmedia.com

Printed in China

INTERNATIONAL STANDARD BOOK NUMBER
978-1-893121-67-6

PUBLISHER'S CATALOGING-IN-PUBLICATION DATA
(Prepared by The Donohue Group, Inc.)

Names:   Broutman, Larry.
Title:   Chicago monumental / Larry Broutman.
Description:   Chicago, Illinois : Broutman Photography, LLC, [2016] |
   [Chicago, Illinois] : Lake Claremont Press, a Chicago joint, an imprint of
   Everything Goes Media, LLC | Includes bibliographical references and
   index.
Identifiers:   ISBN 978-1-893121-67-6
Subjects:   LCSH: Monuments—Illinois—Chicago—Pictorial works. | Public
   sculpture—Illinois—Chicago—Pictorial works. | Chicago (Ill.)—Buildings,
   structures, etc.—Pictorial works.
Classification:   LCC F548.37 .B76 2016 | DDC 977.311—DC23

Page 1: Carrie Eliza Getty Tomb; page 2: Shoenhofen Tomb;
page 3: Stephen A. Douglas Monument; page 4: Ceres,
Chicago's tallest sculpture; pages 6 and 7: Peace in Unity.

20 19 18 17 16     10 9 8 7 6 5 4 3 2 1

# CHICAGO

## CARL SANDBURG

Hog Butcher for the World,
Tool Maker, Stacker of Wheat,
Player with Railroads and the Nation's Freight Handler;
Stormy, husky, brawling,
City of the Big Shoulders:

They tell me you are wicked and I believe them,
    for I have seen your painted women
    under the gas lamps luring the farm boys.
And they tell me you are crooked and I answer:
    Yes, it is true I have seen the gunman kill
    and go free to kill again.
And they tell me you are brutal and my reply is:
    On the faces of women and children I have seen the
    marks of wanton hunger.
And having answered so I turn once more to those who
    sneer at this my city, and I give them back the sneer
    and say to them: Come and show me another city with
    lifted head singing so proud to be alive and coarse and
    strong and cunning.
Flinging magnetic curses amid the toil
    of piling job on job, here is a tall bold slugger set vivid
    against the little soft cities;

Fierce as a dog with tongue lapping for action,
    cunning as a savage pitted against the wilderness,

Bareheaded,
Shoveling,
Wrecking,
Planning,
Building, breaking, rebuilding,

Under the smoke, dust all over his mouth,
    laughing with white teeth,
Under the terrible burden of destiny
    laughing as a young man laughs,
Laughing even as an ignorant fighter
    laughs who has never lost a battle,
Bragging and laughing that under his wrist is the pulse,
    and under his ribs the heart of the people,
Laughing!

Laughing the stormy, husky, brawling laughter of
Youth, half-naked, sweating, proud to be
Hog Butcher, Tool Maker, Stacker of Wheat,
Player with Railroads and Freight Handler to the Nation.

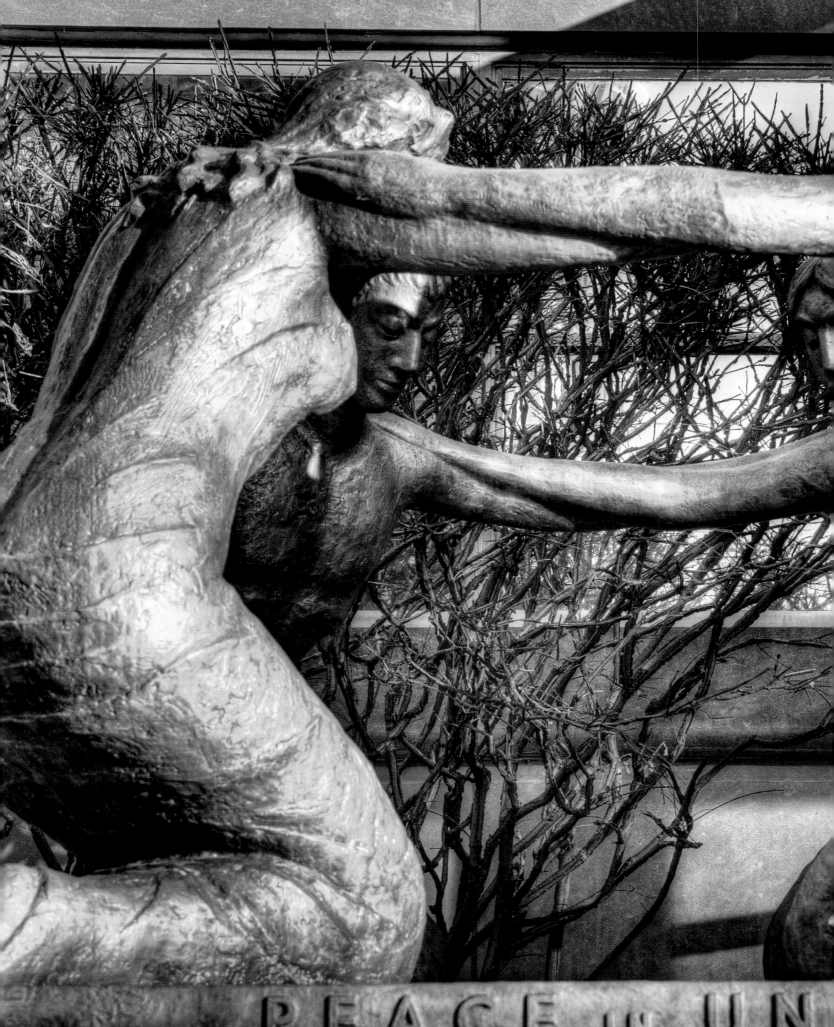
PEACE in UN

3D IMAGES

INDEX

ACKNOWLEDGMENTS

# MEMORY'S GALLERY

## LARRY BROUTMAN

F rom the statue of Leif Ericson standing in Humboldt Park to the lions flanking the Michigan Avenue entrance to the Art Institute, Chicago is densely populated with beautiful public art. One of the most popular works is *Cloud Gate,* Anish Kapoor's huge, curvaceous, and stunningly reflective mass of metal in Millennium Park. Since its installation in 2006, it has come to rival the Picasso that has stood in the Loop since 1967 as a symbol of the city.

While contemporary works testify to Chicago's ongoing commitment to public art, *Chicago Monumental* celebrates the city's long history of erecting statements in bronze and stone, sometimes as works of art, but more frequently to commemorate persons or events. Figurative rather than abstract, these sculptures functioned as expressions of ethnic, municipal, and national pride. Although often of considerable artistic merit, they were essentially civics lessons.

Today, we may not recall all the figures these sculptures honor and may even be a bit fuzzy on the historic events they memorialize. But as a lifelong Chicagoan, I find it difficult to imagine the city without them. They are good company, no matter how you view them.

Although John Quincy Adams—expressing the progressive independence of the new nation—asserted that "Democracy has no monuments," Americans have long paid visible homage to the brave, the daring, the patriotic, and the industrious, to soldiers, politicians, businessmen, and artists. Citizens and those from elsewhere, heroes and victims, all are memorialized in Chicago's great gallery of public sculpture. Situated in parks large and small, on street corners, in plazas and in cemeteries, these works are both history lessons and decorative flourishes, manifestations of a collective memory and architectural adornments in the built environment of the city.

Among the earliest pieces are Leonard W. Volk's *Our Heroes* (1869), which honors the Union dead. In fact, the battles and bloodletting of the Civil War seemed to jumpstart an appreciation for monumental public art which continued through World War II.

In 1893 Chicago was home to the World's Columbian Exposition, and many artists came to the city to display their work or create pieces specifically for the fair. New Englander Daniel Chester French, perhaps best known for his commanding representation of Abraham Lincoln at the president's memorial in Washington, D. C., created *The Republic,* which towered sixty-five feet over the Exposition's Court of Honor. In 1918 a twenty-four-foot-high replica was installed in Jackson Park, where the Exposition once stood.

In 1905 the School of the Art Institute of Chicago began to administer a $1 million fund established by lumber titan Benjamin Franklin Ferguson for "the erection and maintenance of enduring statuary and monuments, in whole or in part of stone, granite or bronze, in the parks, along the boulevards or in other public places." This catalyzed the public art movement. Approximately twenty statues and monuments have been erected in Chicago using these funds, including Taft's *The Fountain of Time,* located in Washington Park.

In addition to Chicago's extensive park system—whose spaces provide the backdrop for so many statues and monuments—the city's rich ethnic makeup played a key role in sustaining an interest in commemorative public art. Polish, Norwegian, Swedish, Czech, Italian, Mexican-American, and African American communities all honored and advocated for their heritage and heroes.

Time, of course, marches on. Not only do tastes change (beginning in the 1960s, modern art—often non-figurative—became the mode of choice for public art), but neighborhoods change, with new immigrants replacing past newcomers. A statue that meant much to one community may have little meaning for today's residents. As a whole, Americans do seem to suffer what the great oral historian (and Chicagoan) Studs Terkel called "national amnesia," forgetting and neglecting our history. So perhaps it is not surprising that some people may not be able to place Alexander Hamilton as they pass his likeness in Lincoln Park, or immediately grasp the significance of the helmeted 19th-century figure behind the Chicago Police Headquarters building at 35th Street (it commemorates the Haymarket Riot of 1886, a historic event in the labor movement, in which eight police officers died). Some works have suffered regrettable neglect, but that is history too, and I show these works as they are today.

Chicago's public sculpture tells the story of the making of a great city. *Chicago Monumental* concentrates on monumental sculpture created prior to 1940. But inasmuch as it records the impulse to commemorate and chronicles the figurative tradition in public work, I have included a few more recent examples, from a statue of the Chicago Cubs legend Ernie Banks to monuments denoting the Chicago Blues District. I have also included monuments and grave markers from some of Chicago's oldest cemeteries, particularly when they serve to commemorate a well-known figure from history or have special beauty or symbolic meaning.

It goes without saying that a photograph cannot equal the physical experience of encountering a monument where it stands. To approximate that experience, we have placed a special section at the end of the book that contains 3D photographs. When you see a 3D icon alongside a monument's title, you will know that a 3D image of that monument appears at the end of the book.

# EXPLORERS

*I*n the beginning . . . the region that would become Chicago was attractive
to newcomers because it was the site where Lake Michigan joined
the Chicago River, and the Chicago River was a pathway to the great Mississippi.
Aboriginal populations had already discovered this geographic advantage,
and the area was inhabited by many Native American groups whose
tribal encampments dotted the shorelines of the river and lake.

The first Europeans to explore the region were Jacques Marquette (1637–1675), a missionary, and Louis Jolliet (1645, last seen 1700), a fur trader. On their way back to Quebec after exploring the Mississippi River to the south, they spent the winter of 1674 with the Kaskaskia tribe in the area. A rival French explorer, Rene-Robert Cavelier, Sieur Lasalle (or Robert de la Salle,1643–1687), not only explored the area but around 1681 built a cabin and stockade along the Chicago River. It provided shelter for passing missionaries and traders.

Another influential early arrival to the region between today's Chicago and Detroit was Jean Baptiste Point du Sable (1745?–1818), a fur trader of mixed West African and French ancestry. He built a home along the Chicago River where it joins Lake Michigan (the approximate location on the north side of the river is now called Pioneer Court, adjacent to the Tribune Tower) before selling in 1800 and moving. The property was eventually purchased by John Kinzie (1763–1828), who arrived in 1804.

Prior to purchase of the DuSable property by Kinzie, a contingent of American soldiers had been sent from Detroit to build Fort Dearborn. By 1808, the fort stood on the south bank of the Chicago river, across the river from the Kinzie property. In 1812, its commander, Captain Heald, was ordered to abandon the fort and come to the defense of Detroit against the British. A band of fifty-five army regulars, with women and children, left the fort for Detroit. They were ambushed along the lakefront by Native Americans. Most of the soldiers were killed in the ensuing fight and the fort was burned. It was rebuilt in 1816, and once again, settlers and traders, who now felt protected by the fort, repopulated the area. Steady growth led to the creation of the city of Chicago and its official incorporation in 1837. By 1840 the population had grown to over 4,000 people, and they elected William Butler Ogden (1837–1838) the city's first mayor.

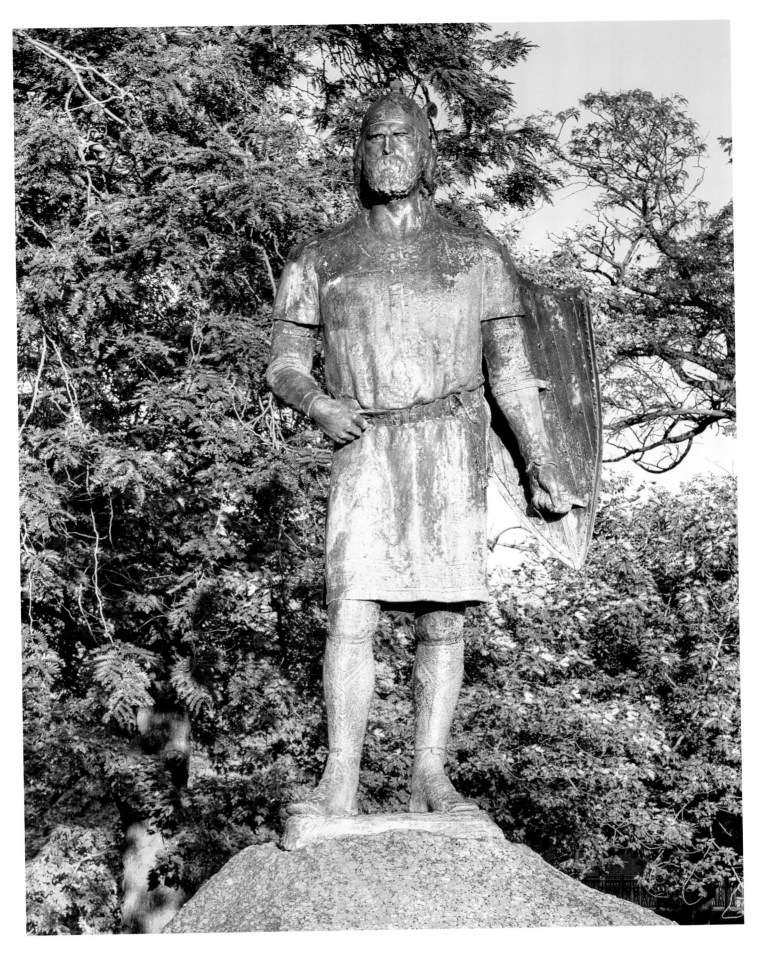

## LEIF ERICSON *by* SIGVALD ASBJORNSEN
BRONZE | INSTALLED 1901 | HUMBOLDT PARK

The Norse explorer Leif Ericson (c. 970–c. 1020) is believed to be the first European to set foot on the American continent at Newfoundland. The sculptor of this representation of Ericson, Sigvald Asbjornsen (1867–1954), was born in Norway and emigrated to the United States in 1892. In Chicago he worked on buildings for the World's Columbian Exposition of 1893. He remained in Chicago, where he created sculptures now placed throughout the United States. These include a statue of Louis Jolliet in Joliet, Illinois.

## CHRISTOPHER COLUMBUS
### *by* CARL BRIOSCHI
BRONZE AND GRANITE | INSTALLED 1933 |
GRANT PARK

The Italian community of Chicago donated
*Christopher Columbus* (1451–1506) to the city;
it was dedicated during the Century of Progress
International Exposition in 1933. The exposition
opened in May and closed in November, as planned.
It was so successful, however, that it reopened in
May 1934 and ran through October. More than 48
million people attended. Chicago added a fourth
star to its flag to commemorate the exposition (the
other three represent the Battle of Fort Dearborn
of 1812, the Great Chicago Fire of 1871, and the
Columbian Exposition of 1893). Reminders of the
exposition today are the Balbo Monument and this
statue, which still stands where it was originally
placed. Inscribed on its base are the words
*"Dedicated at the Chicago / Century of Progress
Exposition / Columbus symbolizes the enduring /
mutual respect and understanding / between Italy
and the United States."*

Carl Brioschi (1879–1941), who sculpted the
work, was born in Milan, trained in Italy, and
emigrated to New York as a young man. He settled
in Minnesota.

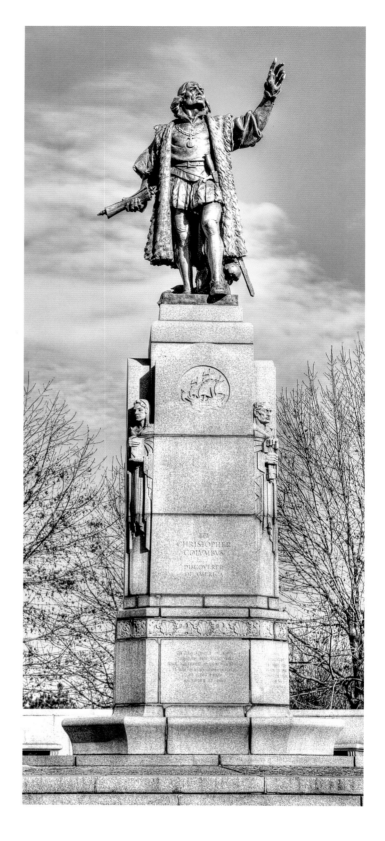

## JACQUES MARQUETE AND LOUIS JOLLIET *by* HERMON ATKINS MACNEIL
### BRONZE | INSTALLED 1926 | 24TH STREET AND MARSHALL BOULEVARD

Jacques Marquette (1637–1675) and Louis Jolliet (1645–
1700?), a Jesuit explorer priest and a soldier explorer, are
depicted with an Algonquin Indian guide.

Hermon MacNeil, an American sculptor, assisted with
the architectural sculptures for the Columbus Exposition
of 1893 in Chicago. He worked with Lorado Taft and
taught at the School of the Art Institute of Chicago. His
work is represented elsewhere in the area by *The Athlete*
and the Scholar at Northwestern University in Evanston
(1916) and the bas reliefs that decorate the exterior of the
Marquette Building (1894). Many of his works depict Native
American themes and subjects. They appear in public spaces
throughout the United States.

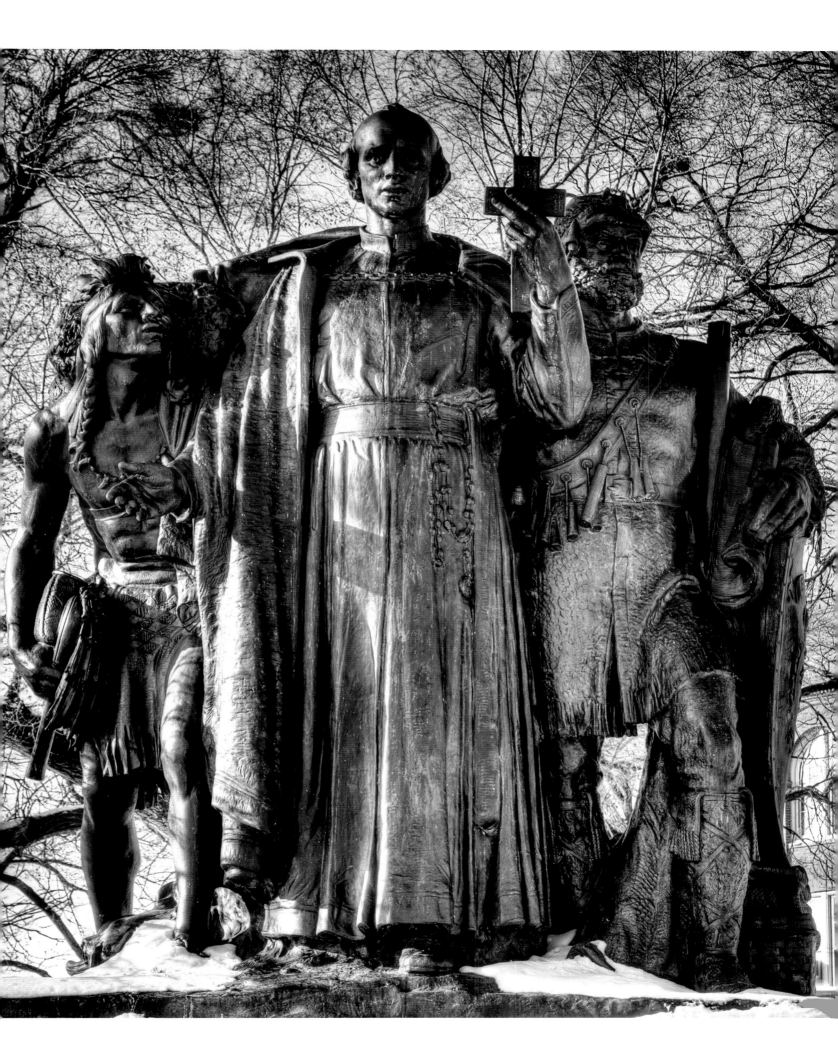

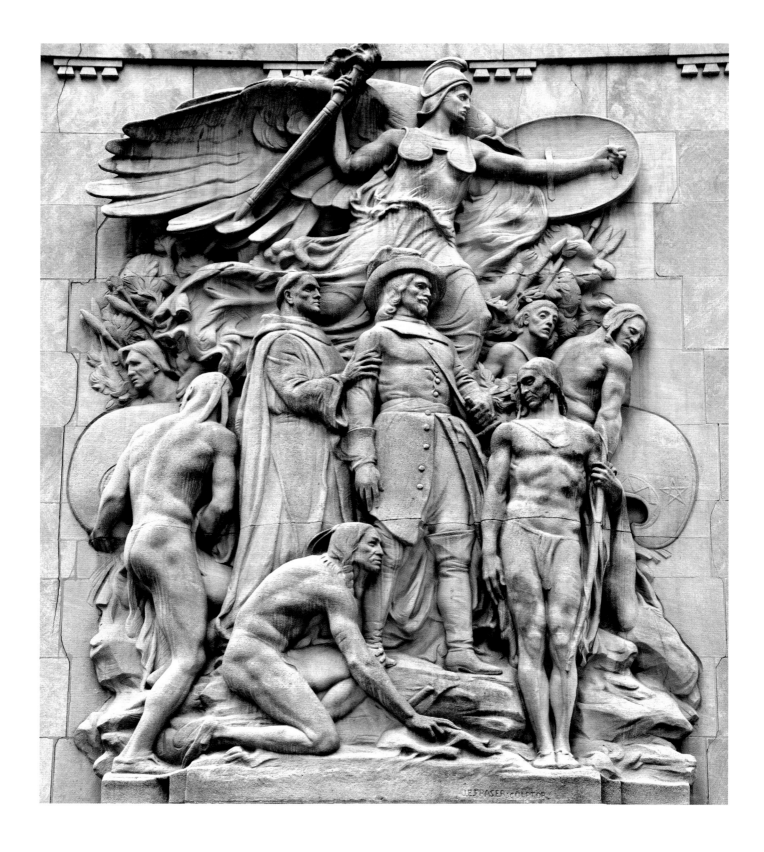

## DISCOVERERS *and* PIONEERS *by* JAMES EARLE FRASER

LIMESTONE | INSTALLED 1928 | MICHIGAN AVENUE BRIDGE, NORTHWEST AND NORTHEAST PYLONS

*Discoverers* honors Jacques Marquette and Louis Jolliet. *Pioneers* commemorates early fur trader John Kinzie, who first settled along the Chicago River in 1804. Kinzie (1763–1828) was instrumental in the development of what would become Chicago. He escaped the Battle of Fort Dearborn in 1812 and returned to the area in 1816. His gravesite is located in Graceland Cemetery, although the original grave marker is so weathered it is impossible to read.

James Earle Fraser (1876–1953) was one of the most prominent American sculptors of the first half of the 20th century. His work includes many iconic monuments in Washington, D.C. Fraser served as an assistant to Augustus Saint-Gaudens (1848–1907) before forming his own studio in 1902. His work can also be seen in Chicago in the rotunda of the Elks National Memorial and headquarters.

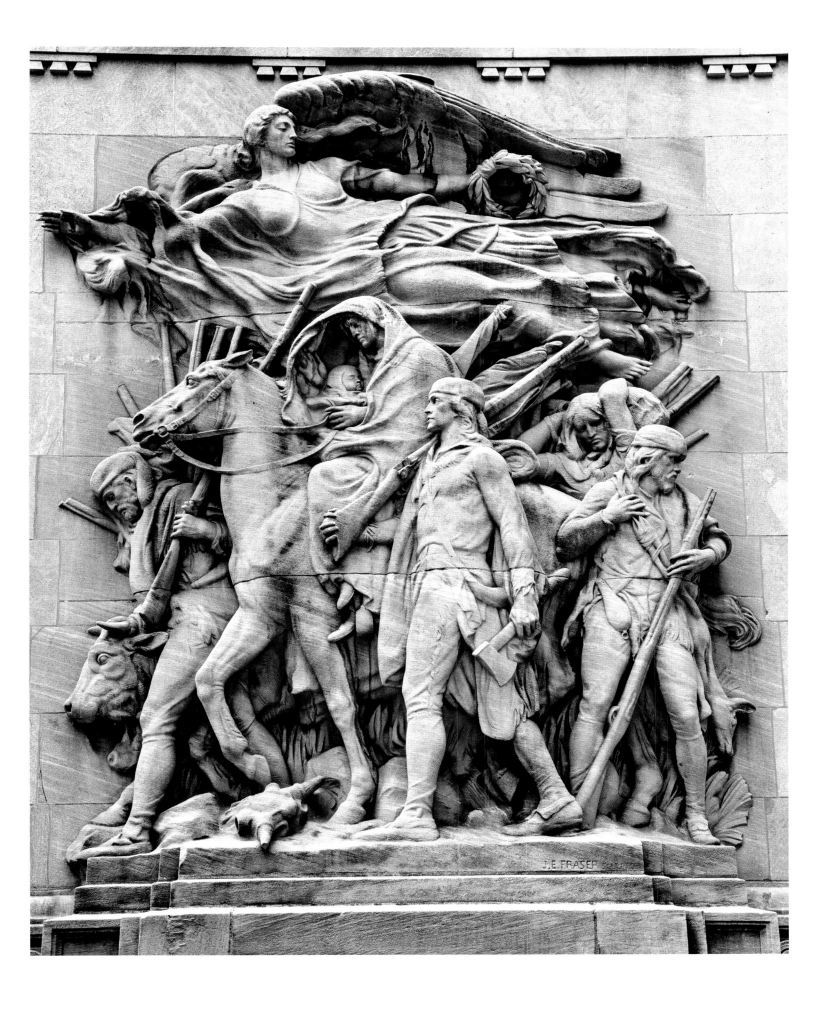

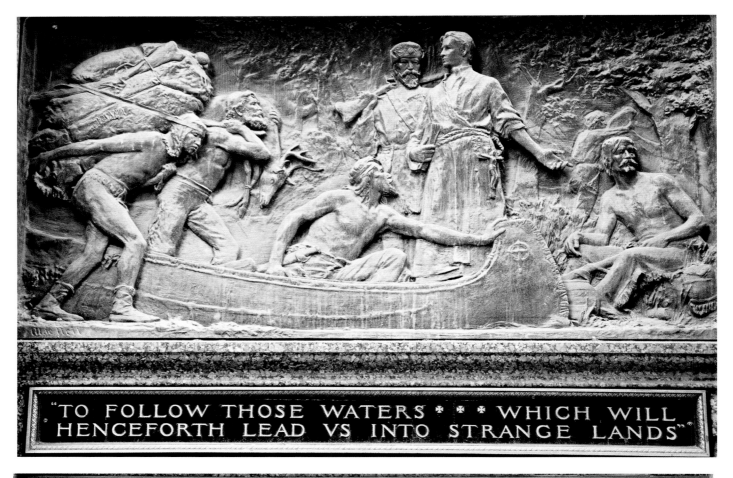

"TO FOLLOW THOSE WATERS * * * WHICH WILL HENCEFORTH LEAD VS INTO STRANGE LANDS"

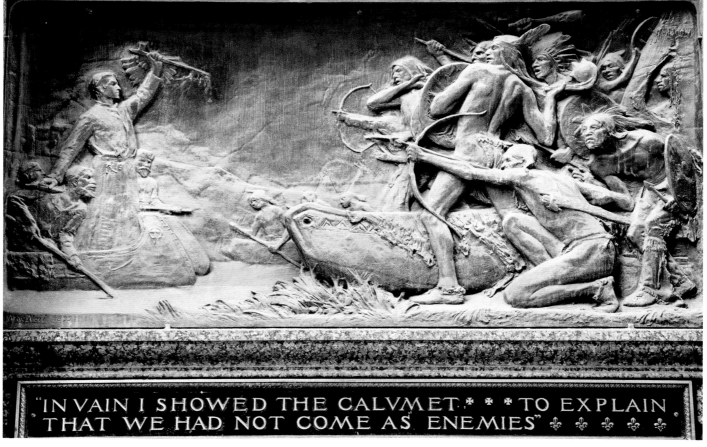

"IN VAIN I SHOWED THE CALVMET * * * TO EXPLAIN THAT WE HAD NOT COME AS ENEMIES"

## JACQUES MARQUETTE MEMORIAL *by* HERMON ATKINS MACNEIL

BRONZE | INSTALLED 1894 | MARQUETTE BUILDING, 140 SOUTH DEARBORN STREET

The developer of the Marquette Building, Owen Aldis, named it in honor of Jacques Marquette and created a memorial to the explorer in its public spaces. Aldis had translated Marquette's journals and was an enthusiastic student of the French Jesuit missionary, who, together with Louis Jolliet, was the first European to map the northern

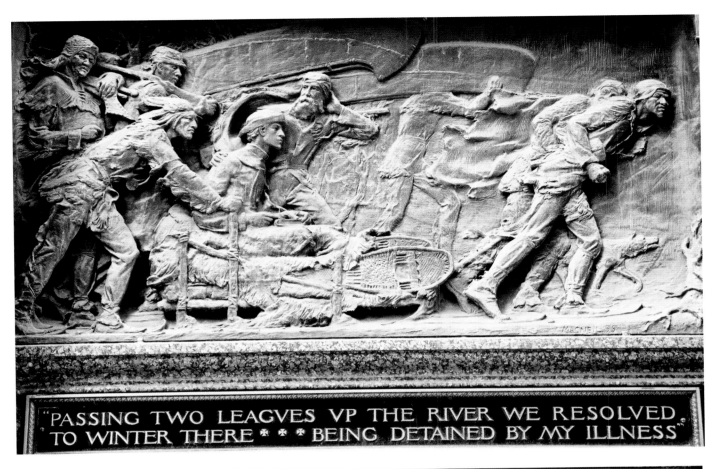

"PASSING TWO LEAGVES VP THE RIVER WE RESOLVED TO WINTER THERE * * * BEING DETAINED BY MY ILLNESS"

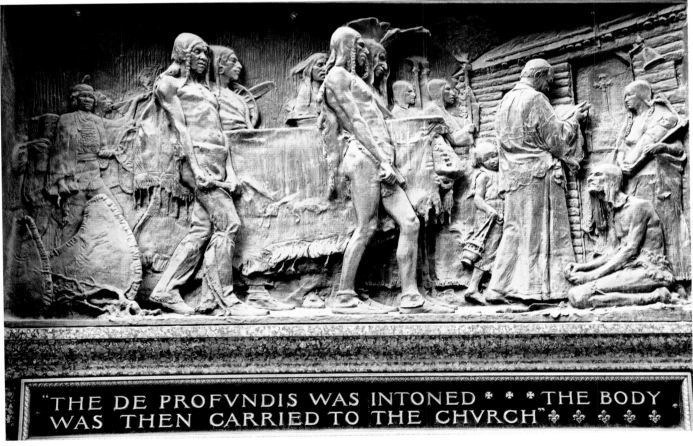

"THE DE PROFVNDIS WAS INTONED * * * THE BODY WAS THEN CARRIED TO THE CHVRCH" * * * * *

reaches of the Mississippi River. Aldis commissioned artists who had done work for the 1893 Columbian Exposition to make plaques, busts, and mosaics for the building's lobby and exterior façade in honor of Marquette. MacNeil (1866–1947) had assisted Philip Martiny in preparing sketch models for the exposition. MacNeil designed the four bronze plaques depicting the travels of Marquette and Jolliet that appear above the doors of the Dearborn Street façade; Edward Kemeys sculpted most of the bronze busts installed in the lobby. MacNeil often depicted Native American themes in his sculptures, which appear in public spaces throughout the United States.

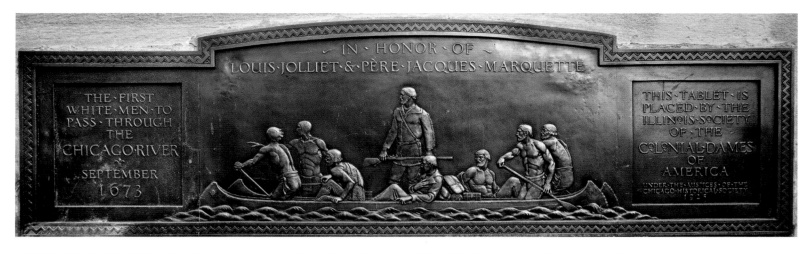

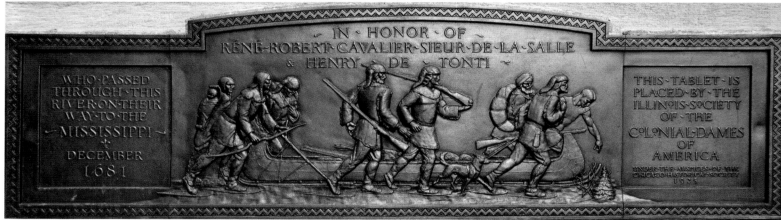

## JACQUES MARQUETTE AND LOUIS JOLLIET *and* RENÉ-ROBERT DE LA SALLE AND HENRY DE TONTI

### *by* WHEELER WILLIAMS

BRONZE | INSTALLED 1925 | EAST AND WEST WALKWAYS, MICHIGAN AVENUE BRIDGE

This sculpted tablet (top), on the East Walkway, part of a pair of pylon-mounted tablets honoring the passage of explorers on the Chicago River, recalls the passage of Marquette and Jolliet down the Chicago River in 1673. Its companion piece (immediately above) honors de la Salle and de Tonti, who canoed downriver in 1861 on their way to the Mississippi.

As described in the bulletin of the Chicago Historical Society, January, 1926, a program was held at the Historical Society on December 5, 1925, following the unveiling of the tablets at the bridge. Williams was born in Chicago and studied sculpture at the School of the Art Institute of Chicago.

## JACQUES MARQUETTE RELIEF *by* EMORY SEIDEL

BRONZE | INSTALLED 1930 | DAMEN AVENUE BRIDGE

When European explorers arrived in what would become Chicago, it was already home to many Native tribes whose encampments dotted the riverbanks and lakeshore. Explorers were attracted to the area where Lake Michigan met the Chicago River, which was also a pathway to the Mississippi River. First to arrive were Jacques Marquette (1637–1675), a Jesuit missionary and explorer, and Louis Jolliet (b. 1645, last seen 1700), a missionary and fur trader. This relief marks the location where Marquette and Jolliet spent the winter of 1674/1675 among the Kaskaskia tribe on their way back to Quebec after exploring the Mississippi River to the south. Now surrounded by industrial buildings, it is in sadly poor condition.

Emory Seidel (1881–1954) was a Chicago artist whose work is displayed publicly throughout the United States. He was affiliated with the School of the Art Institute of Chicago and worked under Charles Mulligan.

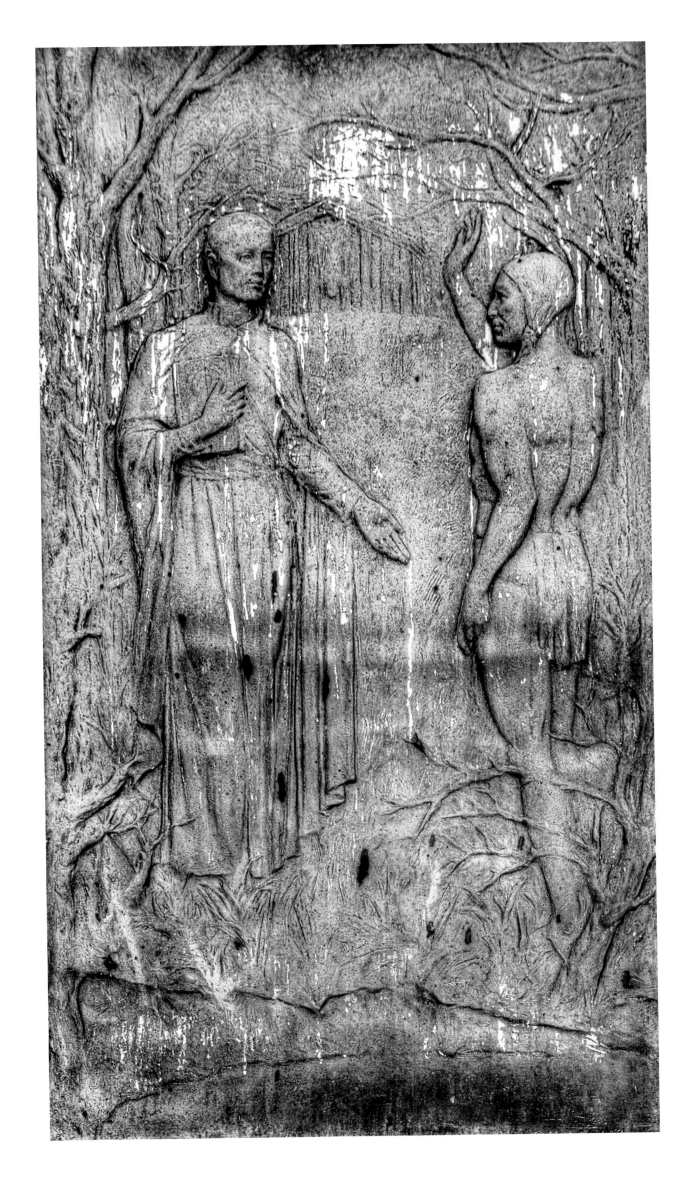

## JEAN-BAPTISE POINTE DU SABLE *by* ERIK BLOME

BRONZE | INSTALLED 2009 |
PIONEER COURT,
NORTH MICHIGAN AVENUE

Jean-Baptiste Point du Sable was influential in the development of the Chicago-Detroit region during the late 1770s. He established a home and trading post along the Chicago River where it joins with Lake Michigan (the approximate location, adjacent to the Tribune Tower, is now called Pioneer Court). It was later owned by John Kinzie, who arrived in 1804 (grave marker inset below). More recent than most of the works shown in *Chicago Monumental,* the du Sable bust is the only monument in the city honoring the historically significant early trader. Du Sable opened his first trading post at this exact location in the 1770s, helping to establish the settlement that would become today's city.

Native Chicagoan and Chicago resident Erik Blome (b. 1967) concentrates on figurative sculpture, from small busts to two-third lifesize (a bronze of an elephant for the Cote D'Ivorie embassy in Washington, D. C. and a likeness of James Jordan).

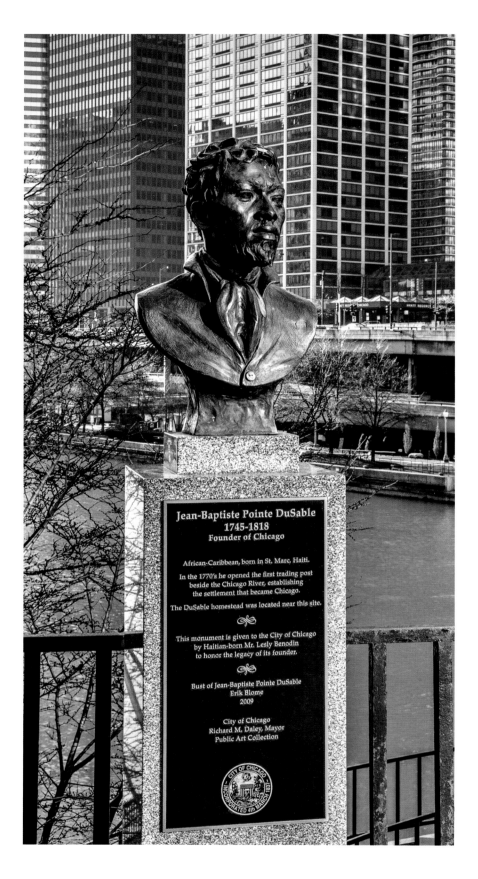

Jean-Baptiste Pointe DuSable
1745-1818
Founder of Chicago

African-Caribbean, born in St. Marc, Haiti.

In the 1770's he opened the first trading post beside the Chicago River, establishing the settlement that became Chicago.

The DuSable homestead was located near this site.

This monument is given to the City of Chicago by Haitian-born Mr. Lesly Benodin to honor the legacy of its founder.

Bust of Jean-Baptiste Pointe DuSable
Erik Blome
2009

City of Chicago
Richard M. Daley, Mayor
Public Art Collection

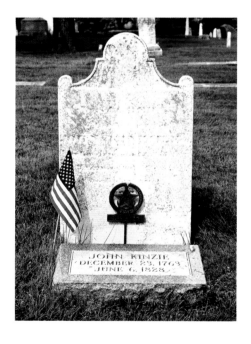

JOHN KINZIE
DECEMBER 23, 1763
JUNE 6, 1828

## ROBERT DE LA SALLE *by* COUNT JACQUES DE LA LAING ③D

BRONZE | INSTALLED 1889 | LINCOLN PARK AT THE JUNCTION OF CLARK AND NORTH AVENUES

The French explorer Rene-Robert Cavelier, Sieur Lasalle, or Robert de la Salle (1643–1687) built a cabin and stockade along the Chicago River in approximately 1681. It provided shelter for passing missionaries and fur traders. This statue was donated to Chicago by Lambert Tree. President Grover Cleveland appointed Tree minister to Belgium in 1885; while there, Tree commissioned Anglo-Belgian Jacques de la Laing (1858–1917) to create the work. It was cast in Belgium. De la Laing was a painter and sculptor specializing in animals who also produced allegorical bronzes and memorial art.

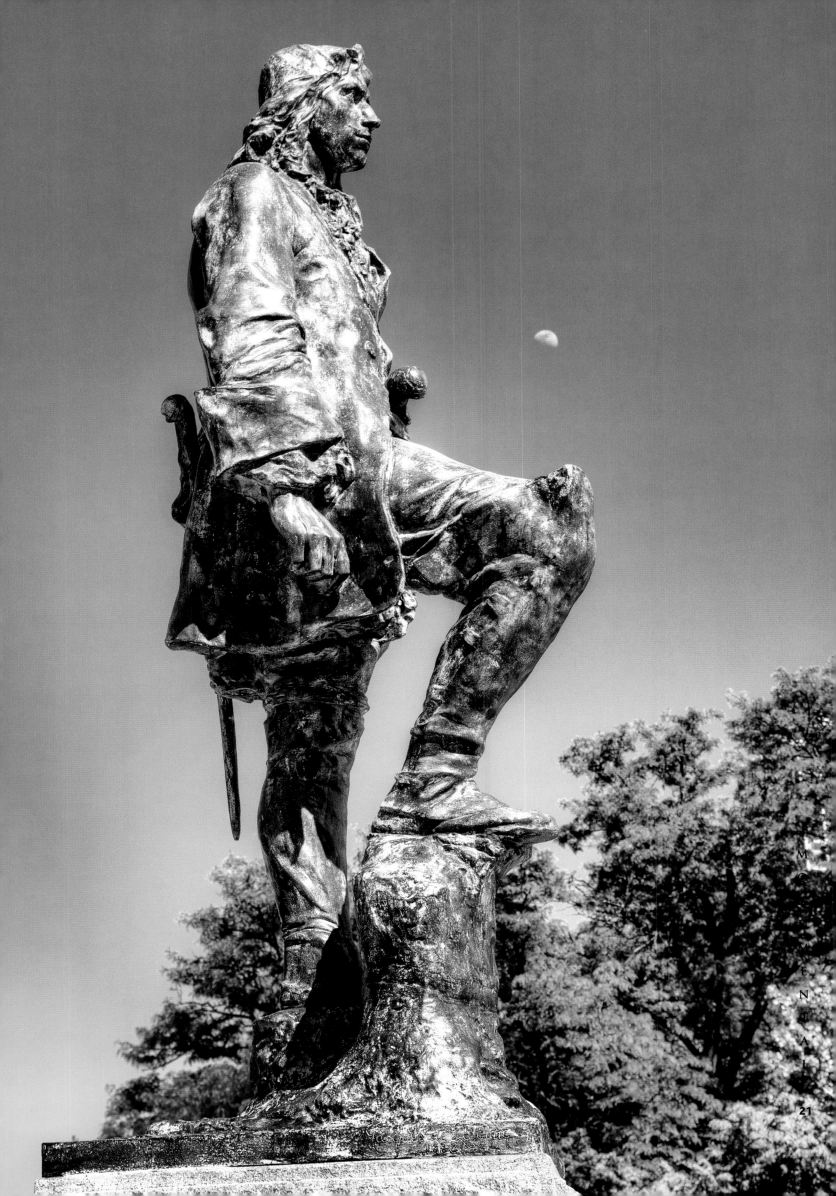

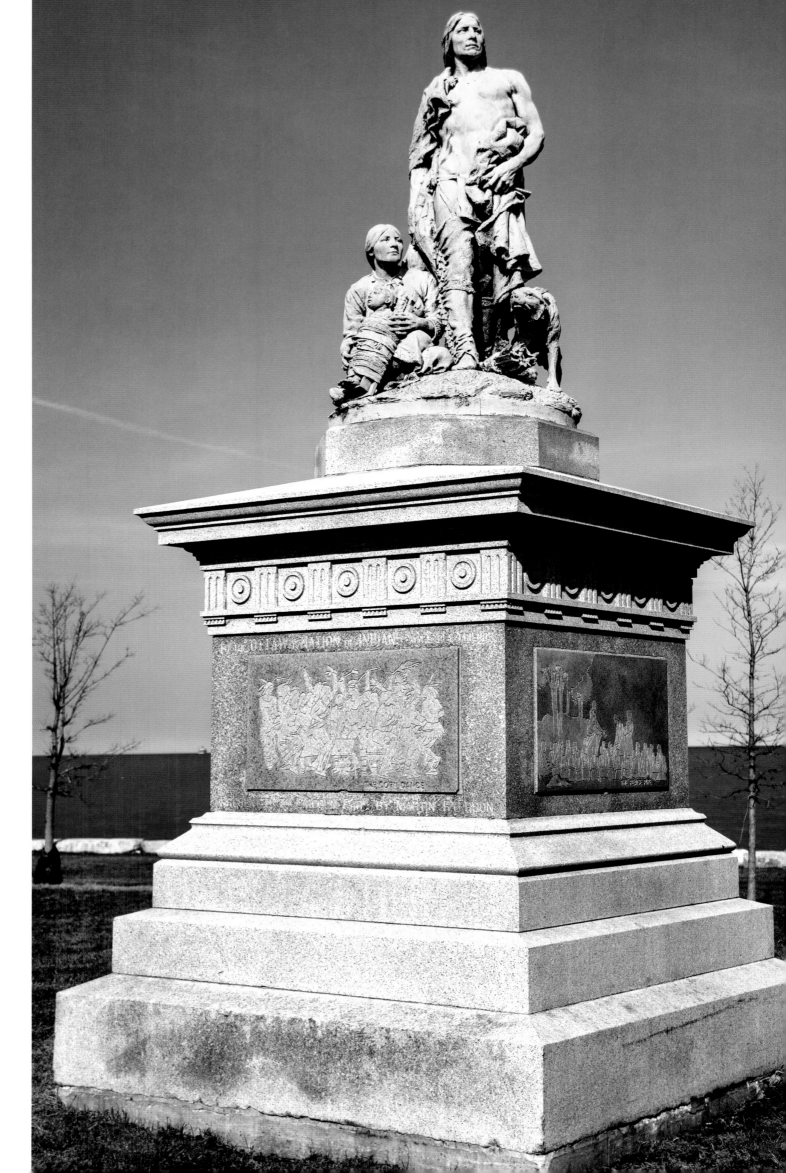

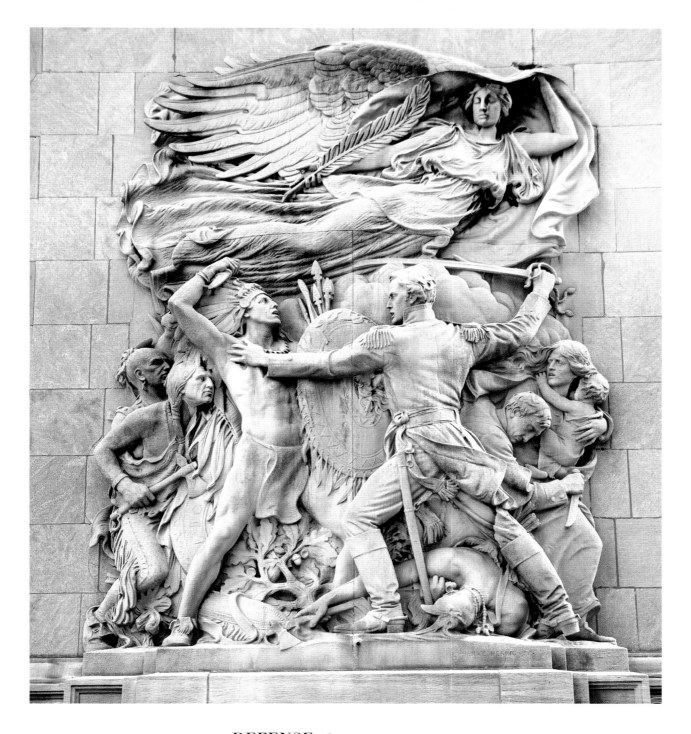

## DEFENSE *by* HENRY HERING

LIMESTONE | INSTALLED 1922 | SOUTHWEST PYLON OF MICHIGAN AVENUE BRIDGE

The soldiers from Detroit who built and occupied Fort Dearborn were ordered back to Detroit in 1812 to defend it against the British. The fifty-five army regulars, with women and children, who responded to the order were ambushed along the lakefront by Native tribesmen. Most of the soldiers were killed and the fort was destroyed by fire. This sculpture depicts the Battle of Fort Dearborn of August 15, 1812.

Henry Hering (1874–1949), born in New York City, studied with and was an assistant to Augustus Saint-Gaudens. He is mostly known for architectural sculpture.

## THE ALARM *by* JOHN J. BOYLE

BRONZE | INSTALLED 1884 | LINCOLN PARK, EAST OF LAKE SHORE DRIVE AT WELLINGTON AVENUE

*The Alarm* is the oldest monument erected on Chicago Park District land and the earliest to depict Native Americans. Commissioned by Martin Ryerson of Chicago, it was meant to serve as a memorial to the Ottawa Nation, early inhabitants of the Great Lakes region.

The work was the first major commission for John Boyle (1851–1917). He spent months observing Native Americans on their land prior to executing it. Other Boyle works are in Philadelphia and Washington, D. C. Boyle also designed bas-reliefs for the 1893 World's Columbian Exposition in Chicago.

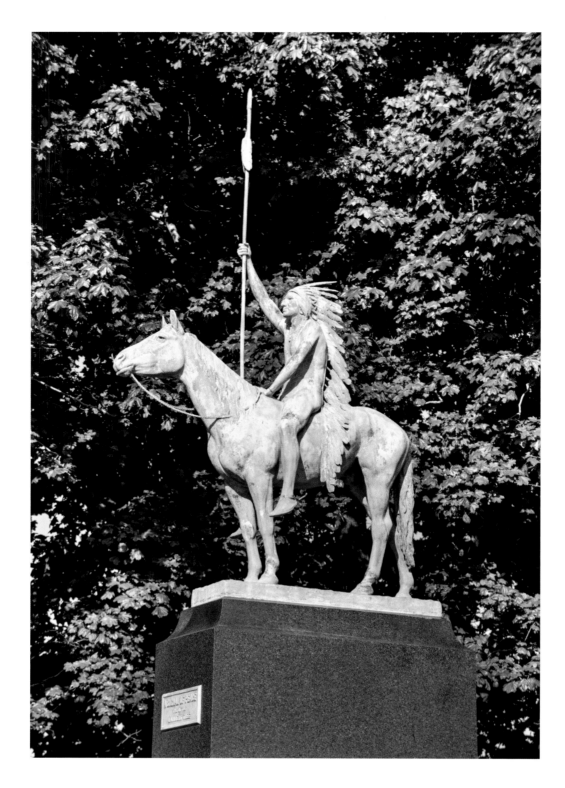

## A SIGNAL OF PEACE *by* CYRUS EDWIN DALLIN

BRONZE | INSTALLED 1894 | LINCOLN PARK, EAST OF LAKE SHORE DRIVE AT 2800 NORTH

*A Signal of Peace* was first exhibited at the World's Columbian Exposition in 1893 in Chicago. Judge Lambert Tree purchased the monument for placement in Lincoln Park. The American sculptor Edwin Dallin (1861–1944) was known for Native American subjects. His some two hundred works include a magnificent statue of Paul Revere located in Boston. He spent many years in the Boston area and for a time was a colleague of Augustus Saint-Gaudens.

## TOTEM POLE (KWA-MA ROLAS) *by* TONY HUNT

RED CEDAR | ORIGINAL INSTALLED 1929, REPLICA INSTALLED 1986 | LINCOLN PARK

The original version of this sculpture, donated to the city by James L. Kraft, founder of Kraft Foods, Inc., is believed to have been carved ca. 1900 in the Pacific Northwest by the Haida people. The Chicago Park District donated it to a museum in British Columbia in the 1980s.

Kraft commissioned Tony Hunt, a sculptor from Canada, to carve a replica; it was installed in Lincoln Park in 1986. Hunt (b. 1942) is a Canadian First Nation artist of Kwakwaka'wakw ancestry, born in British Columbia and known for his carved wood totem poles.

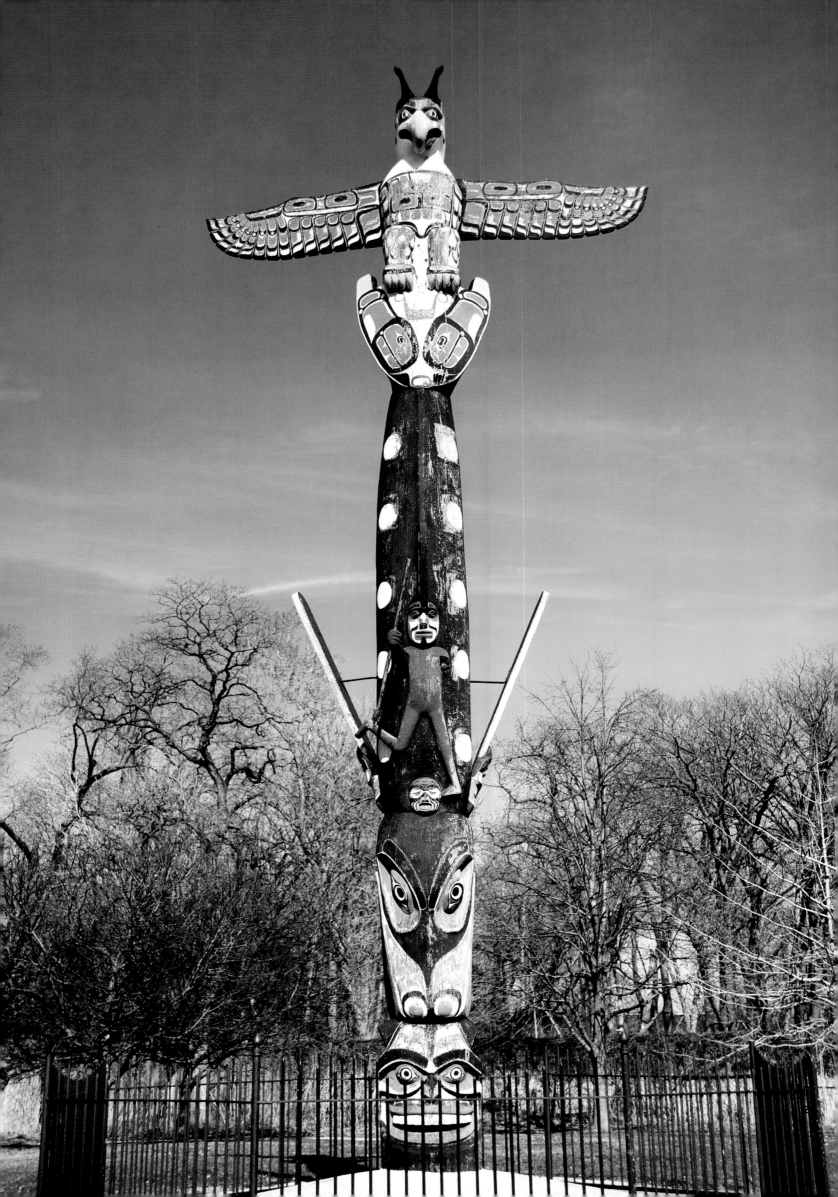

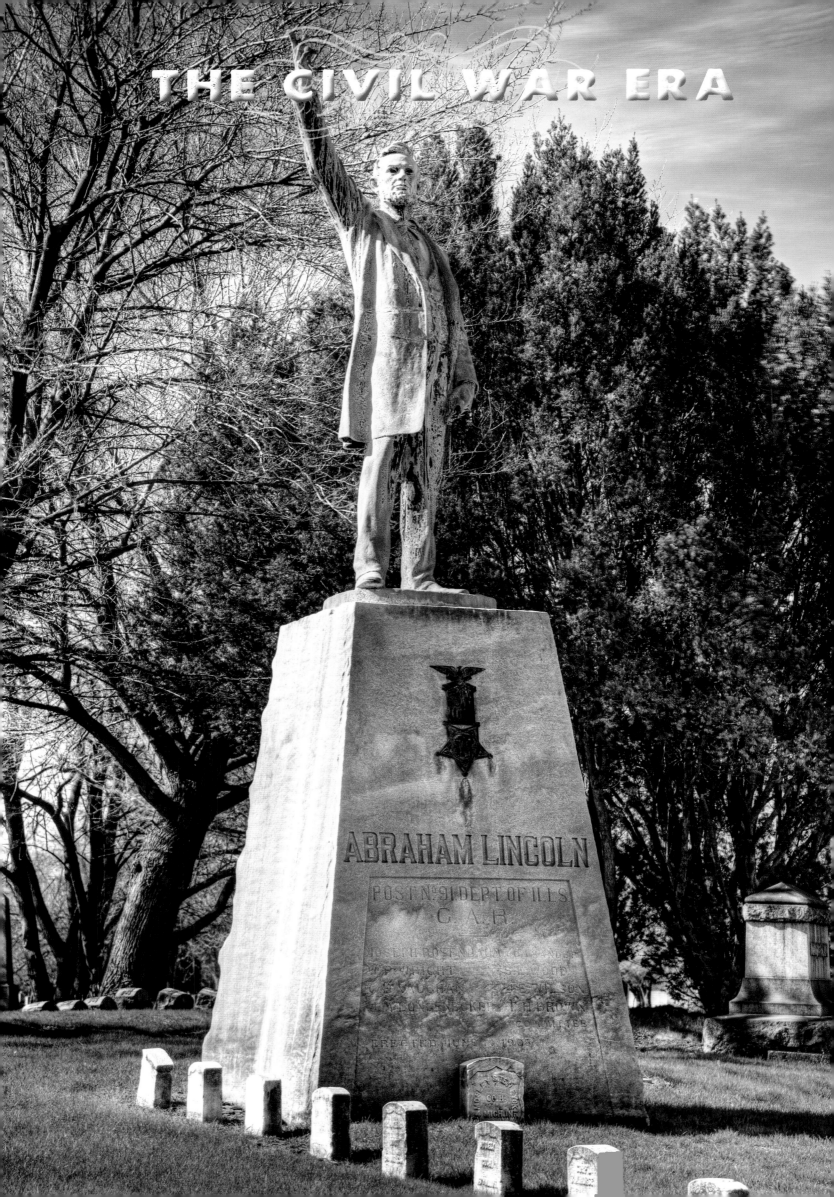

ABRAHAM LINCOLN

POST N° 91 DEPT OF ILLS
G.A.R.

*Four score and seven years ago our fathers brought forth on this continent a new nation, conceived in Liberty and dedicated to the proposition that all men are created equal.*

*Now we are engaged in a great civil war, testing whether that nation, or any nation so conceived and so dedicated, can long endure. We are met on a great battle-field of that war. We have come to dedicate a portion of that field as a final resting place for those who here gave their lives that that nation might live. It is altogether fitting and proper that we should do this. But, in a larger sense, we cannot dedicate—we cannot consecrate— we cannot hallow—this ground. The brave men, living and dead, who struggled here, have consecrated it far above our poor power to add or detract.*

*The world will little note, nor long remember, what we say here, but it can never forget what they did here. It is for us the living, rather, to be dedicated here to the unfinished work which they who fought here have thus far so nobly advanced. It is rather for us to be here dedicated to the great task remaining before us—that from these honored dead we take increased devotion to that cause for which they gave the last full measure of devotion—that we here highly resolve that these dead shall not have died in vain—that this nation, under God, shall have a new birth of freedom—and that government of the people, by the people, for the people, shall not perish from the earth.*

*Delivered by Abraham Lincoln on November 19, 1863, Gettysburg, Pennsylvania.*

## LINCOLN AT GETTYSBURG (LINCOLN THE ORATOR)
### *by* CHARLES MULLIGAN
BRONZE | INSTALLED 1905 | OAK WOODS CEMETERY, CHICAGO

Post 91 of the Department of Illinois Grand Army of the Republic (Union Army veterans) erected this eleven-foot monument in a section of Oak Woods Cemetery reserved for Union soldiers. Lincoln overlooks many graves of soldiers from all over the Union states. Most of their headstones are still legible. The statue is a replica of one by Mulligan installed in Pana, Illinois, in 1903. Here Lincoln wears the beard that he grew after he became president.

The event that triggered the Civil War on April 12, 1861, was the shelling of Fort Sumter by Confederate forces. In the bloody four-year war that ensued, more than 600,000 people would die and another 400,000 be wounded.

On November 19, 1863, at the dedication of the Soldiers' National Cemetery in Gettysburg, Pennsylvania, Lincoln delivered one of the best-remembered speeches in American history. In 272 words in just over two minutes, the president inspired his listeners with the principles espoused in the Declaration of Independence. He proclaimed the Civil War a struggle for the preservation of a Union sundered by secession. The speech was delivered four months after Union armies defeated those of the Confederacy at what is now known as the Battle of Gettysburg.

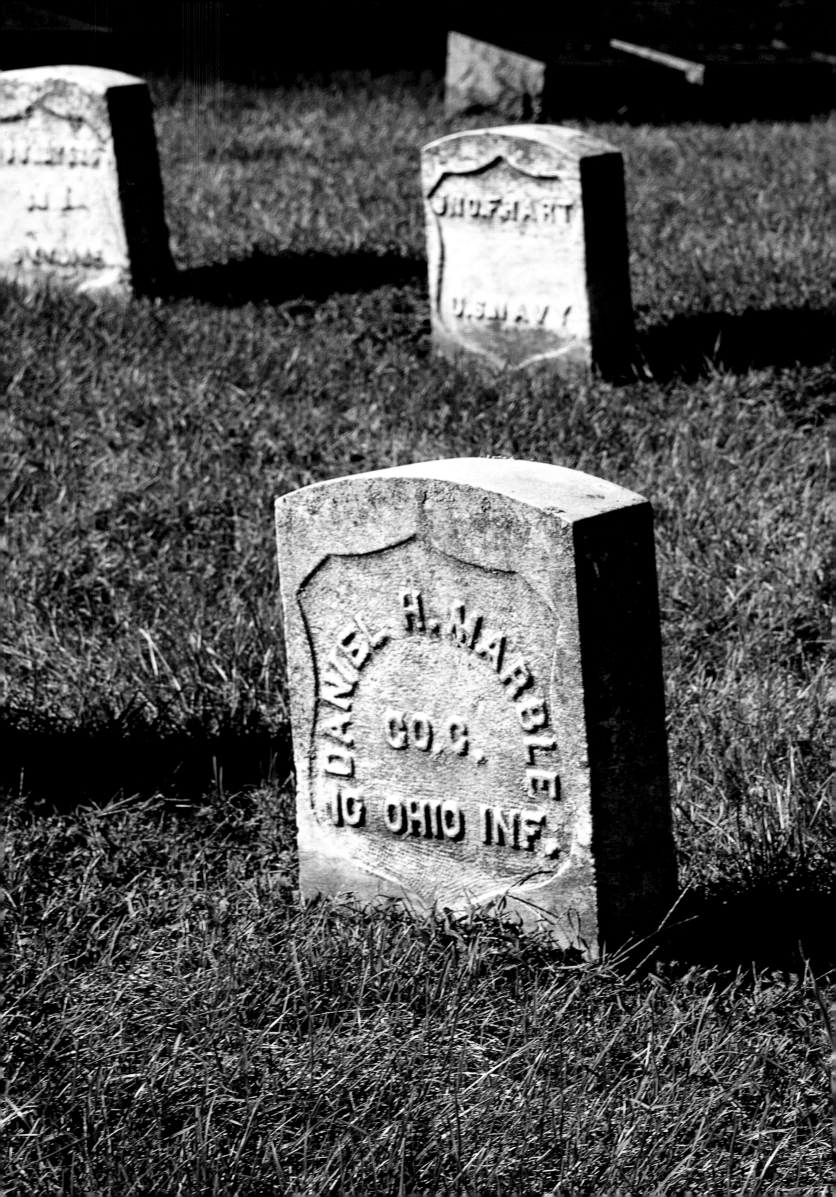

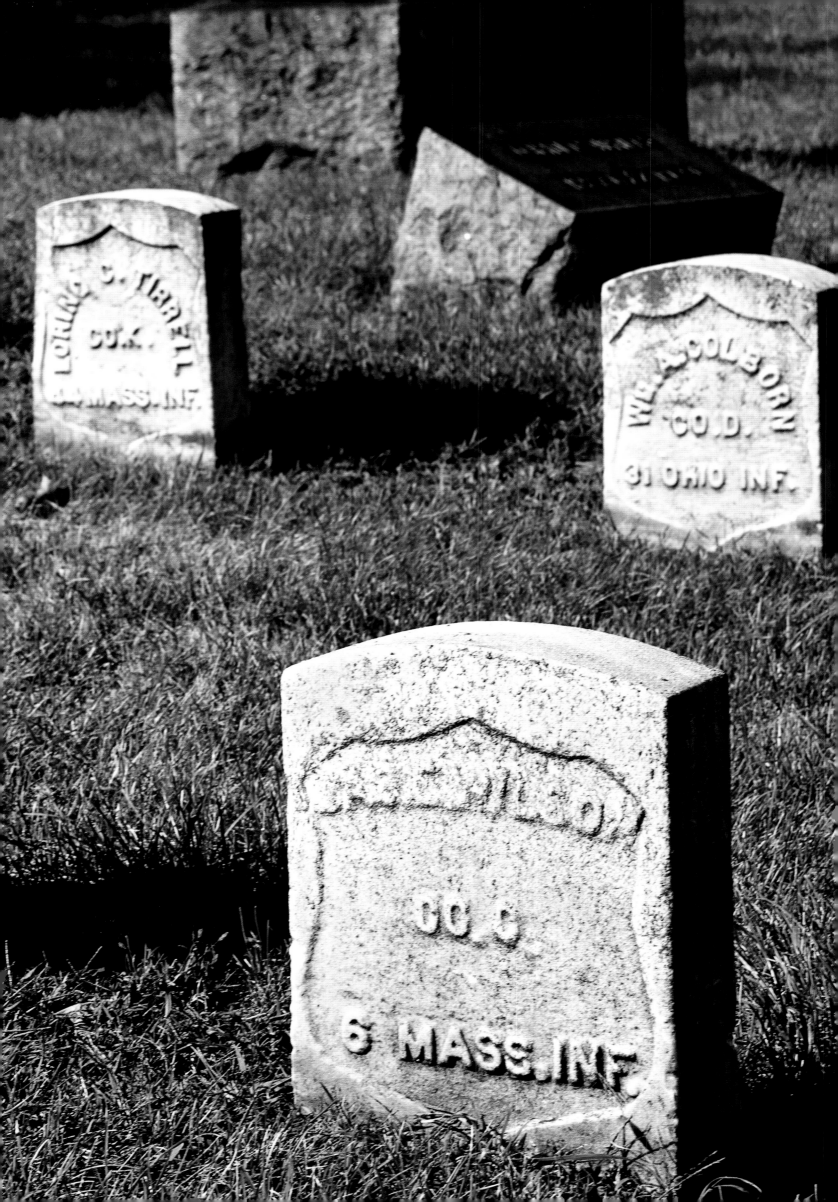

Although no Civil War battles were fought in Chicago, the city's importance during the era can be judged in part by the number of its monuments that commemorate the period. Five American presidents are memorialized in Chicagoland: Grant, Lincoln, McKinley, Washington, and Teddy Roosevelt. Among them are seven honoring Abraham Lincoln, likely the largest concentration of Lincoln commemorations in the U.S. Lincoln is depicted here, axe in hand and sleeves rolled up, as a rail splitter, symbolizing that as a young man he held various odd jobs in an effort to contribute to the support of his family.

Charles Mulligan (1866–1916) studied at the School of the Art Institute of Chicago with Lorado Taft. Taft made Mulligan foreman of the workshop producing sculpture for the 1893 Columbian Exposition in Chicago. His first sculpture of Lincoln, *Lincoln the Orator*, was installed in a cemetery in Pana, Illinois. Other Chicago sculptures include *William McKinley,* 1905; *The Miner and his Child,* 1901; and *Lincoln at Gettysburg* (replica in Oak Woods Cemetery, Chicago), 1905.

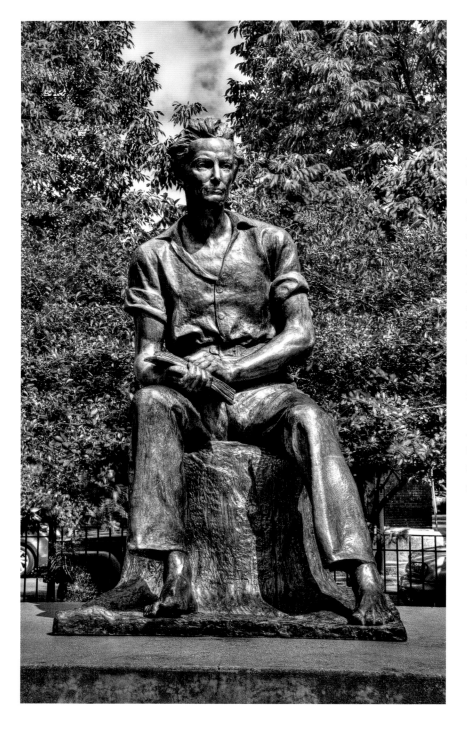

## YOUTHFUL ABRAHAM LINCOLN
### *by* CHARLES KECK
#### BRONZE | INSTALLED 1945 | CHICAGO PUBLIC LIBRARY, MOVED TO SENN PARK IN 1997

Lincoln came from a modest family and was largely self-taught. He is depicted in the thirteen-foot-tall sculpture as an ordinary man sitting on a tree stump with his learning materials. The sculpture was donated by the Keck family to the Chicago Public Library. Lincoln's strong connection to Chicago dates to the move of his family to Illinois when he was twenty years old, his practice of law in Illinois, and his nomination as the Republican presidential candidate in 1860 in Chicago.

Charles Keck (1875–1951), an American sculptor, was an assistant to Augustus Saint-Gaudens from 1893 to 1898. He is noted for architectural sculpture.

C
H
I
C
A
G
O

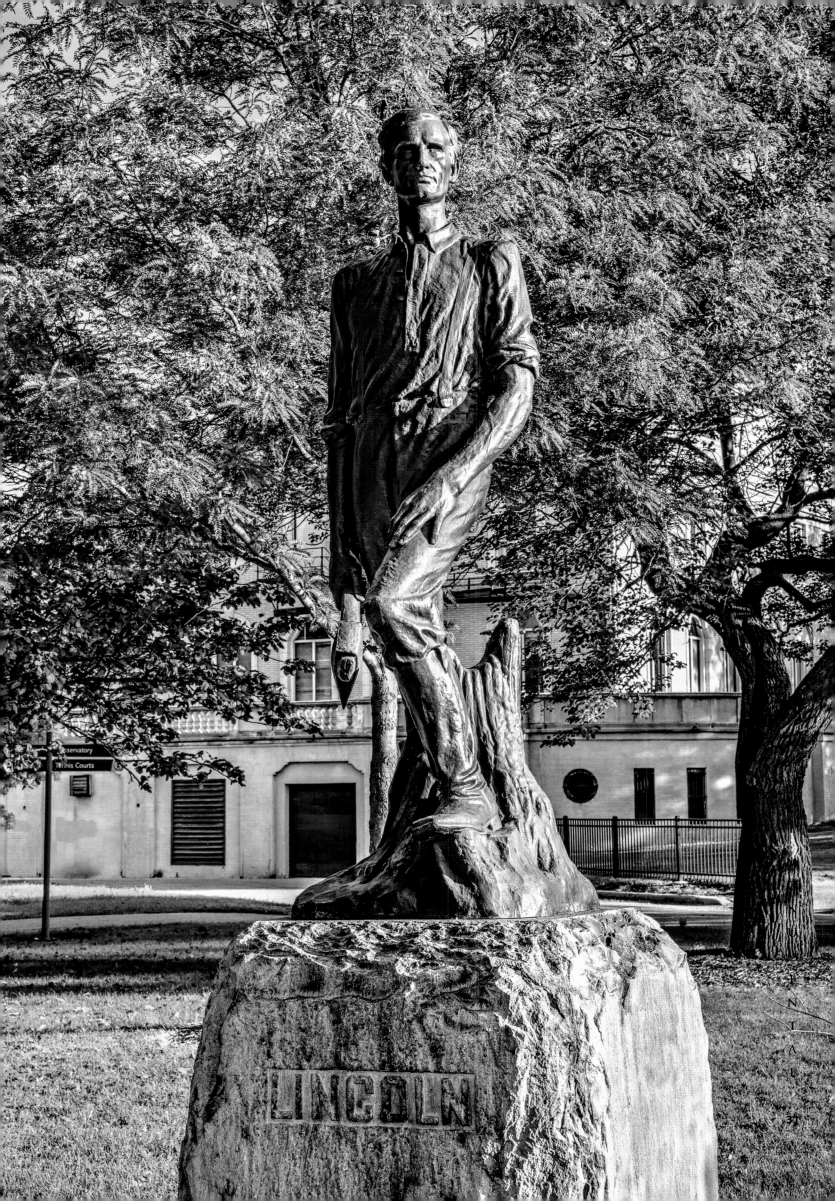

LINCOLN

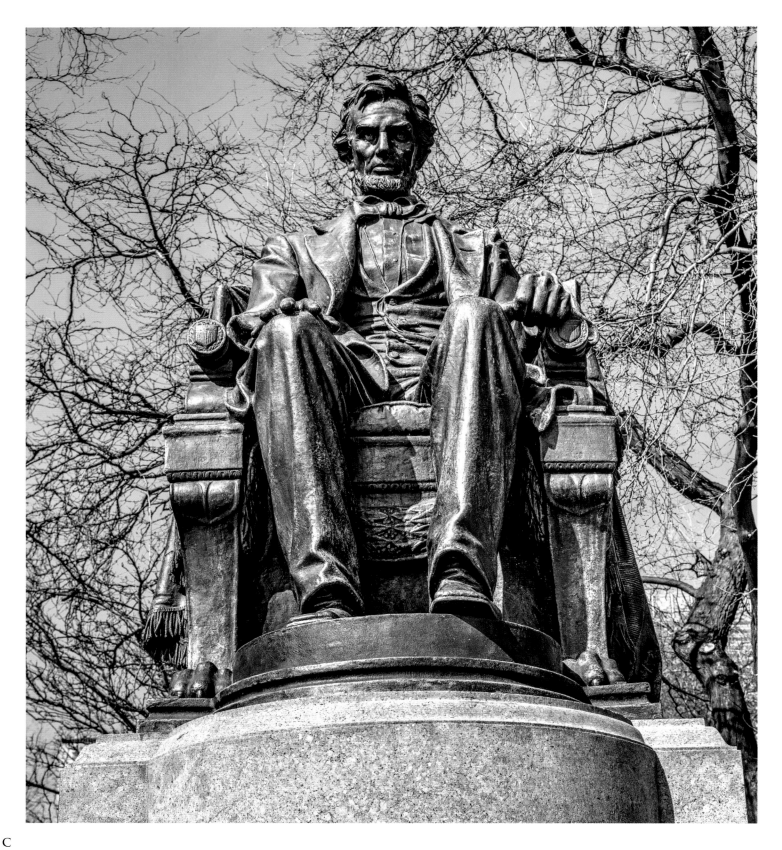

## LINCOLN, HEAD OF STATE (SEATED LINCOLN)
### *by* AUGUSTUS SAINT-GAUDENS
BRONZE | INSTALLED 1926 | GRANT PARK

*The Seated Lincoln* was considered by Saint-Gaudens to be his greatest work. Twelve years in the design stage, it was completed by his studio in 1908, a year after his death. The wealthy Chicago industrialist John Crerar (d. 1889) had bequeathed funds in his will for a Lincoln monument. Executors of his estate commissioned Saint-Gaudens in 1897 to sculpt the work. It was first displayed at the Metropolitan Museum of Art in New York City and then in 1915 at the Panama-Pacific International Exposition in San Francisco.

The delayed installation in Grant Park resulted from a court case brought by Aaron Montgomery Ward, who opposed the proposed location of the monument, which includes not only Lincoln seated on a chair but a 150-foot wide exedra with fifty-foot-tall fluted columns at either end.

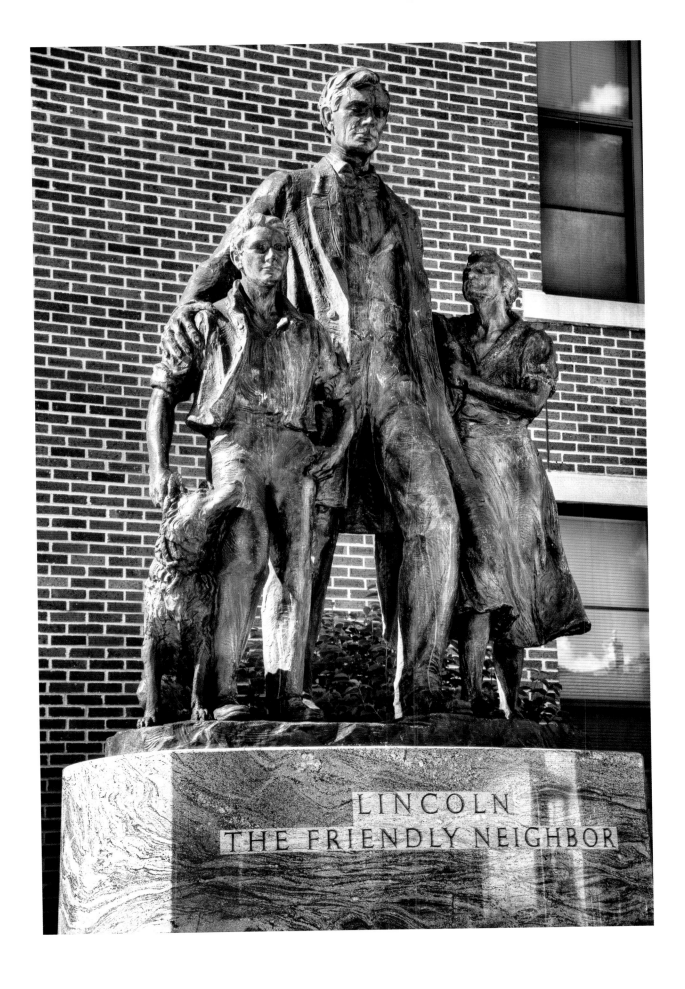

## LINCOLN THE FRIENDLY NEIGHBOR *by* AVARD FAIRBANKS

BRONZE | INSTALLED 1959 | LINCOLN MIDDLE SCHOOL

This statue was commissioned by Lincoln Federal Savings and Loan and originally placed in front of the bank building. The depiction of a friendly Lincoln shows him with two children and a dog, his arm around the young boy.

Avard Fairbanks is also the sculptor of *The Chicago Lincoln* (1956).

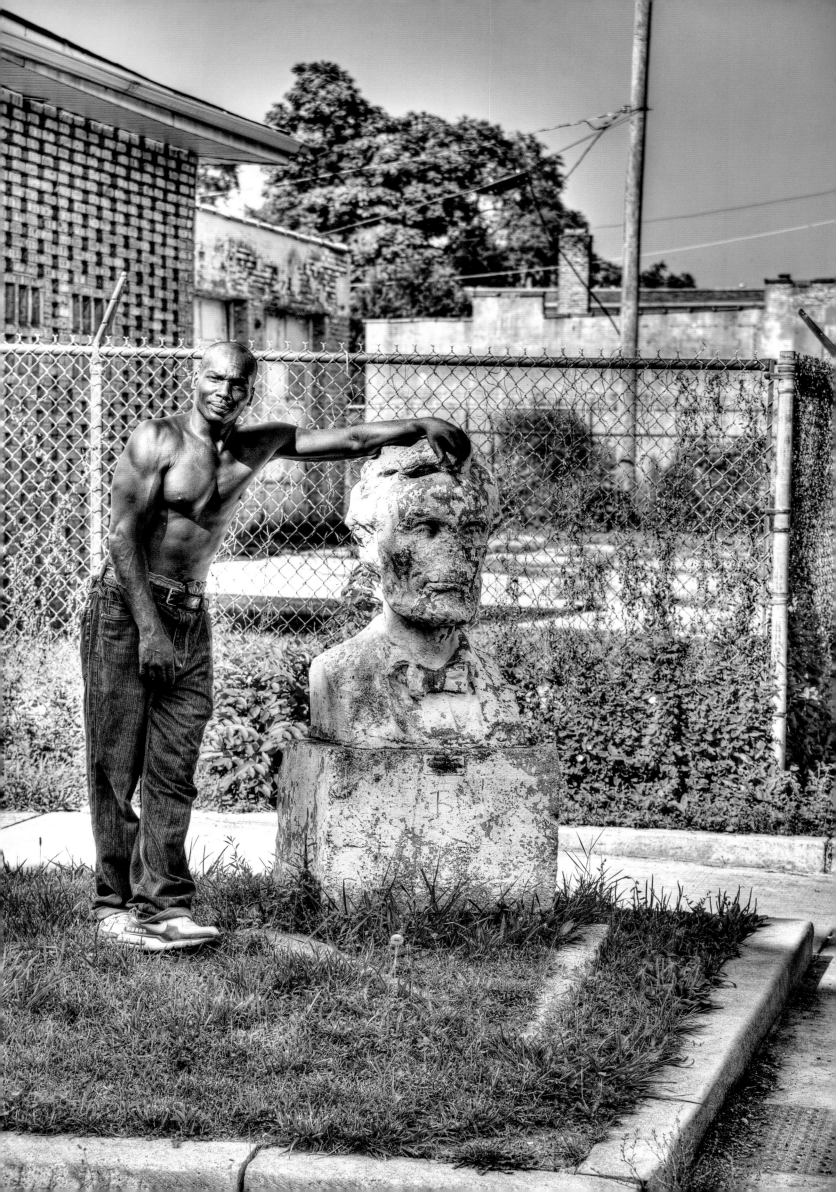

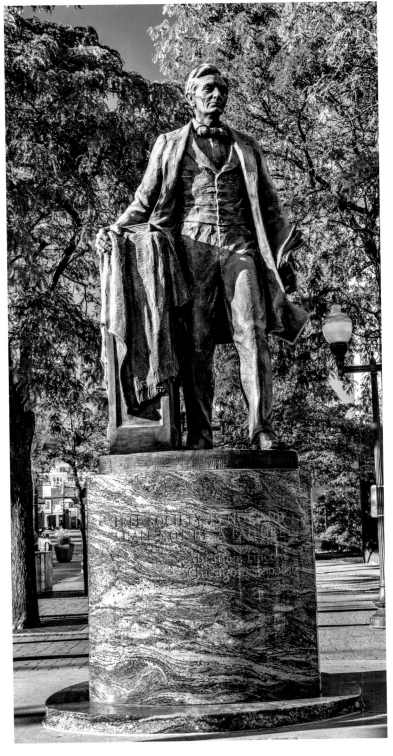

## THE CHICAGO LINCOLN
*by* **AVARD FAIRBANKS**
BRONZE | INSTALLED 1956 |
INTERSECTION OF LINCOLN AND
WESTERN AVENUES

Holding books and his stovepipe hat, Lincoln here has a youthful look. Words from an 1856 Chicago speech inscribed on the base read: *"Free society is not, and shall not be, a failure."* Even before Lincoln's inauguration on March 4, 1861, his known opposition to the expansion of slavery into U.S. territories resulted in seven slave states seceding from the Union and forming the Confederate States of America.

A prolific 20th-century American sculptor, Avard Fairbanks (1897–1987) has three sculptures in Washington, D. C. and many in Temple Square in Salt Lake City, Utah. He is also known for designing the ram symbol for the Dodge Company. Other Chicago sculptures include *Lincoln the Friendly Neighbor* (1959).

## THE FORGOTTEN LINCOLN *by* AN UNKNOWN SCULPTOR
CONCRETE | INSTALLED 1926 | 68TH STREET AND SOUTH WOLCOTT AVENUE

In 1926 Phil Bloomquist erected a bust of Lincoln at the corner of 69th Street and South Wolcott Avenue, where it still stands today. Bloomquist's name and the date 1926 appear on a metal tag attached to the work's base. According to published articles, Wolcott Avenue was originally named Lincoln Street, and the name was changed in 1939. Bloomquist was said to have owned the Lincoln Gas Station on this corner and commissioned the statue as a means of advertising.

In the 1920s, this West Englewood neighborhood was largely populated by Scandinavians, Germans, Italians, and other European immigrants. Today, it is mostly African American. The statue is severely eroded and has been painted various colors over the years; gang symbols and other graffiti have been sprayed on its base.

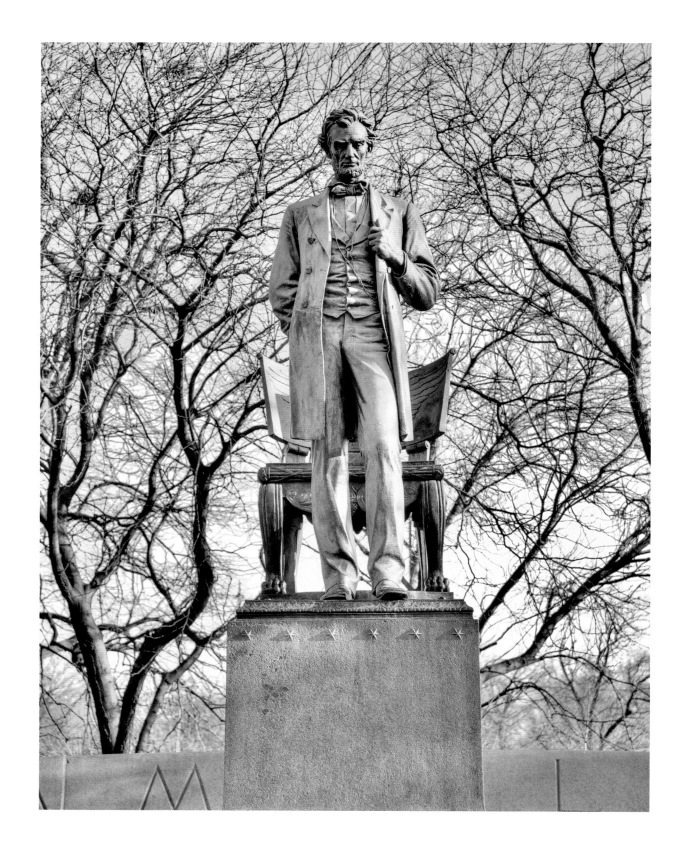

## LINCOLN THE MAN (STANDING LINCOLN) *by* AUGUSTUS SAINT-GAUDENS
### BRONZE | INSTALLED 1887 | LINCOLN PARK

This statue has been regarded the best likeness of Lincoln of any in the United States. It is based on the life masks of face and hands made earlier by Leonard Volk. It has also been considered one of the best works of monumental art in the United States. The nearly twelve-foot-high statue is so lifelike that it appears as if its subject has just arisen from the beautiful chair behind him. It is lit at night, as are many other monuments in Chicago.

The revered Saint-Gaudens (1848–1907) was born in Ireland and raised in New York. He achieved major success for monuments commemorating heroes of the Civil War and was an important artistic adviser for the World's Columbian Exposition of 1893. He employed and taught other major sculptors, including James Earle Fraser and Henry Hering, whose works are in Chicago. Other Chicago sculptures by Saint-Gaudens are *Lincoln the Head of State (Seated Lincoln)*, 1926, and *General John A. Logan*, 1897.

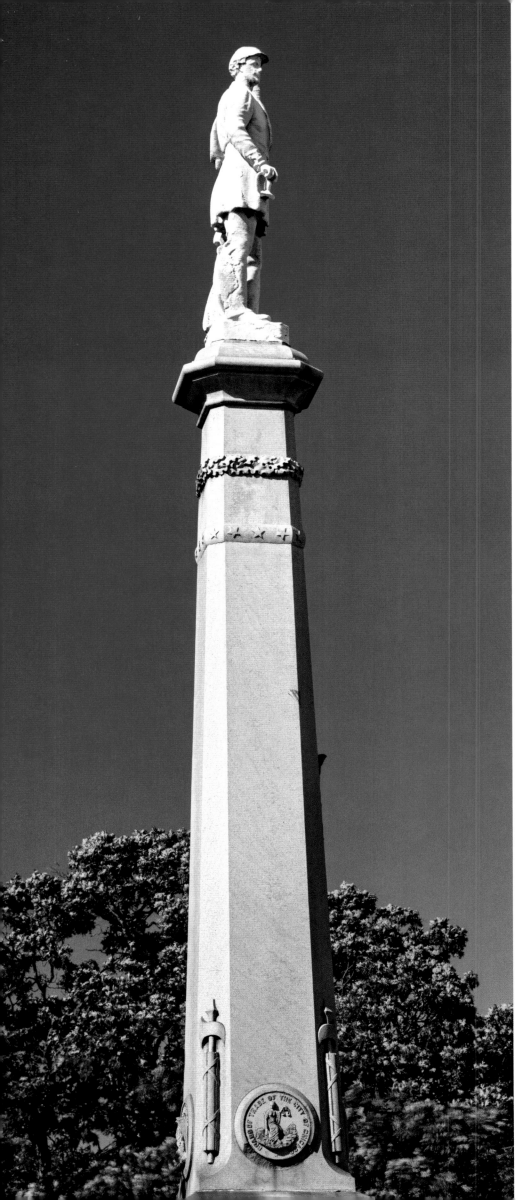

## OUR HEROES 3D
### *by* LEONARD VOLK

LIMESTONE AND MARBLE |
INSTALLED 1869 | ROSEHLL
CEMETERY

There are beautiful, meaningful, and well preserved Civil War memorials in at least four cemeteries in the Chicago area: Oak Woods, Bohemian, Elmwood, and Rosehill. Rosehill Cemetery was founded in 1859, and at 350 acres is the largest cemetery in Chicago. It was built far north of what were then the city limits. Numerous Civil War generals and soldiers, Chicago mayors, and many influential Chicagoans are buried here. In this thirty-foot-high monument dedicated to Union soldiers who died in the Civil War a limestone shaft is topped by a marble Union standard bearer holding his flag. A regimental memorial erected in 1874 near *Our Heroes* consists of a flag-draped marble cannon. It honors the men of the Chicago Light Artillery/Battery A who were killed in the war. Some two hundred graves are located near the cannon. Leonard Volk (1828–1895), is also buried at the cemetery. Other Chicago sculptures by Volk are the *Volunteer Fire Fighters Monument,* the Volk family monument, and the *Stephen Douglas Tomb and Monument.*

## STEPHEN A. DOUGLAS MONUMENT AND TOMB *by* LEONARD W. VOLK
BRONZE AND MARBLE | INSTALLED 1881 | DOUGLAS STATE PARK

Stephen Douglas was Illinois's Democratic senator from 1847 until his death. In those years senators were elected by state legislatures. In 1858 he was challenged for his seat by Republican Abraham Lincoln. Douglas and Lincoln debated on several occasions, now known as the Lincoln-Douglas debates. Douglas was reelected to the Senate, handing Lincoln a major defeat. In 1860, Douglas was the Democratic candidate for the presidency; Lincoln was the candidate of the Republican party. Lincoln defeated Douglas after a vigorous campaign on both sides. Nevertheless, when asked by Lincoln, he toured the border states at the beginning of the Civil War seeking support for the Union cause. He died shortly after of typhoid fever. The epitaph on his tomb reads *"Tell my children to obey the laws and uphold the constitution."*

Douglas's body rests in a sarcophagus of white Vermont marble from his original home state. The mausoleum containing the tomb is flanked by plinths holding seated allegorical female figures. *Justice* rests her hand on a sheathed sword while *Eloquence* points to the

statue of Douglas atop the monument. The mausoleum supports an approximately fifty-foot column which holds a nearly ten-foot statue of Douglas. Bronze panels on the sides of the column depict the advancement of European civilization in America. Douglas was only five feet, five inches, but had a massive chest and head, an intellect to match, and was referred to as "the little giant."

Leonard Volk (1828–1895) is most notable for making a life mask of Lincoln in 1860 during a visit to Chicago by Lincoln. Later in the year he also made castings of both hands. He used these for his sculptures of Lincoln, as did other well-known sculptors creating Lincoln memorials. These castings are preserved in the Smithsonian Institution. As an aside, Volk's wife was a close cousin of Stephen Douglas. Volk and his wife are buried in Chicago's Rosehill Cemetery in a plot marked by a lifelike monument of Volk's design. Other Chicago sculptures by Volk are the *Civil War Monument* (1869) and *Volunteer Firefighters Monument* (1864).

## GENERAL PHILIP HENRY SHERIDAN
### *by* GUTZON BORGLUM
BRONZE | INSTALLED 1923 |
WEST OF LAKE SHORE DRIVE
AT BELMONT

General Sheridan, a celebrated Union Civil War general, is famous for leading critical campaigns that defeated Confederate troops. He was commander of the army headquarters in Chicago at the time of the Great Chicago Fire of 1871 and is credited with limiting the spread of the fire.

While Gutzon Borglum (1867–1941) is most known as the sculptor of the presidential heads at Mount Rushmore, his two sculptures of General Sheridan on his horse, Winchester, one in Washington, D.C. and this one in Chicago, are most impressive. An American artist trained in Paris, he was friendly with and influenced by Auguste Rodin. His other sculpture in Chicago is *John Peter Altgeld*.

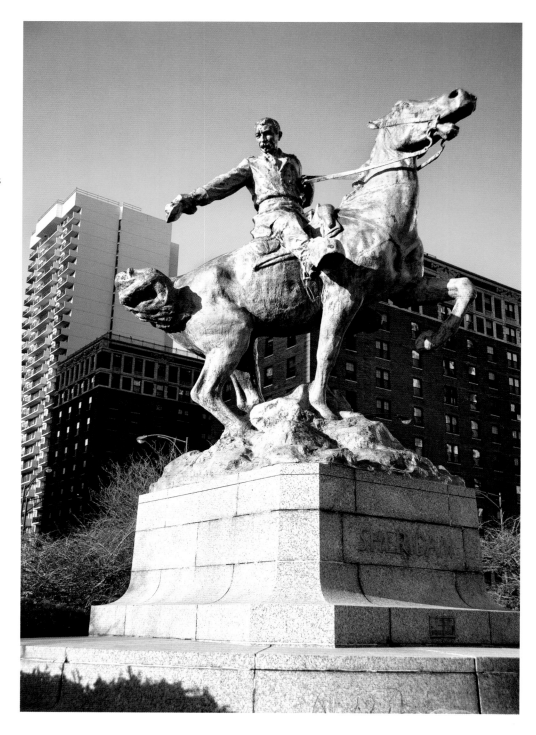

## GENERAL JOHN A. LOGAN *by* AUGUSTUS SAINT-GAUDENS
### *and* ALEXANDER PHIMISTER PROCTOR
BRONZE | INSTALLED 1897 | GRANT PARK

General Logan (1826–1886), born in Illinois, was a volunteer in the Mexican War of 1846–1847 and a U.S. congressman elected in 1858. At the start of the Civil War, he returned to the army and served under generals Grant and Sherman. He was responsible for establishing Memorial Day, first observed on May 30, 1868. Shortly after his death, the state of Illinois commissioned Augustus Saint-Gaudens and Alexander Proctor to create the sculpture.

Other Chicago sculptures by Saint-Gaudens (1848–1907) are *Lincoln, the Man*, 1887; and *Lincoln, Head of State*, 1926. Alexander Proctor (1860–1950), an American sculptor, spent much of his early life in Denver and on the American frontier. He had a keen interest in animals and, after his art studies, concentrated on drawing and sculpting animals in action. Proctor sculpted the horse while Saint-Gaudens sculpted Logan.

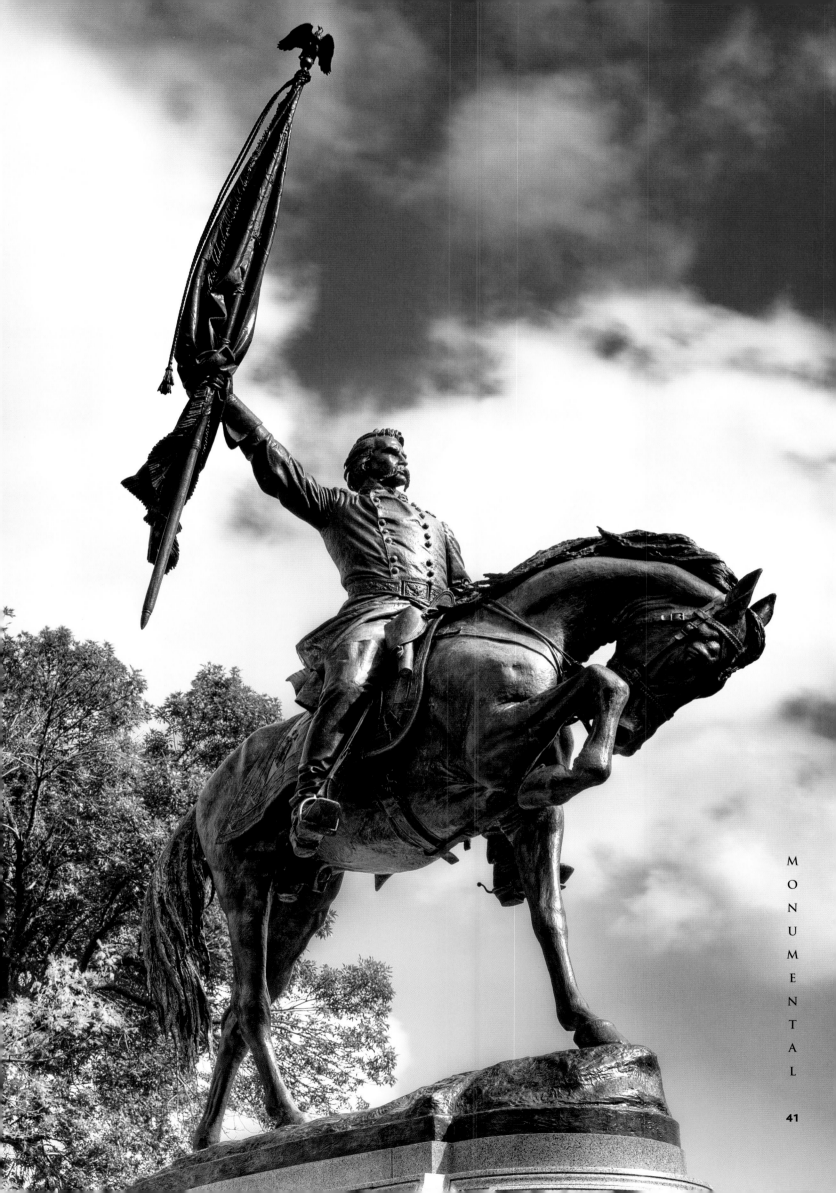

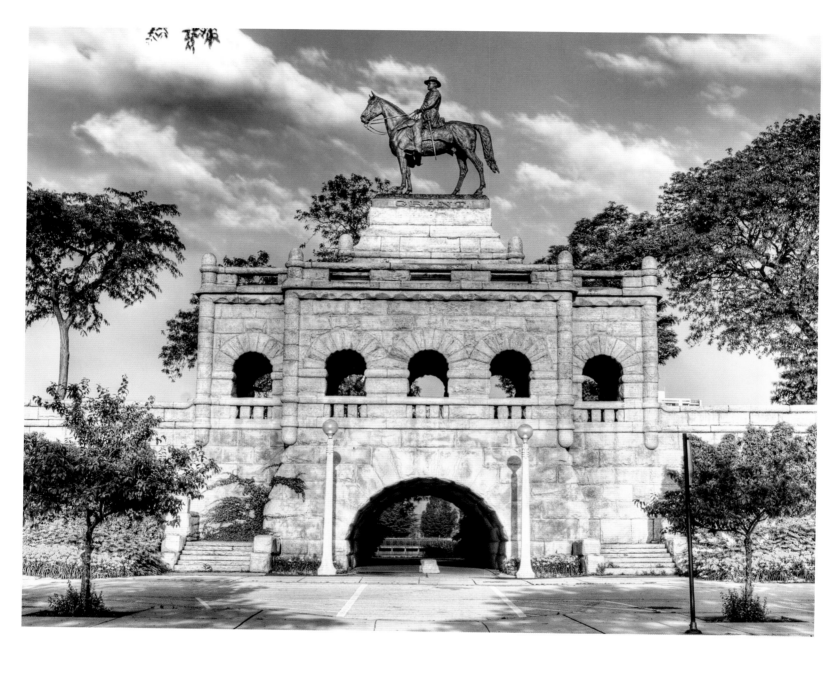

## GENERAL ULYSSES S. GRANT *by* LOUIS T. REBISSO

BRONZE | INSTALLED 1891 | LINCOLN PARK

Ulysses S. Grant (1822–1885), commander of the Union forces, was instrumental in helping to end the Civil War. In 1869, at forty-five, he became the eighteenth and youngest president to that date; he was reelected in 1873 and served until 1877. The memorial sculpture of Grant on his horse stands eighteen feet high and sits atop a stone base on top of a hill, so it is visible from a great distance in all directions.

Grant Park was named for Grant after the Grant monument was installed in Lincoln Park and deemed too expensive to move.

Italian-born Louis Rebisso (1837–1899) won the competition to create the sculpture shortly after the general's death in 1885. More than 200,000 Chicagoans are said to have attended its unveiling.

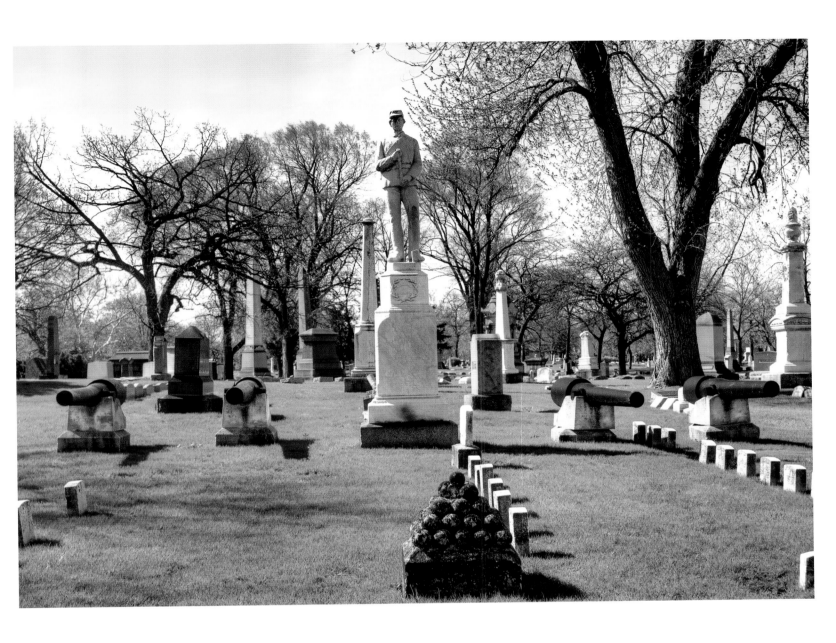

## SOLDIER'S MONUMENT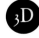

LIMESTONE | INSTALLED 1876 | OAK WOODS CEMETERY

This commemorative monument features a "private soldier" (*Chicago, the Garden City,* by Andreas Simon, 1893) and was erected by a director of the Chicago Soldiers' Home. Included are four Civil War–era cannons with small piles of cannon balls.

Rising from a marble pedestal, the monument overlooks the graves of about seventy Union veterans.

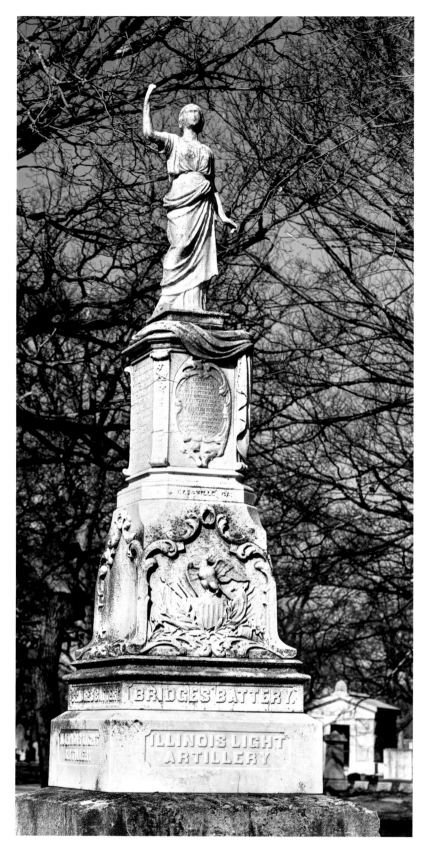

## ILLINOIS BRIDGE'S BATTERY MONUMENT

LIMESTONE | INSTALLED 1869 |
ROSEHILL CEMETERY

Bridge's battery was transferred to the Illinois light artillery in late 1864 after serving in the western theater. The graves of some twenty-five soldiers from the battery are interred on a plot memorialized by a figure representing Hope, with the crest of the United States on her pedestal. It is significantly weathered and eroded, and inscriptions are difficult to read. Surrounding the statue are ten captured cannon barrels sunk into the ground.

Also interred at Rosehill Cemetery is Major General Thomas E. G. Ransom (1834–1864), a model of bravery. Born in Vermont, he lived in Illinois in 1861, where he raised a contingent of soldiers to become Company E of the 11th Illinois Infantry, answering Lincoln's call for volunteers at the start of the Civil War. Severely wounded in four battles between 1861 and 1864, Ransom succumbed to dysentery after returning to Georgia to resume command. When told he was about to die, he is reported to have said, "I am not afraid to die, I have met death too often to be afraid of it now." General Grant often referred to Ransom in his speeches, and General Sherman kept a photograph of him in his office twenty years after the war. General Ransom is buried adjacent to a plot of graves of Union guards and parolees from Camp Douglas, the prisoner-of-war camp in Chicago that held thousands of Confederate soldiers during the war.

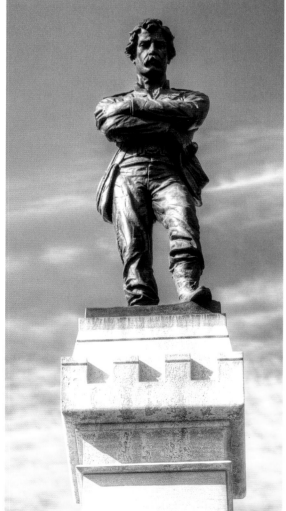

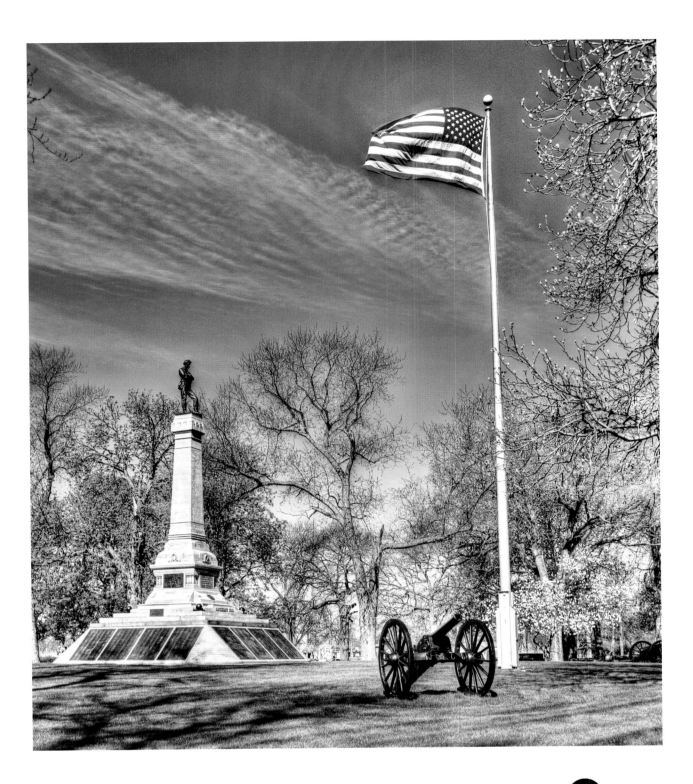

## CONFEDERATE MOUND *by* JOHN C. UNDERWOOD 3D

### BRONZE AND GRANITE | INSTALLED 1893 | OAK WOODS CEMETERY

Topping a thirty-foot column at Confederate Mound Monument (bottom of facing page and above) is a Confederate soldier. The monument was designed by military engineer John Underwood after the painting *Appomatox* by John A. Elder. Graves of those who died at Camp Douglas are arranged concentrically around it. Land once owned by Stephen A. Douglas (south of 31st Street and west of Cottage Grove Avenue) became a training camp for Union troops during the Civil War. After a major win by Ulysses S. Grant resulted in the capture of about 7,000 Confederate soldiers, they were housed there. Eventually some 9,000 were interned. Cold weather, inadequate facilities, and lack of medical care killed more than two-thirds of them. In 1867, the U.S. government acquired a two-acre plot in Oak Woods Cemetery, which it still

maintains, for a monument and burial location for those who died at Camp Douglas. The soldiers' remains had first been interred on the camp's grounds and at the old City Cemetery in Lincoln Park. Between 1865 and 1867 they were moved to Oak Woods.

Underwood (1840–1913), eldest son of a U.S. congressman and the only member of his family to embrace the Confederate cause, became a Confederate general, was captured and imprisoned in 1863, and in 1865 was paroled by President Lincoln. Later he was mayor of his hometown of Bowling Green, Kentucky, and a regional head of the United Confederate Veterans. He attended the monument's dedication on May, 30, 1895, with President Grover Cleveland and some 100,000 others.

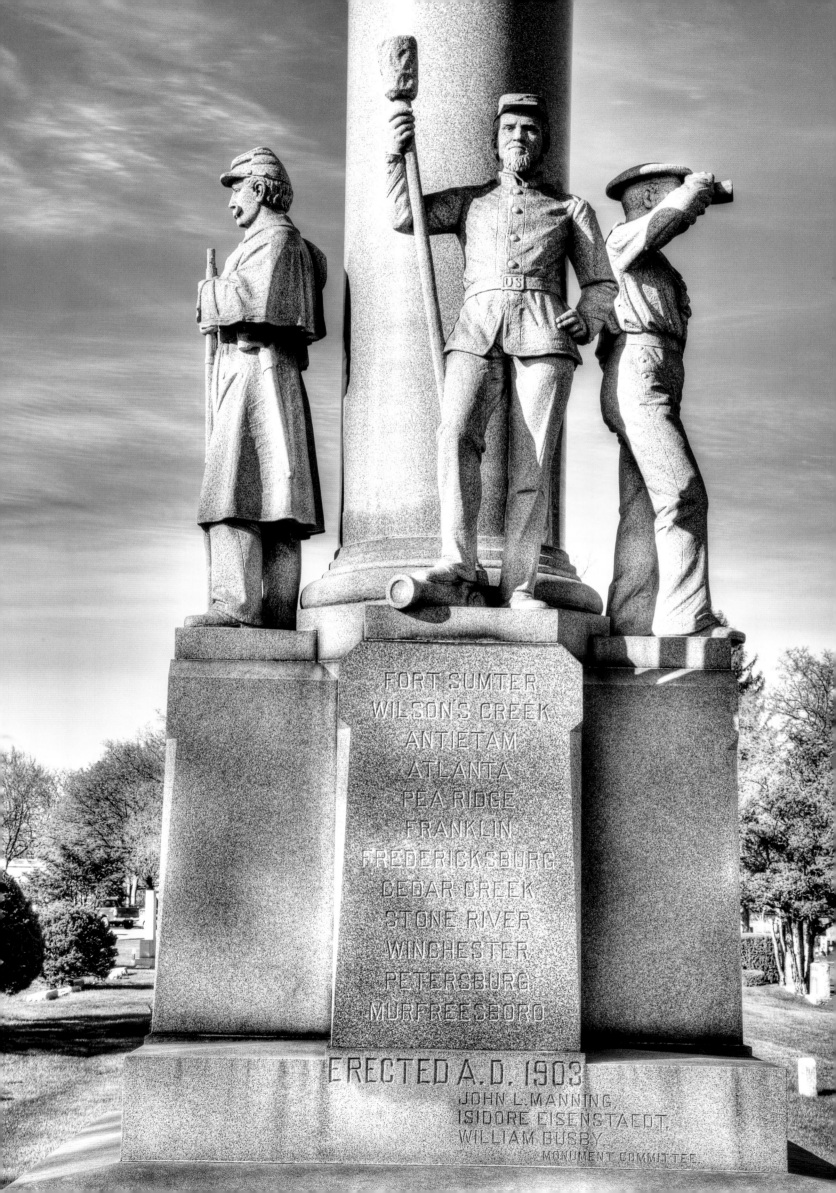

FORT SUMTER
WILSON'S CREEK
ANTIETAM
ATLANTA
PEA RIDGE
FRANKLIN
FREDERICKSBURG
CEDAR CREEK
STONE RIVER
WINCHESTER
PETERSBURG
MURFREESBORO

ERECTED A. D. 1903

JOHN L. MANNING
ISIDORE EISENSTAEDT
WILLIAM BUSBY
MONUMENT COMMITTEE

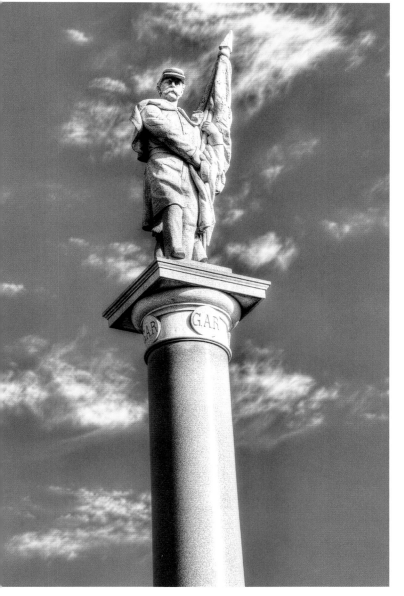

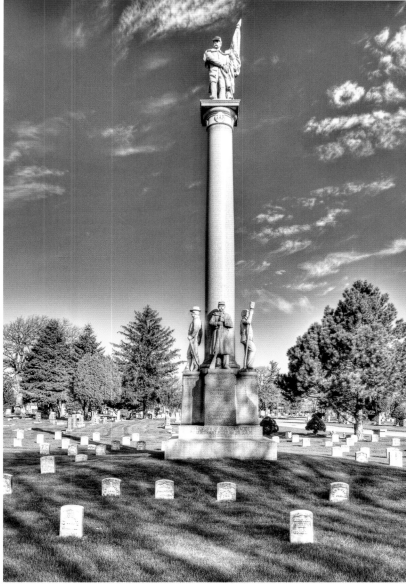

## IN MEMORY OF OUR COMRADES

### INSTALLED 1903 | ELMWOOD CEMETERY

This monument at Elmwood Cemetery in River Grove, Illinois, is inscribed on its base: *"In memory of our comrades / by U. S. Grant Post No. 28 GAR / 1861–1865."* Above the inscription and elsewhere on the monument are listings of Civil War battles. The monument is topped by a flagbearing soldier, and at the base are sculptures representing the armed services.

Many Civil War veterans and their widows are buried at this cemetery, and a monument to Union widows (1904) stands near their graves.

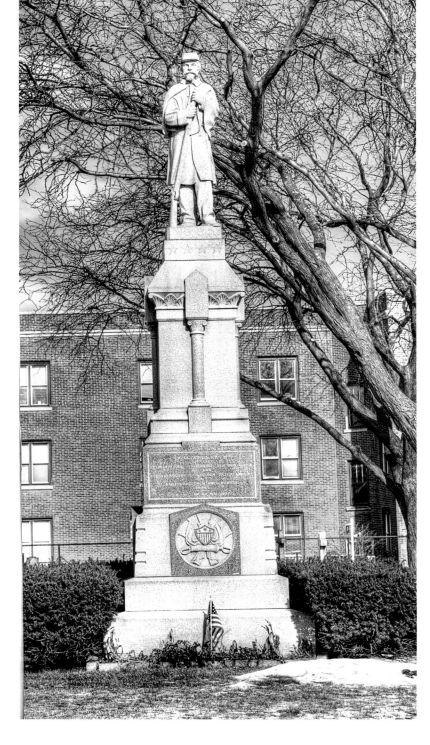

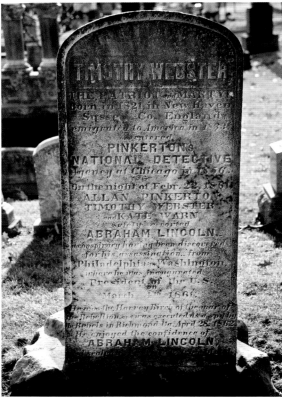

## MONUMENT TO GERMAN SOLDIERS

MARBLE | INSTALLED 1887 | ST. BONIFACE CEMETERY

This monument bears the following inscription, translated from German: *In memoriam of the heroic participation of* *the Germans in defending the new fatherland during the American Civil War 1861–1865 Unveiled May 30, 1887.*

## TIMOTHY WEBSTER CENOTAPH

GRACELAND CEMETERY

Timothy Webster (1822–1862), a Pinkerton agent and Union spy, was the first spy in the American Civil War to be executed. He started his career as a policeman in New York City and joined the Allan Pinkerton Agency in 1856. In early 1861 Pinkerton sent Webster to Baltimore to pose as a southern gentleman and join a pro-southern group planning secession. Webster provided information to Pinkerton concerning a possible assassination planned for Lincoln's inauguration. He continued to provide valuable information during the Civil War but was arrested by Confederate agents in 1862 and sentenced to death. Despite Union pleas, he was executed by hanging in 1862.

## ALLAN PINKERTON MONUMENT
### GRACELAND CEMETERY

Allan Pinkerton (1819–1884) was a Scottish-American detective and spy who emigrated to the United States in 1842. He is best known for the founding of the Pinkerton National Detective Agency in 1852. He settled in the Chicago area and worked for Chicago abolitionist leaders. His home was a stop on the underground railroad. In 1861 he uncovered a plot to assassinate President Lincoln at his inauguration and with the help of other Pinkerton agents (Timothy Webster and Kate Warn, the first female agent) gained helpful intelligence and provided a bodyguard for

Lincoln, not only for the inauguration but throughout the Civil War. At Lincoln's request he began the Secret Service and served as its head. Through the use of a spy he uncovered a plot to free thousands of Confederate prisoners being held at Camp Douglas in Chicago and foiled the plan. His monument at Graceland has plaques on all sides, tributes to the rest of his immediate family also buried on the plot. His plot is surrounded by other Pinkerton agent graves.

# STATESMEN AND LEADERS

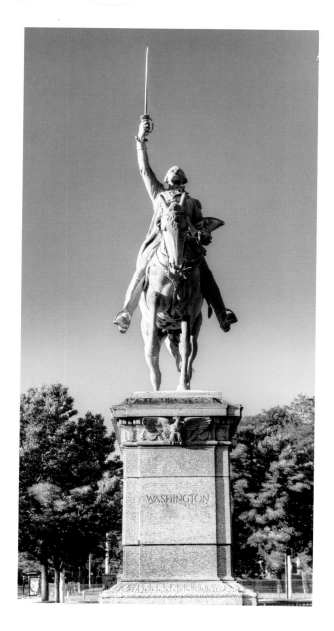

## GEORGE WASHINGTON
### *by* DANIEL CHESTER FRENCH
### *and* EDWARD CLARK POTTER
BRONZE | INSTALLED 1904 | WASHINGTON PARK

This work was a collaboration between French, who sculpted the figure of George Washington (1732–1799), and Potter, who sculpted the horse. An original version was installed in Paris in 1900 and the artists made this copy for Chicago. The statue depicts Washington as commander of the American Revolutionary Army.

Daniel Chester French (1850–1931), known for his work on the Lincoln monument, Washington, D. C., was one of the most prolific American sculptors of his day. Edward Clark Potter (1857–1923) was known for equestrian sculpture. Other Chicago sculptures are the *Statue of the Republic* created for the Columbian Exposition, which was destroyed by fire but was recreated from an original plaster cast, and the 1906 Marshall Field memorial at Graceland Cemetery.

## HEALD SQUARE MONUMENT *by* LORADO TAFT *and* LEONARD CRUNELLE
BRONZE | INSTALLED 1941 | E. WACKER DRIVE AND WABASH AVENUE

A memorial to three distinguished figures of the Revolutionary War, this work depicts George Washington as commander of the Revolutionary War forces, flanked on his right by English-born Robert Morris and on his left by Haym Salomon, a Polish Jew. Morris and Salomon were successful businessmen and the principal financiers of the war, often supporting Washington's army with their own money. This quotation is on the base of the statue: *"The government of the United States / which gives to bigotry no sanction / to persecution no assistance / requires only that they who live under / its protection should demean themselves as good citizens / in giving it on all occasions their effectual support / President George Washington, 1790."*

A group of Chicago civic leaders retained Lorado Taft to design this monument in 1930, but Taft died in 1936 having completed only a small model of the work. It was finished by Leonard Crunelle and other associates from Taft's studio. Taft (1860–1936) taught at the School of the Art Institute of Chicago from about 1890 until 1929. He assisted with sculpture for the Columbian Exposition of 1893 and mentored a prolific group of students who went on to create sculptures and elaborate fountains throughout the United States. In 1965 his Chicago workplace was declared a national historic landmark. Other Chicago Taft works are *Fountain of Time, Eternal Silence, Fountain of the Great Lakes,* and *The Crusader.* Crunelle (1872–1944) studied with and assisted Taft. Other Chicago sculptures by Crunelle are *Richard Oglesby* and *Victory Monument.*

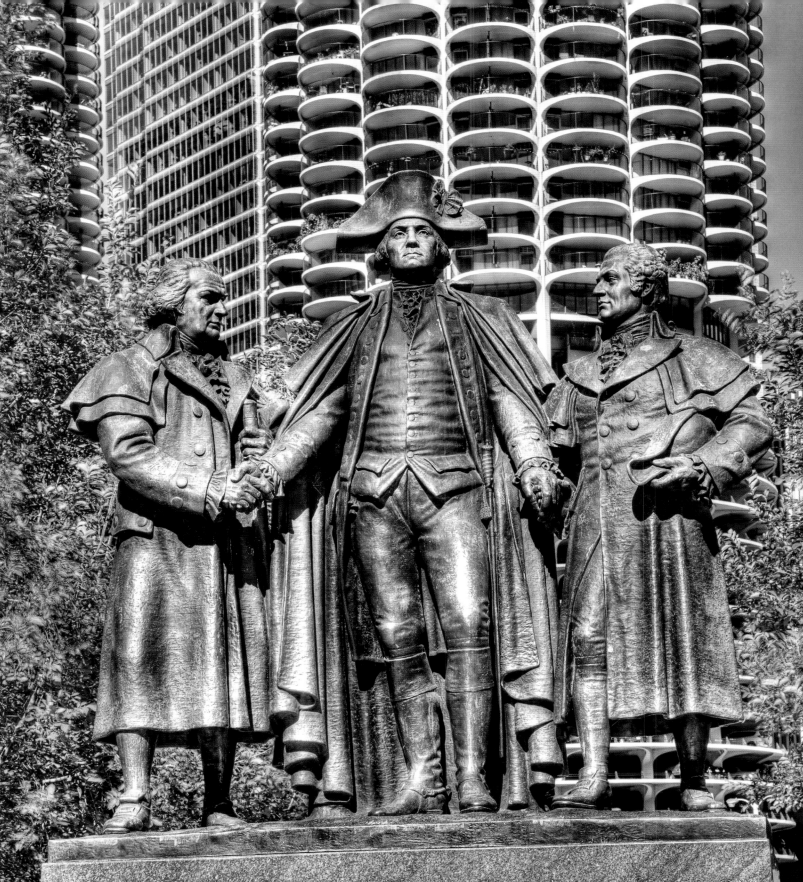

ROBERT MORRIS · GEORGE WASHINGTON · HAYM SALOMON

THE GOVERNMENT OF THE UNITED STATES
WHICH GIVES TO BIGOTRY NO SANCTION TO PERSECUTION
NO ASSISTANCE REQUIRES ONLY THAT THEY WHO LIVE UNDER
ITS PROTECTION SHOULD DEMEAN THEMSELVES AS GOOD CITIZENS
IN GIVING IT ON ALL OCCASIONS THEIR EFFECTUAL SUPPORT
PRESIDENT GEORGE WASHINGTON 1790

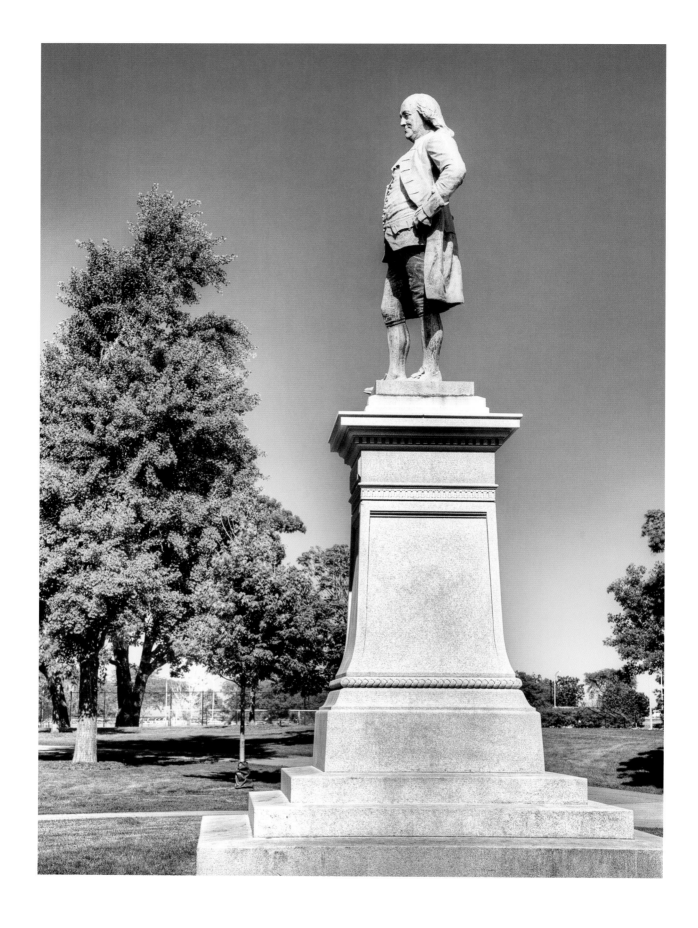

## BENJAMIN FRANKLIN *by* RICHARD HENRY PARK
### BRONZE, GRANITE BASE | INSTALLED 1896 | LINCOLN PARK

Benjamin Franklin (1706–1790) was an American founding father, writer, inventor, ambassador, politician, scientist, a signer of the Declaration of Independence, and a negotiator of the peace treaty ending the Revolutionary War. He was also a member of the Constitutional Convention of 1787.

Richard Henry Park (1832–1902), a distinguished American sculptor, was retained by the *Chicago Tribune* to create this sculpture, which was unveiled by a descendant of Franklin. He participated in the 1893 Columbian Exposition in Chicago and was the sculptor of Chicago's *Drake Fountain*.

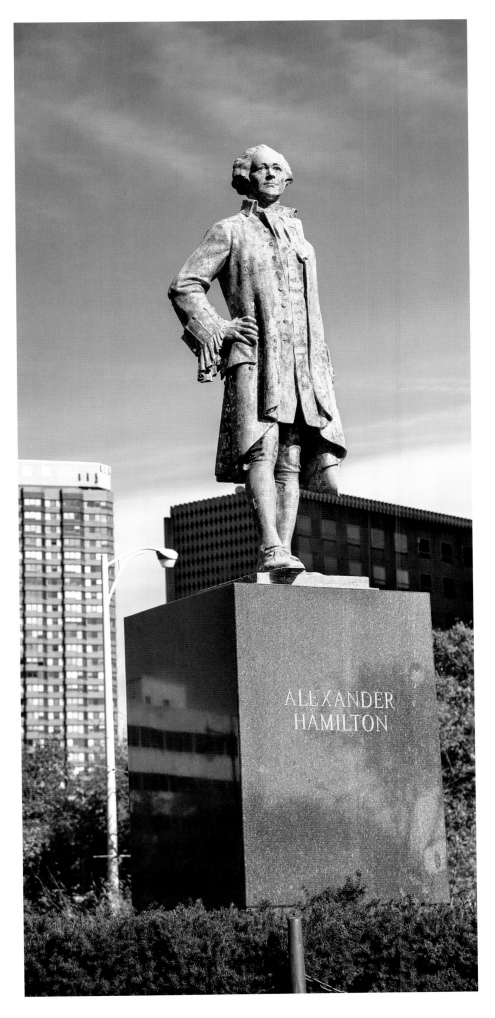

## ALEXANDER HAMILTON
### *by* JOHN ANGEL
GILDED BRONZE |
INSTALLED 1952 |
LINCOLN PARK

Hamilton (1755–1804) was a founding father of the United States, chief of staff to George Washington, founder of the U.S. financial system, and first secretary of the treasury. He was killed in a duel with Vice President Aaron Burr in 1804 over a political dispute. Kate Buckingham (1858–1937) commissioned the work and set up a trust fund in her will to provide for its maintenance. The thirteen-foot-tall statue was completed in 1940, but wartime construction bans and political considerations delayed its installation until 1952. Its original seventy-eight-foot-tall exedra was deemed unsafe in 1993 and replaced with the current base.

John Angel (1881–1960) a British emigrant to the U.S. in 1925, is known as one the foremost sculptors of his period.

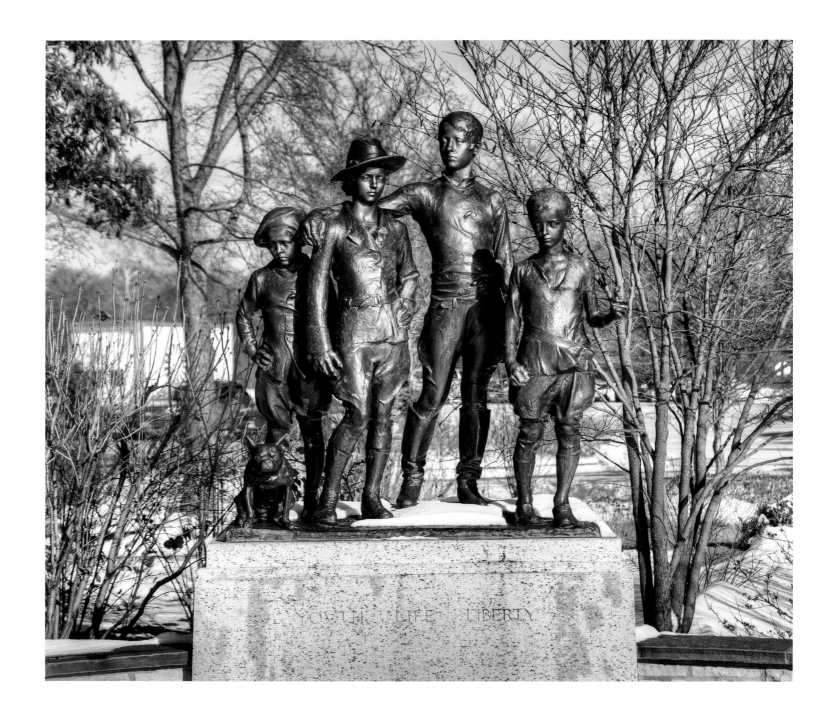

## MEMORIAL TO THEODORE ROOSEVELT *by* ANDREW O'CONNOR

BRONZE | INSTALLED 1919 | GLEN VIEW GOLF CLUB, GOLF ROAD, WEST OF HARMS ROAD

C
H
I
C
A
G
O

A member of the Glen View Golf Club commissioned this statue at the time of Theodore Roosevelt's death in 1919. Roosevelt succeeded William McKinley to the presidency upon McKinley's assassination in 1901. Rather than portraying Roosevelt in the memorial, O'Connor chose to remember him with a monument to the Boy Scouts, an organization Roosevelt had close ties with and which espoused his ideals of patriotism and physical culture. The

four boys serving as models were all sons of the sculptor. The inscription on the base reads "youth, life, liberty."

Andrew O'Connor (1874–1941) was an American-Irish sculptor born in Massachusetts. He died in Dublin. His many sculptures of Lincoln are installed in the United States and London. His work is represented in museums in America, Ireland, England, and France.

## WILLIAM MCKINLEY *by* CHARLES MULLIGAN

BRONZE | INSTALLED 1905 | MCKINLEY PARK

William McKinley (1843–1901), the twenty-fifth president of the United States, led the nation during the Spanish-American War and was the last president to have served in

the army during the Civil War. He was assassinated in his second term while attending the Pan-American Exposition in Buffalo, New York.

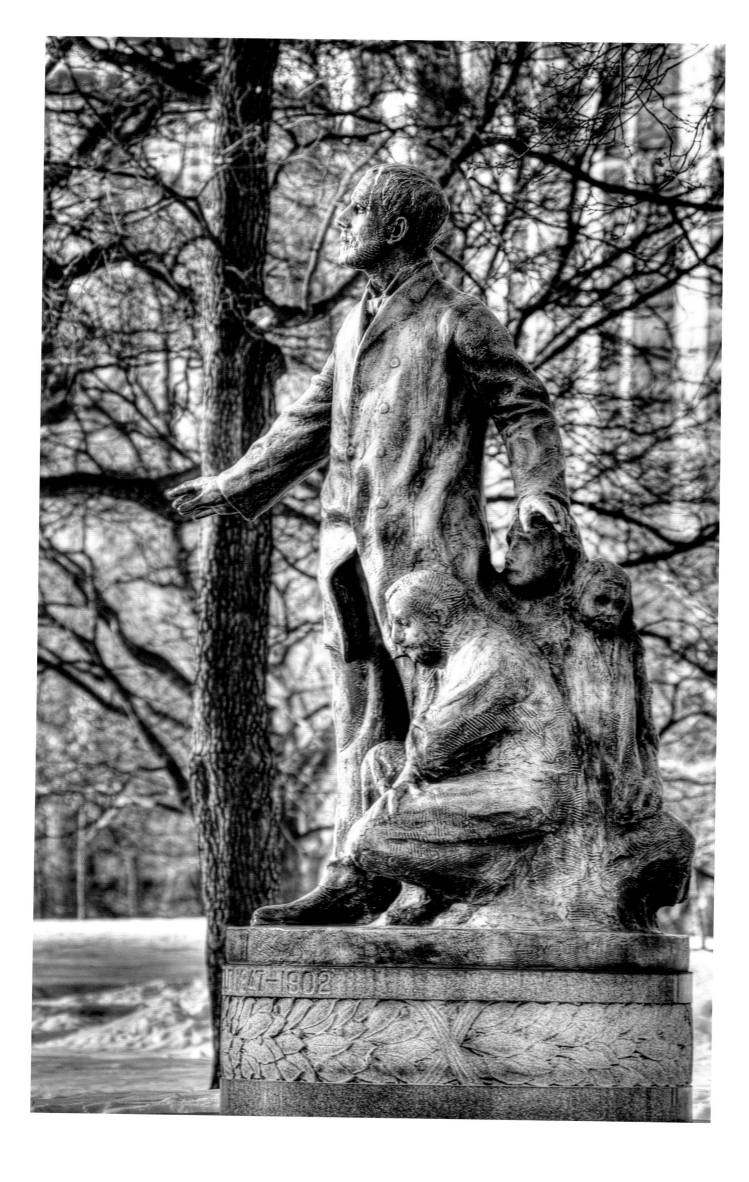

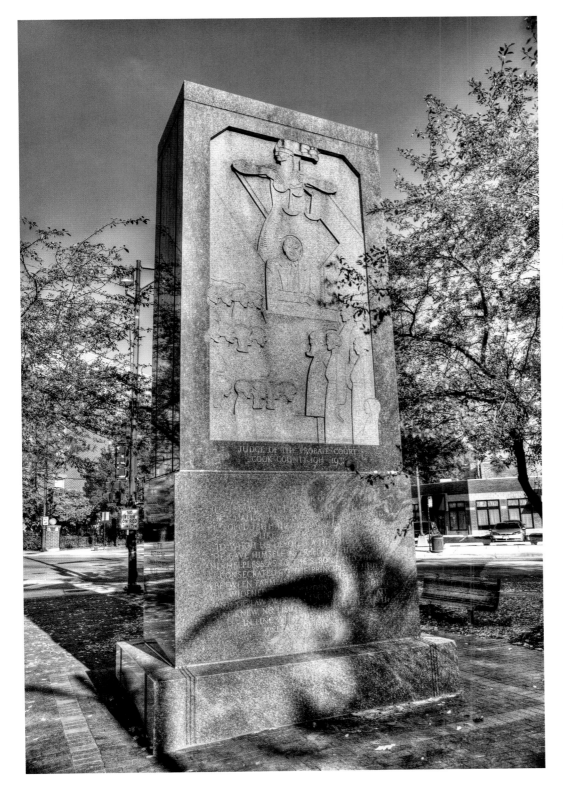

## HENRY HORNER
### *by* JOHN BRCIN
RED GRANITE | INSTALLED 1948, RELOCATED 1956 | MONTROSE AND CALIFORNIA AVENUES

Henry Horner (1878–1940) served as a probate judge from 1915 to 1931 and as governor of Illinois from 1933 until his death in 1940. He was the state's first Jewish governor, serving throughout the depths of the Great Depression, and signed into effect the state's first permanent sales tax. His administration was known for integrity and attention to the needs of the indigent. Bricin's Art Deco–style monument depicts Horner as a judge on one side and as governor on the other.

John Brcin (1899–1983), a Serbian immigrant, studied with Albin Polasek at the School of the Art Institute of Chicago. He worked with Polasek on the Thomas Masaryk sculpture on the midway in Hyde Park.

## JOHN PETER ALTGELD *by* GUTZON BORGLUM
BRONZE | INSTALLED 1915 | LINCOLN PARK

Altgeld (1847–1902) was governor of Illinois from 1893 to 1897. A leading figure of the progressive movement, he rejected calls in 1894 to break up the Pullman strike using force and signed workplace safety and child labor laws. The monument depicts Altgeld with his left hand hovering protectively over a family group, signifying his fight for shorter work hours and other changes that benefited the lives of workers. He also pardoned three of the conspirators convicted in the Haymarket Riot. Altgeld's grave in Graceland Cemetery is marked by a monument with his words regarding the pardon: "If the defendants had a fair trial there ought to be no interference, for no punishment under our laws could then be too severe. But they did not have a fair trial. The evidence utterly fails to connect the unknown who threw the bomb with the defendants. And I am convinced that it is my duty to act."

Gutzon Borglum (1871–1941) is best known as the sculptor of the presidential heads at Mount Rushmore. An American artist trained in Paris, he was influenced by Auguste Rodin.

## RICHARD J. OGLESBY
*by* **LEONARD CRUNELLE**
BRONZE | INSTALLED 1919, CONSERVED 1993 | LINCOLN PARK

Richard Oglesby (1824–1889) was the fourteenth governor of Illinois and served in the Union Army during the Civil War, distinguishing himself as a major general. He was elected governor for three terms, not in succession. The first term was from 1865 to 1869 and the last from 1885 to1889. He also served in the United States Senate from 1873 to 1878. He was governor at the time of the Haymarket Riot of 1886. Eight men were convicted at a controversial trial and sentenced to hang on December 3, 1886. Governor Oglesby intervened in a complex series of appeals, and in the end commuted some of the sentences to life in prison.

Leonard Crunelle emigrated to the United States and first worked as a coal miner in Illinois. He eventually studied at the School of the Art Institute of Chicago with Lorado Taft. Other Crunelle sculptures in Chicago include *Fountain Figures* (Grant Park), *Heald Square Washington Monument,* and the *Victory Monument*, a memorial to African American soldiers who served in World War I.

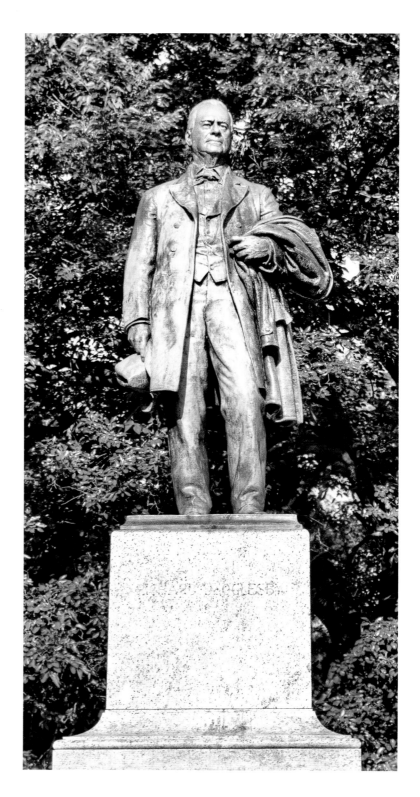

## CARTER HARRISON, SR. *by* FREDERICK C. HIBBARD
BRONZE ON GRANITE PEDESTAL | INSTALLED 1907 | UNION PARK

Carter Harrison, Sr. (1825–1893) was a five-term mayor of Chicago, from 1879 to 1887, and in 1893, when he was assassinated in office. As mayor during the Haymarket Riot, he was instrumental in reducing violence by ordering police to restrain themselves. Harrison was also helpful in guiding the planning for the 1893 Columbian Exposition. He was assassinated in his home three days before the exposition's conclusion. Harrison's family burial site at Graceland is marked by one of the tallest obelisks in the cemetery. His son, Carter Harrison, Jr., was also a five-term mayor of Chicago.

Chicago-based American sculptor Frederick Hibbard (1881–1950) trained under Lorado Taft at the School of the Art Institute of Chicago and is best remembered for his Civil War memorials. Other Chicago works by Hibbard are the *David Wallach Fountain* (1939); *Eagle Fountains* (1931); and *Greene Vardiman Black* (1918).

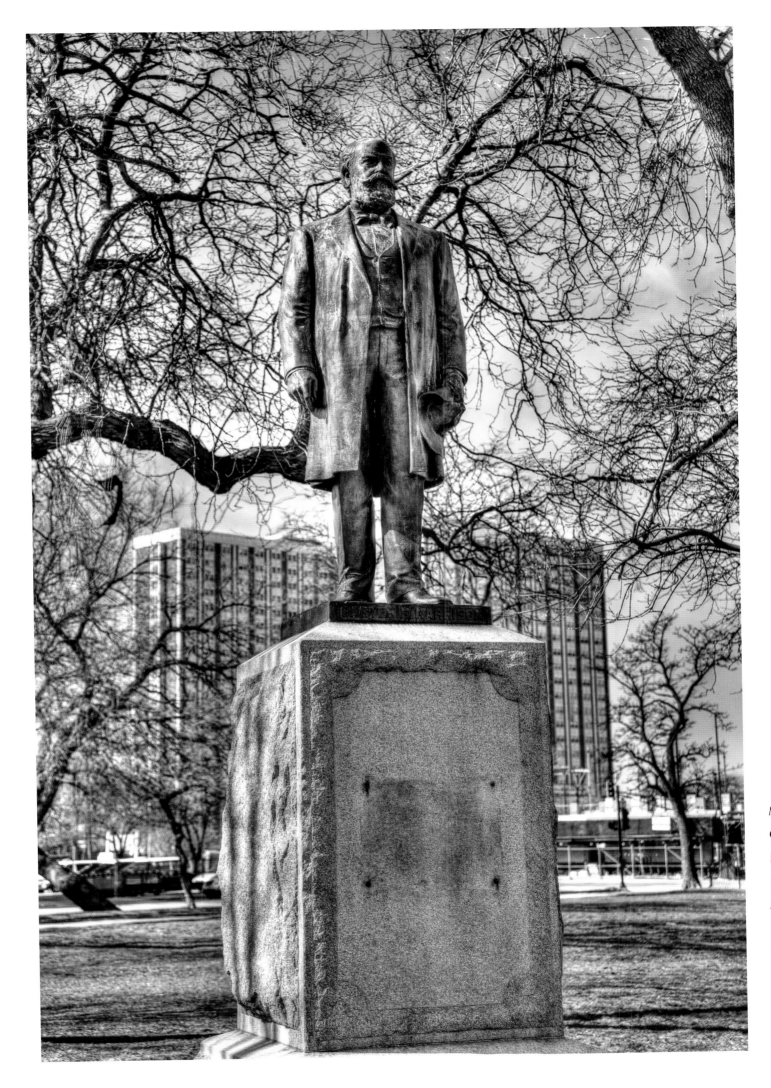

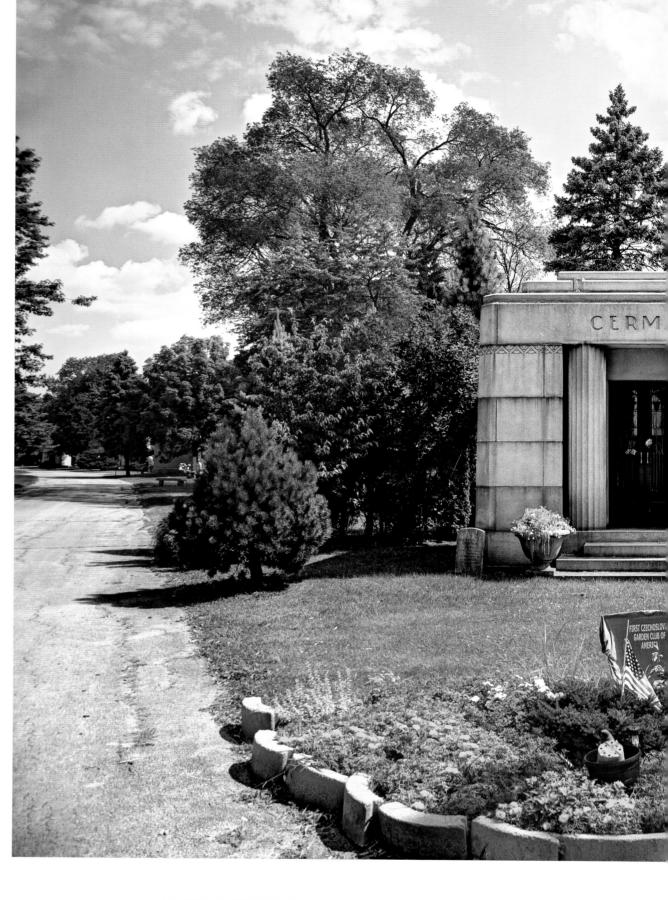

## ANTON CERMAK TOMB

### BOHEMIAN CEMETERY

Anton Cermak (1873–1933), an American politician of Czech origin, served as mayor of Chicago from 1931 until his assassination in 1933. Although no monument commemorates his accomplishments, his beautifully maintained mausoleum in the Bohemian Cemetery serves as a significant memorial. Before Cermak became

mayor, the Democratic party in Cook County was controlled by Irish Americans; with Franklin Roosevelt's support, Cermak used his great political skills to put together a Democatric coalition that could overcome the existing Republican establishment led by "Big Bill" Thompson. The desire to clean up organized crime in Chicago helped

Cermak win the 1931 election. Ever since his victory, the Democratic party has controlled Chicago politics. Cermak was shot in the chest in Miami, Florida, as he was making a public appearance with President Franklin Roosevelt. It is thought by some that Roosevelt was the actual target. Legend has it that his last words to Roosevelt were "I'm glad it was me instead of you." Cermak died in a Miami hospital. Following his death, 22nd Street in Chicago was renamed Cermak Road. Cermak's son-in-law, Otto Kerner, Jr., was

the thirty-third governor of Illinois; a grandson served as a naval officer at the Battle of Iwo Jima in the Second World War, where he was wounded and became a double amputee. After the war he became a medical doctor, and in 1983 was elected president of the American Medical Association.

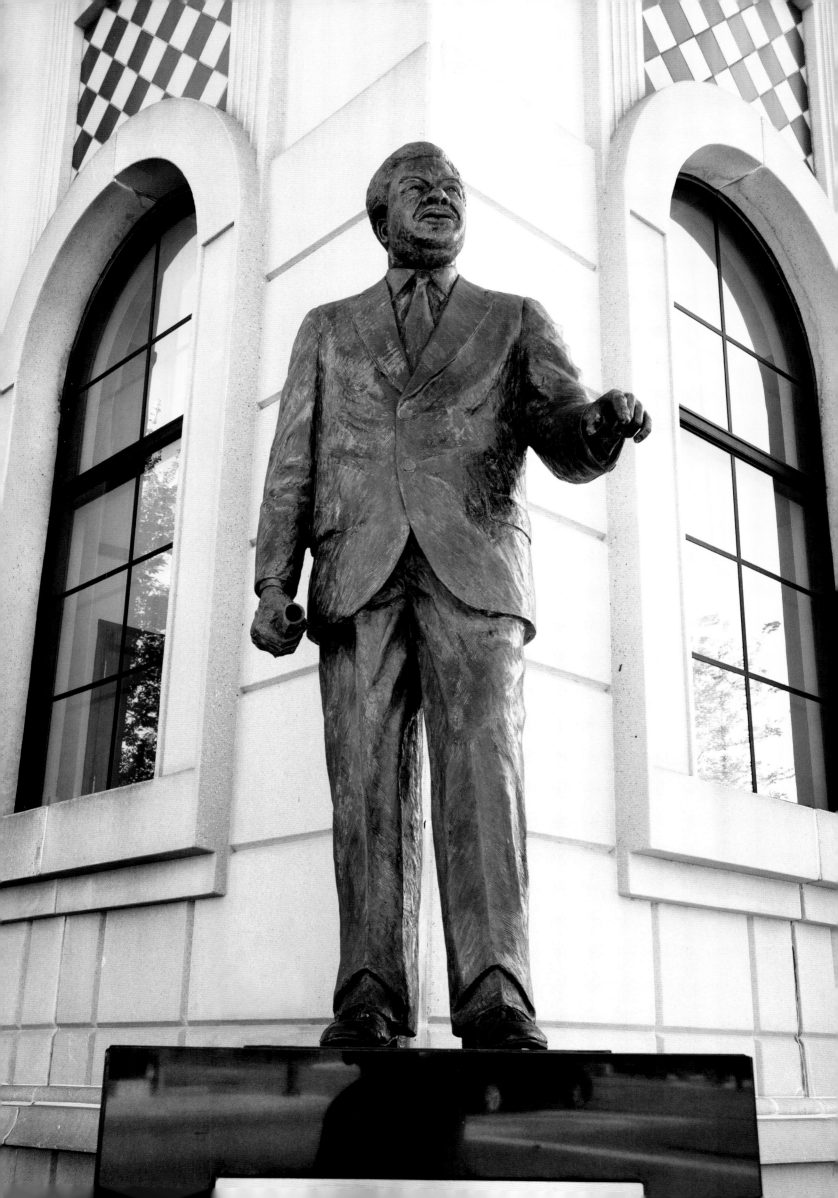

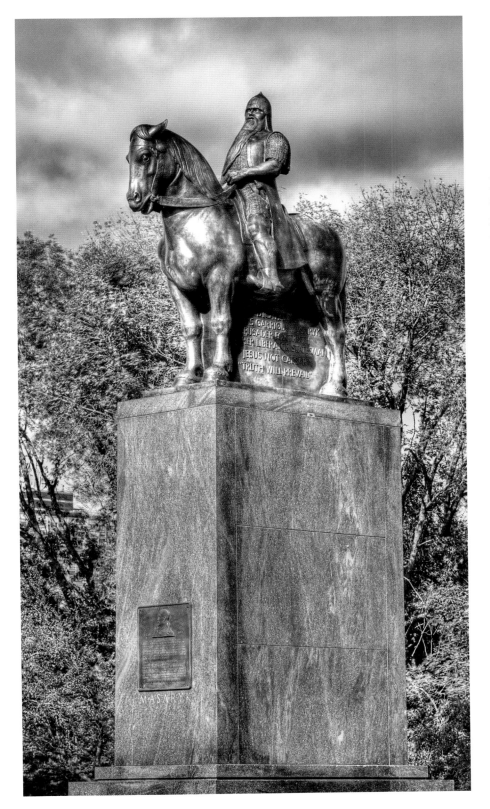

## MASARYK MEMORIAL
### *by* ALBIN POLASEK
BRONZE | INSTALLED 1955
| MIDWAY PLAISANCE EAST
OF BLACKSTONE AVENUE

In the melting-pot city of Chicago, viewers will find monuments to leaders dear to the hearts of people from many different nations. This work is dedicated to the memory of Czechoslovakia's first president, Thomas Masaryk (1850–1937). It depicts Saint Wenceslaus, a knight who by legend led his people from oppression. Masaryk pressed for Czech independence during the First World War and served as the nation's president from 1918 to 1935. Casting of the monument began well before the start of World War I but was stopped due to a shortage of bronze; it was finished in 1949 and dedicated in 1955.

Albin Polasek (1879–1965) headed the Sculpture Department of the School of the Art Institute of Chicago from 1916 to 1946 and produced many public sculptures now in the Czech Republic and the United States. Other Chicago works are *The Spirit of Music* and *Gotthold Lessing.*

## HAROLD WASHINGTON *by* ED DWIGHT
BRONZE | INSTALLED 2004 | HAROLD WASHINGTON CULTURAL CENTER

Chicago-born Harold Washington (1922–1987) lived on the South Side all his life. He joined the army during World War II and afterwards entered Roosevelt University in Chicago. In 1952 he graduated from Northwestern Law School. He served both as an Illinois legislator and U.S. congressman. On April 12, 1983, he became the first African American elected mayor of Chicago. He won a second term on April 7, 1987, but died of a heart attack on November 26 of that year. He is buried at Oak Woods Cemetery in Chicago.

Ed Dwight (b. 1933) was the first African American astronaut candidate. After receiving an MFA in sculpture from the University of Denver, he began a serious art career in 1978. He was commissioned by the Colorado Centennial Commission to create a series of bronzes called *Black Frontier in the American West.* The series depicted the contributions of African Americans to the opening of the West. Much of his art features notable African Americans and jazz musicians. Other Chicago work includes the Chicago Blues District Towers.

# WRITERS AND ARTISTS

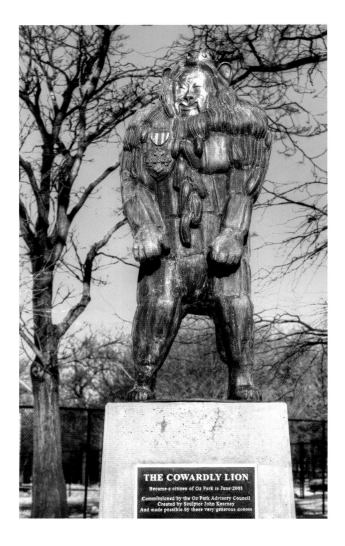

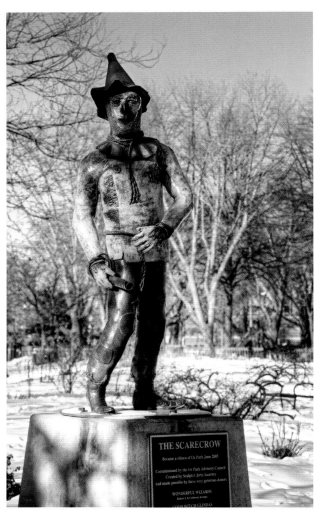

## L. FRANK BAUM (WIZARD OF OZ SERIES) *by* JOHN KEARNEY

BRONZE | INSTALLED 1995–2007 | OZ PARK, LINCOLN PARK

Lyman Frank Baum (1856–1919) was a New York–born writer most noted for his children's books, particularly *The Wonderful Wizard of Oz.* He began as a journalist and playwright and in 1888 moved with his wife to South Dakota to edit a local newspaper. Baum's description of Kansas in *The Wonderful Wizard of Oz* is thought to be related to his experiences as a pioneer in South Dakota. After the failure of the newspaper in 1891, he moved with his wife and four sons to the Humboldt Park section of Chicago, took jobs working for magazines, and began writing children's books. *Oz* was published in 1900 in joint copyright with its illustrator, W. W. Denslow. Baum wrote thirteen more books based on the people and places of Oz. He eventually moved to Hollywood as interest grew in his work in other media. He died of a stroke in 1919.

John Kearney (1924–2014) was famous for figurative sculptures, often of animals, and for using found metal objects like car bumpers. His *Oz* series was installed over a period of years: *Tin Man* in 1995; *Cowardly Lion* in 2001; *Scarecrow* in 2005; *Dorothy and Toto* in 2007. Other Chicago works include *Three Deer* at the Aon Building and a sculpture at the Field Museum's south entrance.

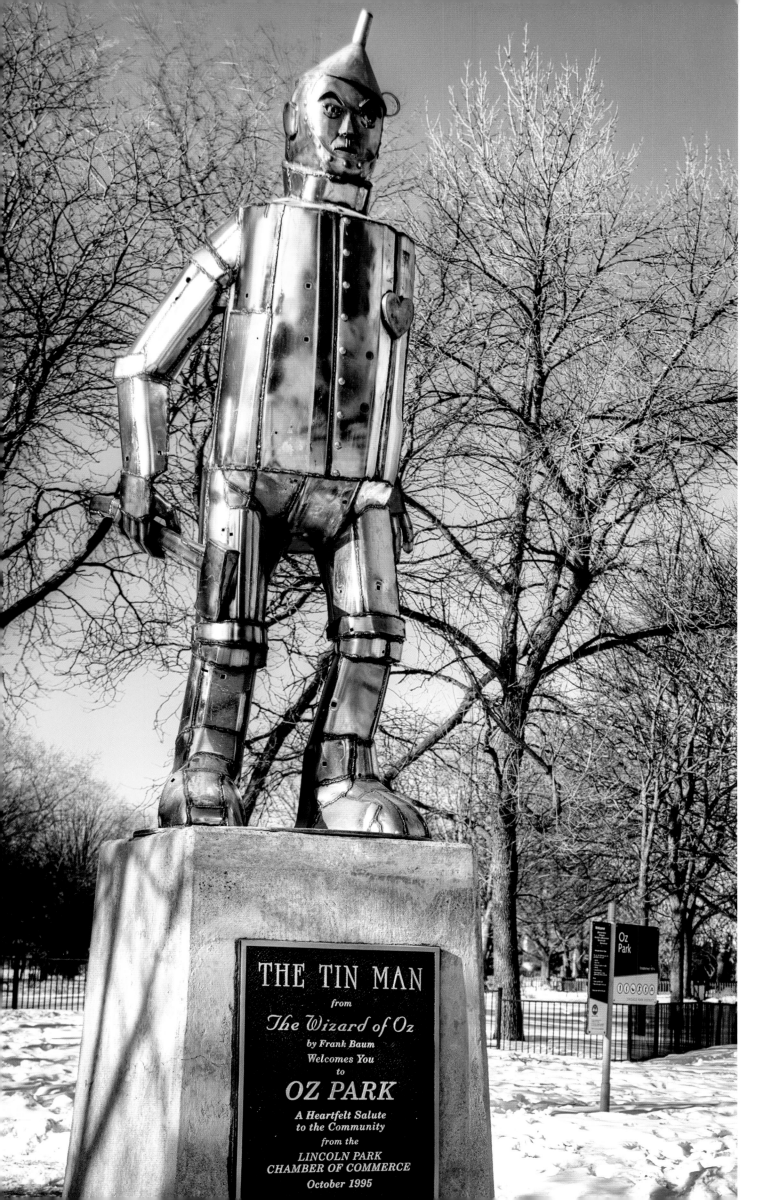

THE TIN MAN

*from*

*The Wizard of Oz*

*by Frank Baum*

**Welcomes You**

*to*

## OZ PARK

*A Heartfelt Salute
to the Community*

*from the*

**LINCOLN PARK
CHAMBER OF COMMERCE**

*October 1995*

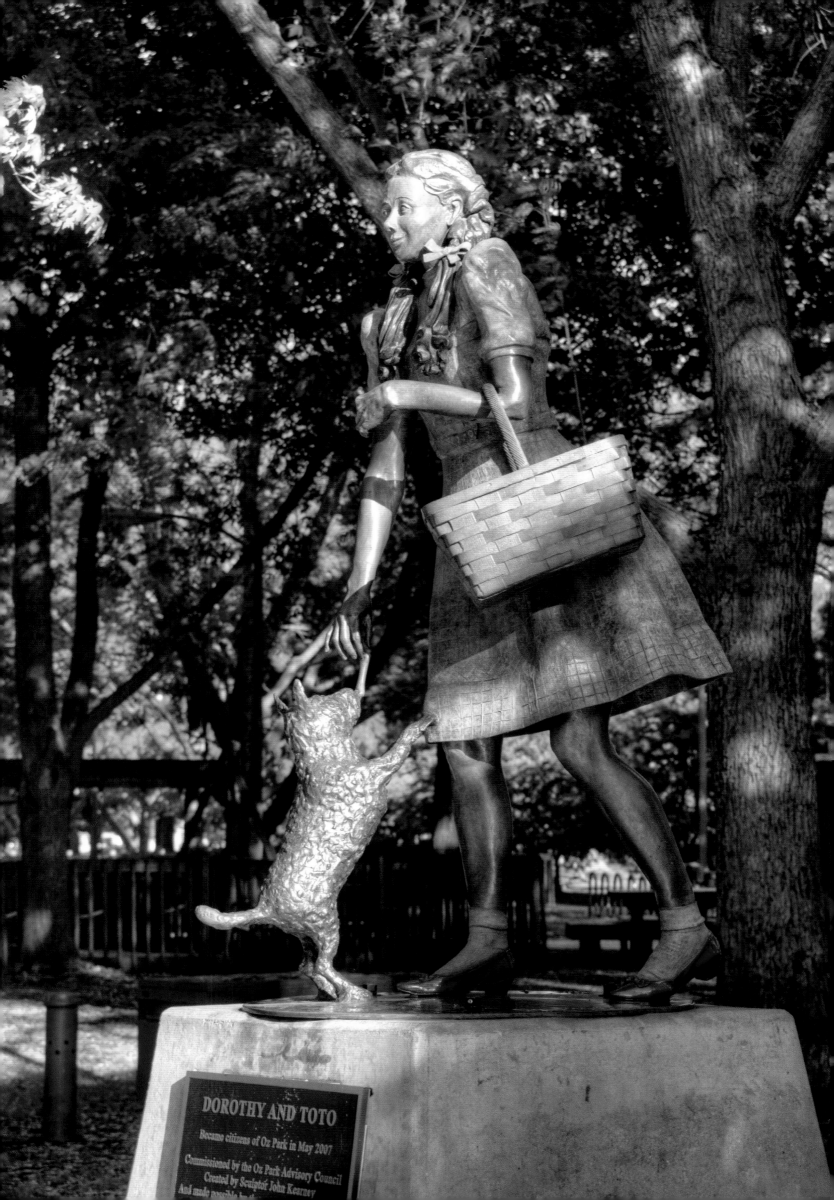

DOROTHY AND TOTO

Became citizens of Oz Park in May 2007

Commissioned by the Oz Park Advisory Council
Created by Sculptor John Kearney
And made possible by the

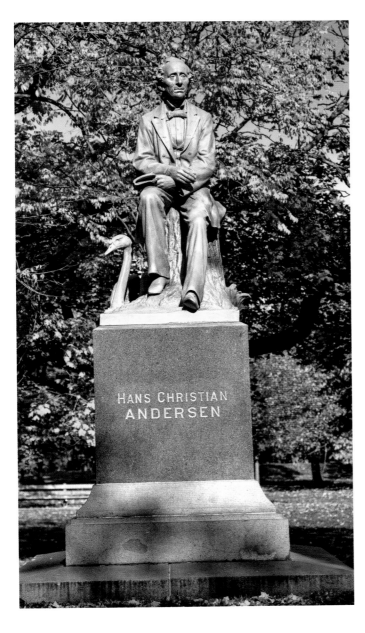

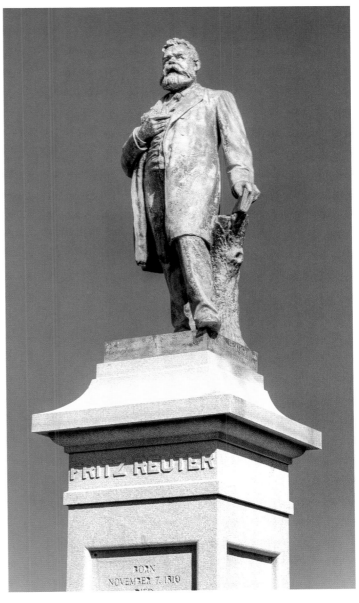

## HANS CHRISTIAN ANDERSON *by* JOHANNES GELERT

BRONZE | INSTALLED 1896 | LINCOLN PARK, STOCKTON DRIVE AT DICKENS AVENUE

Hans Christian Anderson (1805–1875) started writing plays before entering Copenhagen University. After his university studies he began writing tales for children, eventually creating a lasting body of more than 160 fairy tales. The monument depicts Anderson with the ugly duckling from one of his most beloved stories.

Gelert (1852–1923) was a Danish-born sculptor who came to the United States in 1887 and began his career in Chicago. Shortly after his arrival he won a competition to design the Haymarket Riot monument, now at Chicago police headquarters. He also created work for the 1893 Columbian Exposition.

## FRITZ REUTER *by* FRANZ ENGELSMAN

BRONZE | INSTALLED 1893 | HUMBOLDT PARK

Fritz Reuter (1810–1874) was an influential German writer and political activist beloved to many German immigrants in the United States. He was imprisoned by the Prussian government for writing against political oppression but continued his work in spite of confinement and poor health.

The German-American sculptor Franz Engelsman (1859–ca. 1920) was selected by competition to design this sculpture of Reuter, which was cast in Germany. Engelsman was at the time residing in Chicago. The work's dedication in 1893 was attended by more than 50,000 German immigrants.

M
O
N
U
M
E
N
T
A
L

**67**

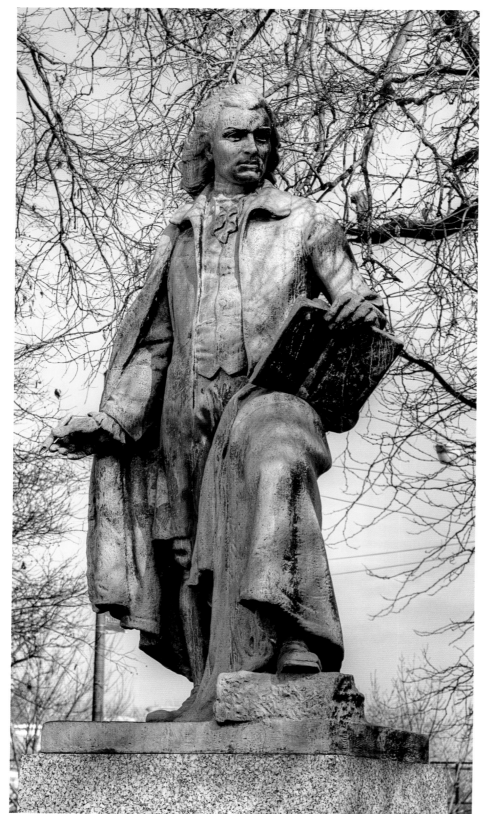

## GOTTHOLD EPHRAIM LESSING
*by* **ALBIN POLASEK**
BRONZE | INSTALLED 1930 |
WASHINGTON PARK

Gotthold Lessing (1729–1781) was a German writer and philosopher and considered the father of modern German drama. Funds for the sculpture were donated by a wealthy Chicago philanthropist, Henry Frank (1839–1926), in the form of a bequest.

Albin Polasek (1879–1965) headed the Sculpture Department of the School of the Art Institute of Chicago for almost thirty years, from 1916 to 1946, and produced many public sculptures in the Czech Republic and in the United States. There is an Albin Polasek Museum in Winter Park, Florida, where Polasek spent his retirement years. Other Polasek sculptures in Chicago are *Spirit of Music* and the Thomas Masayrk monument.

## JOHANN FRIEDRICH VON SCHILLER
*by* **ERNST BILDHAUER RAU**
BRONZE | INSTALLED 1886 |
LINCOLN PARK

Schiller (1759–1805) was a German playwright and poet who explored the theme of human need for freedom in many of his works. Beethoven's *Ode to Joy* is based on the work of Schiller. This monument is a copy of one produced in Germany. It was cast in Germany and placed in Lincoln Park by Chicagoans of German descent.

The German sculptor Rau (1839–1875) worked mostly in Stuttgart. He died at the early age of thirty-six.

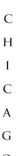

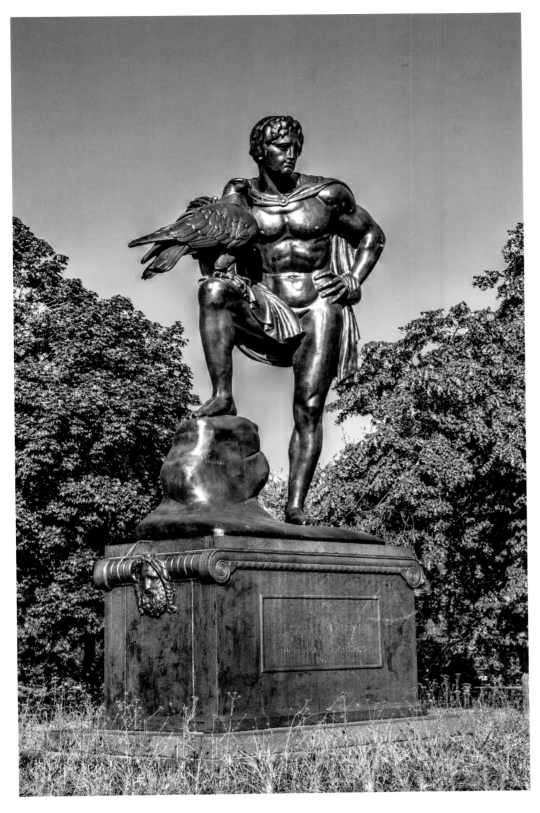

## MONUMENT TO JOHANN WOLFGANG VON GOETHE
*by* **HERMAN HAHN**

BRONZE | INSTALLED 1913 |
LINCOLN PARK

Goethe's drama *Faust* is often referred to as one of Germany's greatest contributions to world literature. The eagle perched on the knee of the classical figure here is a symbol of the German nation. Goethe (1749–1832) wrote fiction, essays, and scientific pieces as well as plays. His twenty-foot-tall commemorative monument was commissioned by Chicago's German community, whose Goethe Monument Association staged a competition to find the ideal sculptor. They did not want a figurative statue but rather a work that embodied the playwright's spirit.

Hahn (1868–1944), winner of the competition, was a German sculptor whose work adorns many German cities.

## THE EUGENE FIELD MEMORIAL (DREAM LADY) *by* EDWARD McCARTAN

BRONZE | INSTALLED 1922 | LINCOLN PARK ZOO

Eugene Field (1850–1895), a writer and newspaper editor, wrote classic poems that appealed to people of all ages. The figures in his memorial represent characters from them.

Edward Francis McCartan (1879–1947), known for his decorative bronzes in the elegant style of the 1920s, became director of the Sculpture Department of the Beaux-Arts Institute of Design in New York City. He studied with and assisted Hermon MacNeil, whose work in Chicago includes the Marquette Memorial.

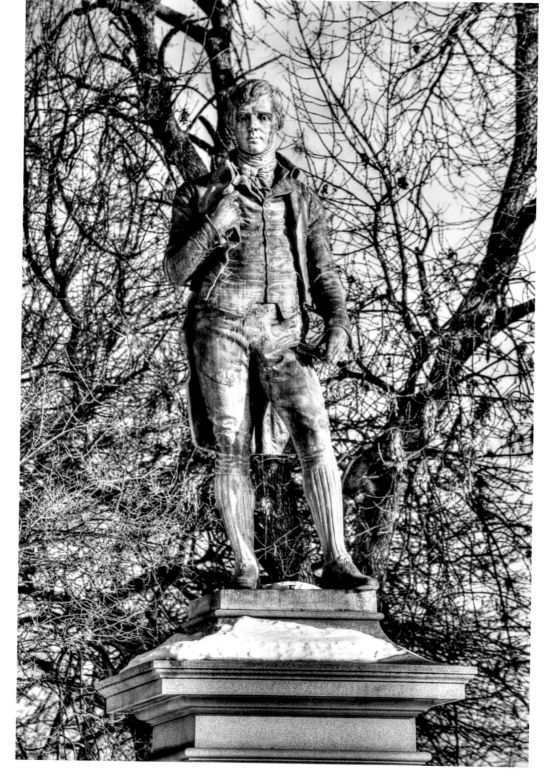

## ROBERT BURNS
*by* **WILLIAM GRANT STEVENSON**

BRONZE | INSTALLED
1906 | GARFIELD PARK,
WASHINGTON AND HAMLIN
BOULEVARDS

In the 1880s a group formed in Chicago to create a monument to Robert Burns (1759–1796), author of the lyrics to the familiar air *Auld Lang Syne* and Scotland's most revered poet. The group's leader traveled to Scotland to meet with Scottish sculptor William Grant Stevenson (1849–1919) about creating the monument. The work was created and cast in Scotland. A second casting resides in Milwaukee.

## THE SPIRIT OF MUSIC *by* **ALBIN POLASEK**
BRONZE | INSTALLED 1923 | GRANT PARK NEAR CONGRESS PARKWAY

Theodore Thomas (1835–1905) was the founder and first conductor of the Chicago Symphony Orchestra. The statue in his honor represents a goddess of music watching over her temple. The German-born Thomas had been touring the United States with his orchestra when Chicagoans invited him to form a permanent orchestra in 1890. Orchestra Hall was built as its home in 1904, but Thomas only lived long enough to conduct one concert there. This memorial, also known as *The Spirit of Music,* commemorates his artistry.

Albin Polasek (1879–1965) headed the Sculpture Department of the School of the Art Institute of Chicago from 1916 to 1946 and produced many public sculptures in both the Czech Republic and America. In Chicago his work includes the Lessing monument and the Masaryk memorial. *The Spirit of Music* was donated by the B.F. Ferguson Monument Fund.

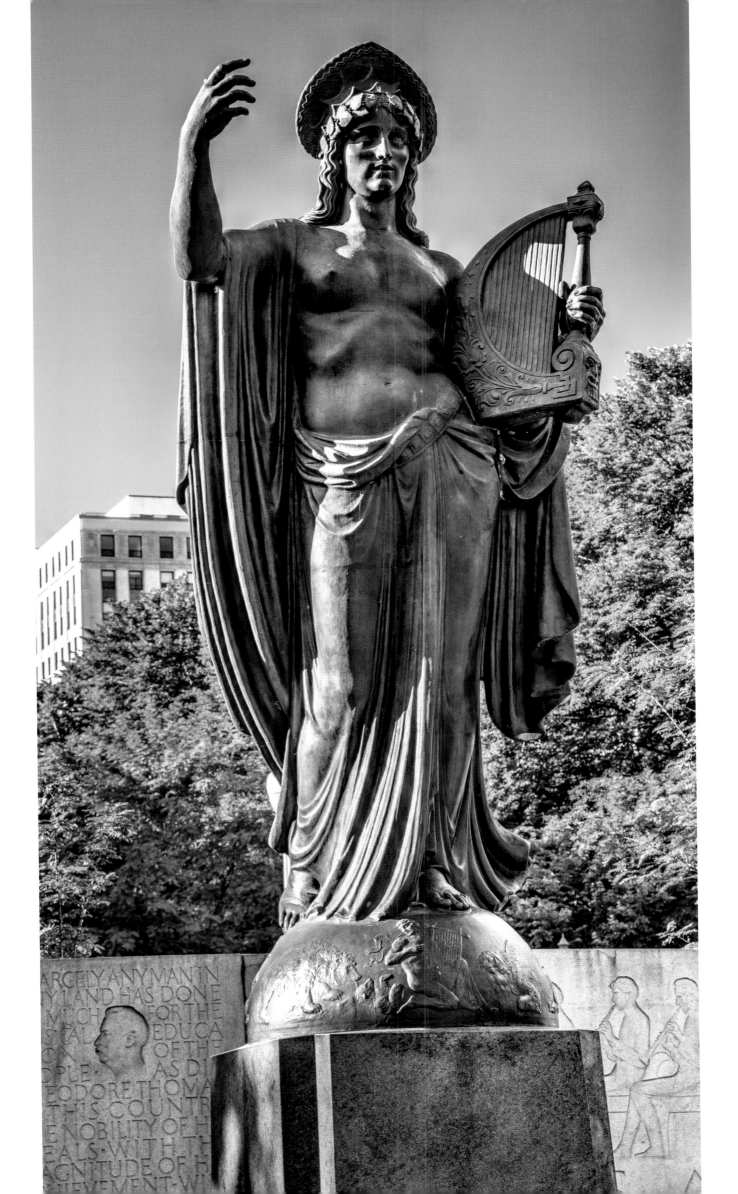

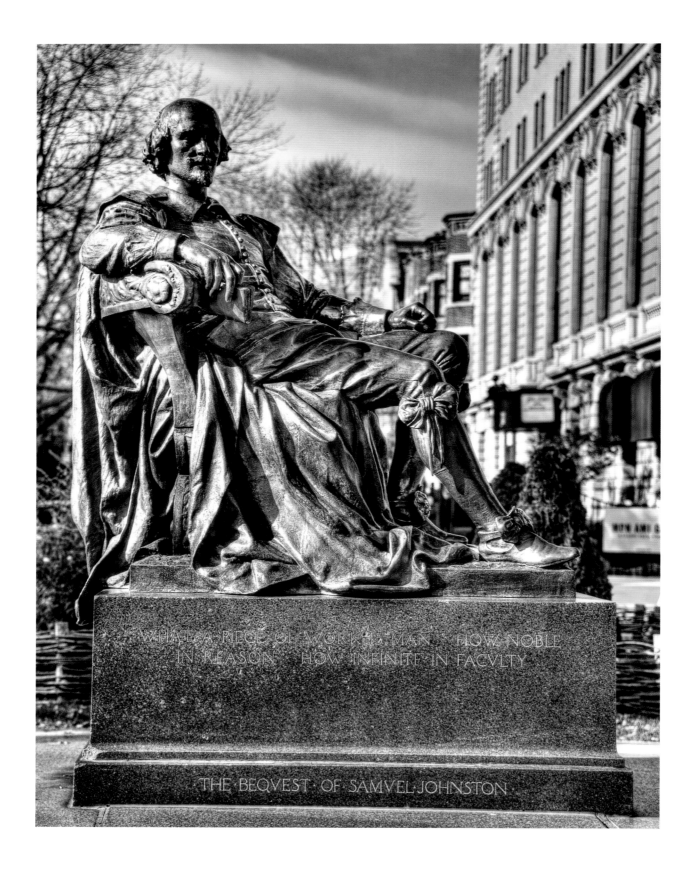

## WILLIAM SHAKESPEARE *by* WILLIAM ORDWAY PARTRIDGE ③D

BRONZE | INSTALLED 1894 | LINCOLN PARK WEST AT BELDEN

"What a piece of work is man! How noble in reason! How infinite in faculty!" These words from Shakespeare's *Hamlet* are inscribed on the bard's monument. Partridge (1861–1930) made a careful study of portraits of Shakespeare and of the clothing he wore in them in order to create as true a likeness as possible of the great playwright (1564–1616). He spent considerable time on research, even traveling to England for the purpose. The sculpture took three years to complete. Funds for it were provided by Chicago financier and real estate mogul Samuel Johnston. Currently it is endowed by the Edelstein and Pritzker Foundations.

Partridge, born in Paris to American parents, won a competition for the commission. As a student of acting and a poet himself, he was an excellent choice. Work he did for the 1893 Columbian Exposition included a plaster model of this piece. The finished work was cast in Paris and shipped to Chicago. Partridge was present at the dedication in 1894.

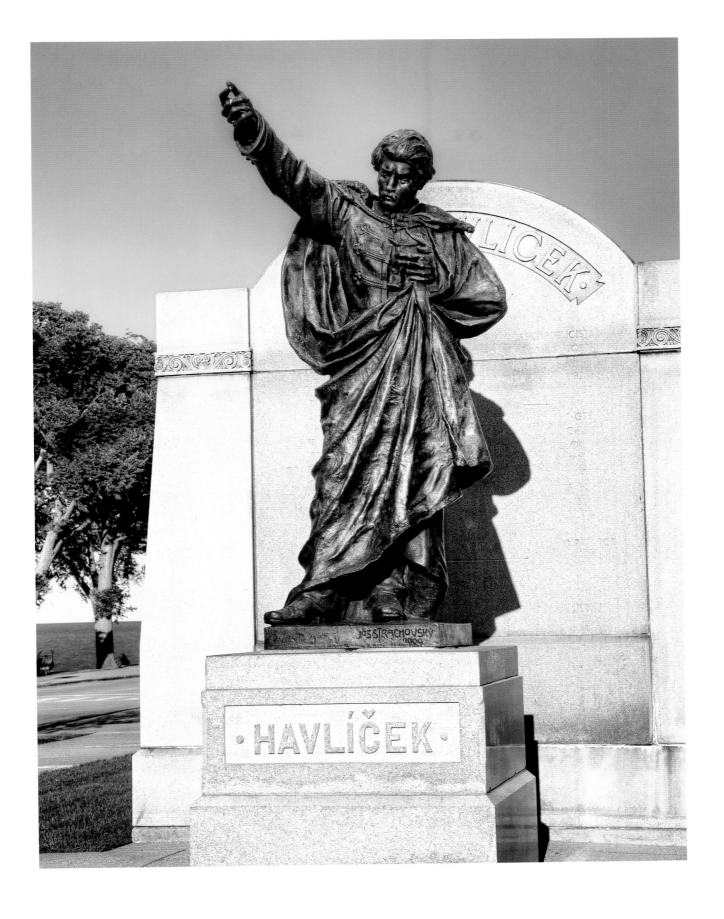

## KAREL HAVLICEK *by* JOSEF STRACHOVSKY

BRONZE AND GRANITE | INSTALLED 1911, MOVED 1983 | SOLIDARITY DRIVE, NORTHERLY ISLAND

Havlicek (1821–1856) was a politically passionate Czech poet, journalist, and newspaper publisher, one of the first of the revolutionary-era Czech liberals. Because of his writings he was forced into exile in 1851, and he died shortly after his return to Prague in 1855.

Czech sculptor Strachovsky (1850–1913) was commissioned by a group of Bohemian Americans in Chicago to prepare this sculpture in Prague. At the time he had produced two other sculptures for American Czech communities. The monument was first installed at Douglas Park and later moved to its location on Northerly Island.

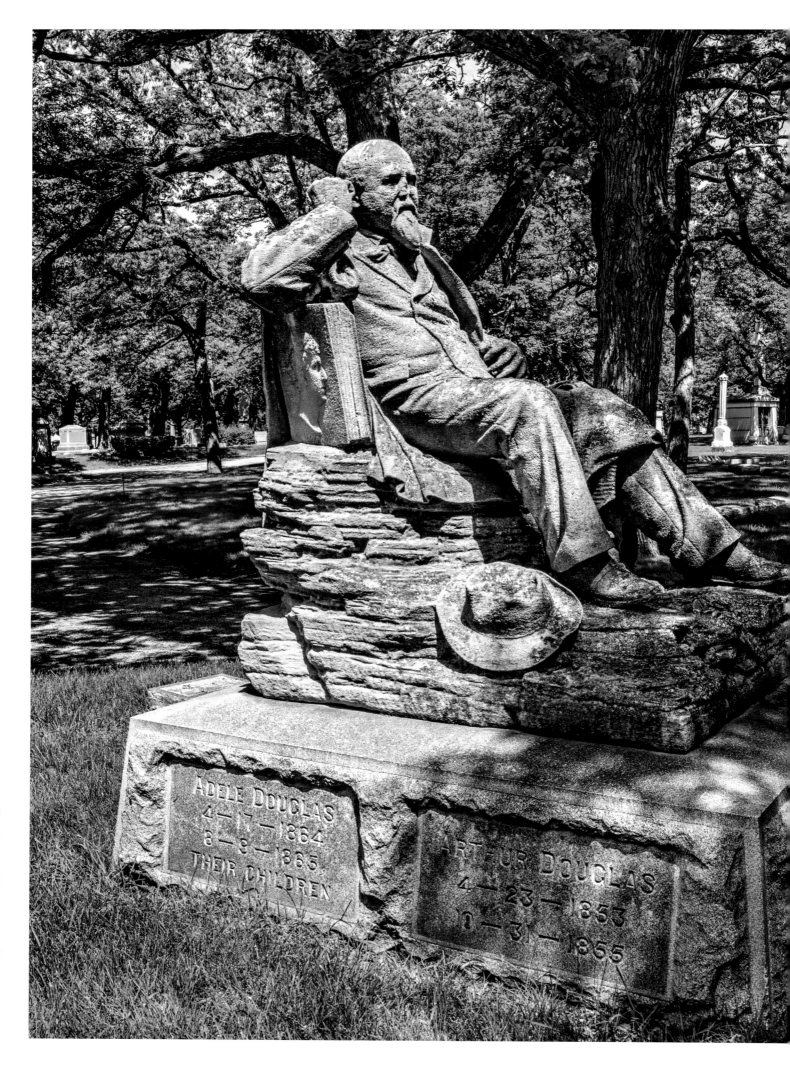

## LEONARD W. VOLK
*by* **LEONARD W. VOLK**
BRONZE AND MARBLE |
INSTALLED 1881 | ROSEHILL CEMETERY

This monument, the sculptor's self portrait and the only likeness of him in Chicago, marks his gravesite and that of his wife at Rosehill Cemetery. Volk is well remembered for making a life mask of Lincoln in 1860 during a visit to Chicago by the great statesman. Later in the year he also made castings of both of Lincoln's hands. He used these for his sculptures of Lincoln, as did other well known sculptors creating Lincoln memorials. The castings are preserved in the Smithsonian Institution.

After the many imposing and monumental sculptures Volk created for others, this reclining self portrait, with the subject's battered hat near his feet, is touching in its lifelike simplicity and modest demeanor.

MONUMENTAL

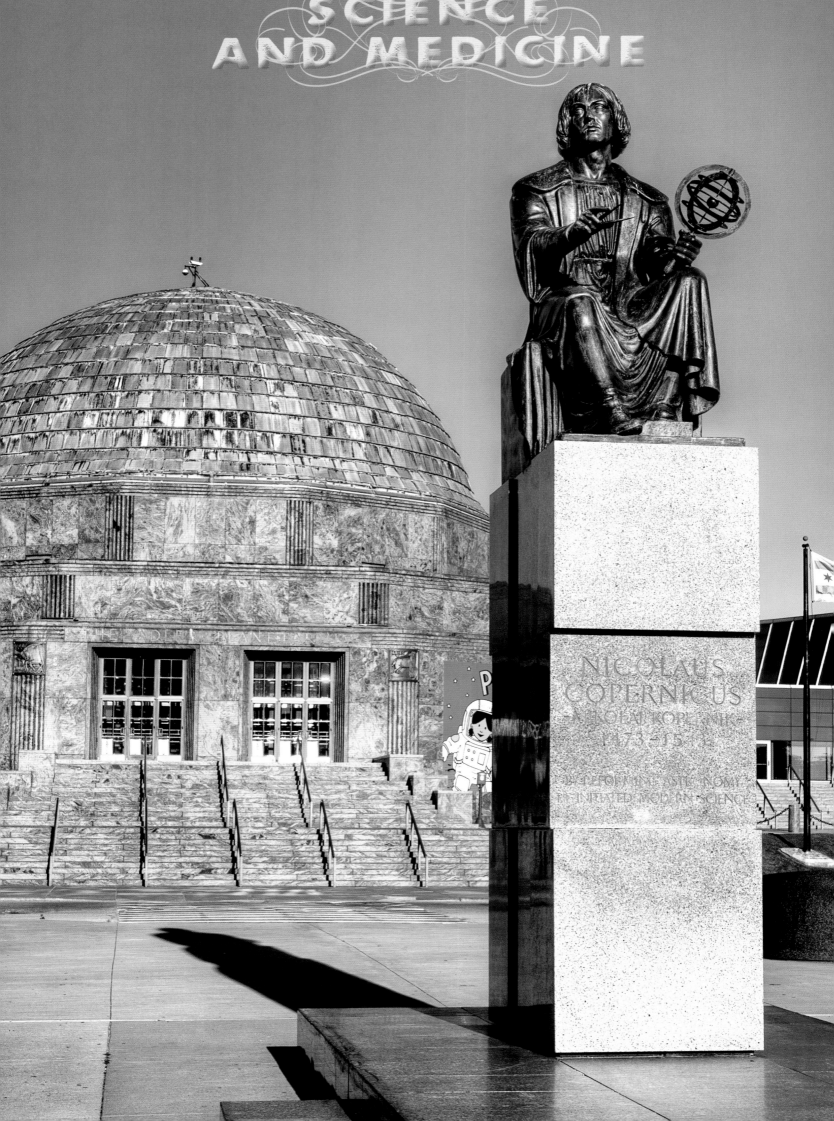

SCIENCE
AND MEDICINE

NICOLAUS
COPERNICUS
NIKOLAI KOPERNIK
1473-15

REFORMING ASTRONOMY
INITIATED MODERN SCIENCE

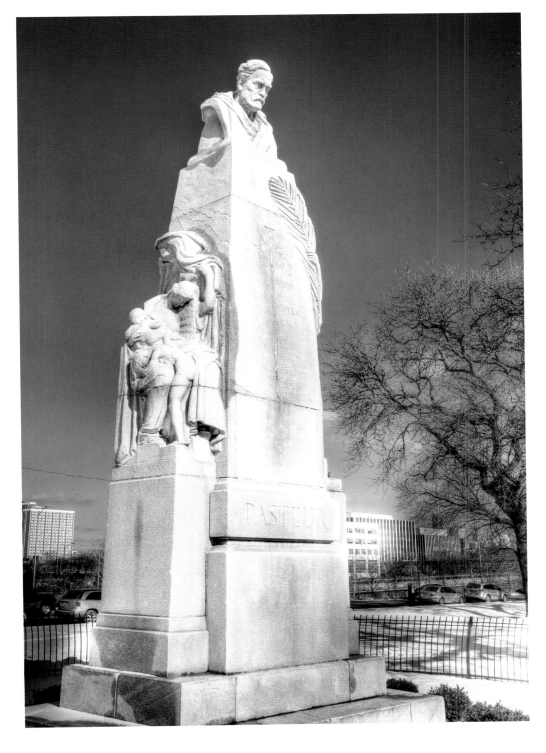

## LOUIS PASTEUR
### *by* LEON HERMANT
LIMESTONE | INSTALLED 1928 |
COOK COUNTY HOSPITAL

"Servant of humanity" is inscribed on the shaft of this monument to Louis Pasteur (1822–1895). The inscription on the back reads: "One doesn't ask of one who suffers: what is your country or what is your religion? One merely says, you suffer. This is enough for me, you belong to me, and I shall keep you." Pasteur developed an inoculation for rabies in 1885. He discovered that yeast organisms cause fermentation, and his research led to the pasteurization of milk and other food products, helping to prevent spoilage and food-borne illnesses.

Hermant (1866–1936) was a French-American sculptor educated in Europe; he came to America in 1904 and was based in Chicago through most of his career. Other Chicago sculptures by Hermant include architectural work at the Illinois Athletic Club and the Cook County Building.

## NICOLAUS COPERNICUS *by* BERTEL THORVALDSEN
BRONZE | INSTALLED 1973 | SOLIDARITY DRIVE, NORTHERLY ISLAND

This monument is in celebration of the 500th anniversary of the birth of Copernicus (1473–1543), the father of modern astronomy. He was born and educated in Poland. He is portrayed contemplating the heavens as he advances his theory that the earth revolves around the sun. The location of the monument at the Adler Planetarium is apt.

Bertel Thorvaldsen (1770–1844), a Dane, executed the work in plaster in 1823; the original was located in Warsaw and destroyed during the Second World War. This copy was cast in Warsaw from the artist's working model.

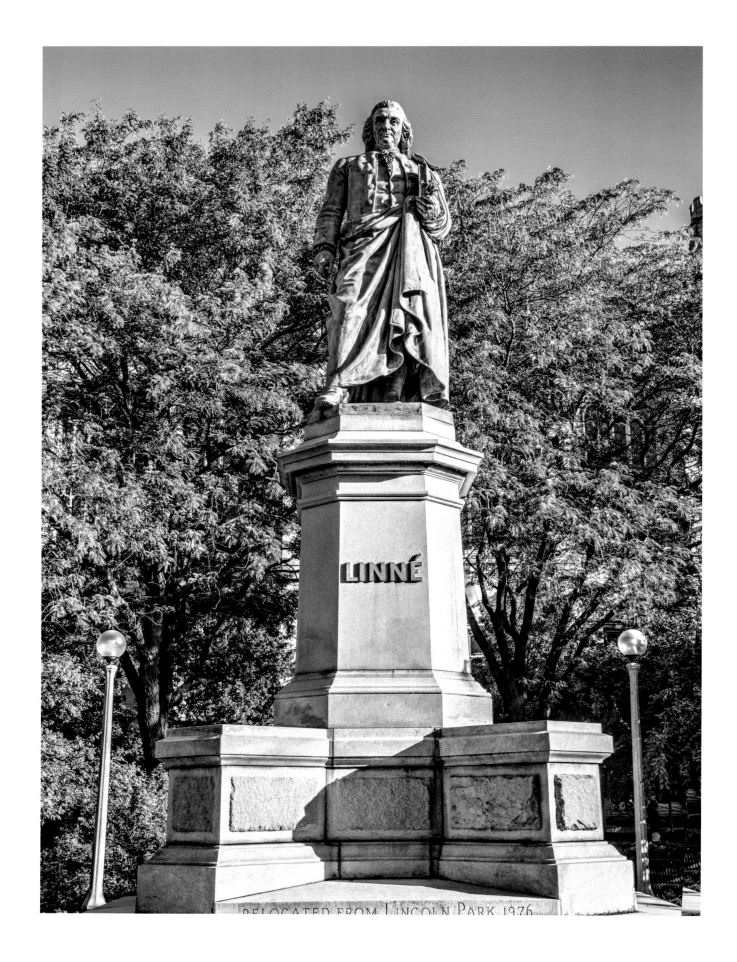

LINNÉ

RELOCATED FROM LINCOLN PARK 1976

## CARL VON LINNE *by* JOHAN DYFVERMAN

BRONZE | INSTALLED 1891, RELOCATED 1976 | MIDWAY PLAISANCE

Carl von Linne (1707–1778, also known as Linneaus) was a Swedish botanist and the first person to employ a system for naming plants and animals. This replica of a Swedish original was commissioned by the Swedish community of Chicago, cast in Stockholm, and shipped to Chicago.

It was first installed in 1891 in Lincoln Park and was relocated in 1976 to Midway Plaisance, at East 59th Streeet and Ellis Avenue.

The Swedish sculptor Dyfverman (1844–1892) worked in Sweden all his life.

## EMMANUEL SWEDENBORG *by* ADOLF JONNSON

BRONZE, GRANITE | FIRST INSTALLED 1924 | LINCOLN PARK, EAST OF LAKE SHORE DRIVE AT DIVERSEY

Swedenborg (1688–1772) was a Swedish scientist, inventor, philosopher, and theologian. Beginning in 1715, he devoted himself to natural science and engineering. He undertook many studies in anatomy and physiology and investigated the functions of the pituitary gland and brain. In 1741, he entered into a spiritual phase and published at least eighteen theological works.

Adolf Jonnson (1874–1945) was commissioned by a Chicago couple, Mr. and Mrs. L. Bracken Bishop, in 1924 to reproduce a bust of Swedenborg he had earlier sculpted in Sweden. The busts were based on studies done in Sweden of Swedenborg's skull. The elaborate unveiling in Lincoln Park involved many from Chicago's Swedish community. Unfortunately, the bronze bust was stolen in 1976 and replaced with a simple pyramidal structure which was seriously damaged by an automobile in 2009. The original bronze was replaced in 2012 by a bust created from a plaster cast by sculptor Magnus Persson in Sweden.

## ALEXANDER VON HUMBOLDT
### *by* FELIX GORLING
BRONZE | INSTALLED 1892 |
HUMBOLDT PARK

Alexander Von Humboldt (1769–1859), a naturalist and explorer from the Kingdom of Prussia, traveled extensively in Latin America, Russia, and Europe. He studied plant life in the Amazon and ocean currents in Siberia. (Note the iguana and globe at the foot of the statue, a reference to Humboldt's pursuits.) Humboldt Park is named in his honor. The statue was donated to the city by Francis Dewes, a wealthy German-American who made his fortune in the brewery business.

The German sculptor Gorling (1860–1935) lived and worked in Germany. The statue was cast in Europe and shipped to Chicago.

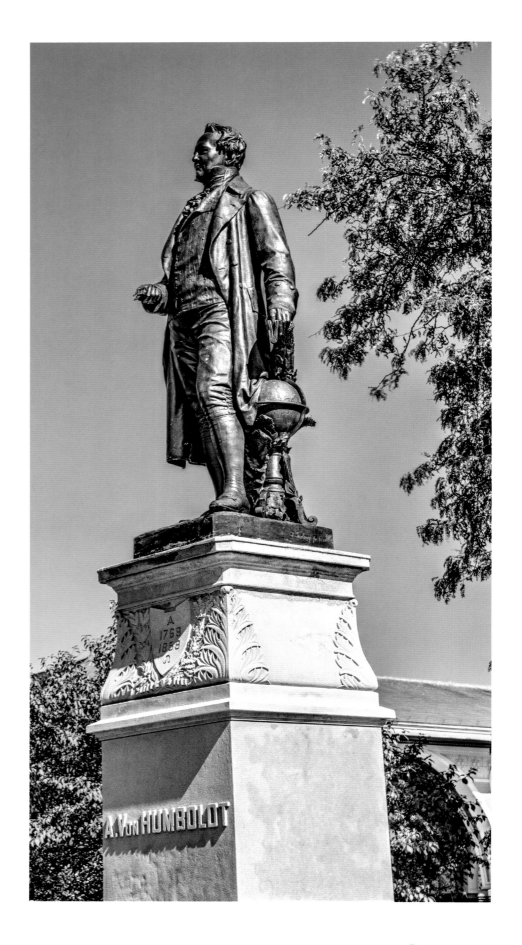

## GREENE VARDIMAN BLACK *by* FREDERICK CLEVELAND HIBBARD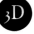
### BRONZE | INSTALLED 1918 | LINCOLN PARK, NORTH AVENUE AT ASTOR STREET

Dr. Black (1836–1915) was associated with various dental schools before becoming dean of the Northwestern Dental School in 1897. He is the author of *Dental Anatomy* (1891), a standard text on the subject.

The Chicago-based American sculptor Frederick Hibbard (1881–1955) trained under Lorado Taft at the School of the Art Institute of Chicago. He is remembered for his Civil War memorials and as the sculptor of a statue of Carter H. Harrison, the David Wallach fountain, and the Eagle fountains.

GREENE VARDIMAN BLACK

# CHAMPIONS OF THE PEOPLE

## DR. MARTIN LUTHER KING JR. MEMORIAL (I HAVE A DREAM)
### *by* ABBOT PATTISON

BRONZE | INSTALLED 1978 | CHICAGO STATE UNIVERSITY CAMPUS

In 1977 Abbott Pattison (1916–1999) was asked by a committee from the B. F. Ferguson Monument Fund and Chicago State University to create a sculpture to memorialize Dr. Martin Luther King, Jr., who was assassinated on April 4, 1968 in Memphis, Tennessee, while preparing to lead a civil rights march. The sculpture's inspiration was to be taken from the famous "I Have a Dream" speech given by Dr. King in Washington, D. C. on August 28, 1963. In it King said:

Go back to Mississippi, go back to Alabama, go back to South Carolina, go back to Georgia, go back to Louisiana, go back to the slums and ghettos of our northern cities, knowing that somehow this situation can and will be changed. Let us not wallow in the valley of despair.

I say to you today, my friends, so even though we face the difficulties of today and tomorrow, I still have a dream. It is a dream deeply rooted in the American dream.

I have a dream that one day this nation will rise up and live out the true meaning of its creed, *We hold these truths to be self-evident; that all men are created equal.*

I have a dream that one day on the red hills of Georgia the sons of former slaves and the sons of former slave owners will be able to sit down together at the table of brotherhood.

I have a dream that one day even the state of Mississippi, a state sweltering with the heat of injustice, sweltering with the heat of oppression, will be transformed into an oasis of freedom and justice.

I have a dream that my four little children will one day live in a nation where they will not be judged by the color of their skin but by the content of their character.

I have a dream today.

I have a dream that one day down in Alabama, with its vicious racists, with its governor having his lips dripping with the words of interposition and nullification, that one day right down in Alabama little black boys and black girls will be able to join hands with little white boys and white girls as sisters and brothers.

I have a dream today.

I have a dream that one day every valley shall be exhalted, every hill and mountain shall be made low, the rough places will be made plain, and the crooked places will be made straight, and the glory of the Lord shall be revealed, and all flesh shall see it together.

This is our hope. This is the faith that I will go back to the South with. With this faith we will be able to hew out of the mountain of despair a stone of hope. With this faith we will be able to transform the jangling discords of our nation into a beautiful symphony of brotherhood.

With this faith we will be able to work together, to pray together, to struggle together, to go to jail together, to stand up for freedom together, knowing that we will be free one day.

Reprinted by arrangement with The Heirs to the Estate of Martin Luther King Jr., c/o Writers House as agent for the proprietor New York, NY.

Pattison was a Chicago area resident most of his life, moving to Maine in 1993. He was a student at the Yale University School of Fine Arts and then served in the United States Navy during World War II. After the war he taught at the School of the Art Institute of Chicago. It is thought that the memorial depicts five figures facing and reaching outwards, actively expressing a plea for brotherhood. The sculpture was cast in Italy, given a dark patina, and unveiled on September 26, 1978 on the new campus of Chicago State University. Other Pattison sculptures are *Chicago Totem* at the Outer Drive East apartment building and *Fountain of the Great Lakes* at Oak Brook Office Plaza.

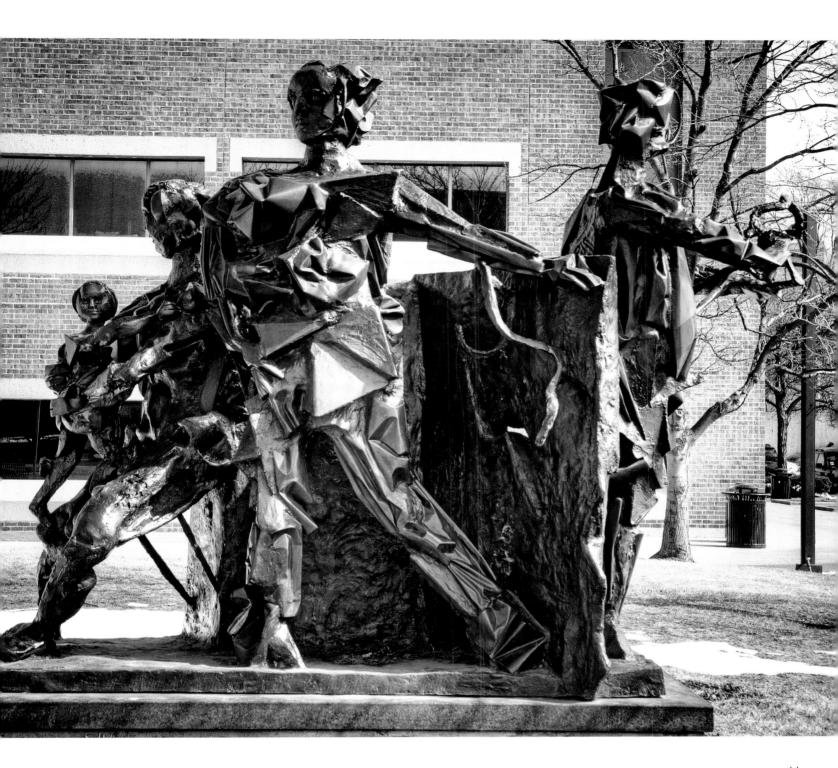

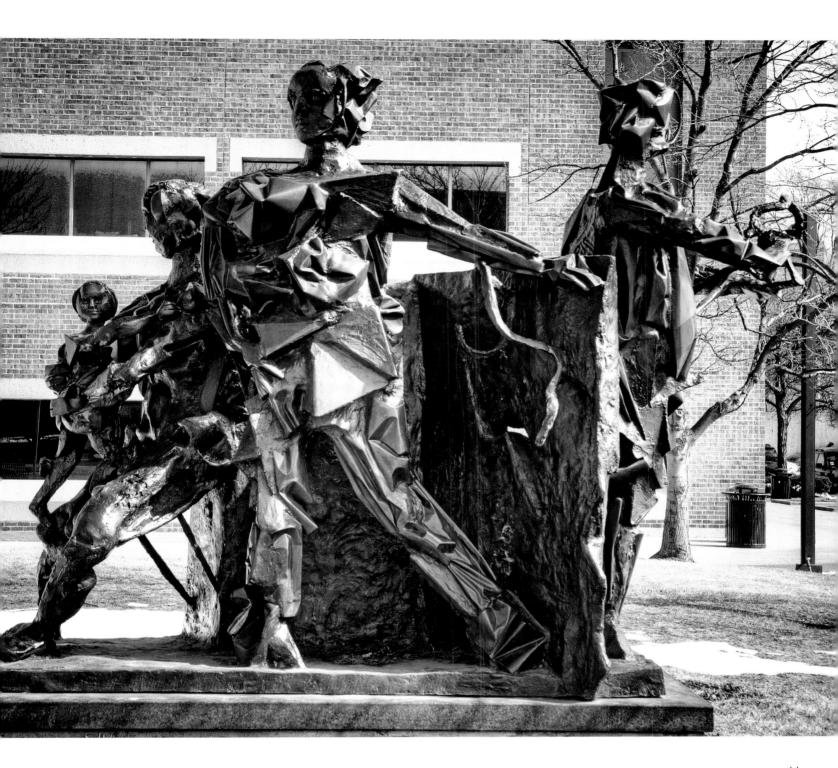

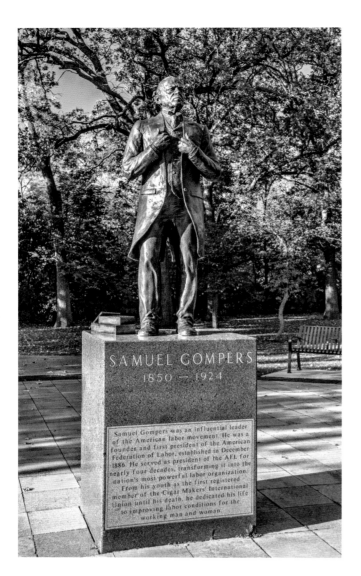

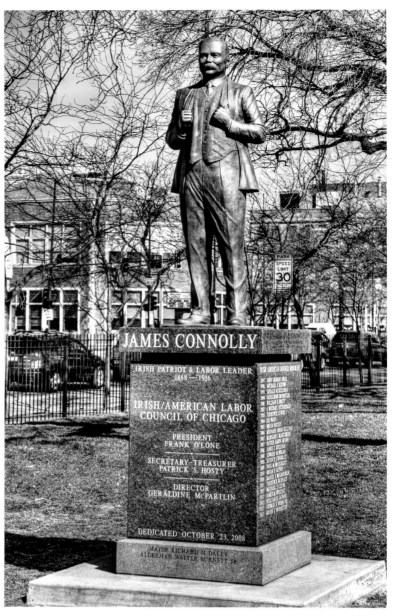

## SAMUEL GOMPERS *by* SUSAN CLINARD

BRONZE | INSTALLED 2007 | SOUTH OF WEST FOSTER AVENUE AND WEST OF NORTH PULASKI AVENUE

Samuel Gompers (1850–1924) was an important figure in the American labor movement. In 1864 he joined the United Cigar Makers. He helped found what was to become the American Federation of Labor (AFL).

Susan Clinard (b. 1971) moved to Chicago in 1995 and taught stone carving at the School of the Art Institute of Chicago. She moved her studio to Connecticut in 2007 and through numerous shows, commissions, and exhibitions

has her work placed throughout the United States. While this monument only dates back to 2007, it is included here because of the importance of Samuel Gompers to the labor movement in the United States. Other Clinard works in Chicago are the *Pourer Statue,* Sipi Metal Co., and a sculpture at the Rehabilitation Institute.

## JAMES CONNOLLY *by* TOM WHITE

BRONZE | INSTALLED 2008 | NORTH ASHLAND AVENUE AND WEST WARREN BOULEVARD

James Connolly (1868–1916) was a labor organizer of international importance. Connolly helped found the Socialist Labour Party in Great Britain. He emigrated to the United States in 1903, where he was involved with the Industrial Workers of the World and the Socialist Party of America. After returning to Ireland in 1910, he formed the Irish Citizens Army and fought for Irish independence. He was executed by the British after he helped plan the Easter Rising of 1916.

Tom White (b. 1961) is a self-taught artist and a native of Texas who currently resides in Arizona. His war memorials, biblical scenes, historical figures, and sports heroes are located across the United States and Canada.

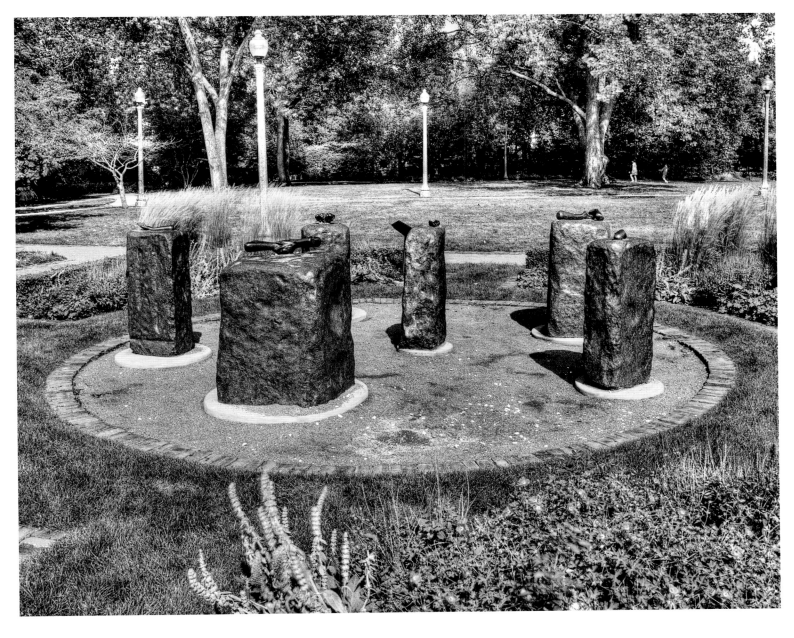

## JANE ADDAMS MEMORIAL (HELPING HANDS)
### *by* LOUISE BOURGEOIS
GRANITE | INSTALLED 1996 | CHICAGO WOMEN'S PARK, 1801 SOUTH INDIANA AVENUE

This is the only commemorative sculpture in Chicago to honor a woman. Jane Addams (1860–1935) was a pioneer American social worker and co-founder in 1889 of the first Chicago settlement house. Hull House provided residence for about twenty-five women and was a center for research, empirical analysis, and debate. Addams's example led to the establishment of social work as a profession in the United States. A public philosopher, sociologist, author, and leader in women's suffrage and world peace, she was awarded the Nobel Peace Prize in 1931.

*Helping Hands* was sculpted in 1993 and first installed in a Chicago lakefront park in 1996. It was removed to Chicago Women's Park in 2011 because of damage due to vandalism.

Louise (1911–2010) was a French-American artist and sculptor of great fame. Her first retrospective was mounted by the Museum of Modern Art in New York City in 1982.

MONUMENTAL

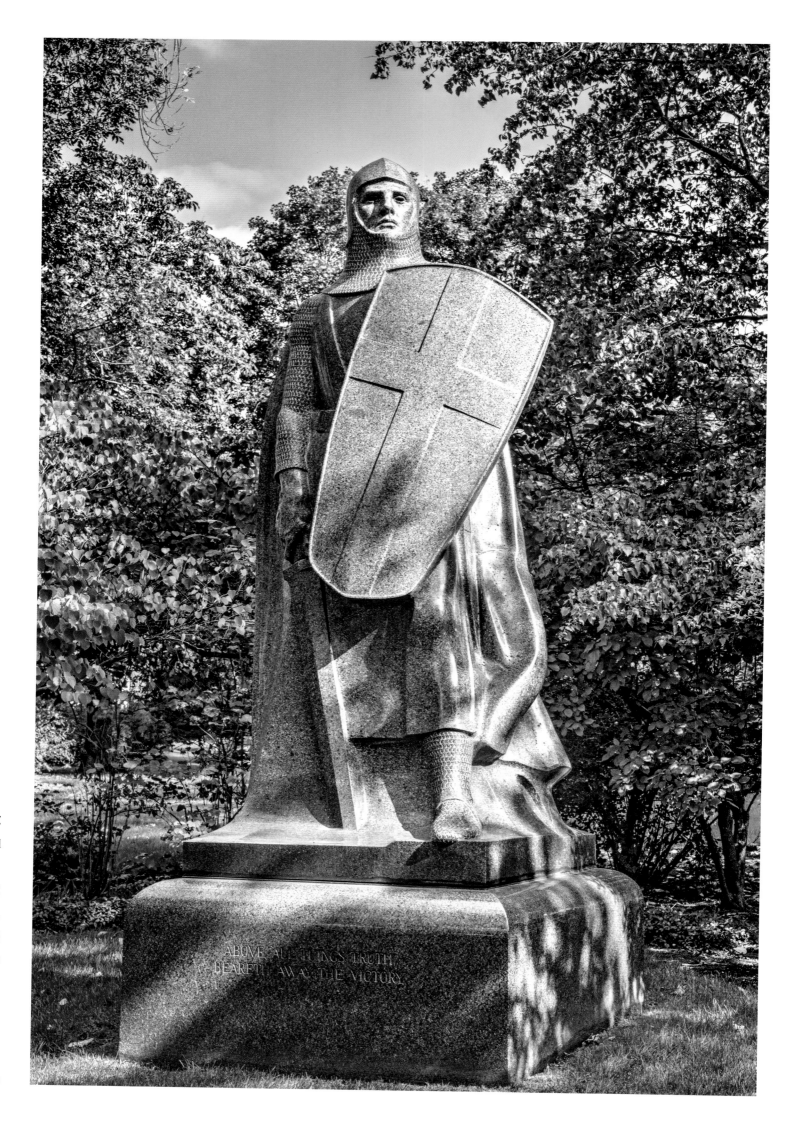

ABOVE ALL THINGS TRUTH
BEARETH AWAY THE VICTORY

## GIUSEPPI GARIBALDI
*by* **VICTOR GHERARDI**

BRONZE | INSTALLED 1901 | LINCOLN PARK, MOVED TO GARIBALDI PARK IN 1982

Giuseppi Garibaldi (1807–1882), an Italian military strategist, was an important figure in the unification of Italy in 1860 and much respected by the Chicago Italian community. Two thousand people attended the unveiling of his memorial sculpture in 1901. The statue was moved in 1982 to a park whose name had been changed to honor Garibaldi in 1979.

Gherardi, a New York sculptor, portrayed Garibaldi as a stern and self-confident man with folded arms and a cape.

## VICTOR FREMONT LAWSON (THE CRUSADER) *by* LORADO TAFT

BRONZE | INSTALLED 1931 | GRACELAND CEMETERY

"Above all things truth beareth away the victory" reads the inscription on the base of this monument to Victor Lawson (1850–1925), publisher of the crusading *Chicago Daily News* from 1876 to his death in 1925. Lawson is represented as a crusading knight.

Lorado Taft (1860–1936) was a sculptor, writer, and educator born in a Chicago suburb. He played a major role in designing sculptures for the 1893 Chicago Columbian Exposition. He attended the University of Illinois and after receiving a master's degree in 1880 studied in Paris for three years. After returning to the United States in 1883, he settled in Chicago and taught at the School of the Chicago Art Institute until 1929. His other Chicago sculptures are *Eternal Silence, Fountain of the Great Lakes, Fountain of Time, Pastoryl* and *Idyll.*

## DR. JOSE RIZAL *by* ANTONIO T. MONDEJAR

BRONZE | INSTALLED 1999 | LINCOLN PARK, NORTH LAKE SHORE DRIVE AND LELAND AVENUE

Dr. Rizal (1861–1896) is a hero of the Chicago Philippine community. A writer, physician, and activist, he was executed by firing squad after a military trial, and it is said this catalyzed the Philippine revolution against Spain and the United States. This sculpture is a replica of one in the Philippines. While this monument is not old, it is included for its historic significance and importance to Chicagoans from the Philippines.

Several films have been made based on Rizal's life, and virtually every city in the Philippines has a street named for him. Mondejar's monument for a shrine in the Philippines was recast to make this bronze for Chicago. Money from the Filipino community of Chicago paid for the reproduction.

## BENITO JUAREZ

BRONZE | INSTALLED 1999 | PLAZA OF THE AMERICAS, MICHIGAN AVENUE NORTH OF WRIGLEY BUILDING

This monument to Benito Juarez (1806–1872), the first Mexican president of Indian ancestry, replaces a bust present on the site that dated to the 1960s. The Mexican consul general presented the statue to the city of Chicago on

behalf of the Mexican government. Juarez is considered as the builder of modern Mexico who helped defend Mexico against the French occupation of 1862.

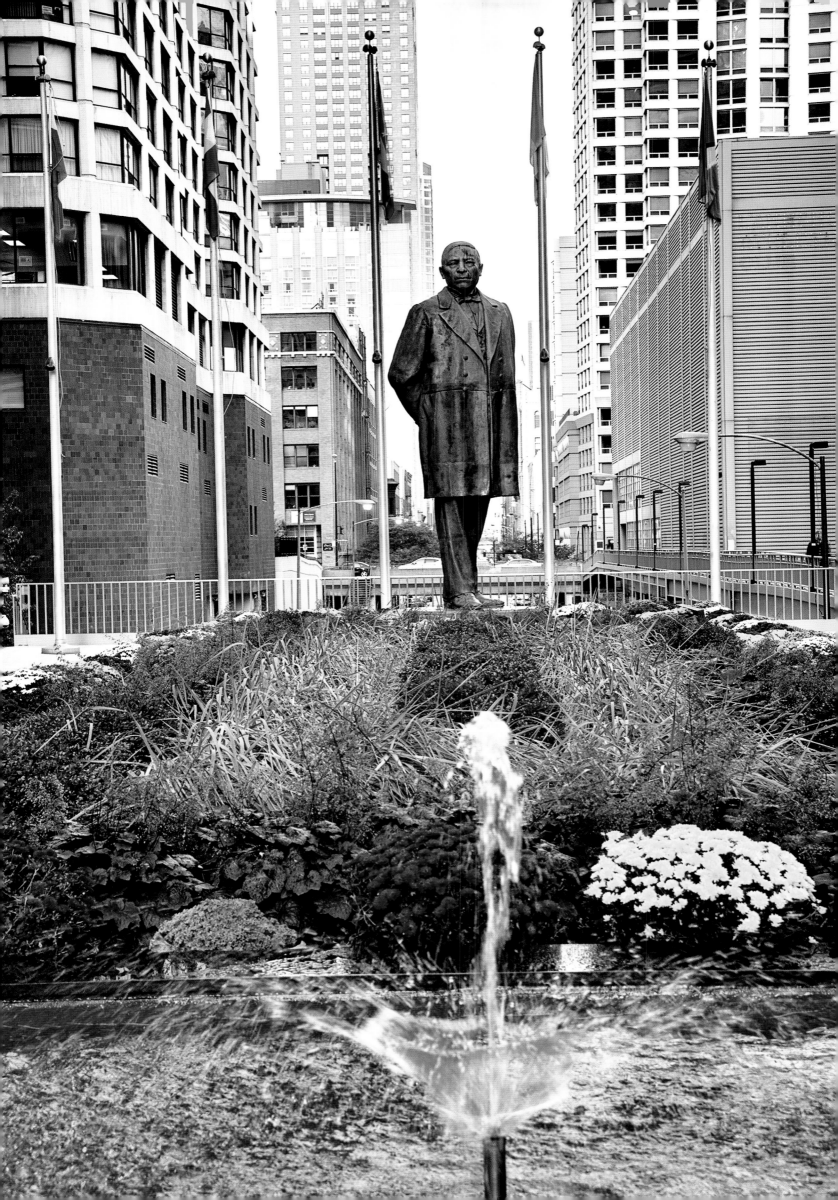

# MEN OF COMMERCE

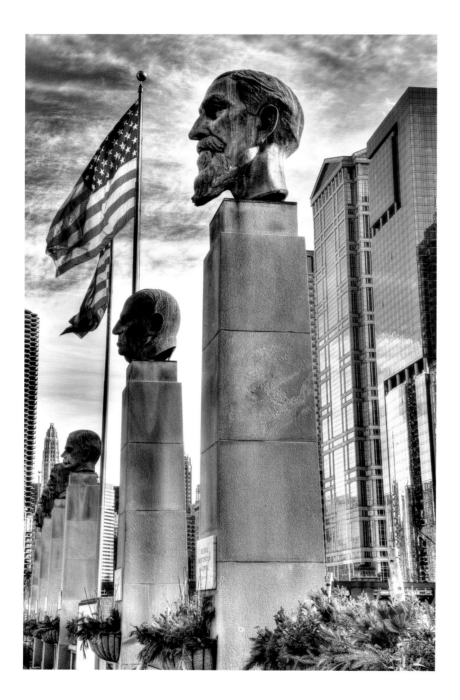

### HALL OF FAME

MARSHALL FIELD (1835–1906)
*founder of Marshall Field and Co.*

SHOWN ON FACING PAGE

GEORGE HUNTINGTON HARTFORD (1833–1917)
*founder of Great Atlantic and Pacific Tea Co.*

SHOWN IN FOREGROUND AT LEFT

JOHN R. WANAMAKER (1838–1922)
*founder of John Wanamaker, Inc.*

FRANK WINFIELD WOOLWORTH (1852–1919)
*founder of F.W. Woolworth Co.*

EDWARD A. FILENE (1860–1937)
*president of William Filene and Sons*

JULIUS ROSENWALD (1862–1932)
*part owner, president and chairman,
Sears, Roebuck and Co.*

GENERAL ROBERT E. WOOD (1879–1970)
*president and chairman, Sears, Roebuck and Co.*

AARON MONTGOMERY WARD (1843–1913)
*founder of Montgomery Ward and Co.*

C
H
I
C
A
G
O

## MERCHANDISE MART HALL OF FAME

BRONZE AND MARBLE │ INSTALLED 1953 │ MAIN ENTRANCE, MERCHANDISE MART

Eight bronze busts of leading American merchandisers are mounted on tall marble pillars in the Hall of Fame created by Joseph Kennedy (1888–1969) while he was owner of the Merchandise Mart. The 1953 dedication was attended by John F. Kennedy, then a senator from Massachusetts.

Sculptors of the eight busts are Minna Harkavy (1887–1987, General Robert Wood); Milton Horn (1906–1995, Frank Woolworth and Aaron Ward); Charles Umlauf (1911–1994, George Hartford and Julius Rosenwald); Lewis Iselin (1913–1990, John Wanamaker and Marshall Field); and Henry Rox (1899–1967, Edward Filene). Horn was also the sculptor of *Chicago Rising from the Lake* and a relief for the Temple Zion.

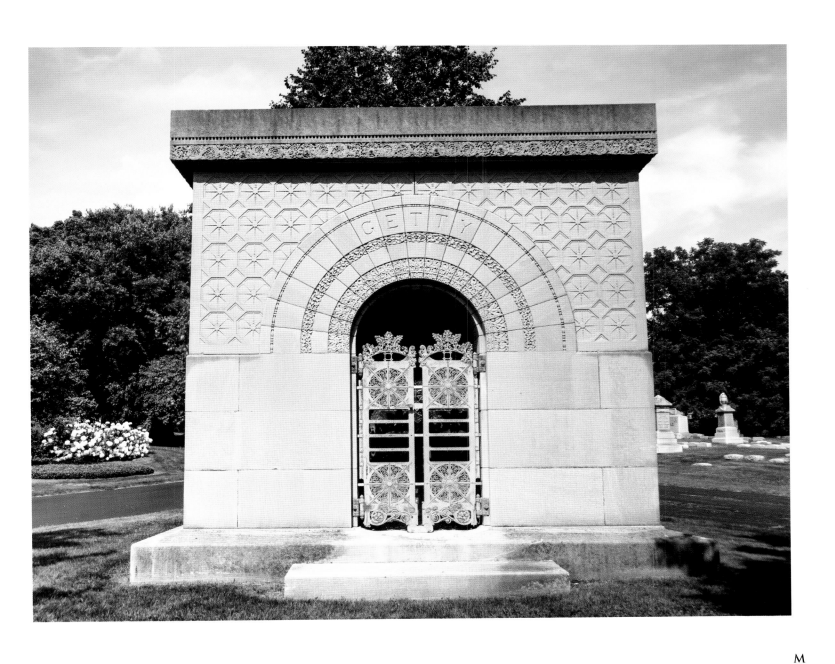

## CARRIE ELIZA GETTY TOMB *by* LOUIS SULLIVAN
BRONZE AND STONE | INSTALLED 1890 | GRACELAND CEMETERY

The tomb of Carrie Eliza Getty was commissioned and built in 1890 by lumber baron Henry Harrison Getty for his wife, Carrie Eliza. Designed by famed architect Louis Sullivan, the simple cube with an overhanging roof is articulated with a delicate surface treatment and a dynamically patterned bronze gate.

Henry Getty died in 1919 and was also buried in the tomb, as is the couple's only daughter, who died in 1946.

## GEORGE MORTIMER PULLMAN *by* SOLON BEMAN
### INSTALLED 1897 | GRACELAND CEMETERY

George Pullman (1831–1897) invented and manufactured the railroad sleeping car. A bitter strike against the Pullman Company in 1894 only ended when President Grover Cleveland sent in federal troops.

Pullman was buried in a fortified concrete block out of fear that former employees might do damage to his grave. The Corinthian column marks the location of the grave.

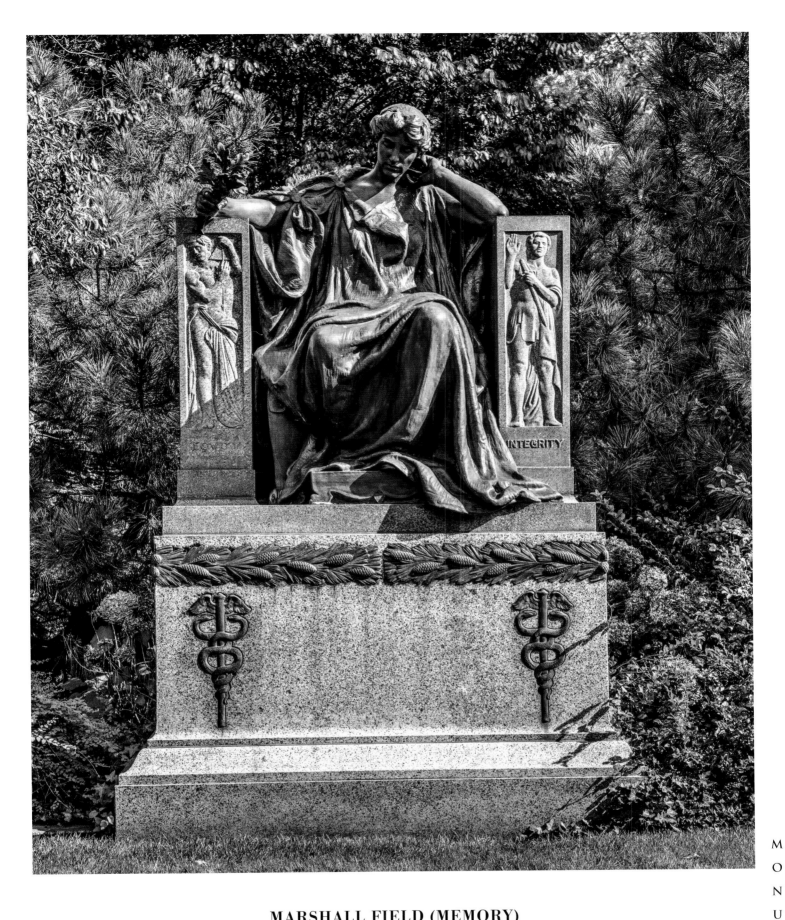

## MARSHALL FIELD (MEMORY)
#### *by* DANIEL CHESTER FRENCH WITH HENRY BACON
BRONZE AND GRANITE | INSTALLED CA. 1906–1910 | GRACELAND CEMETERY

Marshall Field (1835–1906) is buried with family members in Graceland Cemetery. Their plot includes the sculpture *Memory* placed behind a reflecting pool. Field was Chicago's premier merchant, heading one of the largest retail businesses in the world. He was also a philanthropist and left a large sum in his will to make permanent the Field Museum of Natural History.

The work is a collaboration between French (1850–1931), who created the bronze monument, and Bacon (1866–1924), who designed its setting. The two collaborated again on the Lincoln Memorial in Washington, D. C. French is represented in Chicago also by *The Republic* and the George Washington Memorial.

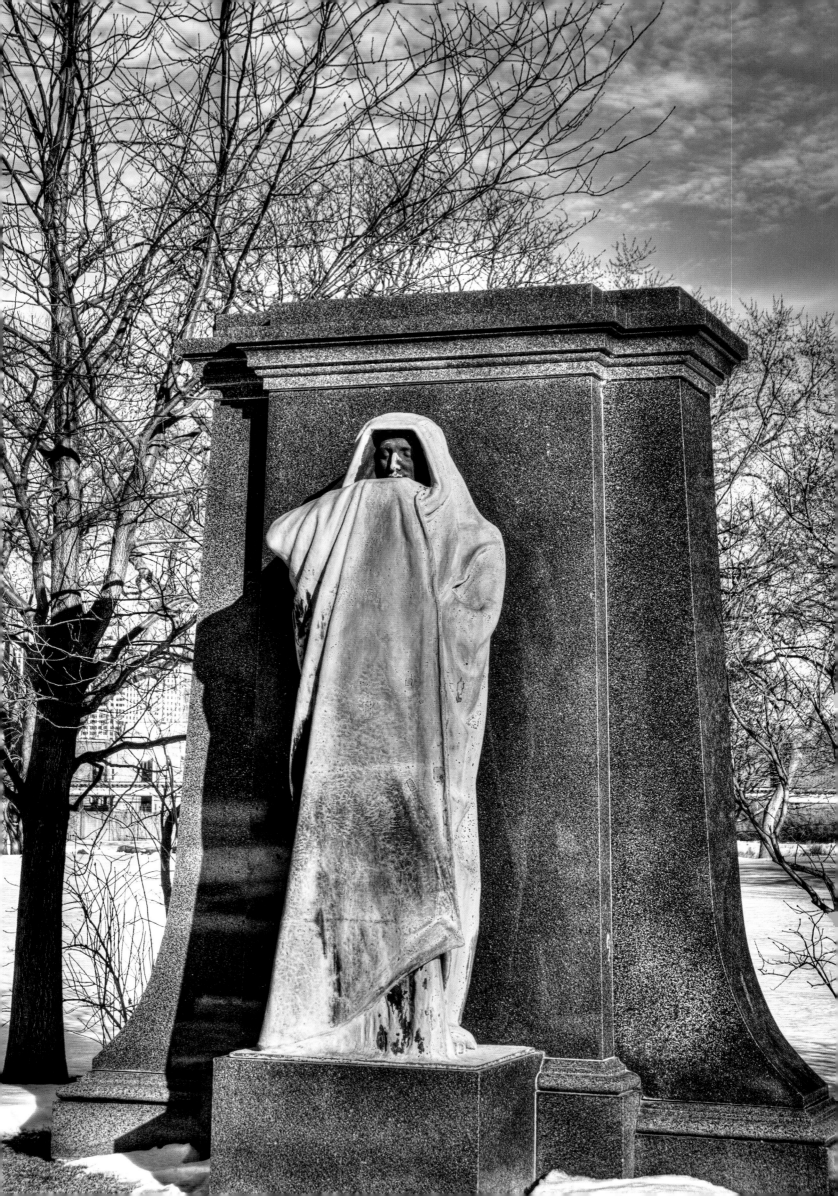

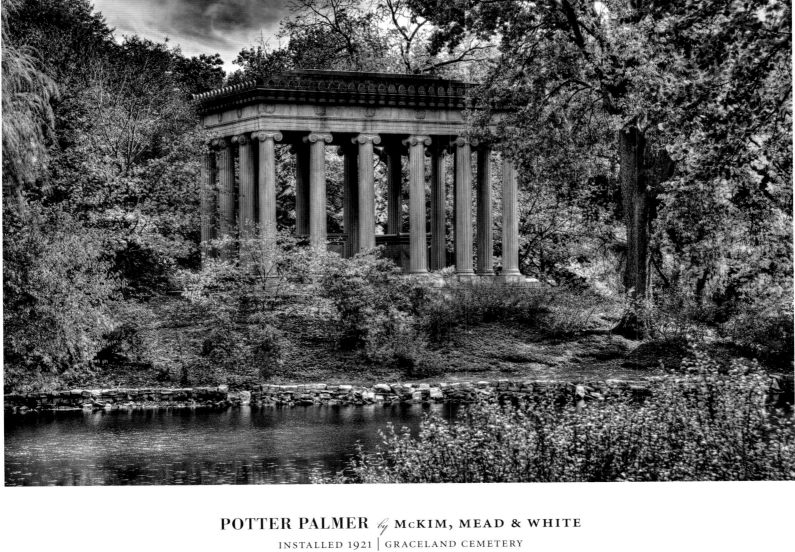

## POTTER PALMER *by* McKIM, MEAD & WHITE
### INSTALLED 1921 | GRACELAND CEMETERY

A beautiful Greek temple overlooking a lake contains the sarcophagi of Potter Palmer (1826–1902) and his wife, Bertha Honore (1850–1918). Palmer was one of the most prominent businessmen in early Chicago. He built commercial buildings all along State Street and even widened the street. He built the Palmer House Hotel. After it was destroyed in the Great Chicago Fire, Palmer rebuilt it into an even grander hotel. He built up the near north side of Chicago and was responsible for creating "the Gold Coast."

## DEXTER GRAVES (ETERNAL SILENCE) *by* LORADO TAFT
### BRONZE AND GRANITE | INSTALLED 1909 | GRACELAND CEMETERY

The Graves family arrived in Chicago in 1831 among the town's earliest settlers. Dexter Graves (1789–1844) became a successful and wealthy hotel owner. This monument was commissioned by Henry Graves for his father. Over the years, while most of the bronze statue has weathered, turning to green, most of the recessed face has remained black, resulting in a very eerie appearance.

Lorado Taft played a major role in designing sculptures for the 1893 Chicago Columbian Exposition. After studying abroad, he settled in Chicago, where he taught at the School of the Chicago Art Institute until 1929. Other Chicago sculptures by Taft are *The Crusader, Fountain of the Great Lakes, Fountain of Time, Pastoral,* and *Idyll.*

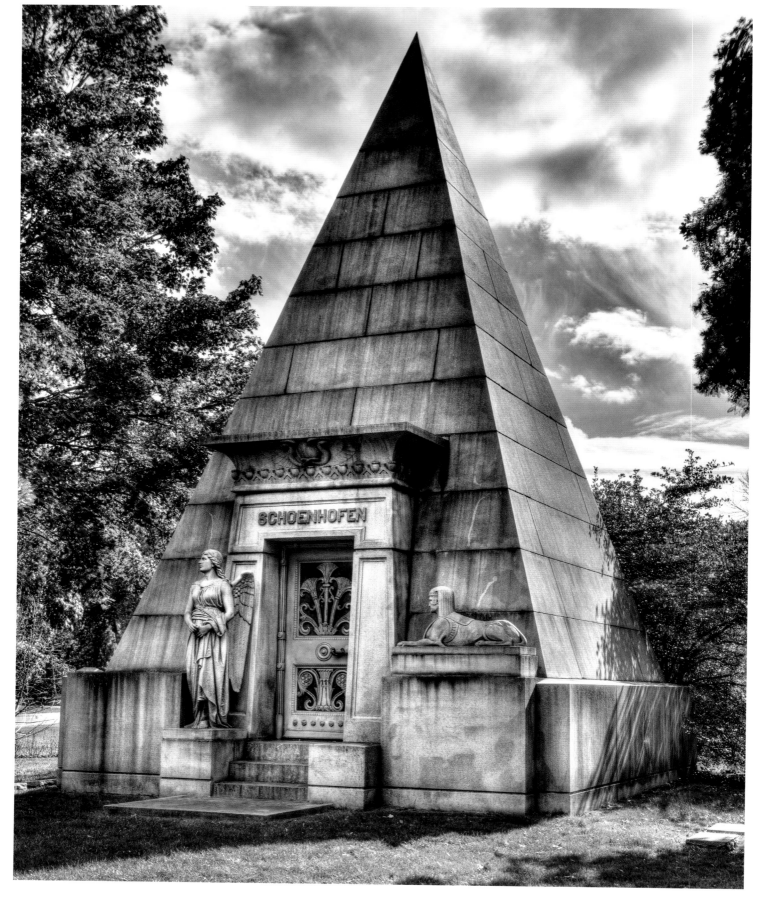

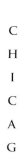

## PETER SCHOENHOFEN *by* RICHARD SCHMIDT
### BUILT 1893 | GRACELAND CEMETERY

Prussian-born Schoenhofen (1827–1893) emigrated to Chicago in the 1850s and started a very successful beer brewing business, which his family continued until the 1970s. His coffin rests in a beautiful pyramid guarded by a sphinx and angel.

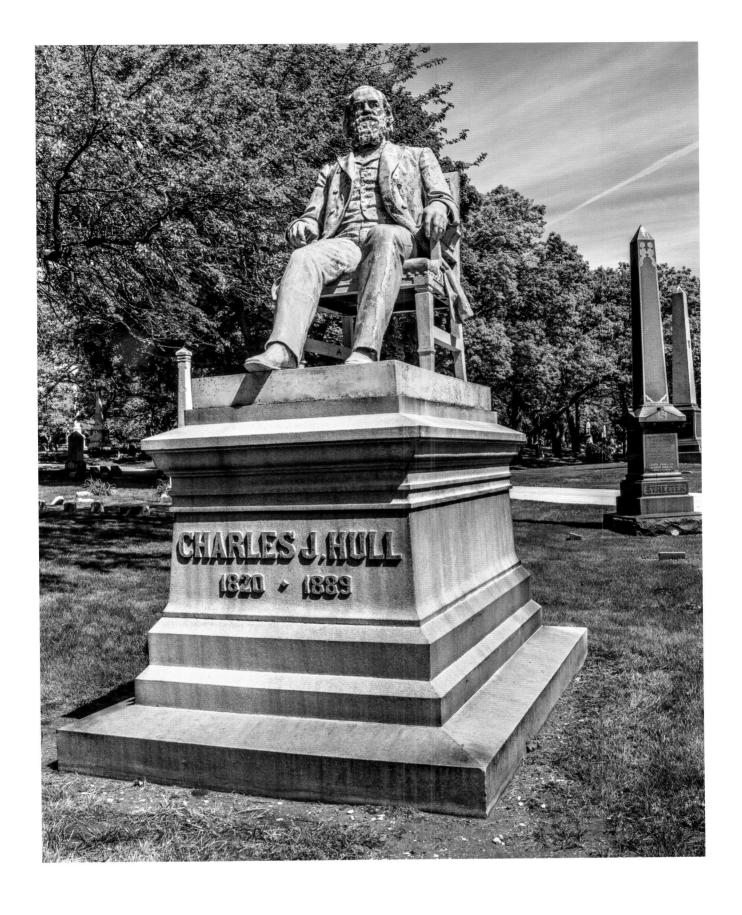

## CHARLES J. HULL *by* RICHARD HENRY PARK
BRONZE │ INSTALLED CA. 1900 │ ROSEHILL CEMETERY

Hull (1820–1889) was a successful real estate developer who built a large mansion in 1856 at the approximate location of Halsted and Polk Streets. In the year of his death, the house was leased to social worker Jane Addams as a settlement house. She was awarded the Nobel Peace Prize in 1931 for her work there.

Richard Henry Park (1832–1902) was a well-known American sculptor who helped with the design of sculptures for the 1893 Columbian Exposition in Chicago. Also in Chicago is his statue of Benjamin Franklin.

# THE LAWLESS
# AND THE LAW

## MELVILLE WESTON FULLER *by* WILLIAM ORDWAY PARTRIDGE

BRONZE | INSTALLED 1913 | FULLER PARK, WEST 45TH STREET AND PRINCETON AVENUE

This portrait bust is a bronze copy of a marble one in the Supreme Court building in Washington, D.C. Fuller (1833–1910) was appointed chief justice of the Supreme Court in 1888, the first Illinoisan to serve on the court. He came to Chicago from Maine to practice law in 1856. Fuller is buried in Graceland Cemetery with his wife Molly, who died in 1904.

Partridge (1861–1930) was a sculptor, poet, actor, and teacher. He is most known for his Shakespeare sculptures, including the one in Chicago.

C
H
I
C
A
G
O

## GOLD STAR FAMILIES MEMORIAL

BRONZE | INSTALLED 2010 | JULIE ROTBLATT-AMRANY AND OMRI AMRANY

Memorial Park, designed by David Woodhouse Architects and covering five acres of Burnham Park east of Soldier Field, was commissioned by the Chicago Police Memorial Foundation to pay tribute to all officers who have died in the line of duty since the formation of the department in approximately 1835. The south end of the park with its large lawn area and water cascading over a wall provides a tranquil setting. Memorial bricks set in the ground contain the names of lost friends, family, or loved ones, not necessarily police officers. The bricks are made available to the public by donation. The spiritual center of the park is an adjacent area enclosed by a concrete circular wall with the names of more than 400 officers who died in service to the city. In 2010 a bronze sculpture of a disabled officer in a wheelchair was placed in the "living sacrifice space." Julie Rotblatt-Amrany and Omri Amrany created the figure. The artists live and work in the Chicago area. They also produced the Michael Jordan sculpture in United Center.

## AL CAPONE GRAVE MARKER AND GENNA CRIME FAMILY TOMB

MOUNT CARMEL CEMETERY

Al Capone, born in Brooklyn in 1899, was the best-known figure in mobster history. He assumed control of one of the most violent Chicago crime organizations in 1925. By promoting himself with donations to charity and handouts to the poor, he became to many Chicagoans a modern-day Robin Hood. It is believed that he planned the St. Valentine's Day massacre of 1929 to eliminate a key rival, Bugs Moran. While Capone could outwit fellow mobsters, he could not outwit the federal government. In 1932, at age thirty-three, he was sent to Atlanta Penitentiary. He finished his term of incarceration at Alcatraz in 1939, venereal diseases eroding his mental faculties. After release from prison and hospital treatment for late-stage syphilis, he moved to his mansion in

Florida. He died of a stroke on January 25, 1947, at forty-eight and was buried at Mt. Olivet Cemetery in Chicago. Due to vandalism of his grave, he was moved to Mt. Carmel Cemetery and buried in concrete alongside family members.

The Genna crime family, headed by six brothers, controlled Chicago's Little Italy during Prohibition, from 1920 to 1925. They were allies of Capone's Chicago gang. Their businesses included bootlegging, extortion, gambling, and other vice-related acitivities. Two Genna brothers were killed by Capone rivals and one in a shootout by Chicago police. The three remaining brothers fled Chicago. All six brothers are buried in the family mausoleum at Mt. Carmel Cemetery.

C
H
I
C
A
G
O

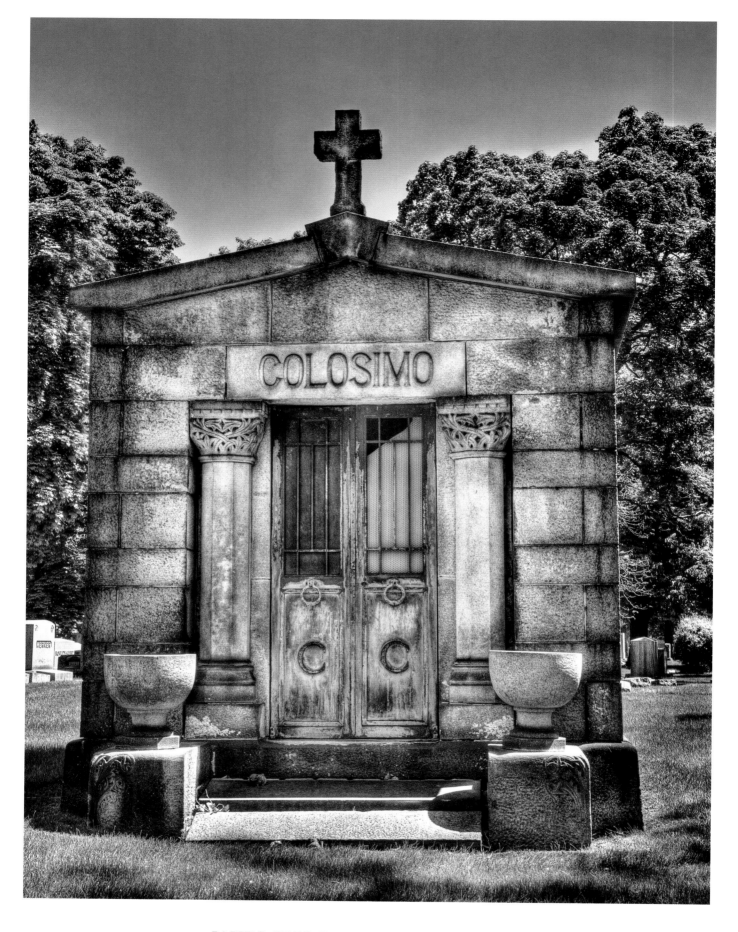

## JAMES "BIG JIM" COLOSIMO TOMB

OAK WOODS CEMETERY

The mobster James "Big Jim" Colosimo emigrated to the United States with his father in 1895 and settled in Chicago. Colosimo became a vice lord after marrying a prosperous madam and eventually controlled over 200 brothels in the levee district of Chicago. He also was heavily involved in gambling and other racketeering enterprises. In 1910, he opened an opulent nightclub, Colosimo's Café, on South Wabash Street. His resistance to entering the bootlegging business with Al Capone led to his assassination in his restaurant in 1920. He was buried in Oak Woods Cemetery at a funeral that included more than fifty pallbearers and two brass bands.

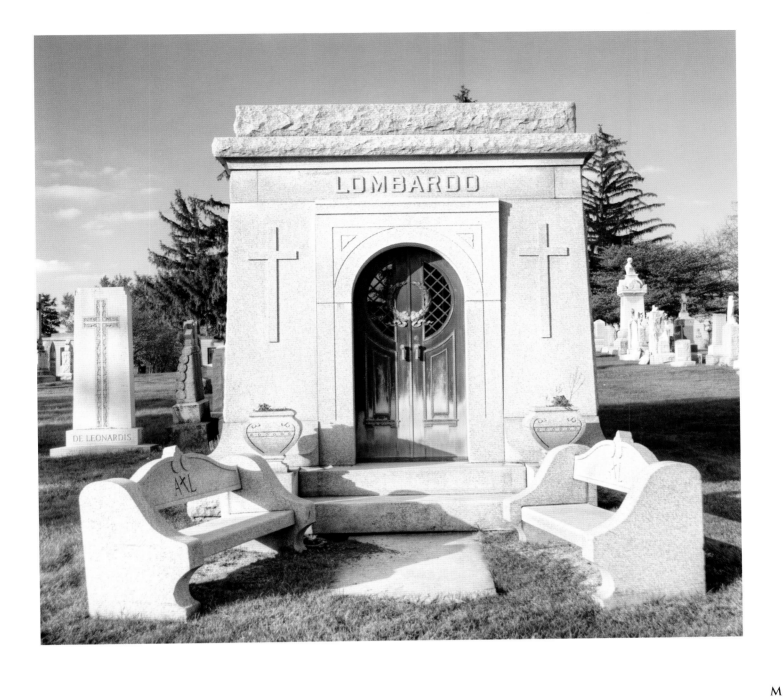

## ANTONIO LOMBARDO TOMB

### MOUNT CARMEL CEMETERY

Antonio Lombardo (1891–1928), born in Sicily, emigrated to the United States in the early 1900s. While he became a successful wholesale grocer in Chicago, he also became associated with organized crime. In 1927, he became Al Capone's consigliere. Lombardo and a bodyguard were gunned down in the center of downtown Chicago on September 7, 1928. Afterwards, Al Capone ordered several members of a rival gang murdered in retaliation. He also began planning a massacre now known as the St. Valentine's Day massacre.

# HEROES

## MICHAEL JORDAN: THE SPIRIT
### *by* OMRI AMRANY AND JULIE ROTBLATT-AMRANY
BRONZE | INSTALLED 1994 | UNITED CENTER

Michael Jordan (b. 1963) spent his entire career with the Chicago Bulls and is considered the best NBA player ever to play the game. His name is synonymous with Chicago and the Bulls even in the remotest parts of the world.

*The Spirit* was commissioned after his retirement. Julie Rotblatt-Amrany (b. 1958) and her husband Omri Amrany (b. 1954) are artists and sculptors as well as instructors at Rotblatt-Amrany Studios, Highwood, Illinois.

## ERNIE BANKS *by* LOU CELLA
BRONZE | INSTALLED 2008 | WRIGLEY FIELD

Ernie Banks (1931–2015) said of this sculpture at Wrigley Field, "Even when I am no longer around, this will be here. When I'm not here, I will be here." This photograph was made on January 29, 2015, during a week set aside to memorialize the athlete. Banks began his major league career as the first African American to play for the Cubs in 1953. He retired in 1971, having spent his entire career with the club. Banks was elected to the Hall of Fame as soon as he became eligible.

His love for the game and for the city of Chicago made him a spokesman for both; there will never be another "Mr. Cub."

Lou Cella grew up in a family of artists in the Chicago area and studied fine arts and graphic design at Illinois State University, graduating in 1985. He is currently working at the fine art studio of Rotblatt-Amrany as an instructor and is engaged in various public art projects. Others of his sculptures in Chicago are the figure of Harry Caray at Wrigley Field and of Carlton Fisk at U.S. Cellular Field.

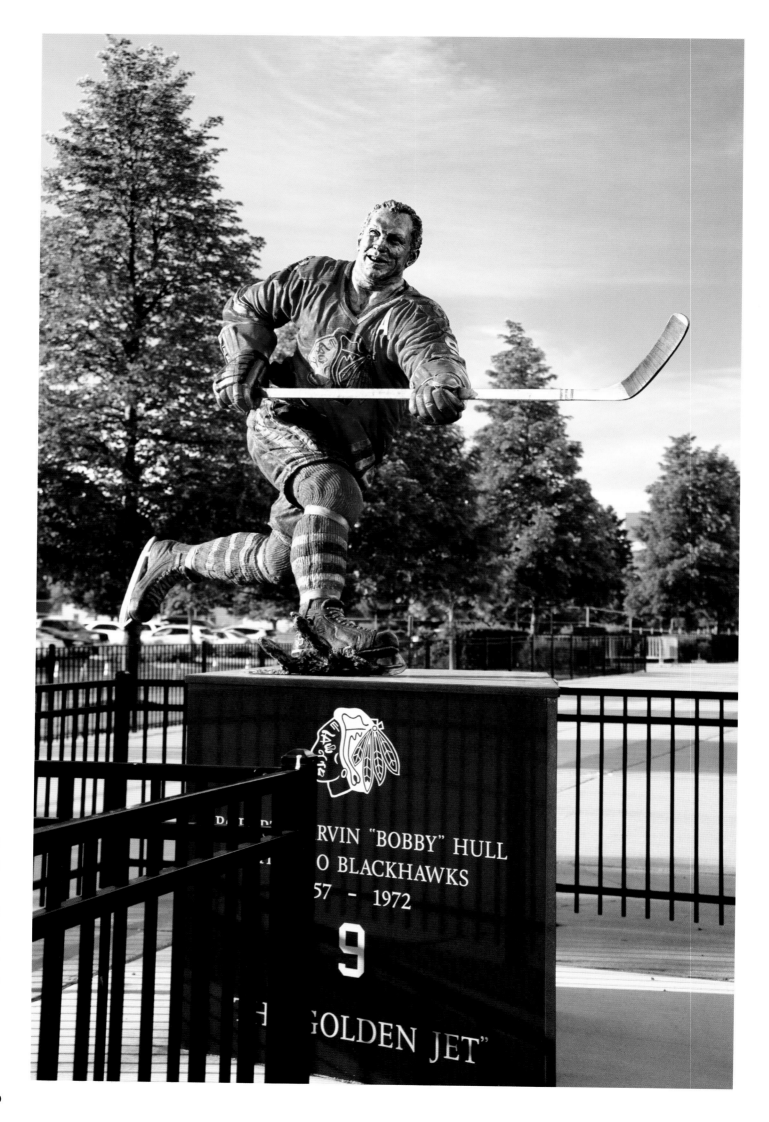

RVIN "BOBBY" HULL
O BLACKHAWKS
57 - 1972
9
"GOLDEN JET"

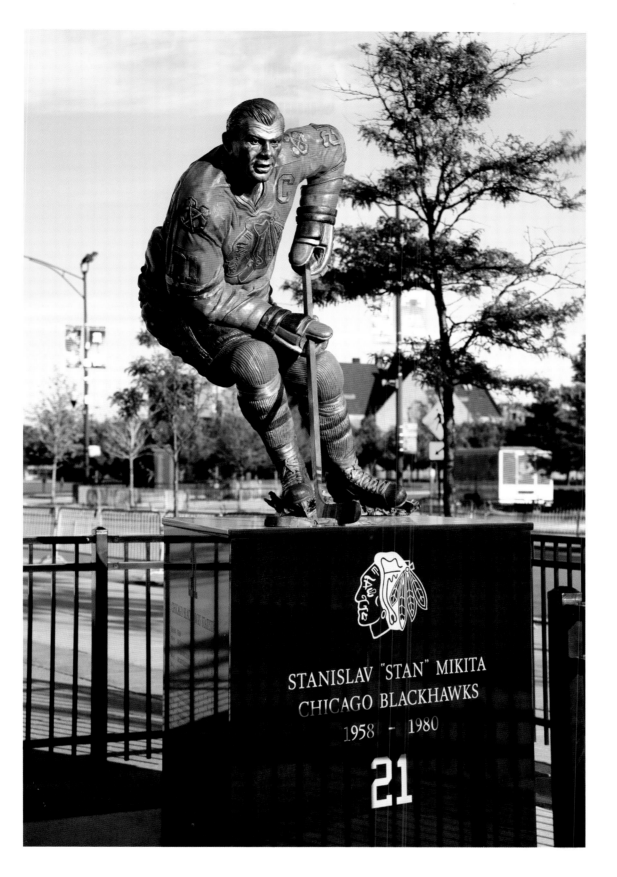

## BOBBY HULL AND STAN MIKITA
*by* **OMRI AMRANY** *and* **JULIE ROTBLATT-AMRANY**
BRONZE AND GRANITE | INSTALLED 2011 |
UNITED CENTER

Hull ("The Golden Jet," b. 1939) and Mikita ("Stosh," b. 1940) dominated the sports scene in Chicago in the 1960s. They helped the Chicago Blackhawks win a Stanley Cup in 1961. Mikita played all of his twenty-two seasons in Chicago, while Hull played fifteen years in Chicago. Their lifesized statues are placed together outside Chicago's United Center. Julie Rotblatt-Amrany and her husband Omri Amrany are artists and sculptors who also teach in their studio outside of Chicago.

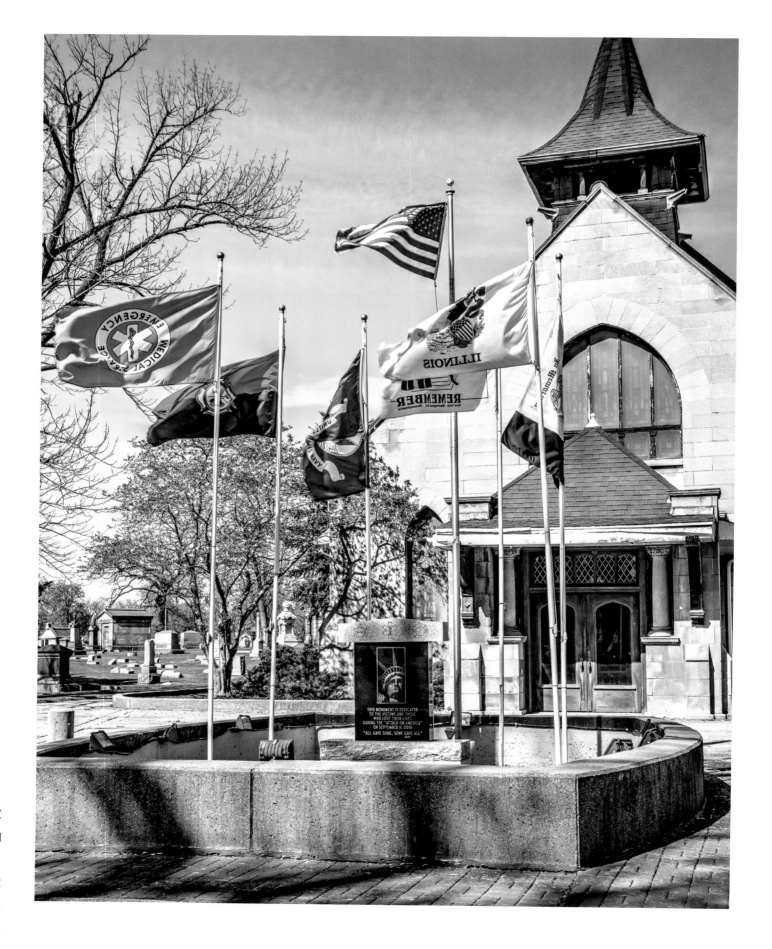

## NINE-ELEVEN MEMORIAL

OAK WOODS CEMETERY, CHICAGO

After the terrorist attack on the United States on September 11, 2001, a memorial was placed near the chapel at Oak Woods Cemetery. It is inscribed with these words:

*This monument is dedicated / To the victims and those / Who lost their lives / During the "attack on America" / On September 11, 2001 / All gave some, and some gave all.*

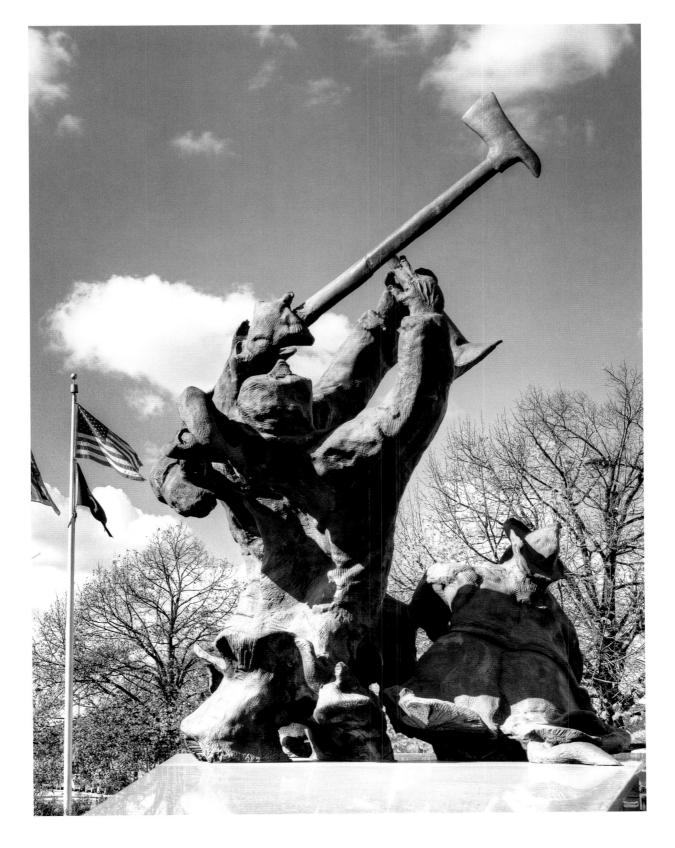

## CHICAGO UNION STOCK YARDS FIRE MEMORIAL *by* S. THOMAS SCARFF

BRONZE AND ALUMINUM | INSTALLED 2004 | WEST EXCHANGE AND PEORIA STREET

*The Fallen 21 Memorial* is the formal name of this remembrance of the stockyards fire that took place in December 1910 and resulted in the deaths of twenty-one firefighters. Until September 11, 2001, this was the deadliest building collapse in American history in terms of fatalities. It was decided that this memorial should honor all firefighters who have died in Chicago fighting fires. At the time of the dedication, they numbered 350, in addition to the stockyards fire victims.

Tom Scarff (b. 1942) is a Chicago sculptor who has had many exhibits and shows in the area. Other Scarff works in the city include *Fountain, Fighter* (Clark and Wisconsin Street) and *Dancing Lady* (North and Orchard).

COMMEMORATING THE TRANS
ATLANTIC FLIGHT FROM NEW
YORK TO KAUNAS LITHUANIA BY
CAPTAIN STEPONAS DARIUS
LIEUTENANT STASYS GIRENAS
JULY 17 1933

LIETUVA

## TADEUSZ KOSCIUSZKO
*by* **KASIMIR CHODZINSKI**

BRONZE | INSTALLED 1904, MOVED 1978 | NORTHERLY ISLAND

Thadeusz Kosciuszko (1746–1817), was a Polish military engineer and architect who became a national hero in the United States, Poland, and Belarus. He moved to America in 1776 and was a colonel, and eventually general, in the Revolutionary War. His skills were employed to build fortifications in various strategic locations, including West Point. As supreme commander of Polish forces in 1794 he led an uprising against Russia.

Kasimir Chodzinski (1861–1919), a Polish sculptor, was commissioned to produce this equestrian sculpture. More than 50,000 Polish-Americans were present for its 1904 unveiling at Humboldt Park. In 1978 it was relocated to Solidarity Drive, Northerly Island.

## DARIUS AND GIRENAS
*by* **CHARLES B. KONEVIC** *and* **RAOUL JOSSET**
BRONZE AND GRANITE | INSTALLED 1935 | MARQUETTE PARK

This monument honors two Lithuanian-American pilots who died while attempting to fly from New York to Lithuania in 1933. They fought for the United States in World War I. Stasys Girenas (1893–1933) emigrated to the United States when he was seventeen years old and settled in Chicago. Stephen Darius (1896–1933) emigrated at eleven. In 1920 he returned to Lithuania to fight for its independence and while there received pilot training. He returned to the United States in 1927 and settled in Chicago to work in civil aviation. Girenas and Darius met in the 1920s, and the two pilots began to plan their trans-Atlantic adventure. On July 15, 1933 they took off from New York bound for Kaunas, Lithuania. Only 400 miles from their destination, they crashed in Germany and both were killed.

Their flight of more than thirty-seven hours ranked second in terms of distance and fourth in terms of duration for a single continuous flight at the time. Several months after the tragedy, the Lithuanian consul in Chicago commissioned a monument to the aviators. The monument contains a bronze globe which shows their flight path.

The architect for the monument was Charles B. Konevic (1909–2000). French-born Raoul Josset (1899–1957) sculpted the figures. Josset came to Chicago in 1932, after training in France as a sculptor after World War I. He eventually moved to Texas. His work can be found in France and in the United States.

## COLD STORAGE WAREHOUSE FIRE MEMORIAL

INSTALLED 1897 |
OAK WOODS CEMETERY

A warehouse at the southwest corner of the 1893 World's Columbian Exposition fairgrounds provided cold storage and ice to exhibitors. It also contained an indoor skating rink. A fire broke out in the building on July 10, 1893, during the exposition. The only escape route for firefighters attempting to quell the fire necessitated a seventy-foot leap. Inscribed on the memorial are the names of fifteen who perished. Seven unidentified bodies are buried at the memorial in the cemetery in a common grave. This fire and the stockyards fire of 1910 (in which twenty-one firefighters were killed) are the two worst disasters the Chicago Fire Department has suffered.

## VOLUNTEER FIRE FIGHTERS' MONUMENT *by* LEONARD VOLK

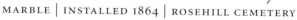

MARBLE | INSTALLED 1864 | ROSEHILL CEMETERY

Atop a Doric column stands the figure of a fireman commemorating fifteen members of the Chicago Volunteer Fire Brigade who are buried in the plot and listed on the monument. The city disbanded the volunteer brigade in 1858 and replaced it with paid firefighters.

Leonard Volk (1828–1895), creator of the monument, is most notable for the life mask of Lincoln he made in 1860 and the castings he made of the president's hands. Other Chicago works by Volk include *Our Heroes: Civil War Monument, Volk Monument,* and the *Stephen Douglas Tomb and Memorial.*

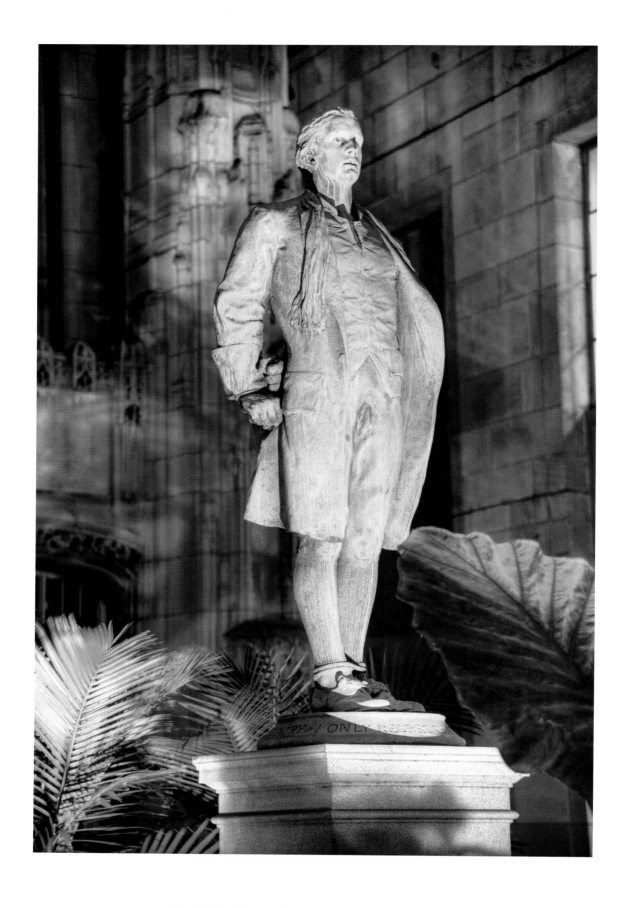

## NATHAN HALE *by* BELA LYON PRATT

BRONZE | INSTALLED 1940 | PLAZA, TRIBUNE BUILDING

"I regret that I have but one life to lose for my country." These are purported to be the last words of Nathan Hale (1755–1776) before he was hung in 1776 by the British for spying. The statue depicts Hale right before his execution. He was educated at Yale University, and Yale commissioned the first bronze statue completed in 1899. This replica was erected by the *Chicago Tribune*.

Bela Pratt (1867–1917) was a student at the School of Fine Arts at Yale University. He sculpted a colossal sculpture for the 1893 Columbian Exposition, which, like many others, did not survive the exposition. He taught at the School of the Museum of Fine Arts, Boston, and many of his best-known works reside in that city.

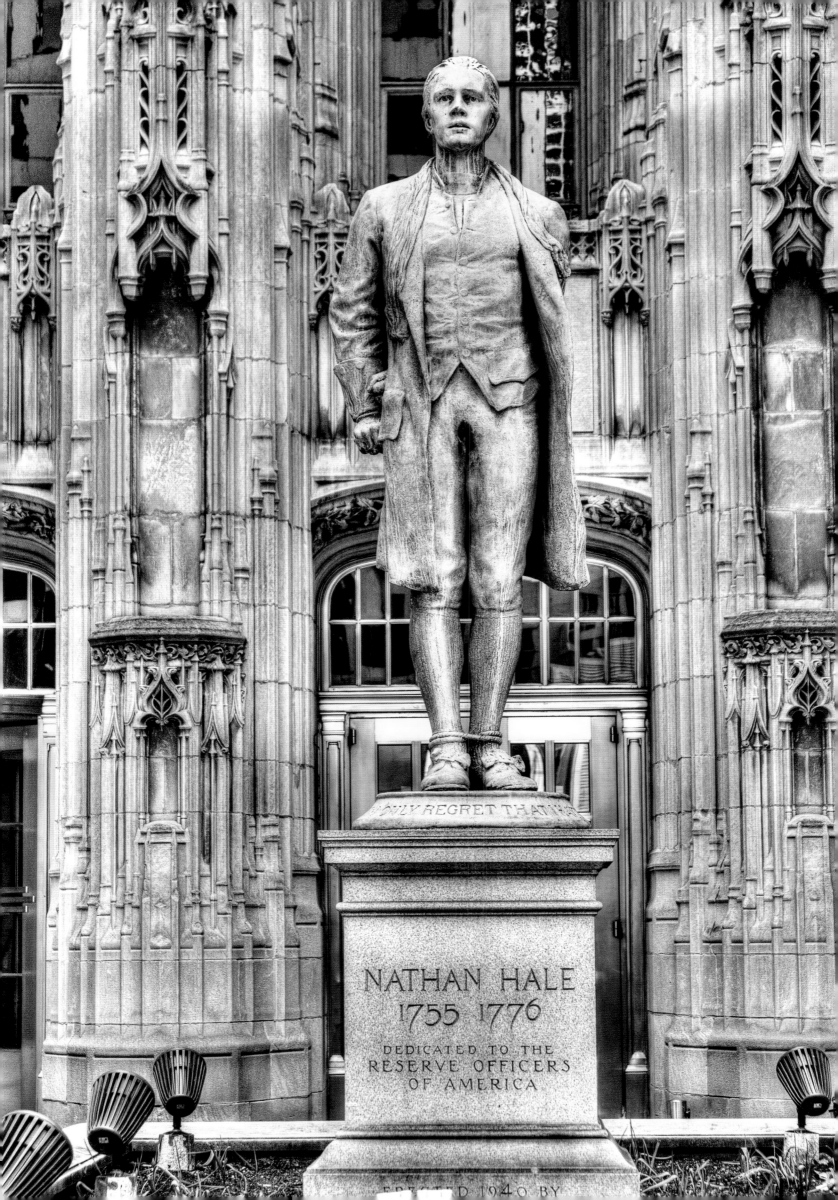

NATHAN HALE
1755 1776

DEDICATED TO THE
RESERVE OFFICERS
OF AMERICA

ERECTED 1940 BY

# WAR MEMORIALS

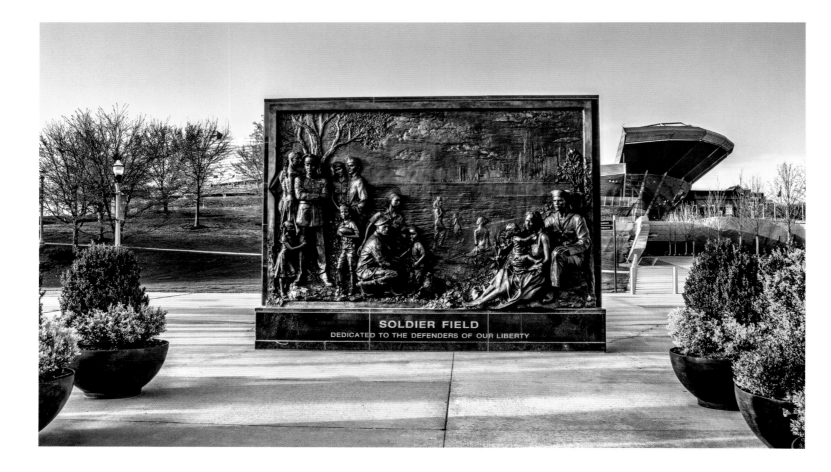

SOLDIER FIELD
DEDICATED TO THE DEFENDERS OF OUR LIBERTY

## TRIBUTE TO FREEDOM, SOLDIER FIELD VETERANS MEMORIAL
### *by* ANNA KOH VARILLA *and* JEFFREY HANSON VARILLA
BRONZE | INSTALLED 2003 | NORTH END OF SOLDIER FIELD

Soldier Field was built as a war memorial to members of the American armed forces who died in service to their country. When it was renovated in 2003, the enhanced exterior included the addition of memorials to veterans. This bronze bas-relief portrays servicemen and women along with their families. On the reverse side is a quotation from President John Kennedy: "Let every nation know, whether it wishes us well or ill, that we shall pay any price, bear any burden, meet any hardship, support any friend, oppose any foe to assure the survival and success of liberty."

The husband-and-wife team Anna Koh Varilla (b. 1957) and Jeffrey Hanson Varilla (b. 1949) have been working on public monuments for over twenty years. They met as students in the Sculpture Department of the School of the Art Institute of Chicago.

## VICTORY, WORLD WAR I *by* LEONARD CRUNELLE
BRONZE AND GRANITE | INSTALLED 1927, 1936 | EAST 35TH STREET AND KING DRIVE

The state of Illinois erected this monument in honor of those who served in the African American Eighth Regiment of the Illinois National Guard in World War I. On its sides are panels with lifesized figures in relief. Shown are an African American soldier representing Courage, an African American woman representing Motherhood, and Columbia holding a tablet listing the regiment's battles.

The doughboy on top was added in 1936. The sculptor, Leonard Crunelle (1872–1944), emigrated to the U.S. and studied at the School of the Art Institute of Chicago with Lorado Taft.

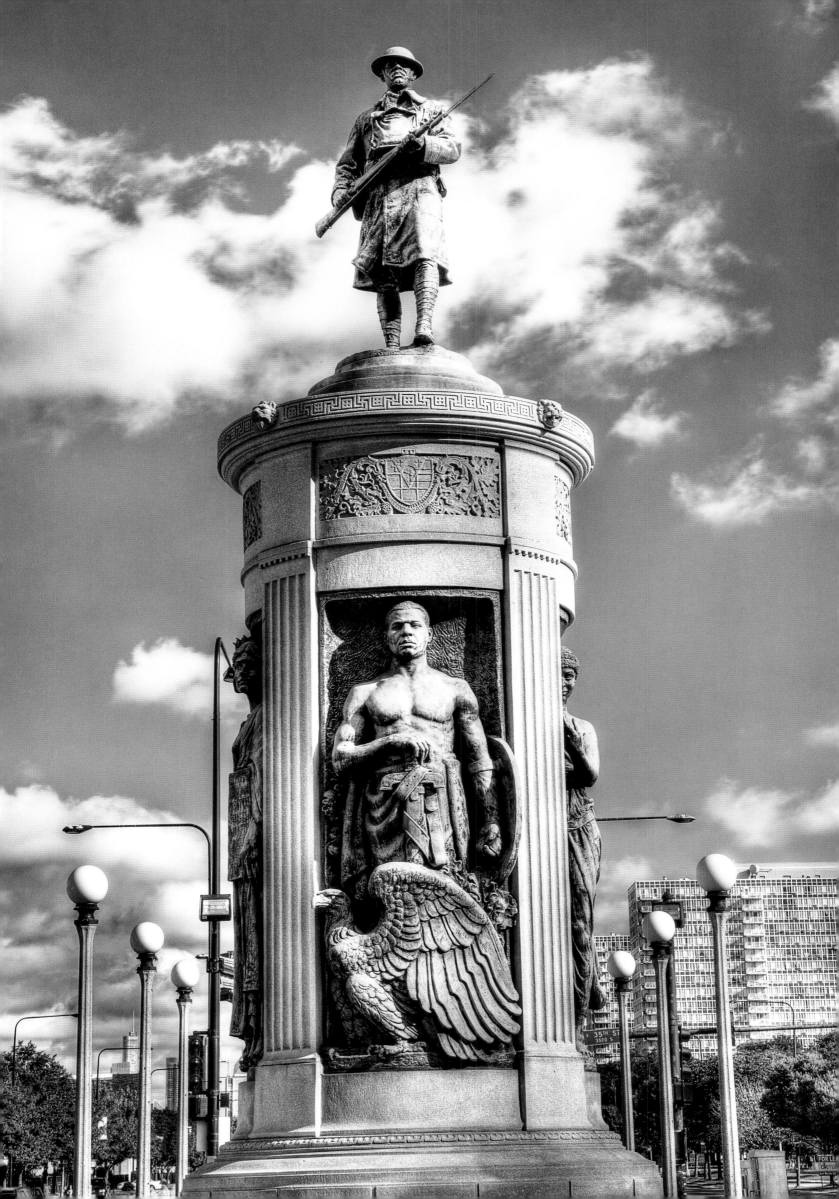

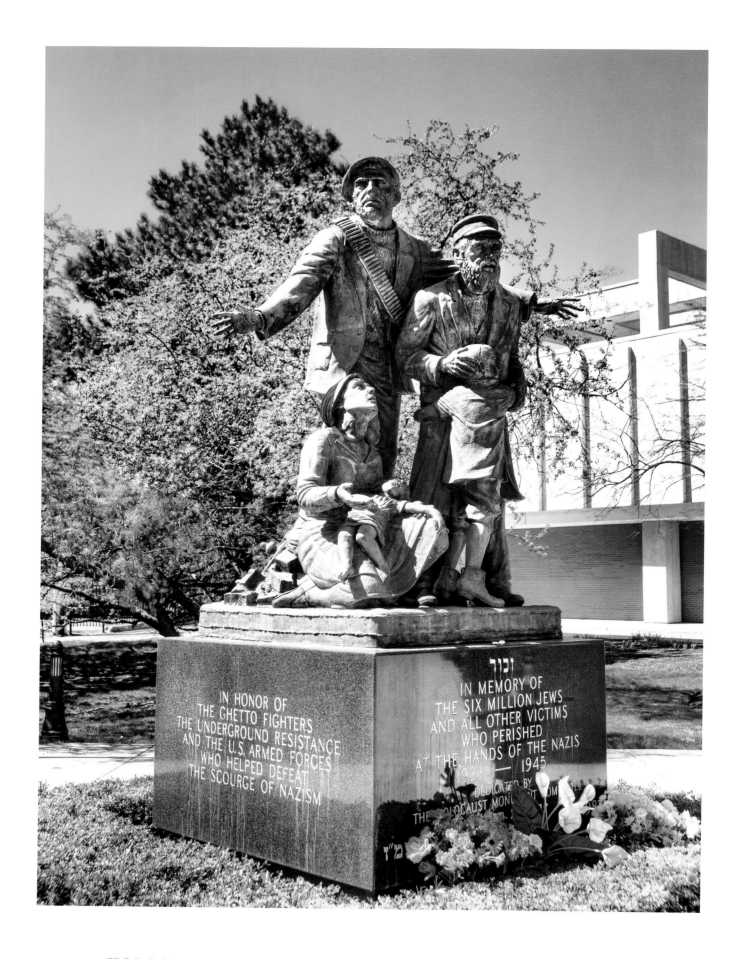

IN HONOR OF
THE GHETTO FIGHTERS
THE UNDERGROUND RESISTANCE
AND THE U.S. ARMED FORCES
WHO HELPED DEFEAT
THE SCOURGE OF NAZISM

זכור
IN MEMORY OF
THE SIX MILLION JEWS
AND ALL OTHER VICTIMS
WHO PERISHED
AT THE HANDS OF THE NAZIS
1933 — 1945
DEDICATED BY
THE HOLOCAUST MONUMENT COMMITTEE

## HOLOCAUST MEMORIAL *by* EDWARD CHESNEY AND BERT J. GAST

BRONZE AND GRANITE | INSTALLED 1987 | SKOKIE VILLAGE GREEN

The monument depicts a Jewish family in the Warsaw ghetto uprising in 1943. Skokie was selected as the site for the monument as it is home to more than 7,000 holocaust survivors.

Sculptor Edward Chesney (1923–2008) was a lifetime Detroiter who fought in the Pacific during World War II and upon his return from the war took up the art of sculpting. His works can be seen in the Detroit area and at the Assyrian-American Veterans Memorial, Elmwood Cemetery, and River Grove. Designer Bert Gast (1925–2005) was also a veteran of World War II and president of Gast Monuments, which specialized in cemetery monuments.

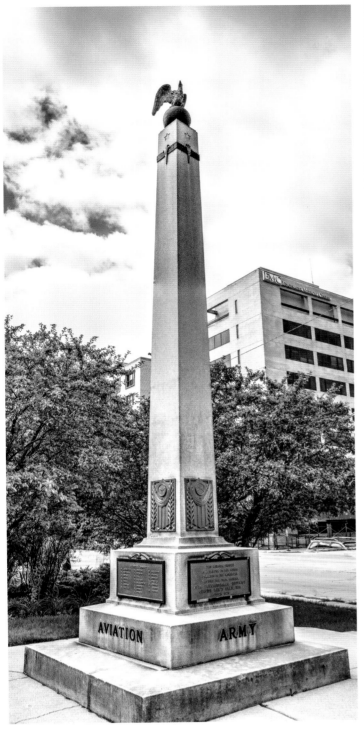

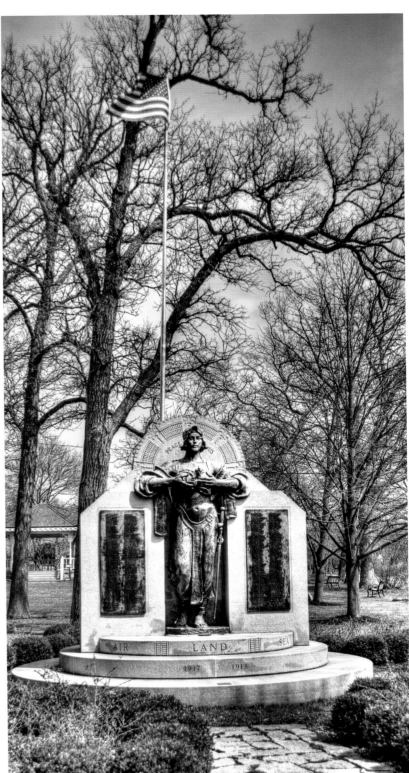

## ANDERSONVILLE MONUMENT *by* AN UNKNOWN SCULPTOR

BRONZE | INSTALLED 1928 | CLARK STREET AND EDGEWATER AVENUE

This bronze eagle on a stone pedestal was installed in October 1928 as a tribute to those who served and died in the First World War.

It was erected by the 10th Congressional District Service Men's Club, Inc.

## HIGHLAND PARK WORLD WAR I MONUMENT *by* JAMES CADY EWELL

BRONZE AND GRANITE | INSTALLED 1926 | MEMORIAL PARK, LAUREL AND LINDEN AVENUES

A heroic female figure symbolizes World War I in this monument. Tablets on either side list names of servicemen from Highland Park, Illinois, who died in the war.

Chicago-born James Cady Ewell (1898–1963), who designed the monument, was primarily a watercolorist trained at the School of the Art Institute of Chicago.

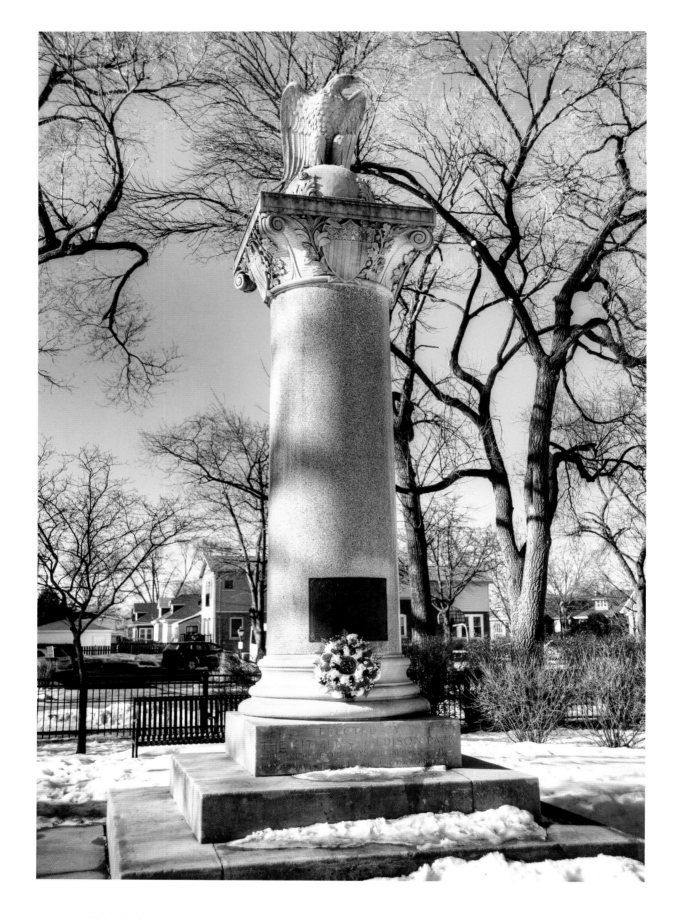

## EDISON PARK MONUMENT PARK *by* AN UNKNOWN SCULPTOR

GRANITE AND LIMESTONE | INSTALLED 1919 | 6670 NORTH AVONDALE AVENUE

War memorials and monuments in Chicago, starting with those memorializing soldiers of the Civil War, are found in many Chicago neighborhoods and suburbs. This one was erected by residents of Edison Park to honor its citizens who served in the military during World War I. Some 300,000 Americans were killed or wounded during

American involvement in the war in 1917–1918. Military and civilian war casualties worldwide between 1914 and 1918 exceeded 37 million. The top of the column is composed of a partial Corinthian column from the Cook County Courthouse, which was demolished in 1906.

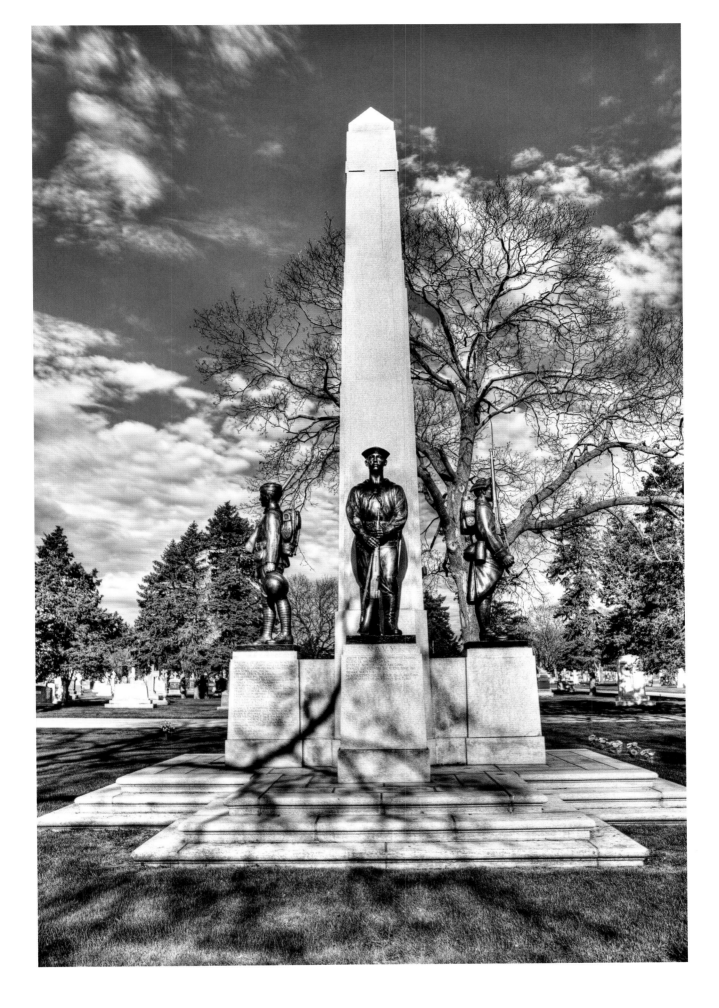

## ST. ADALBERT WORLD WAR I MONUMENT *by* AN UNKNOWN SCULPTOR

BRONZE AND GRANITE │ ST. ADALBERT CEMETERY, NILES │ INSTALLATION DATE UNKNOWN

This World War I monument honors war dead from the marines, army, and navy, and also those from Haller's army—which was comprised of 20,000 Polish Americans—who gave their lives fighting for independence of Poland.

# THE HIKER
## *by* THEO ALICE RUGGLES KITSON
### BRONZE | INSTALLED 1926
### | BOHEMIAN NATIONAL CEMETERY

War memorials in Chicago are generally located in its many cemeteries. Examples of two such include *The Hiker* and *Memorial to a Beloved Son*. *The Hiker* memorializes veterans of the Spanish-American War. Although President McKinley tried to avoid it, the sinking of the American battleship *Maine* in Havana harbor and political pressure from Congress caused the United States to enter into war with Spain in 1898. The main issue was Cuban independence from Spain. The war was not only fought in Cuba but spread to the Philippines. It ended in 1898 with a peace treaty that allowed temporary American control of Cuba and colonial authority over Puerto Rico, Guam, and the Philippines. While the monument was dedicated in 1926, the honor roll was installed in 1964.

Theo Alice Ruggles Kitson (1871–1932) was the first woman admitted to the National Sculpture Society. She exhibited four works at the 1893 World's Columbian Exposition. *The Hiker* was reproduced for many public and private spaces in the United States.

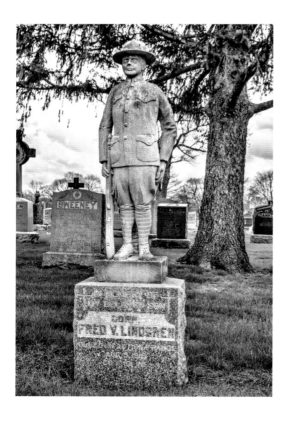

## MEMORIAL TO A BELOVED SON
### *by* AN UNKNOWN SCULPTOR
### INSTALLED AFTER 1918 | MT. OLIVET CEMETERY

Corporal Fred Lindgren, killed in action in 1918 in France, is remembered with this "memorial to a beloved son."

C
H
I
C
A
G
O

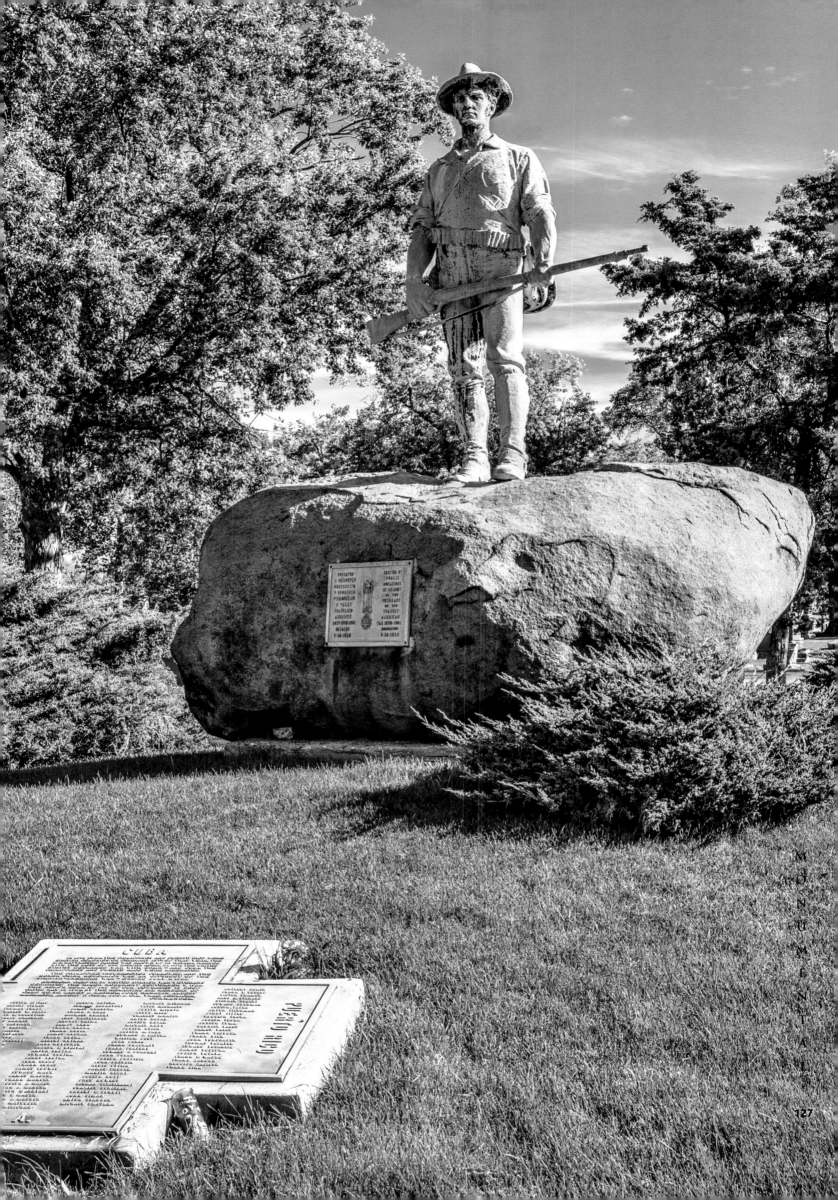

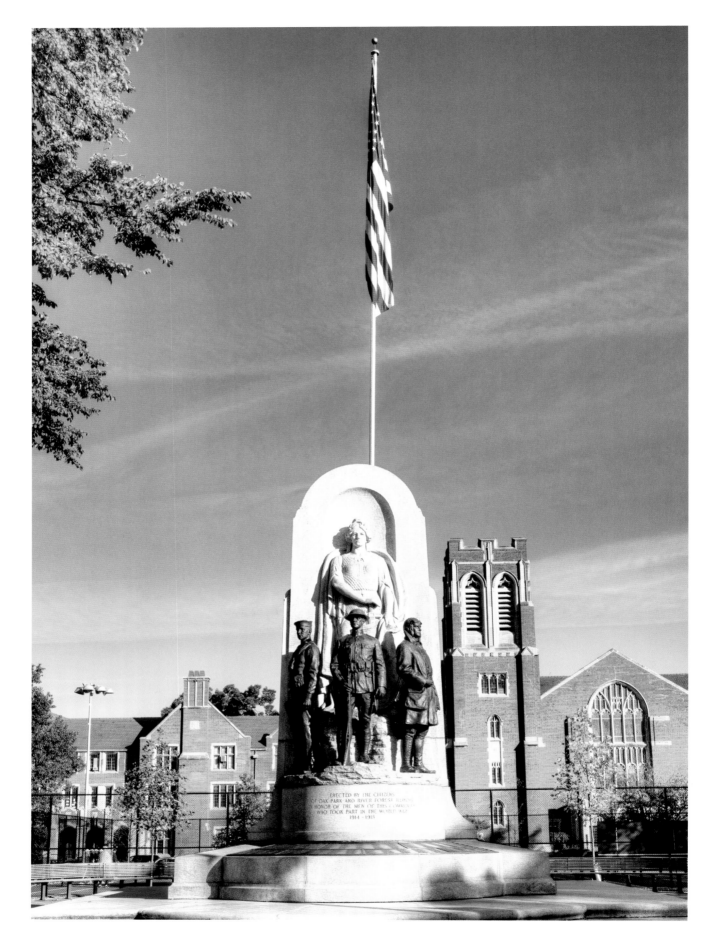

## OAK PARK-RIVER FOREST WAR MEMORIAL *by* GILBERT RISWOLD

### BRONZE AND GRANITE | INSTALLED 1924 | SCOVILLE GREEN, OAK PARK

This monument memorializes World War I dead from Oak Park and River Forest. The monument includes bronze figures representing the army, navy, and air force. The figure of Columbia sheathing her sword represents war's end.

Gilbert Riswold (1881–1938) lived in Oak Park and was a student of Lorado Taft and Charles Mulligan at the School of the Art Institute of Chicago. He is also responsible for a bust of Beethoven seen at the University of Chicago.

## JEFFERSON PARK MONUMENT *by* AN UNKNOWN SCULPTOR

LIMESTONE WITH BRONZE PLAQUES │ INSTALLED 1945 │ MILWAUKEE AND HIGGINS AVENUES

This monument is a war memorial to all who gave their lives
starting with the Spanish-American War and extending
through post-1973 wars. Various plaques attached to the
monument represent various wars.

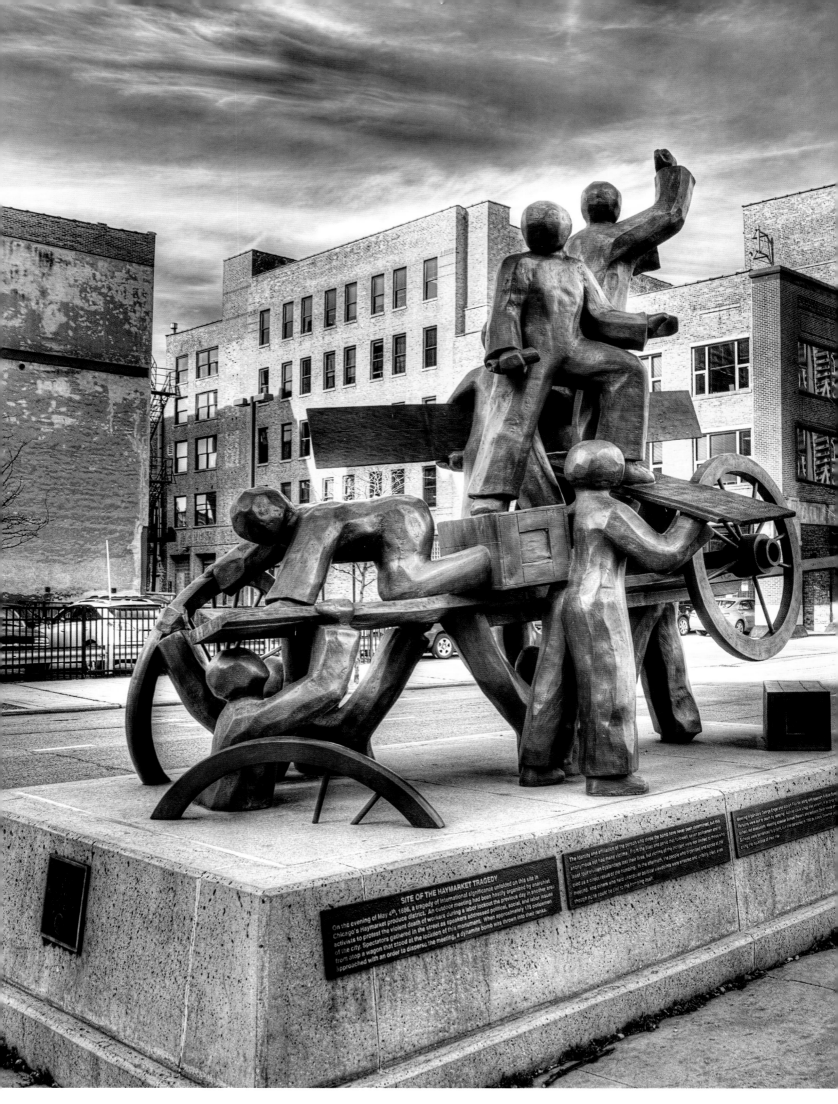

SITE OF THE HAYMARKET TRAGEDY

On the evening of May 4th, 1886, a tragedy of international significance unfolded on this site in Chicago's Haymarket produce district. An outdoor meeting had been hastily organized by anarchist activists to protest the violent death of workers during a labor lockout the previous day in another area of the city. Spectators gathered in the street as speakers addressed political, social, and labor issues from atop a wagon that stood at the location of this monument. When approximately 175 policemen approached with an order to disperse the meeting, a dynamite bomb was thrown into their ranks.

## HAYMARKET MEMORIAL
*by* **MARY BROGGER**
BRONZE | INSTALLED 2004 | 175 N. DESPLAINES

The Haymarket Riot, one of the most significant outbursts
of violence in the late 19th-century American labor
movement, ignited a week of strikes and clashes between
police and demonstrators. It began on the night of May
4, 1886, when Mayor Carter Harrison, Sr. concentrated a
large contingent of police officers near Haymarket Square,
fearing violence during a night of speeches. When a
bomb was thrown into police lines, police opened fire on
the crowd. Sixty-seven police casualties occurred, along
with many civilian casualties. Eight men were eventually
accused of inciting the riot; their trial began on June
21, 1886, and in August all eight were found guilty and
sentenced to hang. In spite of intervention by Illinois
governor Richard J. Oglesby, four of the eight were hung
on November 11, 1887. Fischer and Engel each yelled
out "Hurrah for anarchy!" Fischer then added: "This is
the happiest moment of my life!" Parsons asked, "Will
I be allowed to speak, O men of America?" but the trap
was sprung before he could continue. Spies said, "Let the
voice of the people be heard!" Bodies of the four executed
prisoners plus one who committed suicide prior to the
execution, were brought to the Forest Home Cemetery
for burial in one plot in November 1887. The Haymarket
Riot is well described in the literature (see *Death in the
Haymarket* by James Green, 2007).

 Brogger's memorial depicts the wagon that was serving
as a speaker's platform until the Haymarket Riot broke
out. The piece was paid for with a grant from the state and
marks the actual spot from which the riot spread.

 The well recognized artist Mary Brogger (b. 1958)
received her BFA in 1987 from the School of the Art
Institute of Chicago and worked in Chicago until 2009,
when she moved her studio to Los Angeles.

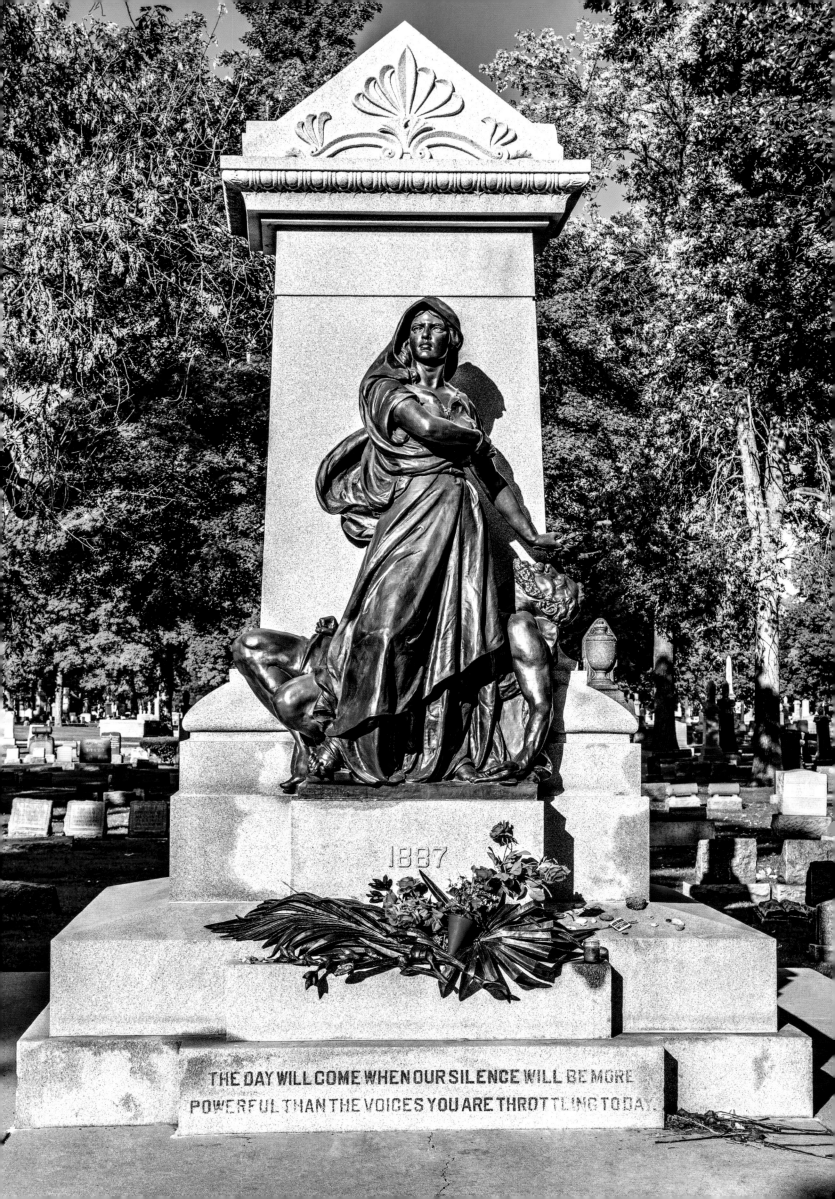

1887

THE DAY WILL COME WHEN OUR SILENCE WILL BE MORE
POWERFUL THAN THE VOICES YOU ARE THROTTLING TODAY.

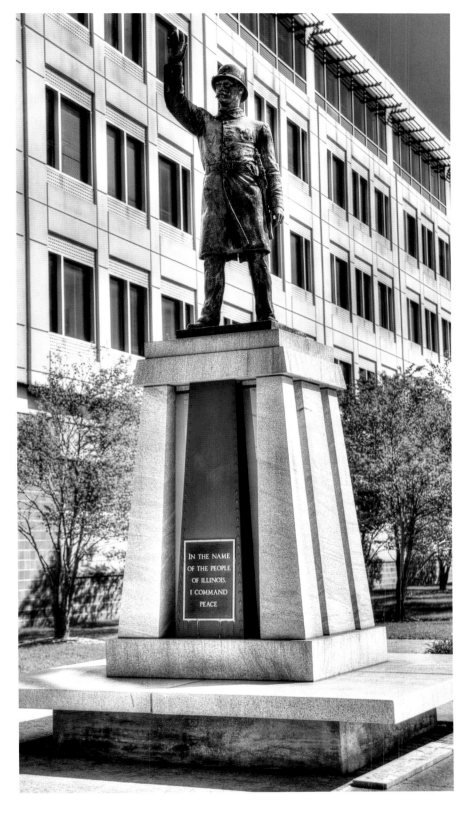

## HAYMARKET RIOT MONUMENT
*by* **JOHANNES GELERT**

BRONZE

| INSTALLED 1889 | CHICAGO
POLICE HEADQUARTERS, 35TH
AND MICHIGAN AVENUE

This statue, like the riots it commemorates, has a storied history. Its first location was Haymarket Square, where it was dedicated in May 1889. The statue was defaced on many occasions and eventually moved to Union Park at Randolph Street and Ogden Avenue. It was accidentally struck by a streetcar and later moved back to the Haymarket area, where in 1969 it was bombed by radical political groups. The statue was repaired on each occasion, and in 1972 was moved to its now secure location at police headquarters.

John Gelert (1852–1923) was born, studied, and worked as a sculptor in Denmark before emigrating to the United States in 1887. He first established his studios in Chicago and in 1898 moved to New York City, where he worked and lived until his death in 1923. He exhibited at the 1893 Columbian Exposition. His statue *Hans Christian Anderson* still stands at Lincoln Park.

## HAYMARKET CEMETERY MEMORIAL *by* **ALBERT WEINERT**

GRANITE AND BRONZE | INSTALLED 1893 | FOREST HOME CEMETERY

This monument was erected in 1893 during the World's Columbian Exposition; thousands came to its dedication. The figure of Justice places a crown of laurels on the brow of a fallen worker while preparing to draw a sword. The monument bears the last words of August Spies: "The day will come when our silence will be more powerful than the voices you are throttling today." On the back of the monument is a quote from Governor Altgeld, who granted pardons to three of the alleged conspirators, two of whom were buried here upon their deaths in 1898 and 1916.

Every year on the Sunday closest to May 4 and on the anniversary of November 11, labor organizations come to this monument to pay tribute. Tokens, flowers, and inscriptions can be found at the base of the memorial throughout the year.

German-born Albert Weinert (1863–1947) emigrated to the United States in 1886, first living in San Francisco and then New York City. He created many major sculptures such as the William McKinley monument in Toledo, Ohio.

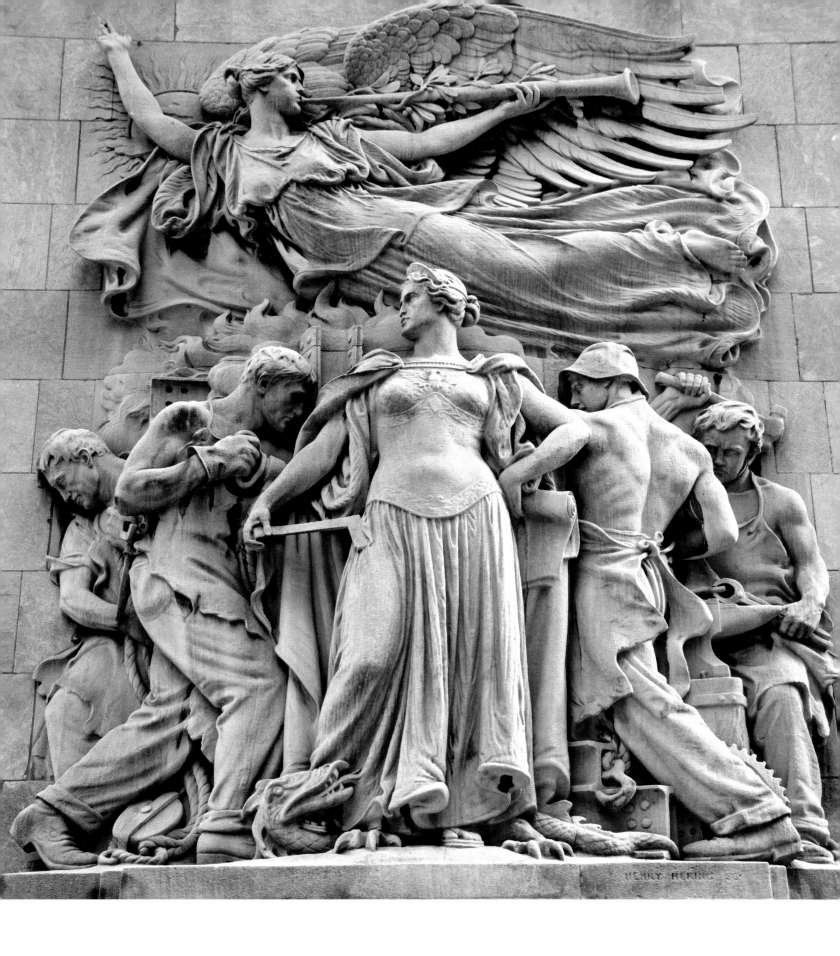

## REGENERATION *by* HENRY HERING

LIMESTONE | INSTALLED 1928 | SOUTHWEST PYLON OF MICHIGAN AVENUE BRIDGE

The Great Chicago Fire of October 7, 1871 started on the west side of town in a barn owned by the Catherine and Patrick O'Leary family. It destroyed over 17,000 buildings and killed more than three hundred people. A rumor circulated that the fire began when Mrs. O'Leary's cow kicked over a lantern, and although no evidence exists to support this, it has become part of Chicago popular legend. Catherine O'Leary died in 1895. *Regeneration* depicts the reconstruction of Chicago and the vitality and determination shown by those affected.

Henry Hering (1874–1949) was a student of Augustus Saint-Gaudens and his assistant until 1907.

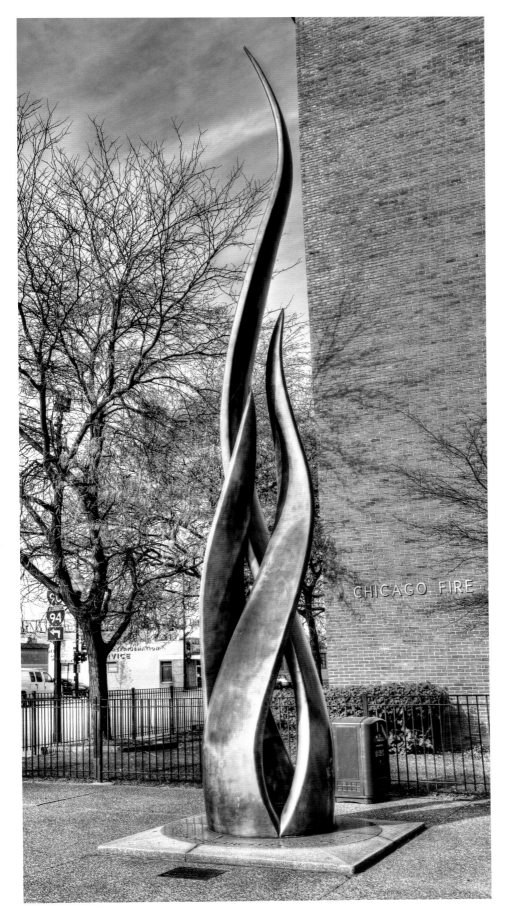

*Catherine O'Leary is buried in Mt. Olivet Catholic Cemetery beside her husband.*

## PILLAR OF FIRE *by* EGON WEINER

BRONZE | INSTALLED 1961 | CHICAGO FIRE ACADEMY, 558 WEST DEKOVEN STREET

*Pillar of Fire* is located in front of the Chicago Fire Academy, which happens to be the former location of the barn of Mrs. Catherine O'Leary. Weiner is said to be memorializing not only victims of the Chicago fire, but all who have perished in fires.

Egon Weiner (1906–1987) fled Austria in 1938 to escape Nazi persecution. He was a professor at the School of the Art Institute of Chicago from 1945 to 1971, where he mentored sculptor Richard Hunt. His other Chicago sculptures include *Brotherhood, The Christ,* and *Ecco Homo.*

**135**

## PICKAS AND DANDA MONUMENTS

STONE MOMUMENT │ BOHEMIAN CEMETERY

The S.S. *Eastland* was a passenger ship based in Chicago and used for various tours in Lake Michigan. On July 24, 1915, the ship capsized while tied to a dock on the south side of the Chicago River between Clark and LaSalle Streets. On that day the ship had been chartered by Western Electric Company to take its employees to a picnic in Indiana, and more than 2,500 passengers were on board. Eight hundred and forty-four people died, making it the greatest maritime disaster in American history It was concluded that the ship had a topheavy instability that caused it to capsize if too many passengers were out on the top deck.

The only memorials recognizing the dreadful tragedy are individual grave markers at various Chicago cemeteries, particularly in the Bohemian Cemetery. In the latter, most of the victims' headstones are identified by the phrase *Obeti Eastlandu,* which in Czech translates to *Eastlandia Victim.* The Pickas family monument is the most dramatic of these; one member of the family died in the disaster. Many other cemeteries in Chicago and in the surrounding suburbs also contain the remains of *Eastland* victims.

# THE EASTLAND *by Carl Sandburg*

Let's be honest now
For a couple of minutes
Even though we're in Chicago.

Since you ask me about it,
I let you have it straight;
My guts ain't ticklish about the *Eastland.*

It was a hell of a job, of course
To dump 2,500 people in their clean picnic clothes
All ready for a whole lot of real fun
Down into the dirty Chicago River without any warning.
Women and kids, wet hair and scared faces,
The coroner hauling truckloads of the dripping dead

To the Second Regiment armory where doctors waited
With useless pulmotors and the eight hundred motionless stiff
Lay ready for their relatives to pick them out on the floor
And take them home and call up the undertaker . . .

Well I was saying
My guts ain't ticklish about it.
I got imagination: I see a pile of three thousand dead people
Killed by the con [consumption], tuberculosis,
too much work and not enough fresh air and green groceries

A lot of cheap roughnecks and the women and children of wops,
and hardly any bankers and corporation lawyers or their kids,
die from the con—three thousand a year in chicago and a
hundred and fifty thousand a year in the united states—all
from the con and not enough fresh air and green groceries

If you want to see excitement, more noise and crying than you ever
heard in one of these big disasters the newsboys clean up on,
Go and stack in a high pile all the babies that die in Christian
Philadelphia, New York, Boston, and Chicago in one year
before aforesaid babies haven't had enough good milk;

On top of that pile put all the little early babies pulled from mothers
willing to be torn with abortions rather than bring more
children into the world—Jesus, that would make a front page picture
for the Sunday papers

And you could write under it:
Morning glories
Born from the soil of love,
Yet now perished.

Have you ever stood and watched the kids going to work of a
morning?  White faces, skinny legs and arms, slouching along
rubbing the sleep out of their eyes on the go to hold their jobs?

Can you imagine a procession of all the whores of a big town,
marching and marching with painted faces and mocking struts,
all the women who sleep in faded hotels and furnished rooms
with any man coming along with a dollar or five dollars?

Or all the structual iron workers, railroad men and factory hands
 in mass formation with stubs of arms and stumps of legs, bodies
broken and hacked while bosses yelled, "speed-no slack-go to it!"?
Or two by two all the girls and women who go to the hind doors of
restaurants and through the alleys and on the market street
digging into the garbage barrels to get scraps of stuff to eat?

By the living Christ, these would make disaster pictures to paste on
the front pages of the newspapers.

Yes, the *Eastland* was a dirty bloody job — bah!
I see a dozen *Eastlands*
every morning on my way to work
and a dozen more going home at night.

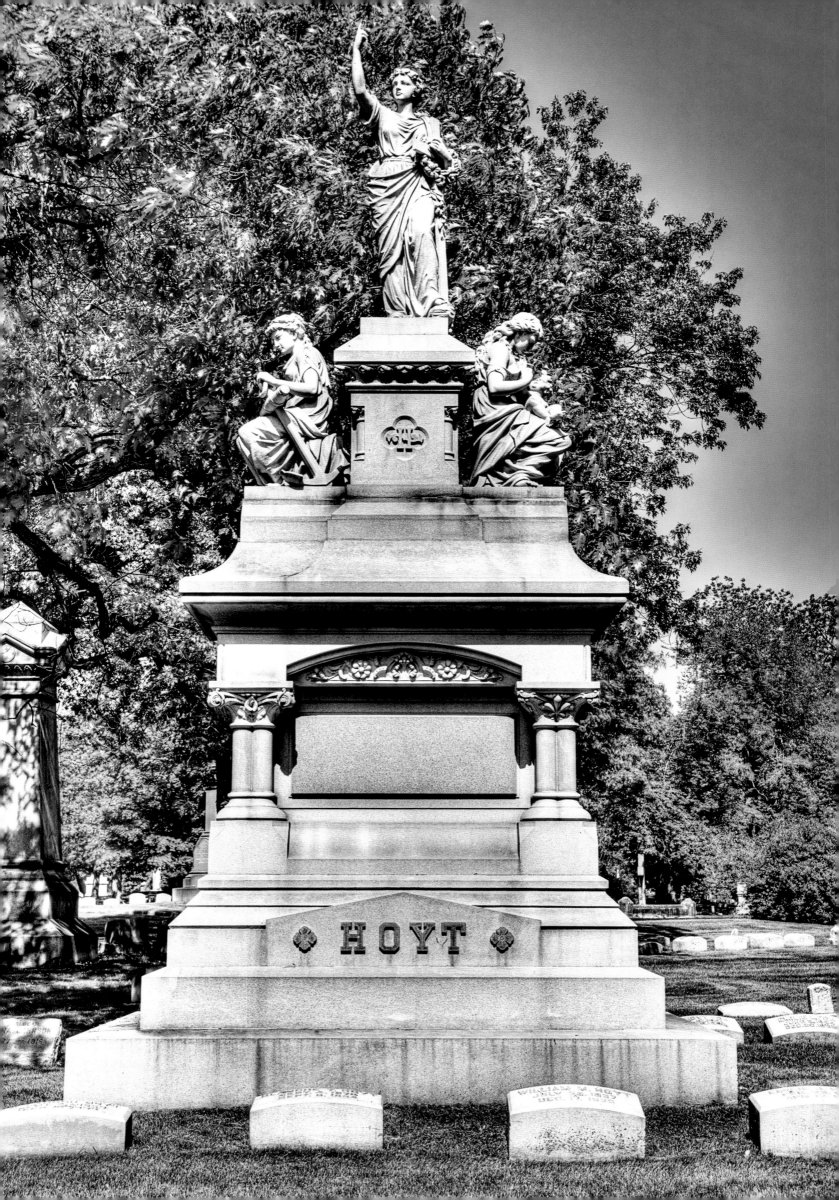

# HOYT FAMILY MEMORIALS

CARVED STONE | 1904 | GRACELAND CEMETERY

After the Great Chicago Fire of 1871, a number of other disasters caused serious loss of life in Chicago. Besides the Haymarket Riot of 1886, two of the most serious were the capsizing of the S. S. *Eastland* on July 24, 1915 and the Iroquois Theater fire of December 30, 1903. The Oriental Theater now stands where once the Iroquois stood.

The Iroquois Theater fire is still is thought to be the deadliest single building fire in U.S. history. At a matinée performance an arc light above the stage shorted and sparks from it ignited a curtain. Without adequate safety precautions in place to stop it, the fire quickly spread, and more than six hundred people died. Bodies stacked ten high were found at some of the exit doors. The doors were unopenable in the crush because they opened inward rather than out onto the street.

A memorial plaque to victims of the fire is mounted on a wall in the lobby of Chicago City Hall, and another was placed at Montrose Cemetery by its owner in 1908, though only a few of the fire's victims are buried at Montrose. A family monument at Graceland Cemetery poignantly recounts the tragedy through the losses of the Hoyt family. William M. Hoyt arrived in Chicago in 1855 and by 1894 operated one of the largest wholesale grocery operations in the city. His daughter, Emilie Hoyt Fox, and three grandchildren (aged nine, twelve, and fifteen) were at the theater on December 30, and all perished. Emilie's husband, Frederick Morton Fox, died shortly thereafter, perhaps from grief. The monument for the family is one of the most striking at Graceland Cemetery, and all the family members are buried around it.

# SHOWMEN'S REST

MEMORIAL PLOT WITH STONE MARKERS | INSTALLED 1918 | WOODLAWN CEMETERY

On the morning of June 22, 1918, a twenty-six-car circus train was traveling from the Chicago area to Hammond, Indiana, with four hundred performers and roustabouts on board. While the train was halted on the tracks, a troop train traveling at high speed failed to heed warning signals and crashed into the rear of the circus train. The horrible crash caused both trains to catch fire. At least eighty-six circus employees were killed.

The Showmen's League of America selected a burial plot at Woodlawn Cemetery in Forest Park for the victims and named it Showmen's Rest. It is still used today for deceased showmen. Five statues of elephants mark the boundaries of the plot. Many of the circus performers from the train wreck could not be identified and are buried in a mass grave. Some of the grave markers are identified as Unknown Male or Female with a number, and some are designated by the performer's role, such as "Four Horse Driver."

THE WATERS OF MEMORY

## GOTHIC FOUNTAIN AT FOURTH PRESBYTERIAN CHURCH

### INSTALLED 1914 | MICHIGAN AVENUE ENTRANCE COURTYARD

A beautiful Gothic fountain resides in a courtyard at the Michigan Avenue entrance to the Fourth Presbyterian Church of Chicago. The church formed in 1871. Its first place of worship was destroyed in the Great Chicago Fire. Its second, designed by architect Ralph Adams Cram in 1874 at Rush and Superior, was in use by the congregation until the current church was dedicated in 1914. This makes the building the oldest on Michigan Avenue besides the original water tower.

## ROSENBERG FOUNTAIN *by* FRANZ MACHTL

### BRONZE | INSTALLED 1893 | MICHIGAN AVENUE AND 11TH STREET

Joseph Rosenberg (1848–1891), born in Chicago, moved to San Francisco as a young man. He left a bequest in his will for an ornamental drinking fountain to be located on the South Side of Chicago. The resulting fountain depicts a miniature Greek temple on top of which is an eleven-foot statue representing Hebe, daughter of Zeus and Hera. The fountain no longer creates drinking water.

Franz Machtl was born and lived in Germany, where the statue was cast. A Chicago architecture firm designed the base.

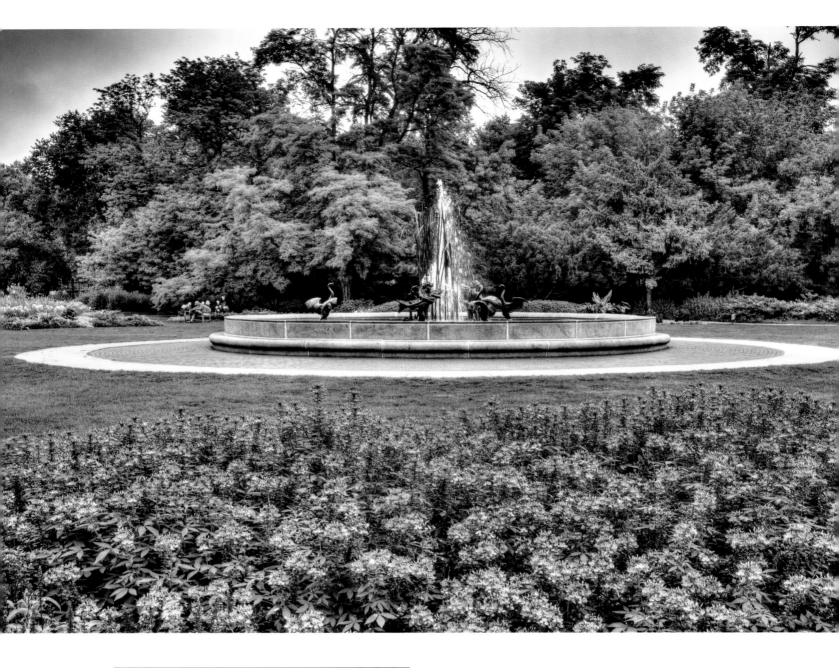

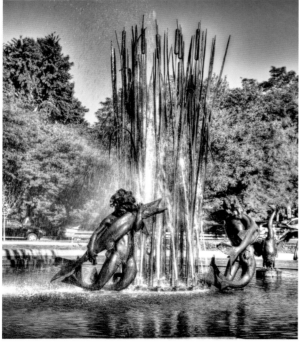

## ELI BATES FOUNTAIN
### *by* AUGUSTUS SAINT-GAUDENS
### *and* FREDERICK MACMONNIES

BRONZE | INSTALLED 1887 | LINCOLN PARK AT
STOCKTON DRIVE AND BELDEN AVENUE

Eli Bates was a wealthy Chicago businessman who left money
upon his death for a statue of Abraham Lincoln and a fountain
to be placed in Lincoln Park. The fountain has also been called
*Storks at Play* for the beautiful stork sculptures.

Saint-Gaudens (1848–1907) was born in Ireland and raised
in New York. He achieved major success for his monuments
commemorating heroes of the Civil War and was an important
artistic adviser for the world's Columbian Exposition of 1893
in Chicago. Over his career, he employed and trained many
sculptors such as James Earle Fraser, Henry Hering, and
Frederick Macmonnies, all of whom created works now in
Chicago. His include *General John Logan, Seated Lincoln,* and
the *Standing Lincoln.*

Macmonnies (1863–1937) began working for Saint-
Gaudens as an assistant at sixteen. He went on to study in
Paris and maintained a studio there until World War I. He
made significant sculptural contributions to the 1893 World's
Columbian Exposition.

## INDEPENDENCE SQUARE FOUNTAIN *by* CHARLES J. MULLIGAN

BRONZE AND GRANITE | INSTALLED 1902 | DOUGLAS AND INDEPENDENCE BOULEVARDS

Also referred to as the Fourth of July Fountain, this fountain depicts four children celebrating Independence Day and was dedicated on July 4, 1902. The children stand on a granite base that resembles the Liberty Bell. Various original adornments to the fountain are now missing.

Charles Mulligan (1866–1916) studied at the School of the Art Institute of Chicago with Lorado Taft. During the 1893 Columbian Exposition in Chicago, Taft made Mulligan the foreman of the sculpture workshop. *Home, Lincoln the Orator, Lincoln the Rail Splitter,* and the *William McKinley Monument* in Chicago are also by Mulligan.

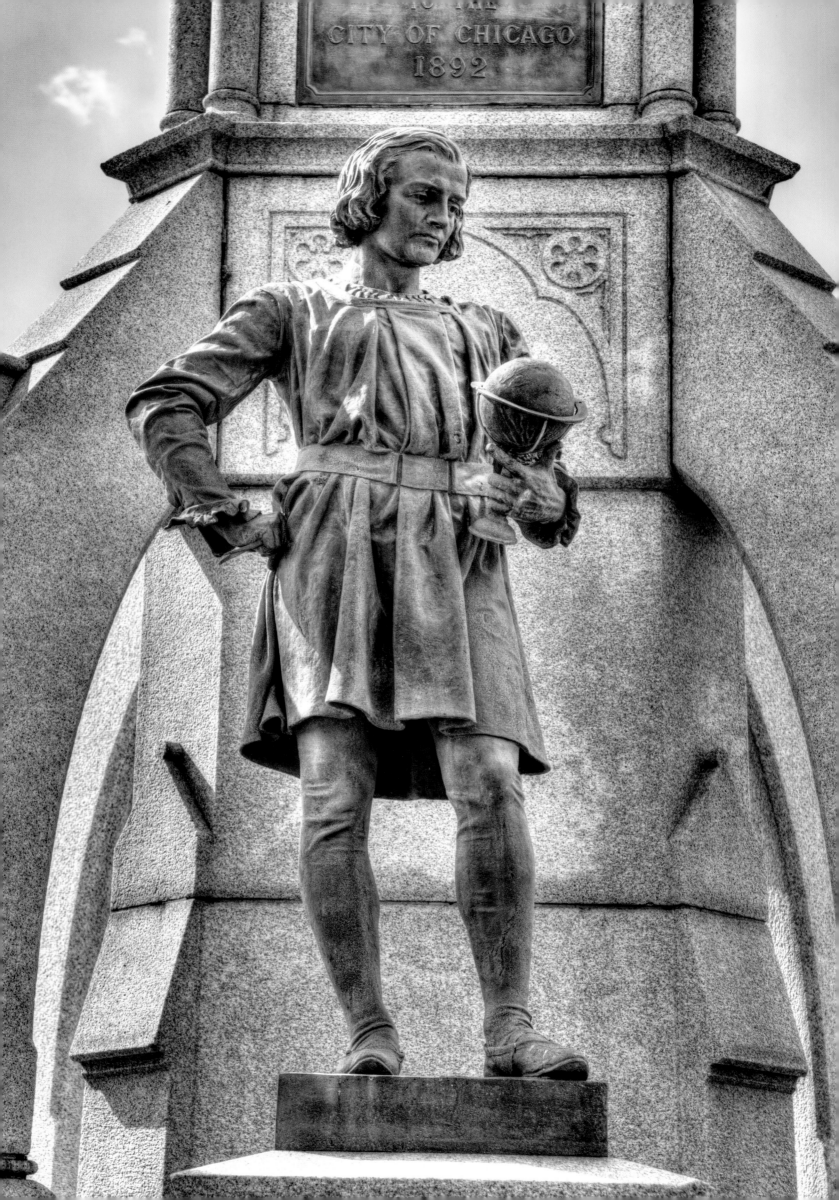

## MCCORMICK FOUNTAIN *by* JANS JENSEN

CONCRETE AND LIMESTONE | INSTALLED 1906 | WASHINGTON PARK ACROSS FROM NEWBERRY LIBRARY

Colonel Robert McCormick (1880–1955) donated money to improve Washington Square (Washington Park) and this led to the building of the fountain now named for him.

The original fountain was designed and built by sculptor Jans Jensen (1860–1951). It was razed and completely reconstructed in 1999.

## DRAKE FOUNTAIN *by* RICHARD HENRY PARK

BRONZE | INSTALLED 1892, MOVED 1909 | EAST 92ND STREET
AT SOUTH CHICAGO AND EXCHANGE AVENUES

This fountain, shown in whole at right and in detail on the facing page, was a gift to the city by hotel magnate John B. Drake. Its original location was near City Hall, where it was designed to serve as a drinking fountain cooled by ice, and as a monument to Christopher Columbus in celebration of the 400th anniversary of his sailing to the Americas. The current location of the monument at a busy intersection surrounded by power lines and light poles makes it difficult to appreciate its beauty.

Richard Henry ' (1832–1902), a well-known American sculptor, was born in New York and participated in the 1893 Columbian Exposition in Chicago. He is the creator of the Benjamin Franklin and Charles Hull monuments.

## EIGHTH STREET FOUNTAIN *by* BENNET, PARSONS AND FROST

CONCRETE | INSTALLED 1927 | MICHIGAN AVENUE AND EAST 8TH STREET

Edward Bennet (1874-1954), who co-authored the influential Plan of Chicago, was consulting architect to the Chicago planning commission after Daniel Burnham died in 1912. He planned the design of this fountain, which opened the same year as did the Buckingham Fountain.

## FOUNTAIN GIRL *by* GEORGE WADE

BRONZE | ORIGINAL INSTALLATION 1893 | CURRENT LOCATION LINCOLN PARK

This fountain has an amazing history. In the late 1800s the Woman's Christian Temperance Union (WCTU) created public fountains throughout the world to provide drinking water as an alternative to liquor. The Children's Division collected donations throughout the world to create a fountain to be displayed at the 1893 Columbian World's Exposition in Chicago, and English sculptor George Wade was commissioned to do the work. Replicas of the fountain were also created for other cities. The fountain, installed near the WCTU booth, was designed to provide water to horses, dogs , birds, and also people. After the exposition it was moved to the Women's Temple at Lasalle and Monroe Streets. In 1921 the temple was demolished and it was moved to Lincoln Park. In the 1930s it was placed in storage due to road construction. It was reinstalled in 1940 in the current location, but stolen in the late 1950s. In 2008 the Chicago Park District raised funds to recreate the statue from a copy in Portland, Maine, and it was reinstalled in 2011.

The self-taught British sculptor George Wade (1853–1933), born in London, was known for statues of British royalty and politicians.

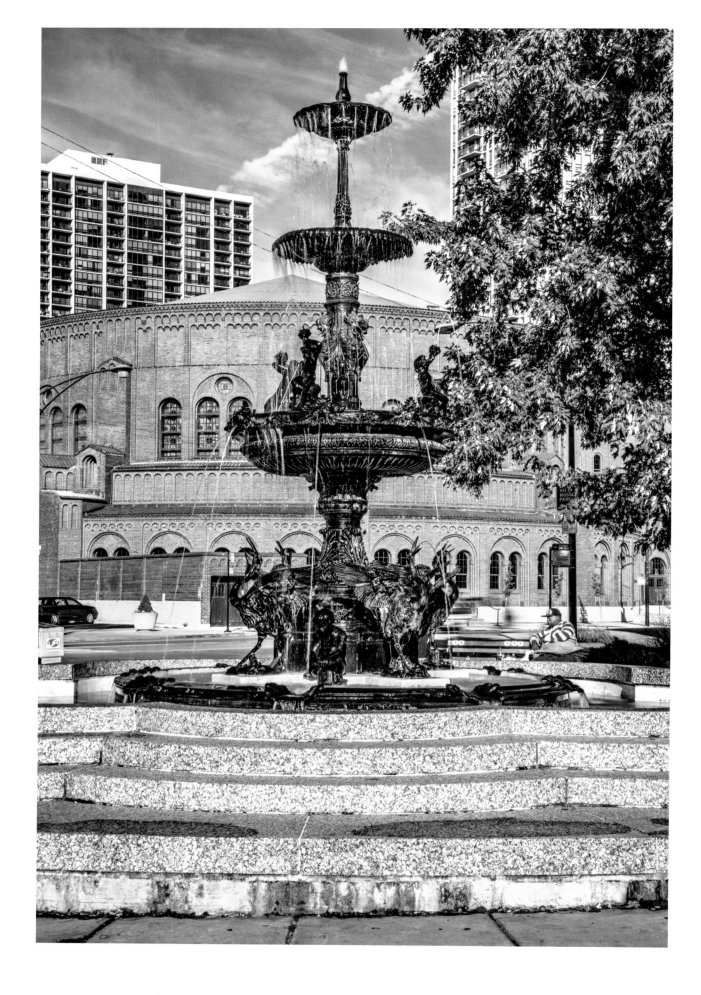

## CHILDREN'S FOUNTAIN *by* ROBINSON IRON CO.

CAST IRON | INSTALLED 1982, RELOCATED 2005 | NORTH AVENUE AND CLARK STREET

While not as old as many other Chicago fountains, this one has historic significance. Jane Byrne, (1934–2014), Chicago's only female mayor, played an active role in its design and creation. It was manufactured by the same iron company that built the Wicker Park Fountain.

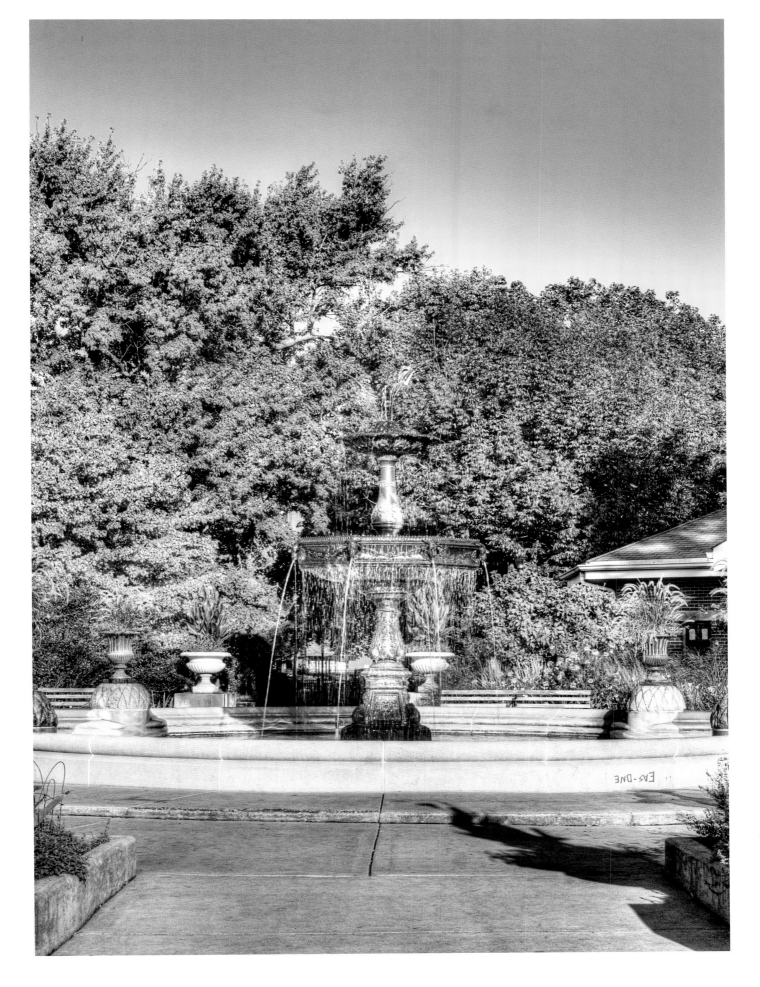

## WICKER PARK FOUNTAIN *by* J. L. MOTT IRON CO.

CAST IRON | INSTALLED 1895 | SCHILLER AND DAMEN AVENUES

This fountain was purchased from the Mott Iron Co. (now Robinson Iron Co.), in connection with the development of Wicker Park in 1895. Water emerges from gargoyle faces around the circumference of the base as well as from the top portion of the fountain. It was completely rebuilt from original plans and rededicated in 2002.

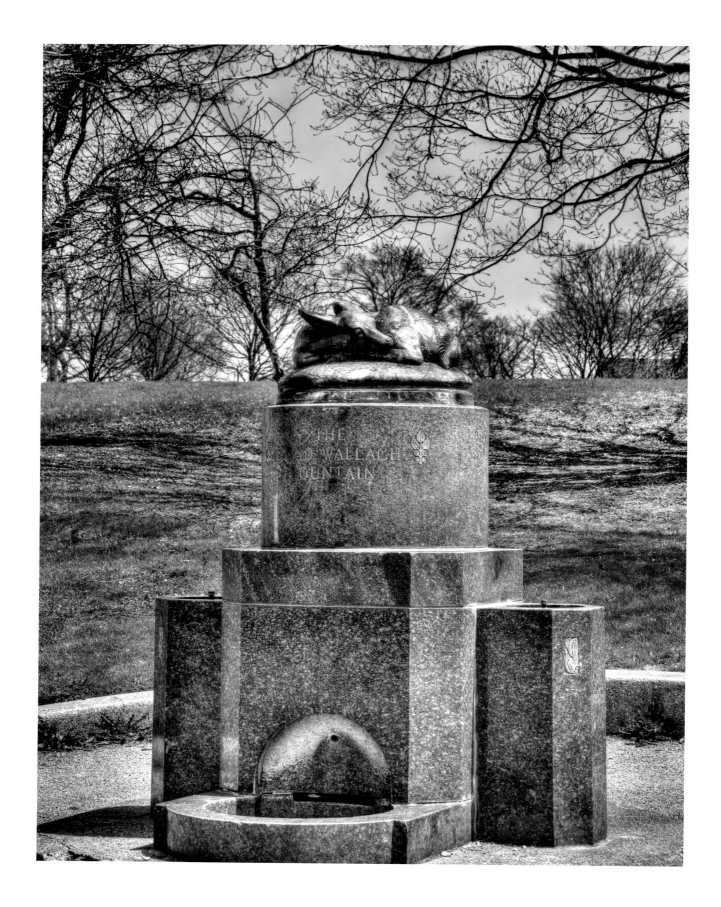

## DAVID WALLACH FOUNTAIN *by* ELISABETH AND FREDERICK HIBBARD

BRONZE AND MARBLE | INSTALLED 1939 | PROMONTORY POINT NEAR 55TH STREET

David Wallach, a Chicago resident and animal lover, died in 1894 leaving money to commission a fountain in Burnham Park to serve people and animals. The Hibbards were commissioned much later to create the fountain and it was designed to provide water for dogs as well as people.

Chicago-based Elisabeth (1889–1950) and Frederick (1881–1966) Hibbard trained under Lorado Taft at the School of the Art Institute of Chicago. Frederick is best remembered for his Civil War memorials and Elisabeth for her animal figures. Elisabeth sculpted the fawn and her husband designed the fountain. Elisabeth also taught art at the University of Chicago. The Hibbards are also associated with the Carter H. Harrison and Greene Black sculptures and Eagle Fountain.

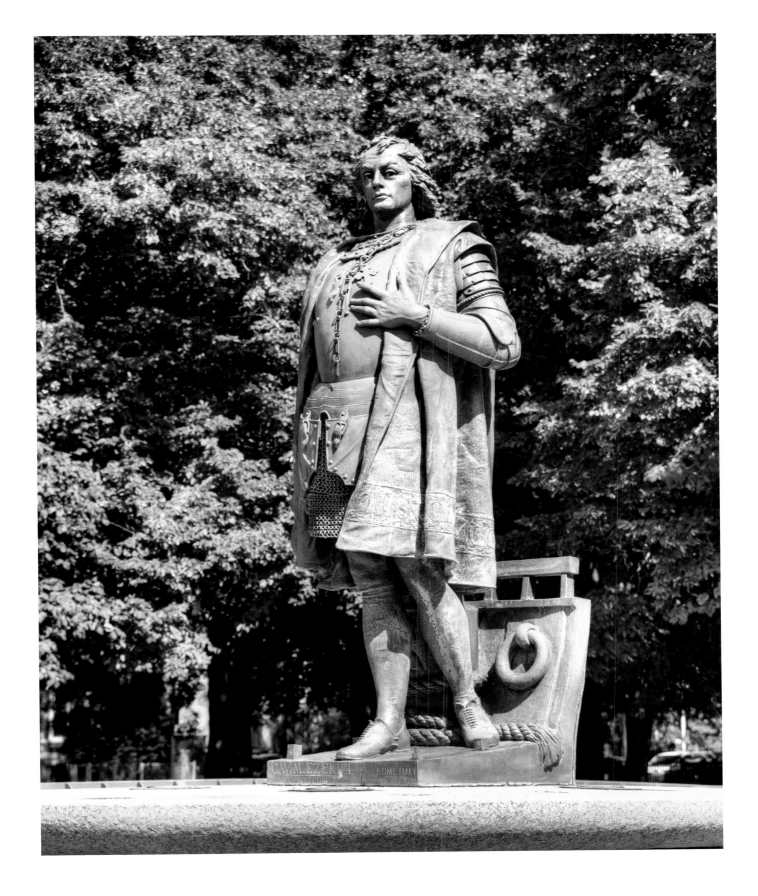

## CHRISTOPHER COLUMBUS FOUNTAIN *by* MOSES EZEKIEL

BRONZE │ INSTALLED CA. 1894, RELOCATED 1966 │ 801 SOUTH LOOMIS STREET, ARRGO PARK

This nine-foot-tall Columbus wearing a flowing cloak over a suit of armor was commissioned in the 1890s for the Columbus Building in downtown Chicago. Prior to its installation, it was displayed at the 1893 Columbian Exposition. In 1959 the building was razed and the owners tried to find a new home for Columbus. Eventually the statue was donated to the park district and installed in the Little Italy area.

Moses Ezekiel (1844–1917) was born in Virginia one of fourteen children. He was the first Jewish cadet at Virginia Military Institute and served in the Confederate Army in the Civil War. After the war, he studied in Germany and settled in Italy, becoming an internationally prominent artist. He sculpted this figure of Columbus in his Rome studio. The statue was blessed by Pope Leo XIII.

# FOUNTAIN
## OF THE GREAT LAKES
### *by* LORADO TAFT
BRONZE | INSTALLED 1913 |
CHICAGO ART INSTITUTE COURTYARD

Five female figures represent the five Great Lakes in this fountain; water flows from shells in the same way that it does in the lakes. Superior at top and Michigan on the side empty their water into the basin held by Huron, who sends her stream on to Erie. Ontario receives the water as it flows to the St. Lawrence River. The fountain was created by funds from the B. F. Ferguson bequeath to establish public sculpture in Chicago. Commissioned in 1907, it represented the first use of these funds.

Taft (1860–1936), an Illinois native educated at the University of Illinois, studied art in Paris. He returned to Chicago in 1886 and began his career as a sculptor and teacher. His first recognition resulted from two sculptures for the horticulture building at the 1893 Columbian Exposition. Other Chicago sculptures include *The Republic, The Crusader, Eternal Silence, Fountain of Time, Pastoral*, and *Idyll*. The *Fountain of the Great Lakes* was his first major work in the city.

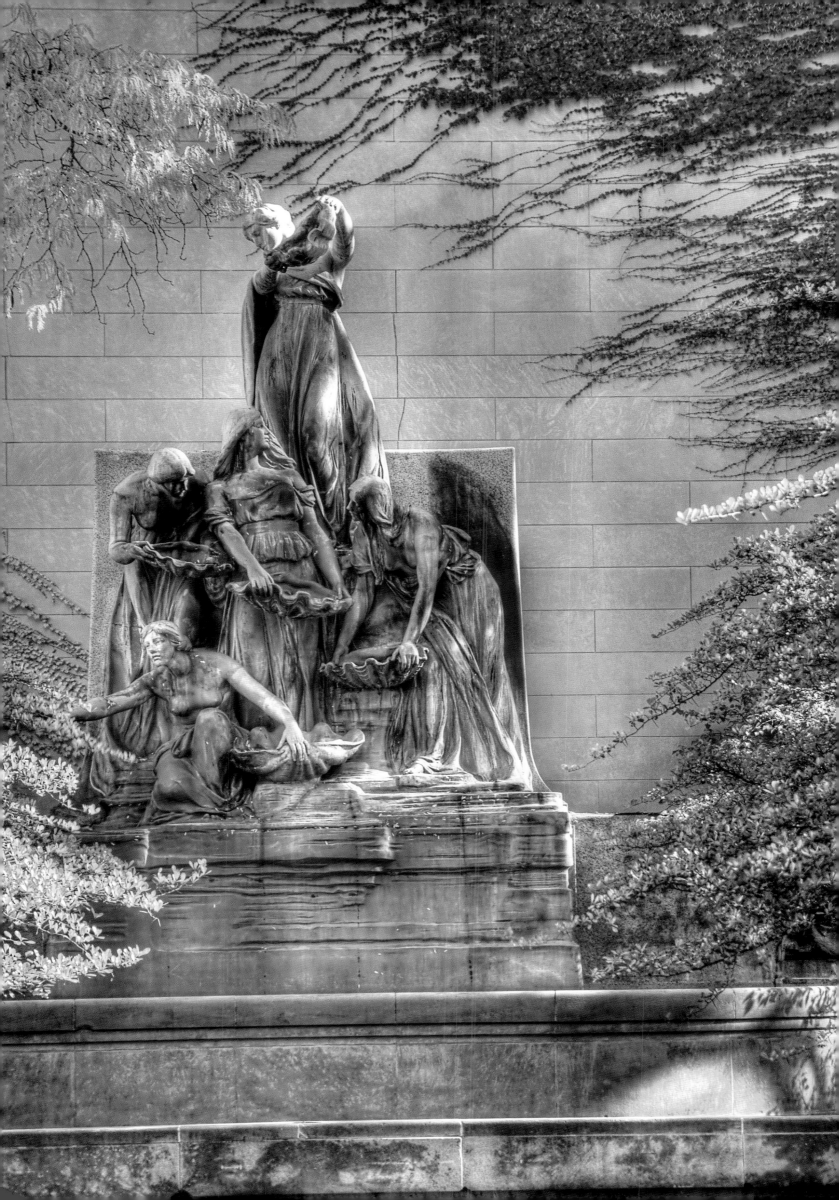

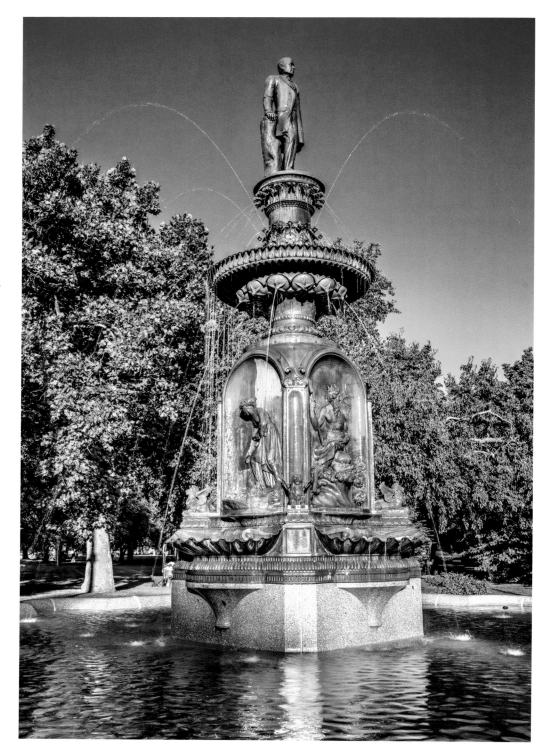

## DREXEL FOUNTAIN

*by* **HENRY MANGER**

BRONZE AND GRANITE

| INSTALLED 1881

| DREXEL SQUARE

This fountain was donated to the city by the sons of Francis Drexel, a Philadelphia banker who helped develop the South Side of Chicago. The figure on top is meant to represent Francis Drexel. A four-sided pedestal at the base features scenes such as Neptune riding a dolphin.

Henry Manger (b. 1833) was born in Odessa to German parents and worked as a sculptor in Philadelphia from 1859 to 1869. Afterwards he returned to Germany and continued to work from Berlin. He is known in the U.S. for his monumental sculptures, including some commemorating the Civil War.

## EAGLE FOUNTAINS *by* **FREDERICK CLEVELAND HIBBARD**

BRONZE | INSTALLED 1931 | MICHIGAN AVENUE AND CONGRESS PARKWAY

On the north and south sides of Congress Plaza are twin fountains with a bronze eagle holding a fish in its talons at the centers of circular pools. The fountains complement a pair of Beaux-Arts columns and two statues of Native American figures on horseback. These decorative sculptures were designed for either side of a monumental stairway that served as an entrance to the Century of Progress International Exposition celebrating Chicago's first century as a city.

Native Missourian Frederick Hibbard (1881–1950) did university undergraduate studies in Chicago and then enrolled at the School of the Chicago Art Institute to become a sculptor. He lived in Chicago and completed many sculptures still in the city, among them a sculpture of Carter Harrison, the David Wallach fountain, and the Greene Black monument. Other works by Hibbard reside in various American cities.

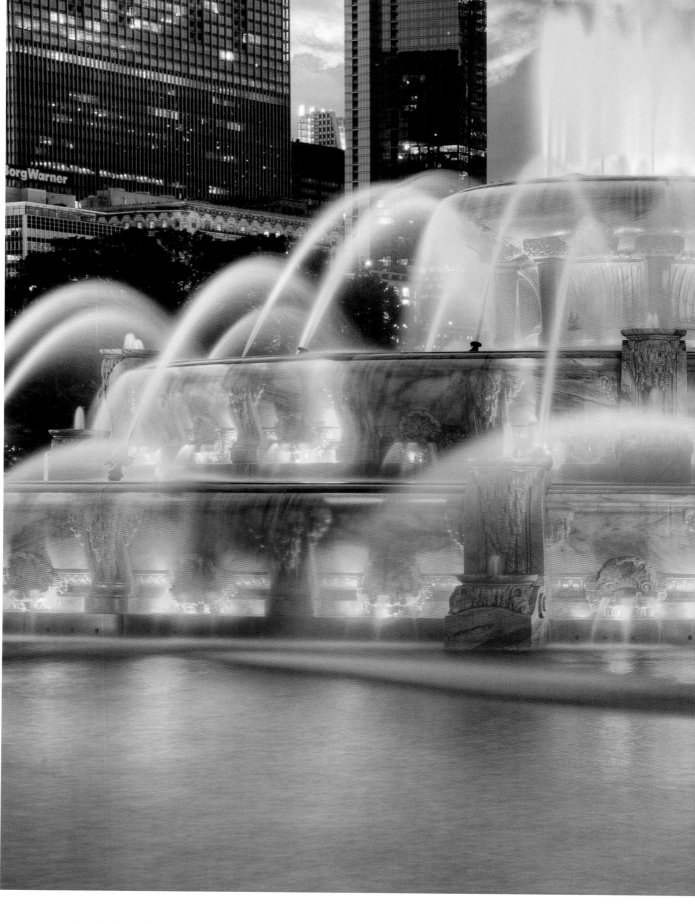

## CLARENCE BUCKINGHAM MEMORIAL FOUNTAIN
*by* BENNETT, PARSONS AND FROST; MARCEL FRANÇOIS LOYAU

MARBLE AND BRONZE │ INSTALLED 1927 │ GRANT PARK AT CONGRESS PARKWAY

Philanthropist and art patron Kate Buckingham (1858–1937) donated $1 million to the city for a fountain dedicated to her brother, Clarence. The fountain is the

centerpiece of Grant Park as envisioned by its architect, Edward H. Bennett (1874–1954), and sculptor, Marcel François Loyau (1895–1929). It is designed to symbolize

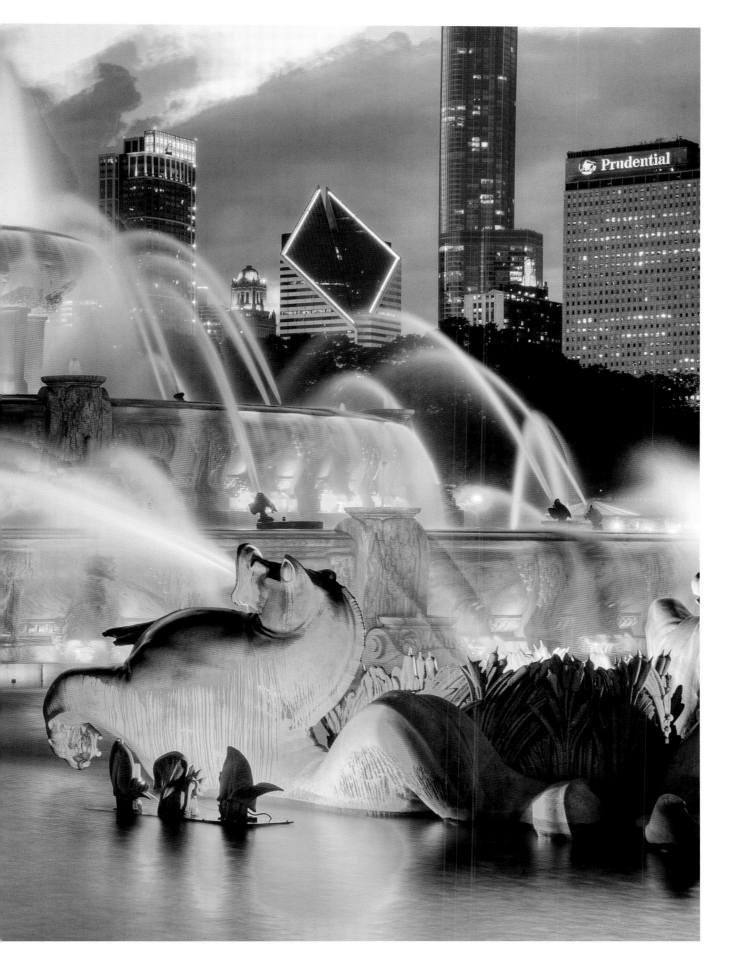

Lake Michigan. Conveying the enormity of the lake, its display uses 15,000 gallons of water per minute and sprays water to a height of 150 feet. The lower basin features four Art Deco seahorses representing the four states that border Lake Michigan. At the dedication in 1927, 50,000 people were on hand to hear John Philip Souza lead his band in *Pomp and Circumstance*. Thousands are attracted each summer to watch the programmed nightime water sprays and color.

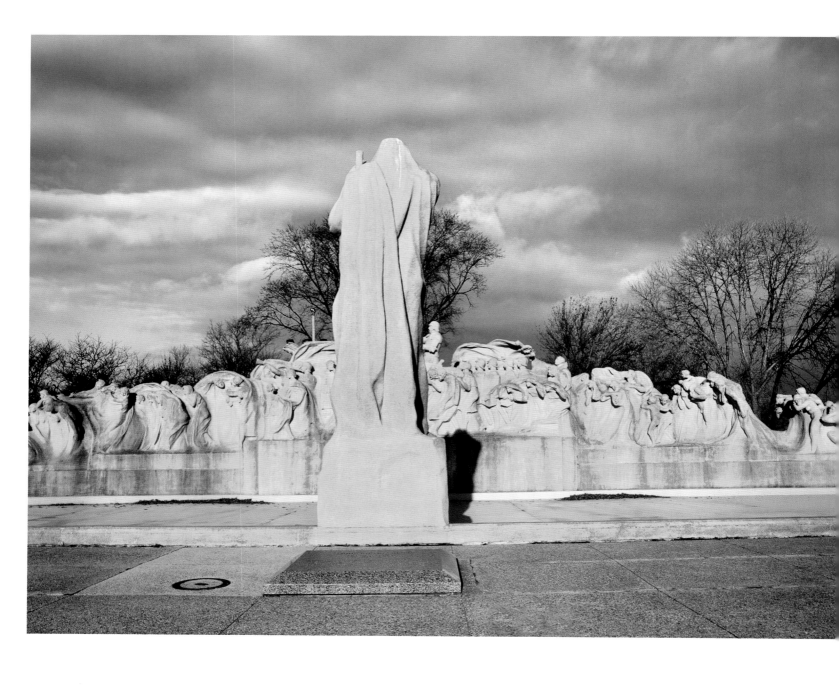

## FOUNTAIN OF TIME *by* LORADO TAFT

STEEL-REINFORCED HOLLOW-CAST CONCRETE | INSTALLED 1922 | WASHINGTON PARK PLAISANCE

Lorado Taft (1860–1936) spent more than fourteen years on this sculpture, using a recently developed concrete that has unfortunately not weathered well. He was inspired by words from a poem of Austin Dobson: "Time goes, you say? / Ah, no, Alas, time stays: we go."

A lone sentinel, Father Time, stands across a pool from an enormous 110-foot-long stream of humanity passing by, including a central soldier on horseback surrounded by soldiers, refugees, lovers, and youths at one end, and the aged at the other end. They represent birth, struggle for existence, love, family, life, religion, poetry, and war. Lorado Taft, in smock, can be seen in the middle on the back side, along with some of his assistants. The fountain models were

constructed in his Midway studio two blocks east of the fountain, which stands at Washington Park at the west end of Midway.

Taft studied at the University of Illinois, then in Paris. He returned to Chicago in 1886 and began his career as sculptor and teacher. His first recognition resulted from two sculptures for the Horticulture Building at the 1893 Columbian Exposition. Other Chicago sculptures by Taft are *The Republic, The Crusader, Eternal Silence, Fountain of the Great Lakes* (his first major Chicago work), *Pastoral,* and *Idyll.*

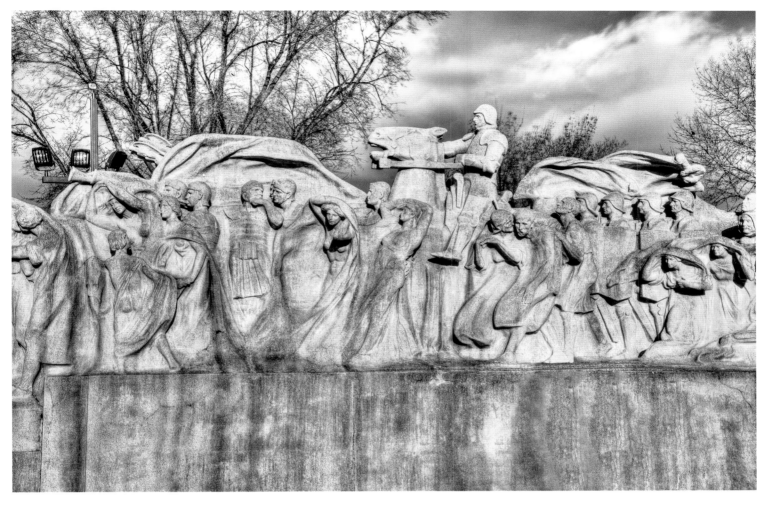

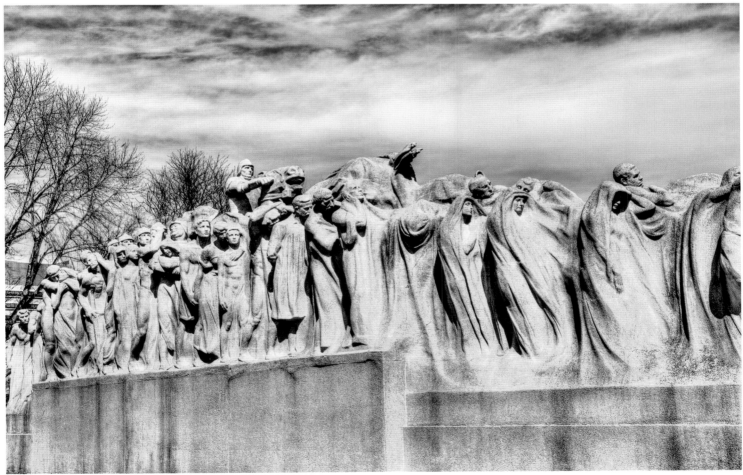

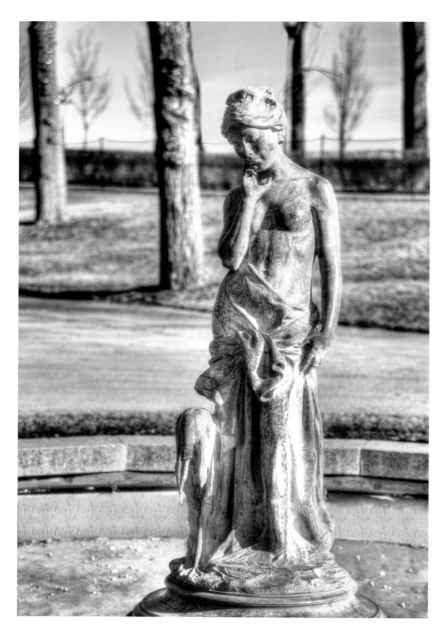

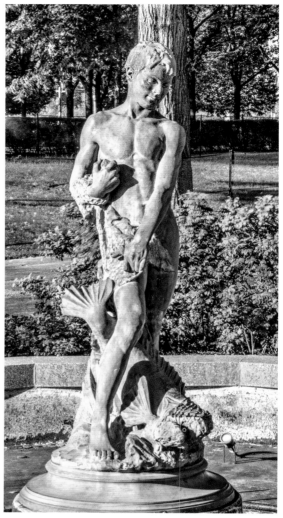

## CRANE GIRL, FISHER BOY, TURTLE BOY, DOVE GIRL
### *by* LEONARD CRUNELLE
BRONZE | INSTALLED 1905 | HUMBOLDT PARK,
MOVED TO GRANT PARK 1964

At the four corners of Grant Park's rose gardens flanking
Buckingham Fountain are four twenty-foot pools. In the
center of each is the figure of a young boy or girl. They were
originally commissioned for the rose gardens in Humboldt
Park and were unveiled there in 1905.

 After emigratiing to the United States, Leonard Crunelle
(1872–1945) studied at the School of the Art Institute of
Chicago with Lorado Taft, whom he assisted with many
sculptures. He went on to create many of his own sculptures
installed around the United States. Other Crunelle works in
Chicago are a statue of Richard J. Oglesby and *Victory*.

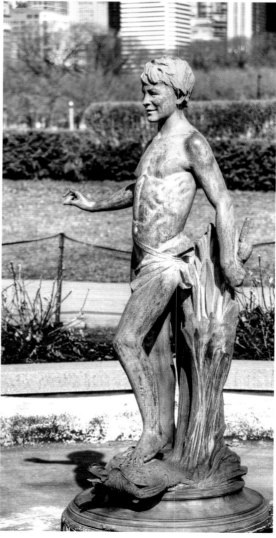

C
H
I
C
A
G
O

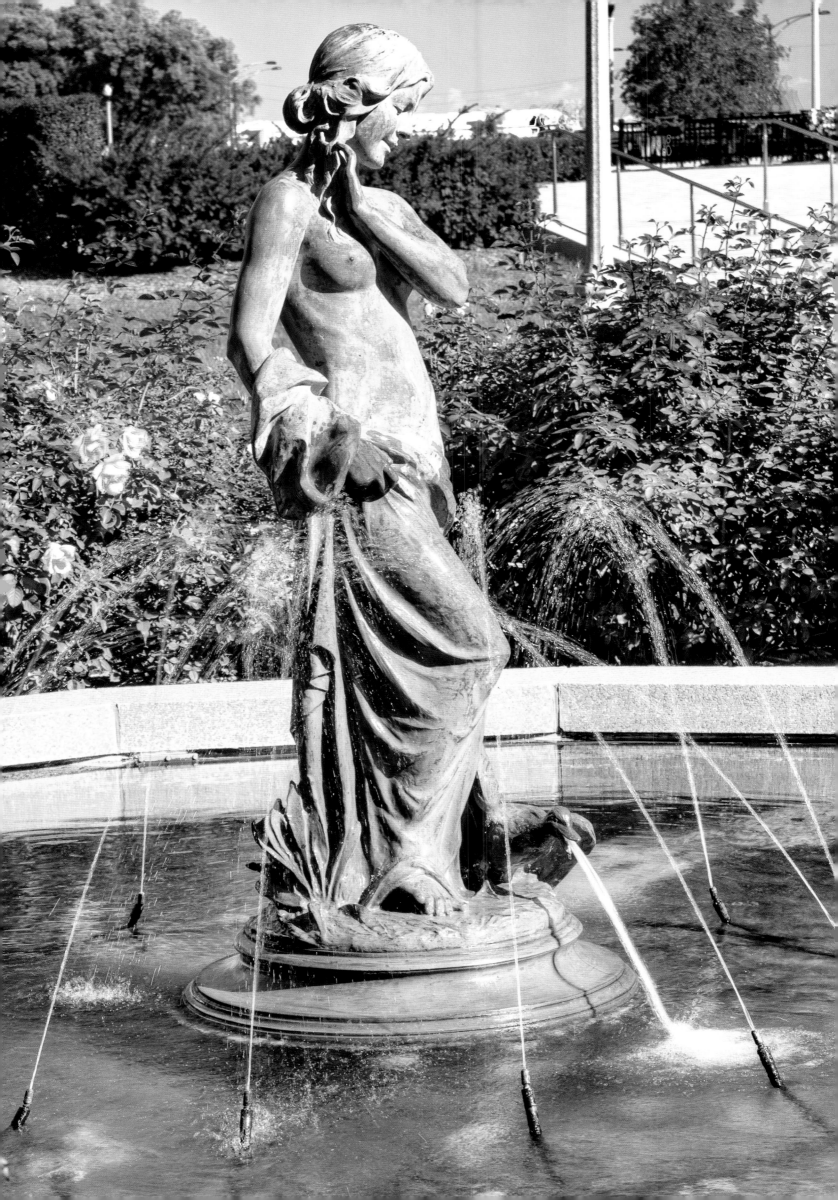

# ARCHITECTURAL SCULPTURE

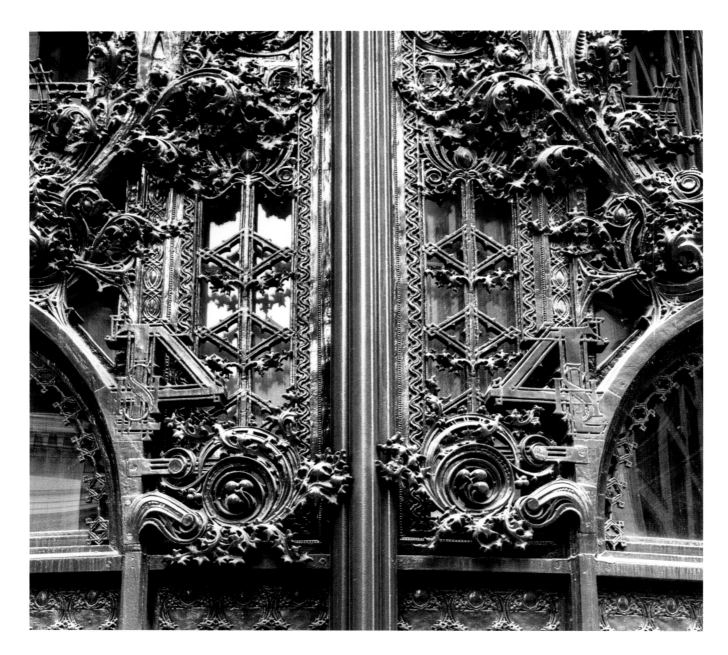

## CARSON PIRIE SCOTT CORNER ENTRANCE *by* LOUIS H. SULLIVAN
### ORNAMENTAL IRON | BUILT 1899–1904 | 1 SOUTH STATE STREET

This Sullivan-designed masterpiece was built between 1899 and 1904 and changed hands a number of times before it was leased to the Schlessinger & Meyer department store (popularly known as the Carson Pirie Scott building), ca. 1904. Unique for the time, it had a steel-framed structure allowing for large bay windows. Sullivan sited the corner entrance to be easily seen from both State and Madison Streets and designed ornamentation to make the store inviting to enter. He was aided by extremely skilled draftsmen, artists, and craftsmen who converted his designs into plaster models for metal castings that were more precise than ever before produced in iron.

Native Bostonian Louis Sullivan (1856–1924) studied architecture at the Massachusetts Institute of Technology, moved to Chicago after the fire of 1871, and had a successful fifteen-year partnership with Dankmar Adler. Adler left the firm in 1895. He also worked on the Chicago Stock Exchange, Auditorium Building, and the Getty Tomb at Graceland Cemetery. Sullivan's last great work was the Carson Pirie Scott Building; his commissions diminished with time and he began to struggle to make a living designing small midwestern banks.

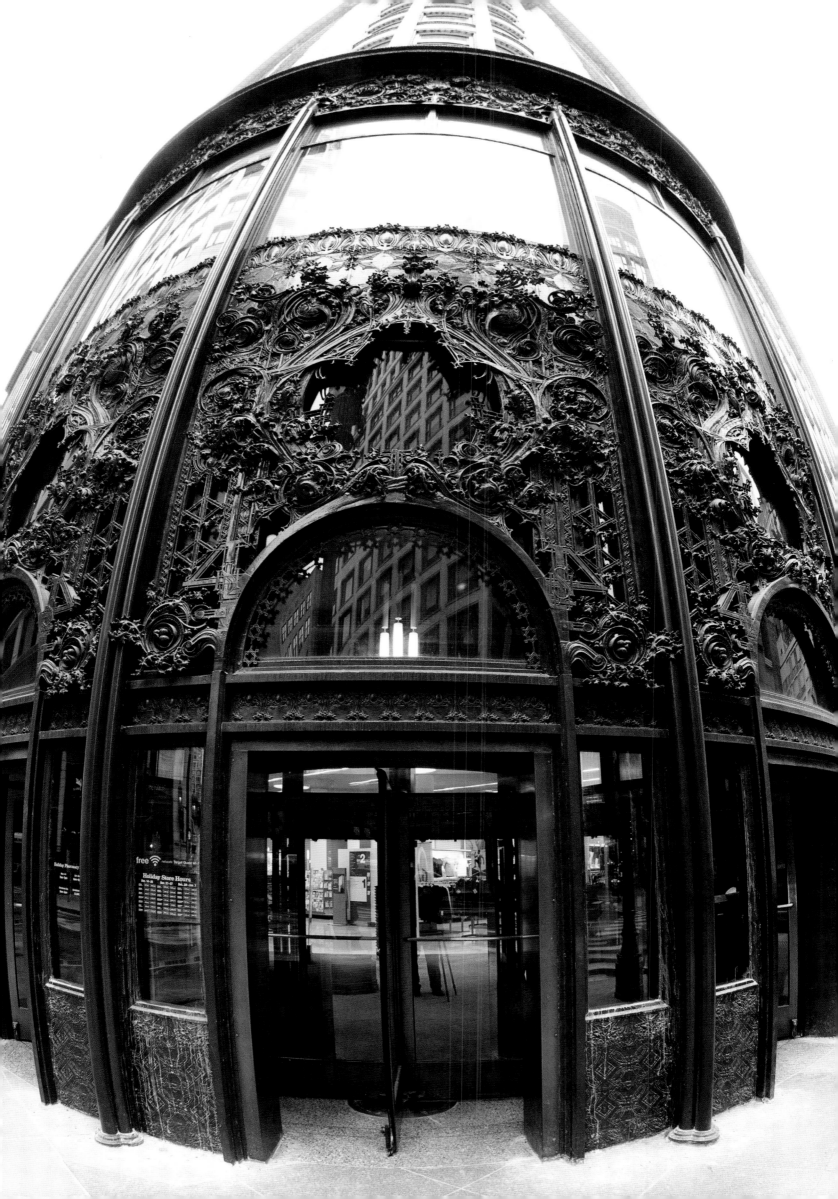

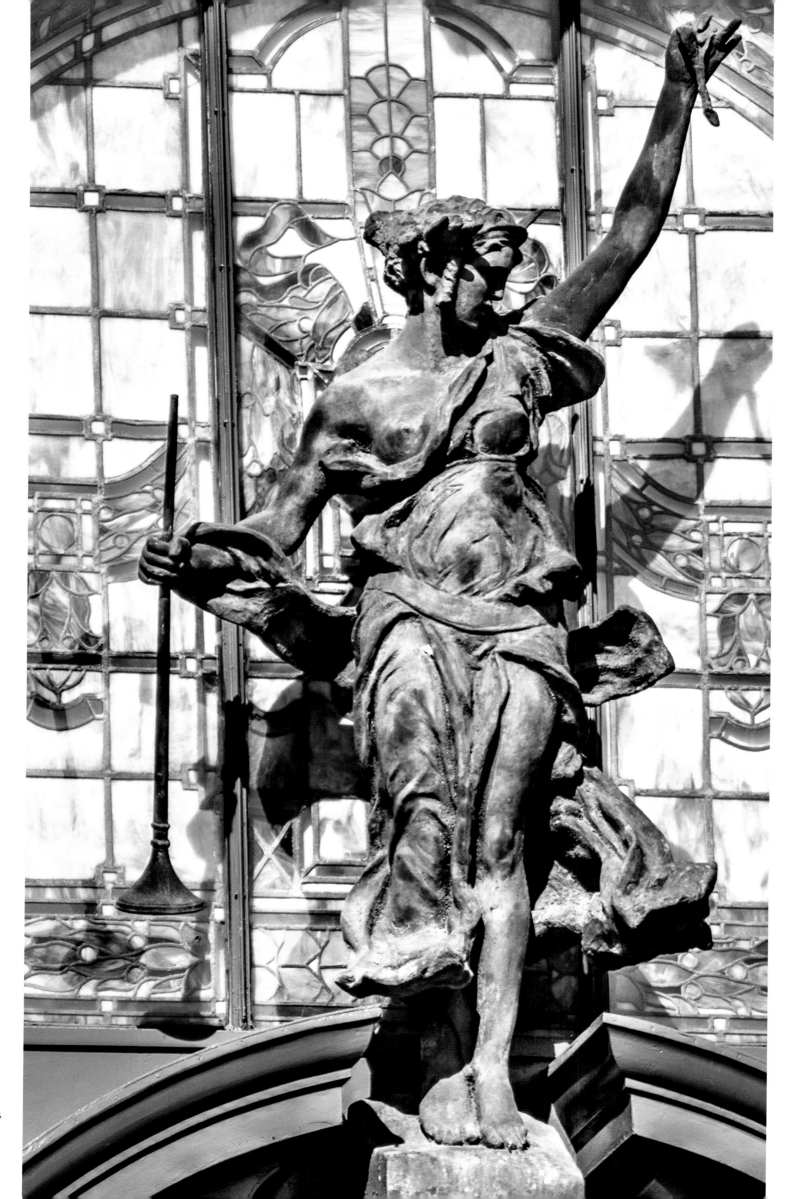

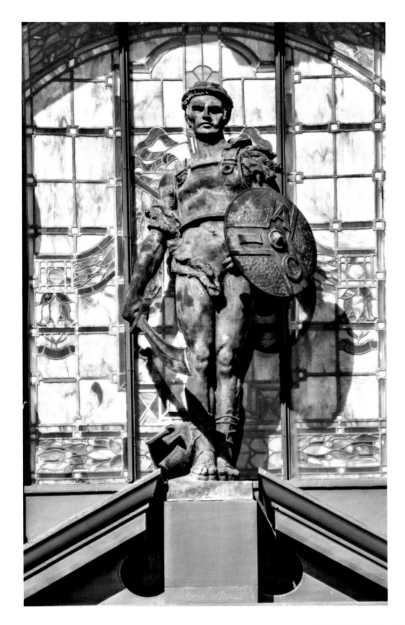

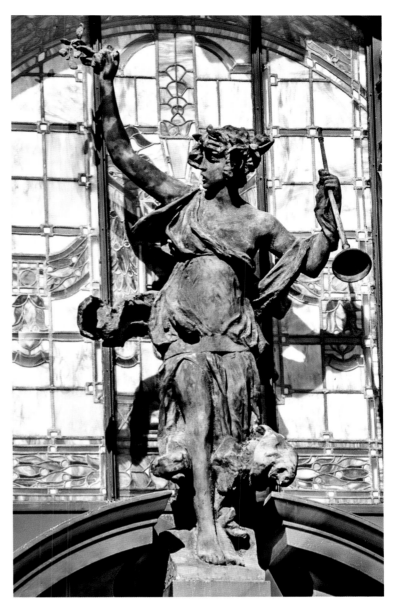

## SCHOOL OF THE ART INSTITUTE OF CHICAGO FRIEZE *by* LEON HERMANT

BRONZE | INSTALLED CA. 1908 | 112 SOUTH MICHIGAN AVENUE

This prominent building on Michigan Avenue that is adorned by a Leon Hermant frieze started as the home of the Illinois Athletic Club. The club selected Barnett, Haynes and Barnett, a St. Louis firm, to design the building. It included an athletic inspired Greek-style frieze by Leon Hermant (1866–1936) with three heroic bronze figures framed by arched windows overlooking Michigan Avenue. The central figure bears a shield with the motto of the Illinois Athletic Club. The figure to the north holds out a crown of wild olive, the symbol of victory in ancient Olympic athletic events. The side figures are heralds with trumpets. It is not known whether these sculptures were also the work of Hermant. The building was dedicated in 1908 and sold to the School of the Art Institute of Chicago in 1992.

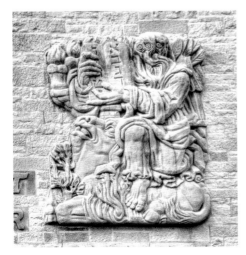

## NOT BY MIGHT: TEMPLE HAR ZION RELIEF
### *by* MILTON HORN

STONE | INSTALLED 1950 | 1040 NORTH HARLEM AVENUE

In Horn's words, "The function of sculpture is not to decorate but to integrate, not to entertain but to orient man within the context of his universe."

Horn (1906–1995) emigrated from Russia in 1913 and maintained a prolific studio in Chicago. He is known for *Chicago Rising From the Lake, Hymn to Water, The Spirit of Jewish Philanthropy,* and work at the Merchandise Mart Hall of Fame.

MONUMENTAL

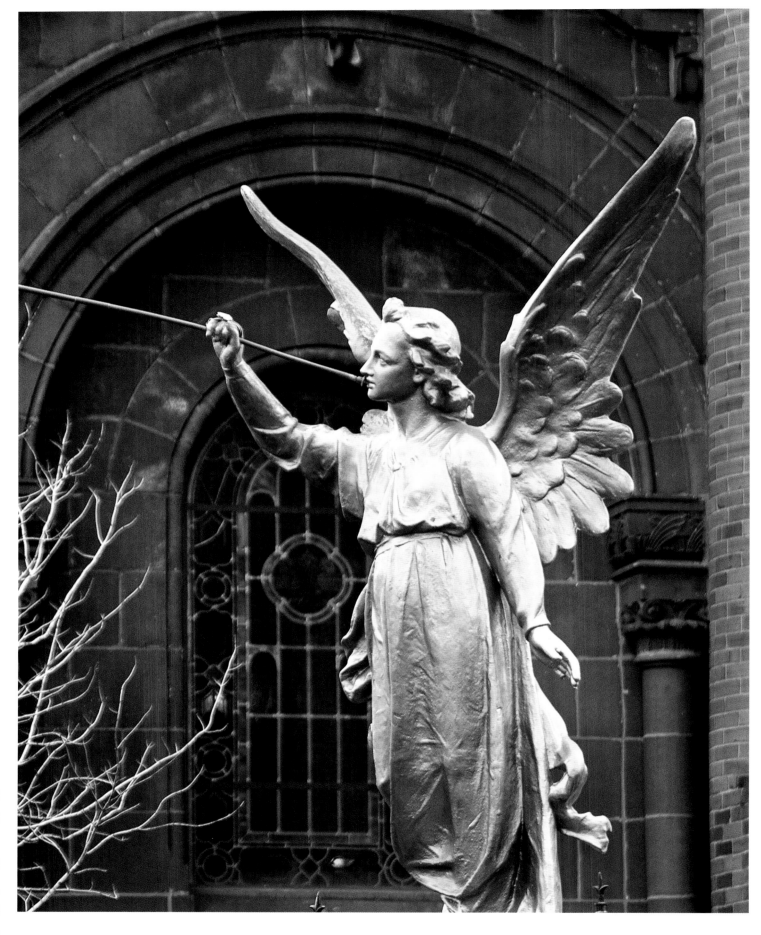

## SAINT GABRIEL *by* AN UNKNOWN SCULPTOR

INSTALLED CA. 1914 OR 1917 | 45TH STREET AND LOWE AVENUE

St. Gabriel Church was designed by Daniel Hudson Burnham (1846–1912) and John Wellborn Root

(1850–1891) between 1884 and 1887. This monument to its patron saint was added by an unknown artist.

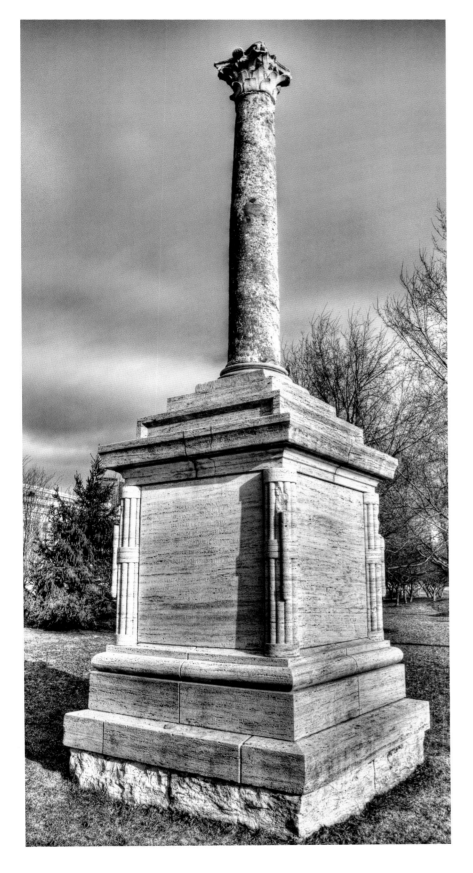

## BALBO MONUMENT
### *by* AN UNKNOWN SCULPTOR

BRECCIA (COMPRESSED STONE) |
INSTALLED 1933 | EAST OF
SOUTH MUSEUM CAMPUS DRIVE
AND SOLDIER FIELD

The Balbo Monument is said to have been part of a Roman structure dating to the time of Julius Caesar (117–38 B.C.E.). It was presented to Chicago by the Italian Fascist leader Benito Mussolini during the Century of Progress International Exposition, 1933 through 1934. The column was dismantled and delivered to Chicago by a fleet of twenty-four Italian amphibious planes commanded by Italo Balbo, head of the Italian air force. The planes landed in Lake Michigan to great fanfare and with thousands of curious onlookers. As a result of this gesture, Chicago renamed 7th Street Balbo Drive. This gift and the street renaming remain controversial due to their connection with the Italian Fascists, allies of Adolf Hitler, and there have been many attempts to reverse the street name change.

An inscription on the pedestal of the monument, translated from the Italian, reads: *"This column / twenty centuries old / was erected on the beach of Ostia / the port of Imperial Rome / to watch over the fortunes and victories / of the Roman Triremes / Fascist Italy / with the sponsorship of Benito Mussolini / presents to Chicago / as a symbol and memorial in honor / of the Atlantic squadron led by Balbo / which with Roman daring flew across the ocean / in the eleventh year / of the Fascist Era."*

The Century of Progress International Exposition opened in May 1933 in celebration of Chicago's centennial. Despite the ongoing Great Depression, it was a success. Its theme of scientific progress was captured in its motto: "Science finds, Industry applies, Man conforms." The fair spread across three miles of newly reclaimed land along the shore of Lake Michigan from 12th Street to 39th Street. An international flavor was marked by a visit from the German airship *Graf Zeppelin* in October. It circled the fair for two hours in a display that proved to be controversial because of its connection to the ascendancy of Adolph Hitler in Germany.

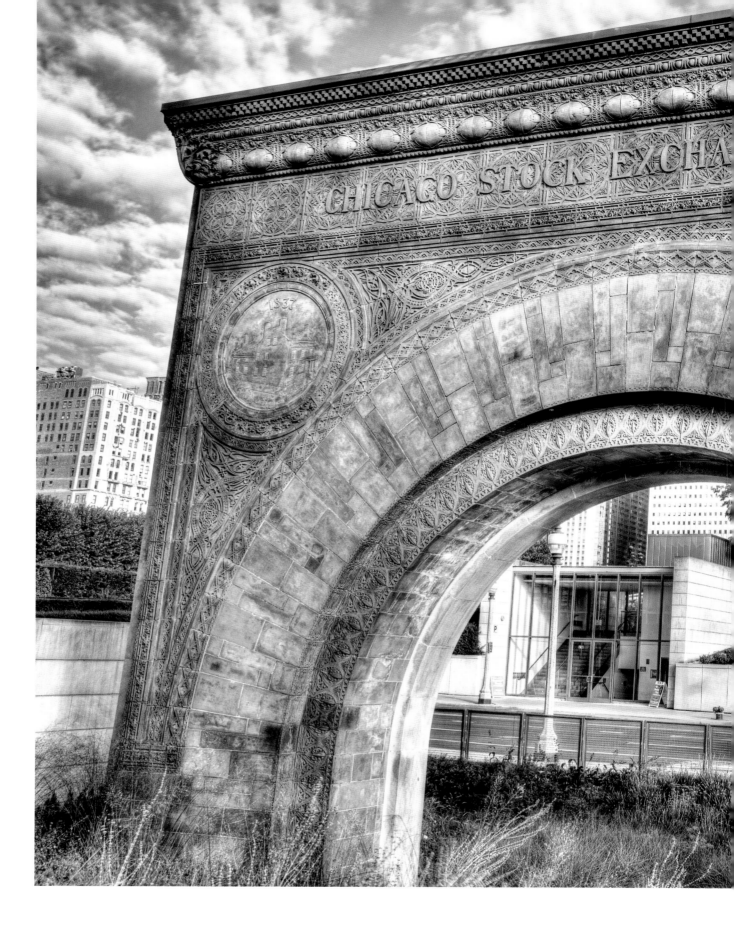

## CHICAGO STOCK EXCHANGE ARCH *by* ADLER AND SULLIVAN

TERRACOTTA AND LIMESTONE | INSTALLED 1893, RELOCATED 1977 | COLUMBUS DRIVE AND MONROE

This two-story structure stood for eighty years at the entrance to the Chicago Stock Exchange Building, designed by Adler and Sullivan. Carson, Pirie, Scott and Company assisted with the project. The building was demolished in 1972, but the arch was preserved and donated to the School of the Art Institute of Chicago, where it is now regarded as

sculpture. The arch's ornamentation is considered to be some of Sullivan's finest work. At the top left corner is depicted the home of Philip Peck, built in 1837, which originally stood on the site of the Stock Exchange. From 1880 to 1895, Adler and Sullivan was one of the most innovative architectural firms in America. At one point, Frank Lloyd Wright was

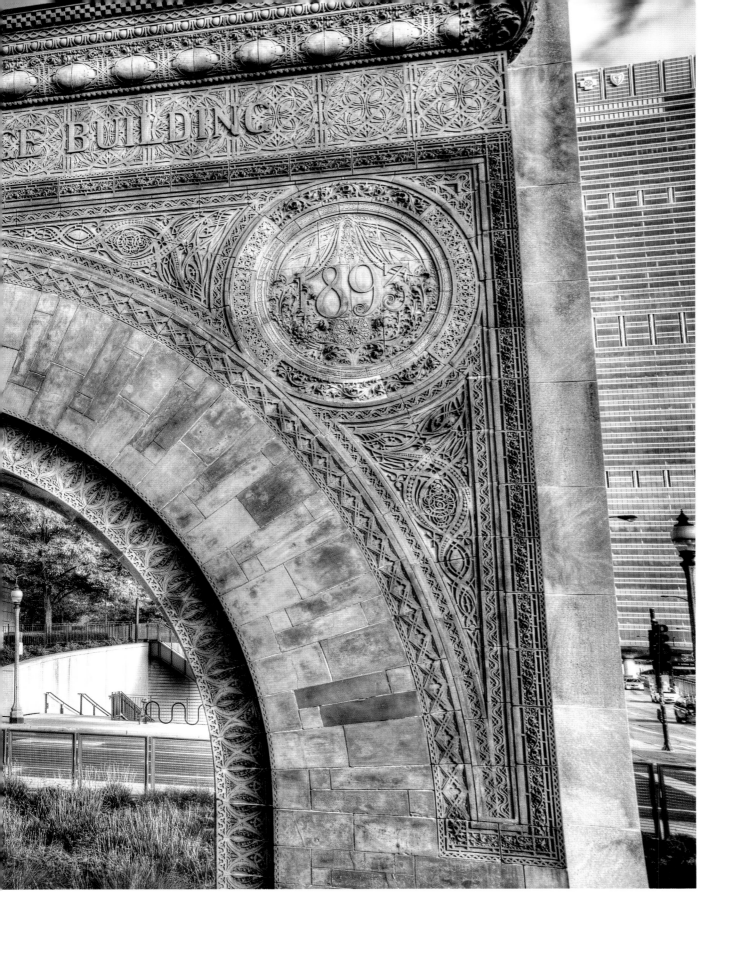

chief draftsman in the firm. Dankmar Adler (1844–1900) emigrated to the United States from Germany in his youth and settled in Chicago in 1861. He was never formally trained, but his talent for drawing and architecture gained him an apprenticeship with a well-known Chicago architect. He was involved in many battles with the Illinois Light Artillery during the Civil War, was wounded, and returned to Chicago a hero. There he began work as an architect. He was also a gifted structural engineer.

Louis Sullivan (1856–1924) was born into an intellectually rich environment in Boston. His parents moved to Chicago in 1868, but Sullivan remained behind to study architecture at the Massachusetts Institute of Technology. He moved to Chicago after the Great Fire of 1871 to help rebuild the city. Adler hired Sullivan in 1880. He shortly became a full partner, and the innovative firm was responsible for helping to develop the tall buildings that populate today's Chicago skyline.

## FIELD MUSEUM CARYATIDS
### *by* HENRY HERING
MARBLE | INSTALLED 1921 |
SOUTH FAÇADE, FIELD MUSEUM

The Field Museum, incorporated in 1893, was originally known as the Columbian Museum of Chicago. It housed artifacts from the 1893 Columbian Exposition in the only Jackson Park building remaining from the exposition, the Palace of Fine Arts, which now houses the Museum of Science and Industry. The museum's name was changed in 1905 to honor its benefactor Marshall Field. In 1921 the museum moved to its present site, where it remains one of the largest natural history museums in the world. The museum's façade is surrounded by figural sculptures including the caryatids serving as architectural supports, almost all of which were sculpted by Henry Hering.

Henry Hering (1874–1949), born in New York City, was a student and assistant of Augustus Saint-Gaudens. He is mostly known for architectural sculpture. Other Chicago sculptures are *Defense* and *Regeneration* and the Michigan Avenue bridge pylons.

## CERES *by* JOHN STORRS
ALUMINUM | INSTALLED 1930 | BOARD OF TRADE BUILDING

Chicago's tallest sculpture, a thirty-one-foot-tall statue of Ceres, Greek goddess of the harvest, stands 609 feet off the street. Lit at night, it can be seen from several miles away. The Board of Trade Building at the time of its completion was the tallest building in Chicago and housed the world's busiest grain exchange. The face is an oval without features and the folds of the gown are sharply cut parallel sections.

Storrs (1885–1956) was born in Chicago, studied at the School of the Art Institute of Chicago with Lorado Taft, and moved to Paris at an early age to become a student of Auguste Rodin. During World War II he was imprisoned twice by the Germans. This work was designed in France and cast in Rhode Island.

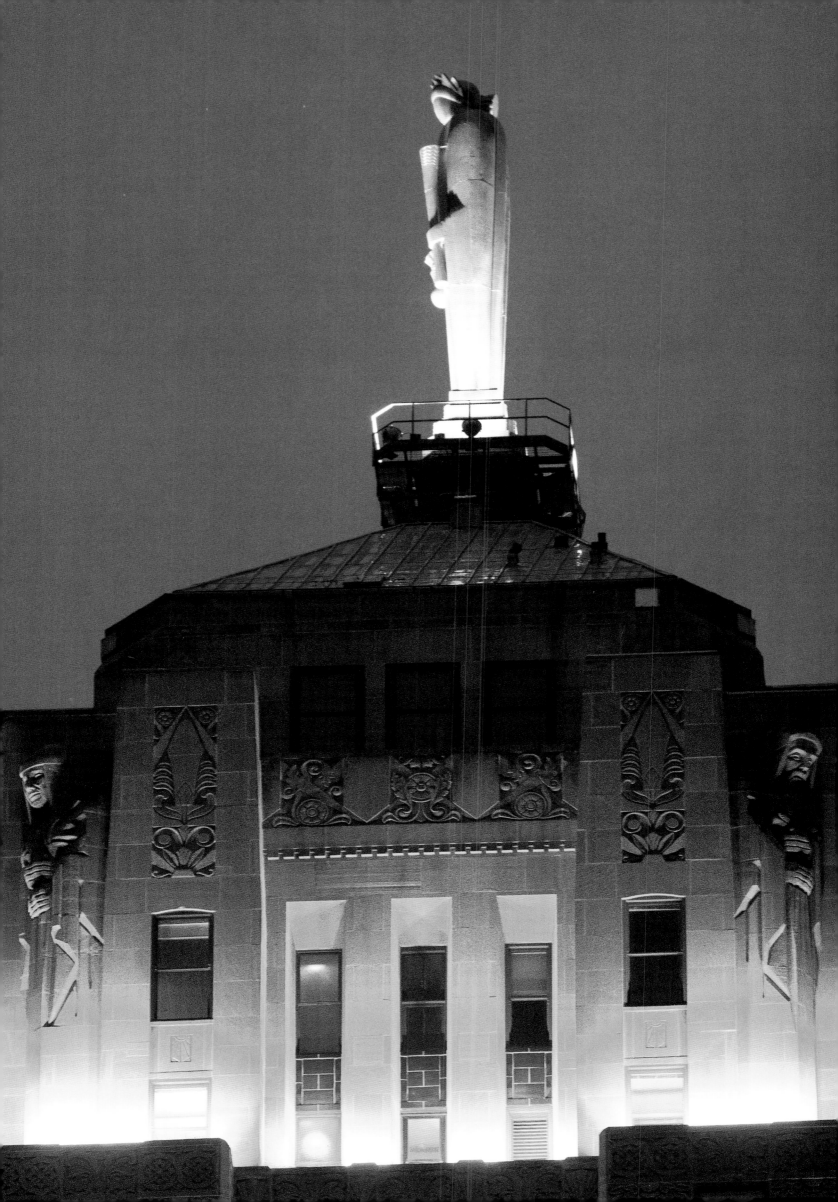

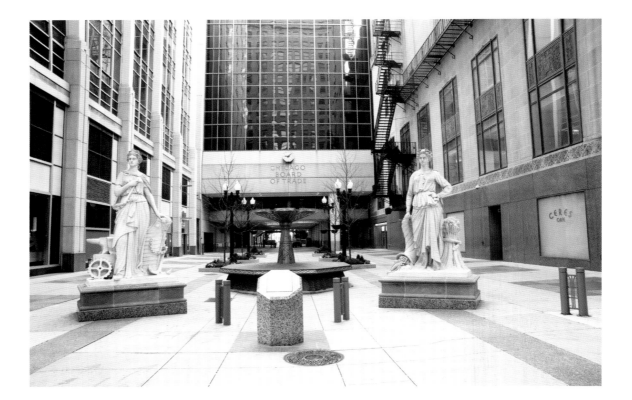

## INDUSTRY AND AGRICULTURE
### *by* AN UNKNOWN SCULPTOR
GRANITE │ INSTALLED 1885 │ BOARD OF TRADE BUILDING

The Board of Trade in Chicago was initiated in 1848 and acquired its first permanent home in 1885. The building was designed by William Boyington, who also worked on the Chicago water tower, and stood ten stories tall. *Industry* and *Agriculture* stood over its main entrance. When the original building was razed in 1929 to make way for the current

building, the statues went missing. In 1978, they were found by Forest Preserve officials near Downers Grove. While no one has traced the movement of the statues, the preserve was the former estate of a prominent trader from the early 1900s. The statues are now a part of the plaza at the Board of Trade.

## PATRIOTISM AND FRATERNITY
### *by* ADOLPH ALEXANDER WEINMAN
BRONZE │ INSTALLED 1926 │
LAKE VIEW AVENUE AT DIVERSY PARKWAY

The Elks Memorial Building was built in 1926 to honor members of the Benevolent and Protective Order of Elks killed in World War I. Besides being a beautiful building, it has wonderful art and sculptures both inside and out. Two fourteen-foot-high sculptural groups, *Patriotism* and *Fraternity,* occupy niches of the administrative wings. *Patriotism* has a central figure of Columbia carrying a torch of liberty. *Fraternity* has a central figure representing nature. Both are protected by netting which covers the niches.

Weinman arrived in the U.S. from Germany at fourteen and lived in the New York area most of his life. He studied with Auguste Saint-Gaudens and Daniel Chester French.

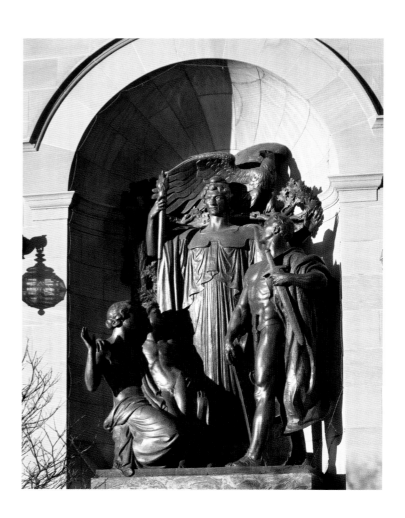

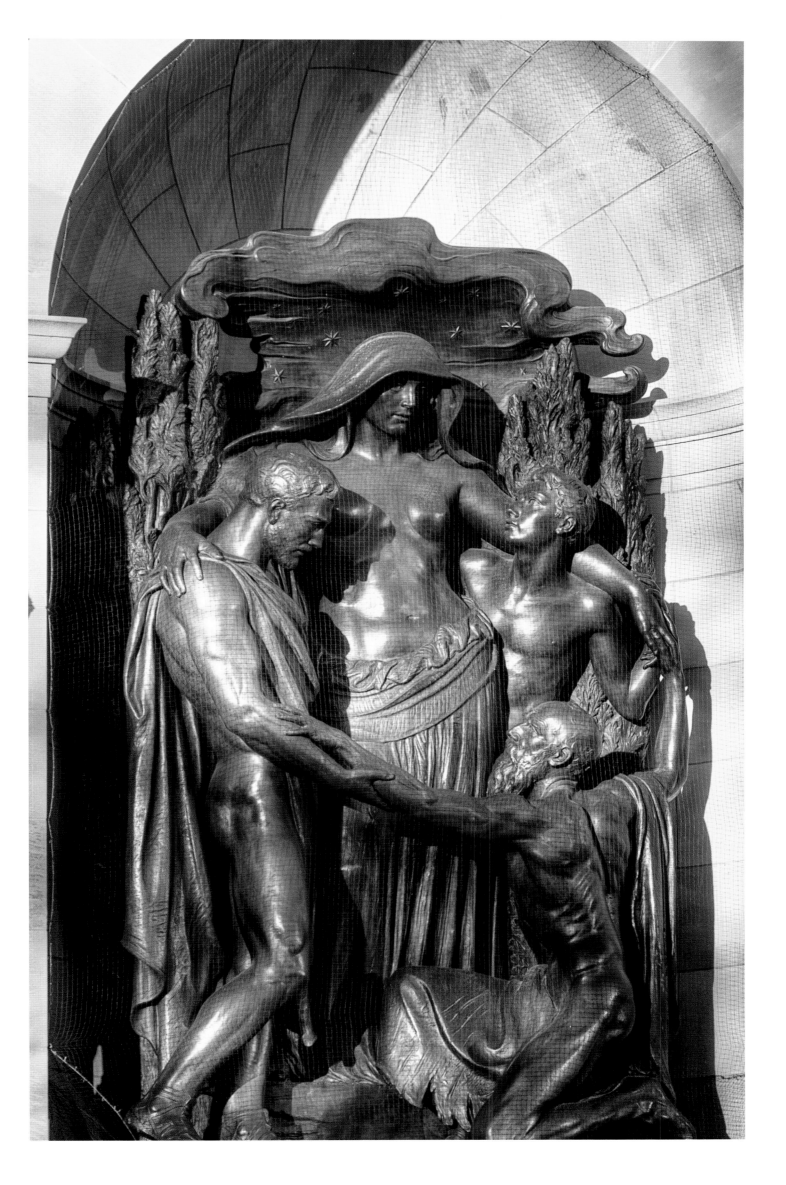

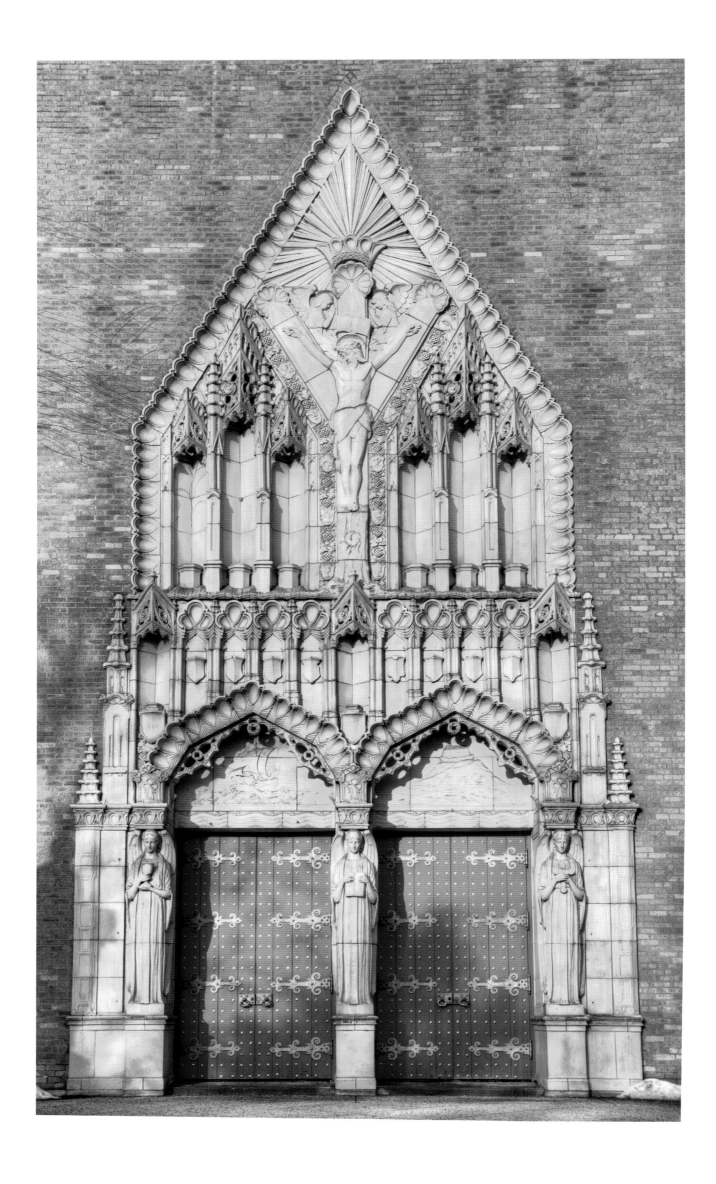

## ARCHBISHOP QUIGLEY
*by* **AN UNKNOWN SCULPTOR**

LIMESTONE

| INSTALLED 1917

| RUSH AND CHESTNUT STREETS

James Quigley (1854–1915) was a Canadian-born prelate of the Catholic Church and archbishop of Chicago from 1903 to 1915. In 1905, Archbishop Quigley established Cathedral College of the Sacred Heart, a preparatory high school seminary. In 1915, shortly before his death, he had plans to build a larger seminary. When the seminary was built, it was named in his honor.

## ST. THOMAS THE APOSTLE CHURCH FAÇADE *by* ALFONSO IANNELLI

TERRACOTTA | INSTALLED 1924 | 5472 SOUTH KIMBARK AVENUE

Architect Barry Byrne and sculptor Alfonso Iannelli collaborated closely in the design of this church, the first Catholic church in the United States to be built in a modern style. The entrance is particularly intricate in its design.

Iannelli emigrated to the United States from Italy. He studied with the Gutzon Borglum before moving to the Chicago area and working on many architectural projects. He also worked on various building façades for the 1933 Century of Progress International Exposition and designed the main entrance of the Immaculata High School building at 640 West Irving Park Road.

## THE SPIRIT OF PROGRESS (DIANA) *by* GEORGE E. MULLIGAN
BRONZE | INSTALLED 1929 | CHICAGO AVENUE AT CHICAGO RIVER

This sixteen-foot-tall *Spirit of Progress* was commissioned by Montgomery Ward and placed atop the company's office building, which was built in 1928. The sculpture is quite prominent on the Chicago skyline because of its height and unimpeded views of it, particularly from west Chicago Avenue. It is modeled after a sculpture of Diana by Auguste Saint-Gaudens that graced the Agriculture Building at the 1893 World's Columbian Exposition in Chicago.

George E. Mulligan (1891–1951) was a son of sculptor Charles Mulligan (1866–1916). He studied with and assisted his father. It is believed that he completed some of his father's unfinished work upon the elder Mulligan's death at the age of fifty.

## FAÇADE OF THE GOODMAN THEATER BUILDING

TERRACOTTA | CONSTRUCTED 1922 | DEARBORN AND LAKE STREETS

What is now the Goodman Theater building began in 1922 as home to the Harris and Selwyn Theaters, which were operated separately as live playhouses. Architects for the building were C. Howard Crane and H. Kenneth Franzheim. Both theaters were purchased by Michael Todd in the 1950s for use as movie theaters, the Harris becoming The Michael Todd Theater and the Selwyn becoming Michael Todd's Cinestage. In 2000, the two theaters were acquired and rebuilt to house the Goodman Theater complex. The exterior façade of the theaters was preserved and the terracotta sculptures on the exterior facing Dearborn Street remain intact.

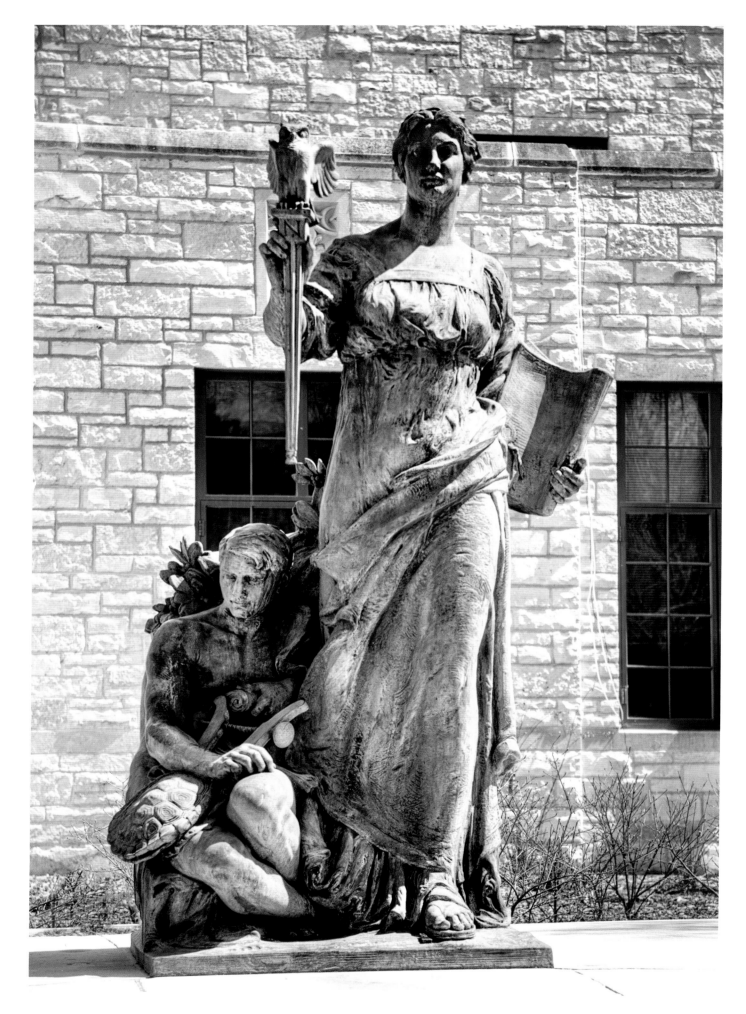

## THE ATHLETE AND THE SCHOLAR
*by* **HERMON ATKINS MACNEIL**
BRONZE | INSTALLED 1916 | SHERIDAN ROAD
AT LINCOLN AVENUE

These works stood outside a Northwestern University gymnasium opened in 1910. It was torn down in 1940 and replaced by a new gymnasium with the original doors from the old building and the two original sculptures.

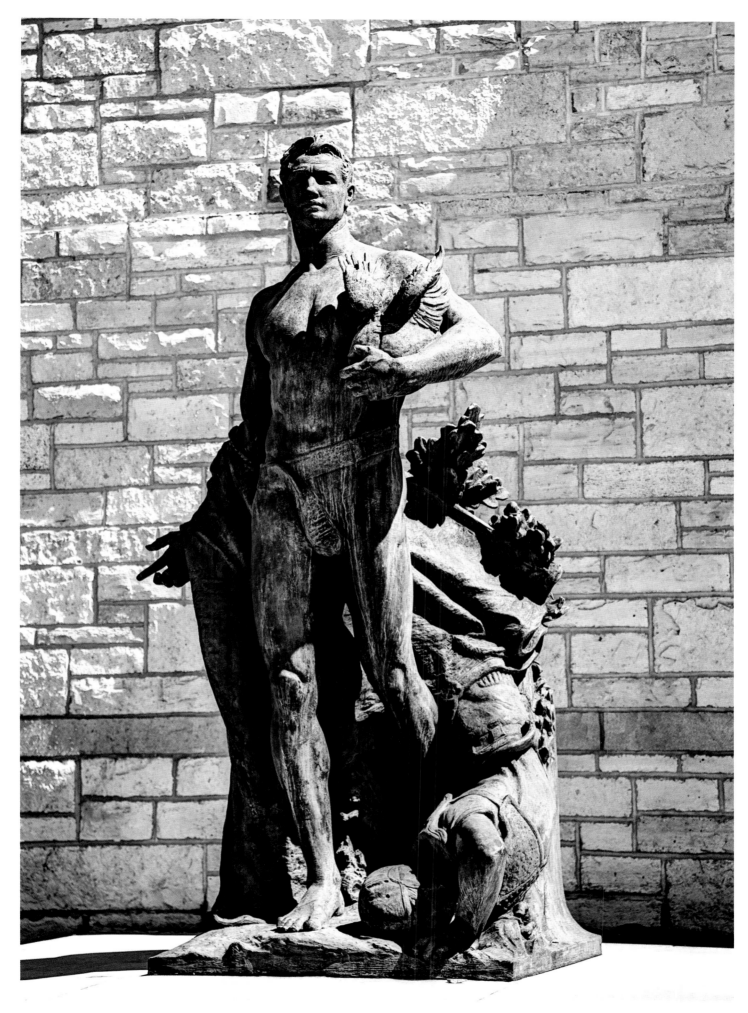

American Hermon Atkins MacNeil (1866–1947), assisted with architectural sculptures for the world's Columbian Exposition of 1893 in Chicago. During this time he worked with Lorado Taft and taught at the School of the Art Institute of Chicago. Many of his sculptures depict Native American themes; they appear in public spaces throughout the United States. He is also responsible for the Jacques Marquette Memorial in Chicago.

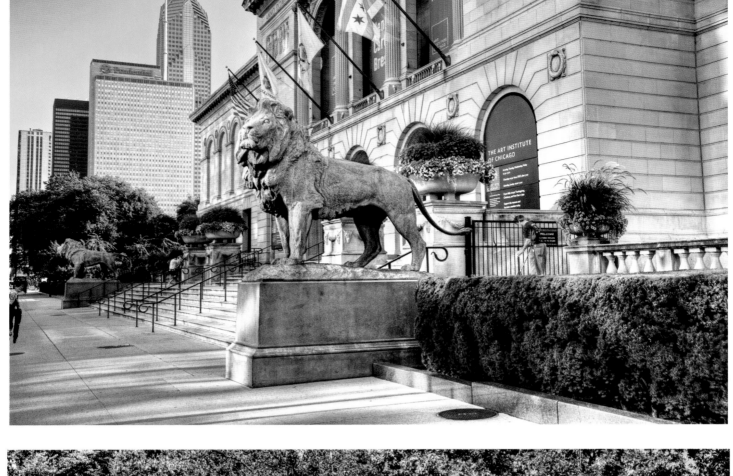

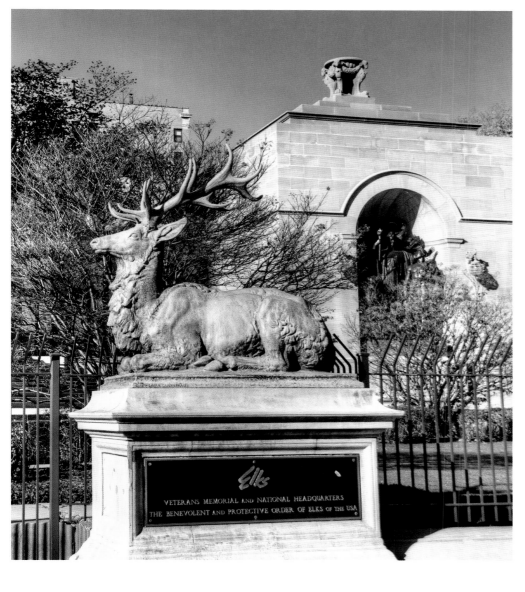

## RECLINING ELKS 3D
### *by* LAURA GARDIN FRASER

BRONZE | INSTALLED 1926 |
ELKS MEMORIAL BUILDING

Two lifesize elks flank the entrance steps to the Elks National Memorial Building.

Laura Fraser (1889–1966), wife of sculptor James Earle Fraser, was a Chicago native specializing in animal sculptures. She was best known for her commemorative medals which often featured animals. She also created *Air and Water,* featured in the reception room of the building.

## LIONS *by* EDWARD KEMEYS 3D
BRONZE | INSTALLED 1894 | ART INSTITUTE OF CHICAGO

In 1866 a group of artists formed the Chicago Academy of Design, which led to formation of the Art Institute of Chicago. When the World's Columbian Exposition in Chicago was in the planning stages, the Art Institute pushed for a permanent building to be constructed for the fair that could afterwards serve as an art museum. The building was erected. During the World's Fair Congress it hosted meetings and symposia related to the exposition and housed the World's Congress Auxiliary, which presented lectures and discussions about current issues of the day. Plaster models of the lions on display on the exposition grounds were cast in bronze later for the new museum. These two large male lions have guarded the entrance to the Art Institute building since it opened.

Native Georgian Edward Kemeys specialized in wild animals. His *Bisons* were also cast in bronze from plaster models created for the Columbian Exposition.

## BISONS *by* EDWARD KEMEYS
BRONZE | INSTALLED CA. 1915 | HUMBOLDT DRIVE AND DIVISION STREET

The two bronze bisons at Humboldt Park were reproduced from plaster models that Kemeys originally created for the grounds of the 1893 Columbian Exposition and cast in bronze after his death. They were first placed in Garfield Park (ca. 1911) and moved to Humboldt Park.

Kemeys (1843–1907), also sculptor of the Art Institute of Chicago lions, was self-taught. Many of his sculptures decorated the grounds of the 1893 Columbian Exposition. He spent several years in Chicago while working on these animal sculptures.

## C.D. PEACOCK JEWELERS CLOCK AND MARSHALL FIELD CLOCK

C.D. Peacock was one of the oldest and finest jewelry stores in Chicago. Its origin can be traced back to the mid-1800s. The company was liquidated in the 1990s. The peacock clock above the entrance to what was formerly its flagship store on State and Monroe Streets is still a distinguishable sight in downtown Chicago, even though the clock now has Kay (another jewelry store) imprinted on its face.

The Marshall Field and Company building, or Macy's at State Street, was the flagship location of the Marshall Field department store chain. The building is known for its atria and two clocks, each weighing over 10,000 pounds. The southwest clock (State and Washington streets) shown here was installed in 1897.

## FATHER TIME CLOCK AT THE JEWELERS' BUILDING

When the forty-story Jewelers' Building at 35 East Wacker Drive was completed in 1926 it was considered one of the tallest buildings outside of New York City. Its clock, topped by a five-foot-high statue of Father Time, was the symbol for the Elgin Watch Co., which had offices in the building. Each of the four dials has a bezel with fifty-six red lights surrounding the dials.

# IDEAS GIVEN FORM

## GHOST BIKES

Ghost bikes have become somber memorials for cyclists killed while riding their bikes on the street. A bicycle is painted all white and locked to a street sign near the crash site. Often a photo of the cyclist is attached to the bike with other decorations.

This form of memorial has become familiar over all the world. Remembered in Chicago are Jaqueline, age twenty-five; Bobby Cann, age twenty-six; and Clinton Miceli, age twenty-three.

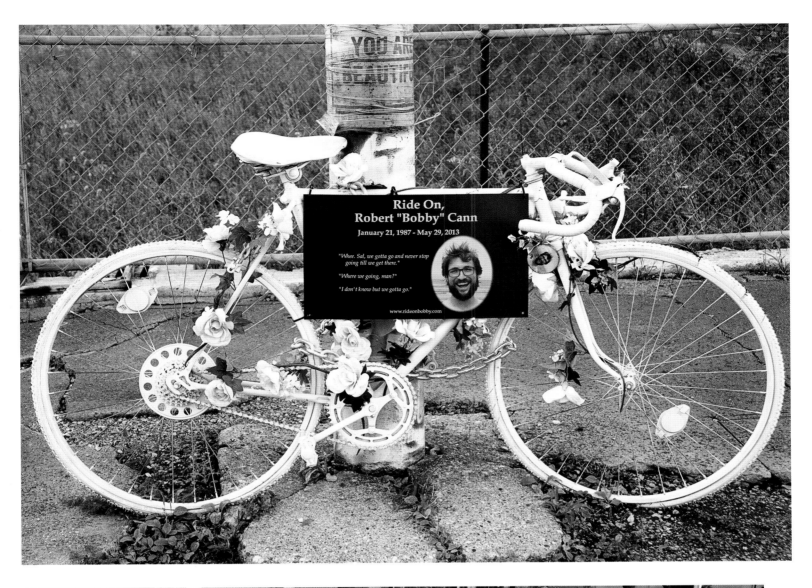

Ride On,
Robert "Bobby" Cann
January 21, 1987 - May 29, 2013

*"Whee. Sal, we gotta go and never stop
going till we get there."*

*"Where we going, man?"*

*"I don't know but we gotta go."*

www.rideonbobby.com

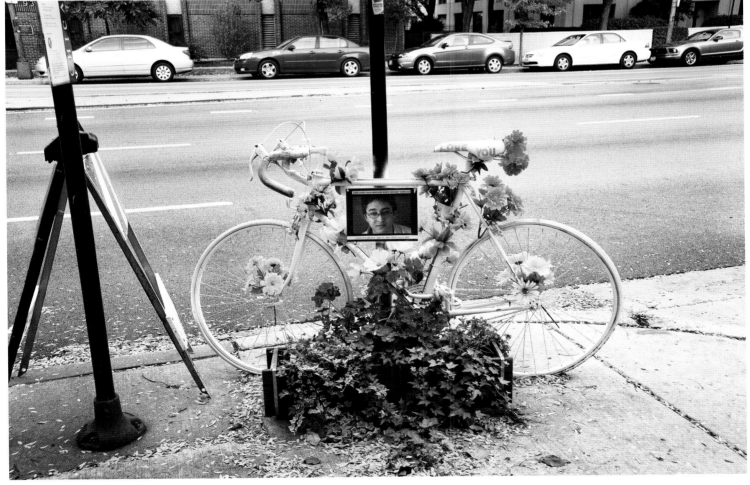

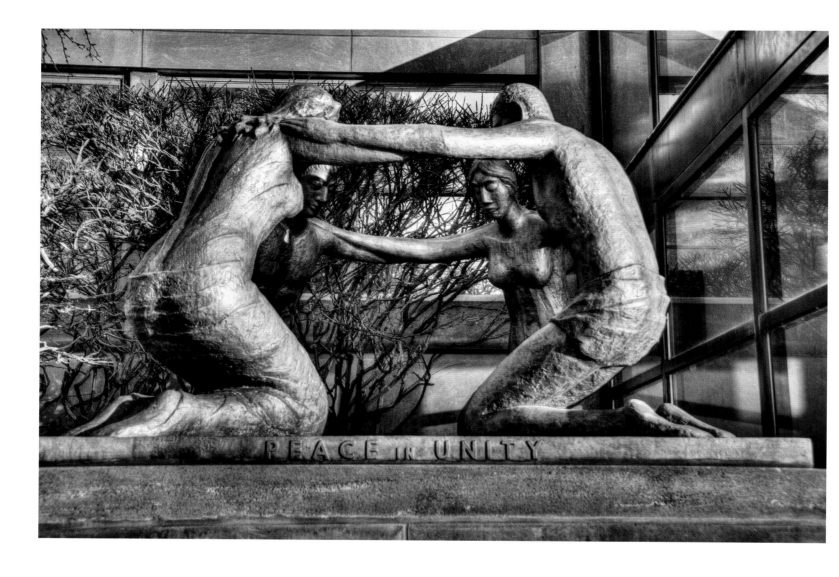

## BROTHERHOOD *by* EGON WEINER

BRONZE | INSTALLED 1954 | DIVERSEY PARKWAY AND SHERIDAN ROAD

Two identical groups of four bronze figures flanked the entrance to what was originally the Amalgamated Meat Cutters and Butcher Workmen building. The building later became St. Joseph Hospital's medical offices and is now the Stone Medical Office Building. The sculpture represents the unity of peoples from Europe, Asia, Africa, and North America.

Egon Weiner (1906–19878) fled Austria in 1938 to escape Nazi persecution. He was a professor at the School of the Art Institute of Chicago from 1945 to 1971. *Pillar of Fire* is another of his Chicago sculptures.

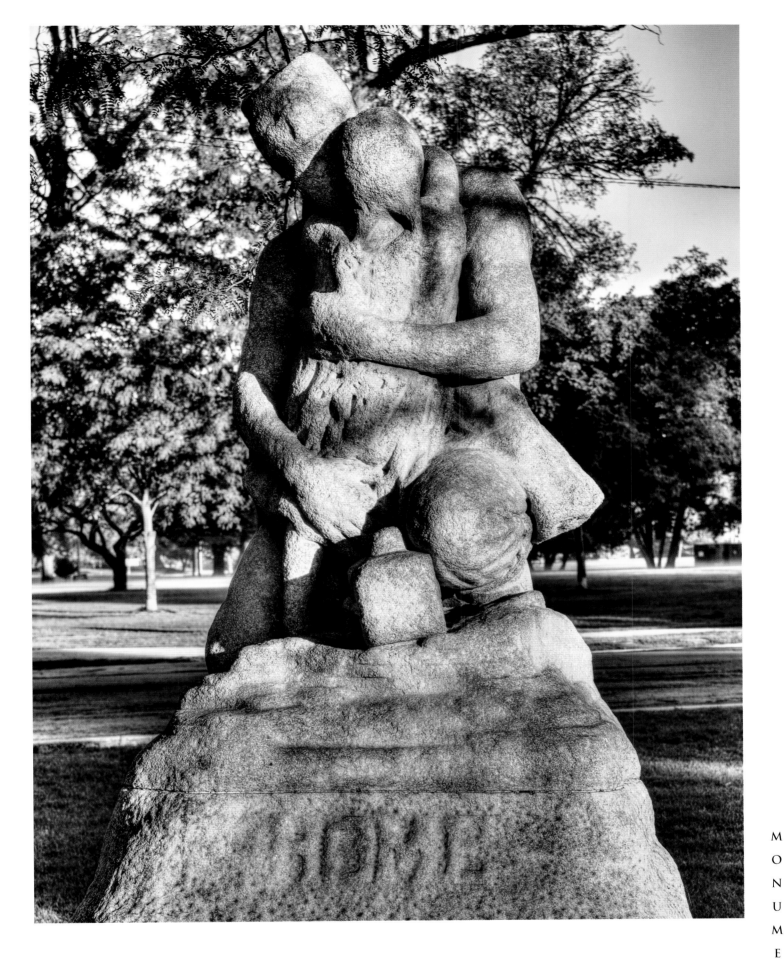

## THE MINER AND CHILD (HOME) *by* CHARLES J. MULLIGAN

LIMESTONE | INSTALLED 1911 | HUMBOLDT PARK, DIVISION AND CALIFORNIA AVENUE

Mulligan studied at the School of the Art Institute of Chicago with Lorado Taft. During the 1893 Columbian Exposition in Chicago, Taft made Mulligan the foreman of the workshop producing sculpture for the exposition.

Other Chicago sculptures by Mulligan (1866–1916) include the Fourth of July Fountain, *Lincoln the Orator,* *Lincoln the Rail Splitter,* and *William McKinley.*

## MONUMENT TO THE GREAT NORTHERN MIGRATION

*by* **ALISON SAAR**

BRONZE | INSTALLED 1996 | KING DRIVE AT 26TH STREET

This monument symbolizes the journey of African Americans who migrated to Chicago and other points north following the Civil War. The statue depicts a man wearing a suit made of shoe soles rising from a mound of soles. The soles suggest a long and difficult journey. Metal bollards surrounding the monument take the form of suitcases and are textured with a pattern reminiscent of the tin ceilings of the early 20th century.

Alison Saar (b. 1956) is an African American artist living in Los Angeles who often works with the themes of African spirituality and cultural diaspora. She has many installations in the United States and her work has been exhibited internationally.

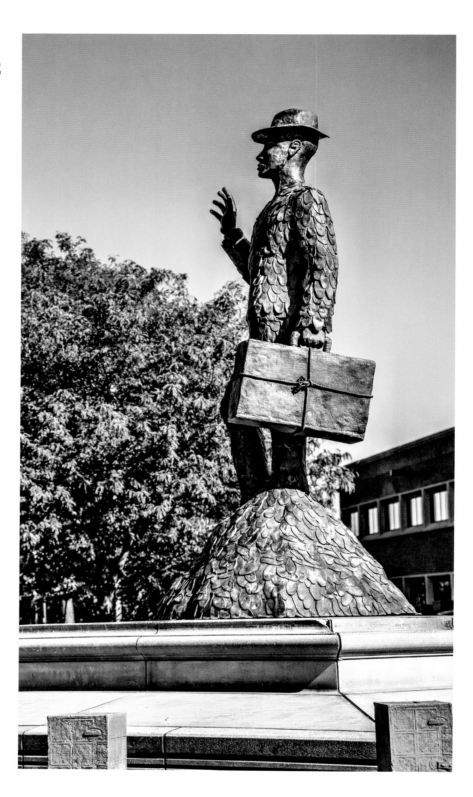

## HOPE AND HELP *by* EDOUARD CHASSAING

LIMESTONE | INSTALLED 1955 | 1515 NORTH LAKE SHORE DRIVE

This figure in surgical apparel offering hope and help is a fitting monument for the entrance to the Museum of the International College of Surgeons.

Chassaing (1895–1974) came to Chicago from France in 1928. He supervised the sculptural program funded by the Federal Art Project of the Works Progress Administration (WPA). He joined the faculty of the School of the Art Institute in 1941. Other stone sculptures by Chassaing reside at the University of Illinois Medical Center.

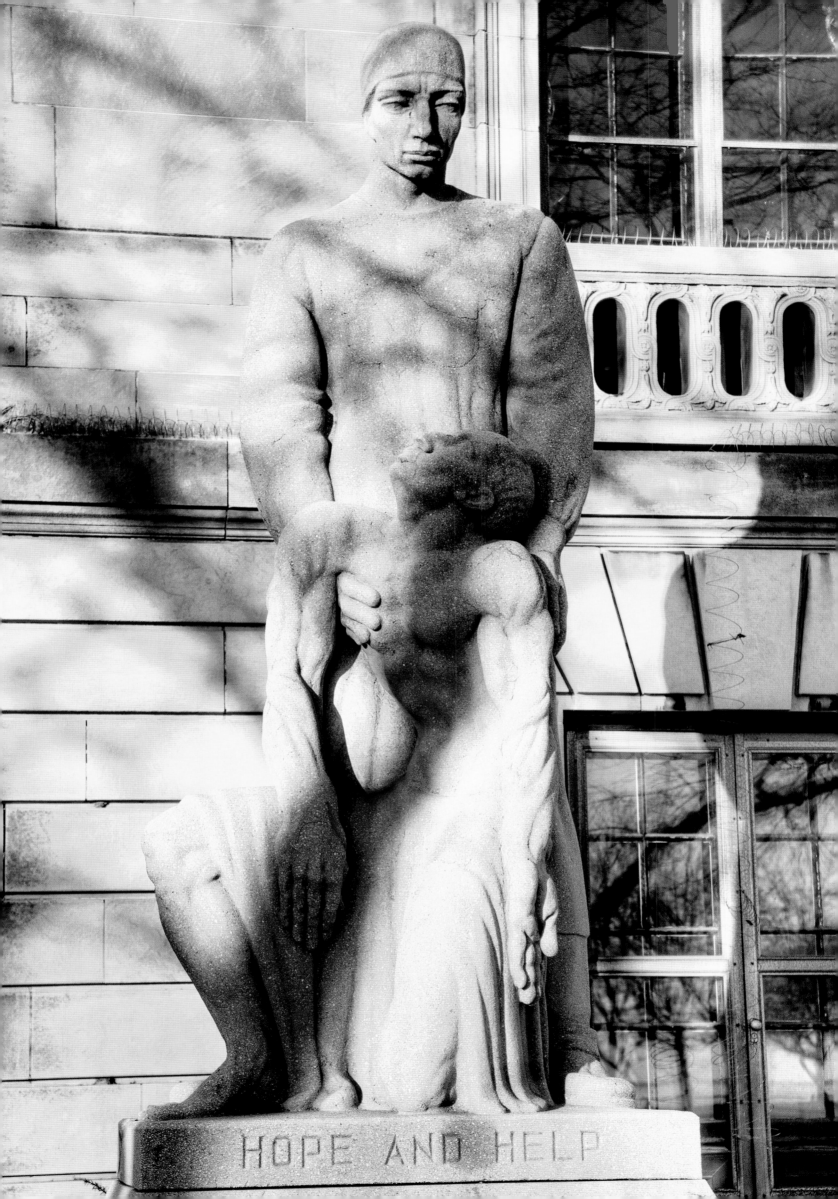

HOPE AND HELP

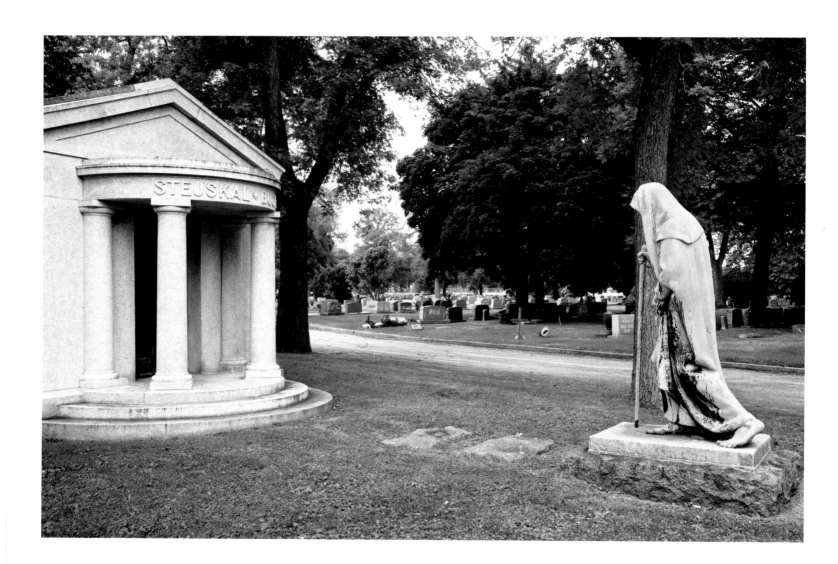

## THE PILGRIM AND THE MOTHER *by* ALBIN POLASEK

BRONZE │ THE PILGRIM NSTALLED 1929; THE MOTHER INSTALLED 1927

│ BOHEMIAN NATIONAL CEMETERY

Two works in the Bohemian National Cemetery are commissions executed by Albin Polasek (1879–1965). Polasek headed the sculpture department of the School of the Art Institute of Chicago from 1916 to 1946. He produced many public sculptures in both the Czech Republic and the U.S. In Chicago he was responsible for the Masaryk Memorial, Theodore Thomas Memorial (*Spirit of Music*), and Gotthold Lessing Memorial.

*The Pilgrim* was commissioned by the Stesjkal-Buchals for placement with their family mausoleum. Mr. Stesjkal was the founder of a Chicago bank. *The Mother* was commissioned by the Bohemian National Cemetery and erected in 1927 on the occasion of its fiftieth anniversary.

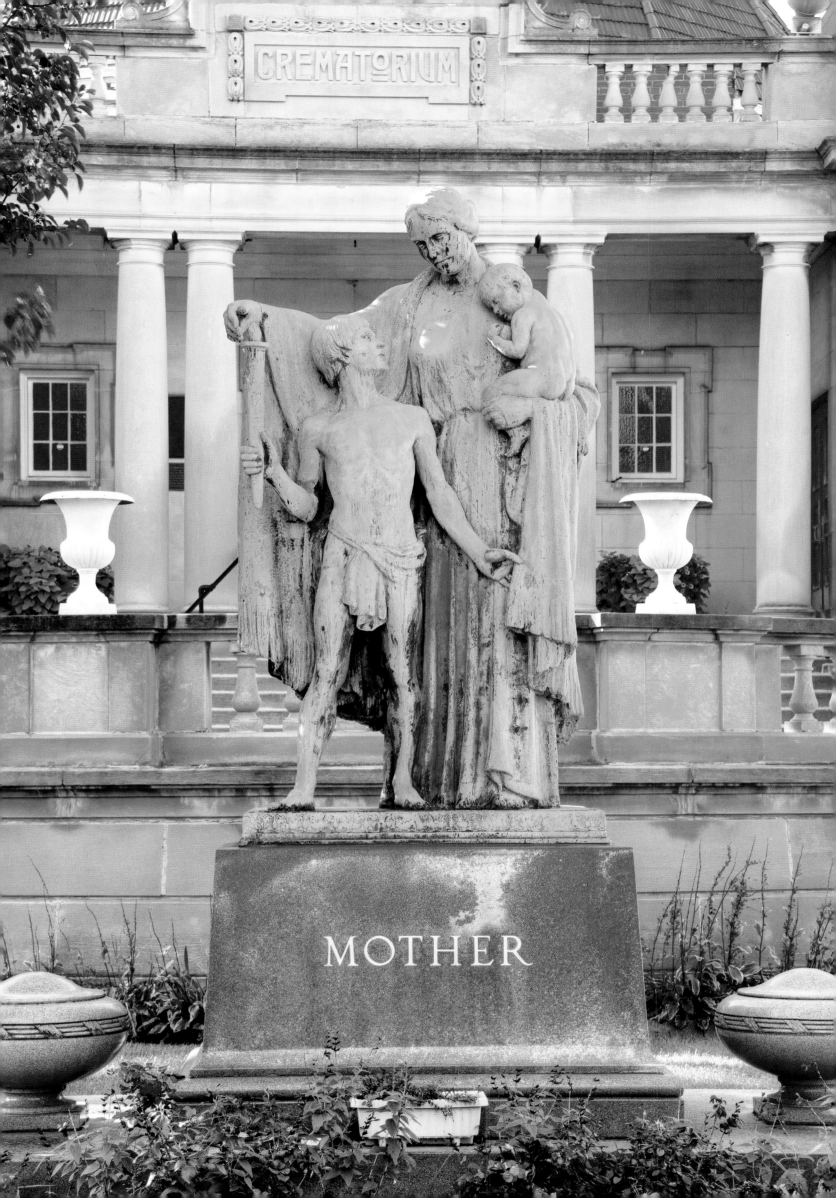

CREMATORIUM

MOTHER

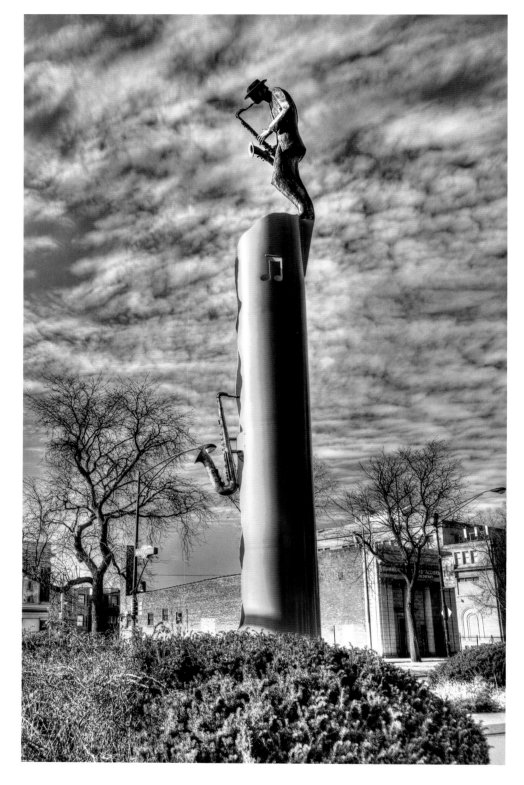

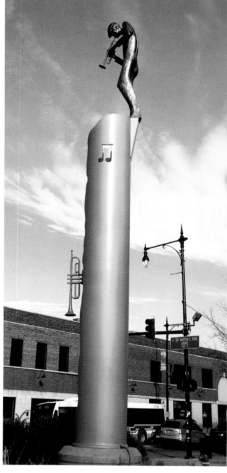

## CHICAGO BLUES DISTRICT *by* ED DWIGHT

BRONZE | INSTALLED 2004 | 47TH STREET AND KING DRIVE

Commissioned by the city of Chicago, this project was established by Mayor Richard Daley. The intent was to bring to life the jazz and blues era of the 1940s in Chicago. Dwight worked together with an architectural firm to redesign six blocks along King Drive beginning at 47th Street, adding decorated light poles and streetscapes. The entry point includes four twenty-seven-foot jazz towers with sculpted musicians atop them.

Ed Dwight (b. 1933) was commissioned by the Colorado Centennial Commission to create a series of bronzes depicting the contribution of African Americans to the opening of the west. His work often features notable African Americans (such as his other Chicago work, a sculpture of Harold Washington) and the development of American jazz.

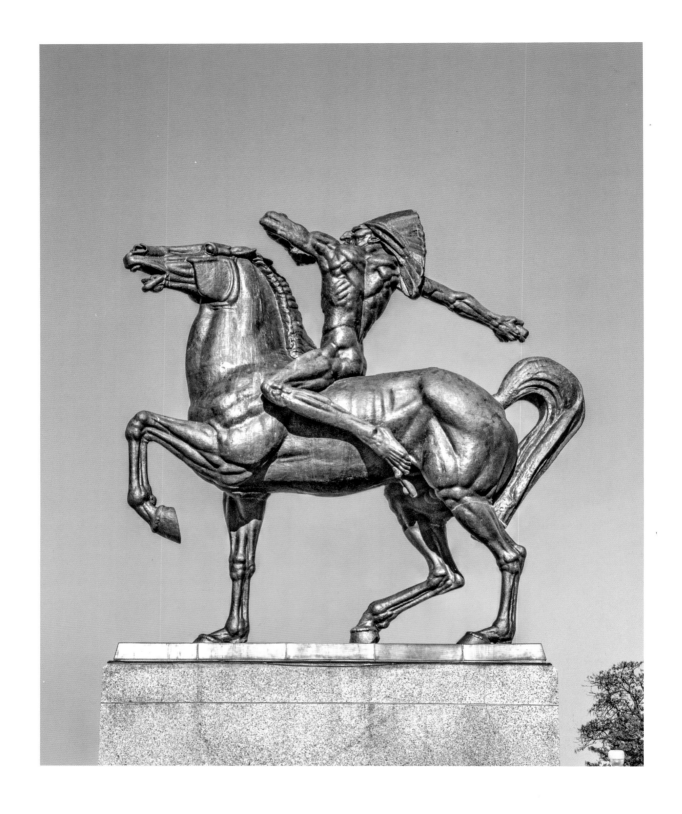

## THE BOWMAN AND THE SPEARMAN *by* IVAN MESTROVIC
### BRONZE | INSTALLED 1928 | MICHIGAN AVENUE AT CONGRESS PARKWAY

These twin statues provide a dramatic frame for viewing Buckingham Fountain from Michigan Avenue. An imaginary spear for *Spearman* and bow for *Bowman* add to the creativity of these two highly stylized sculptures honoring Native Americans.

Mestrovic (1883–1962) was born in Croatia and lived much of his life in Europe. He came to Chicago in 1926 as a result of an exhibition of his work at the School of the Art Institute of Chicago. He designed these figures during his stay; they were later cast in bronze in Yugoslavia. He moved to the United States after World War II and became a U.S. citizen in 1954.

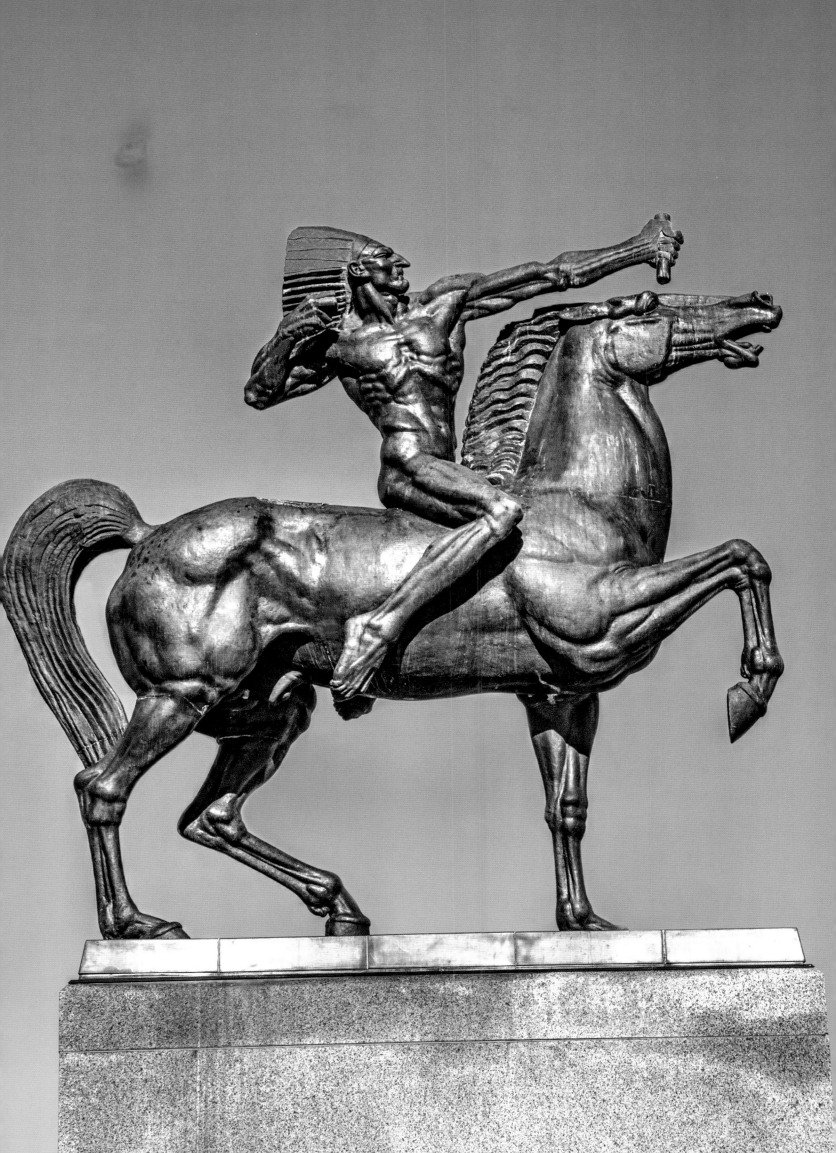

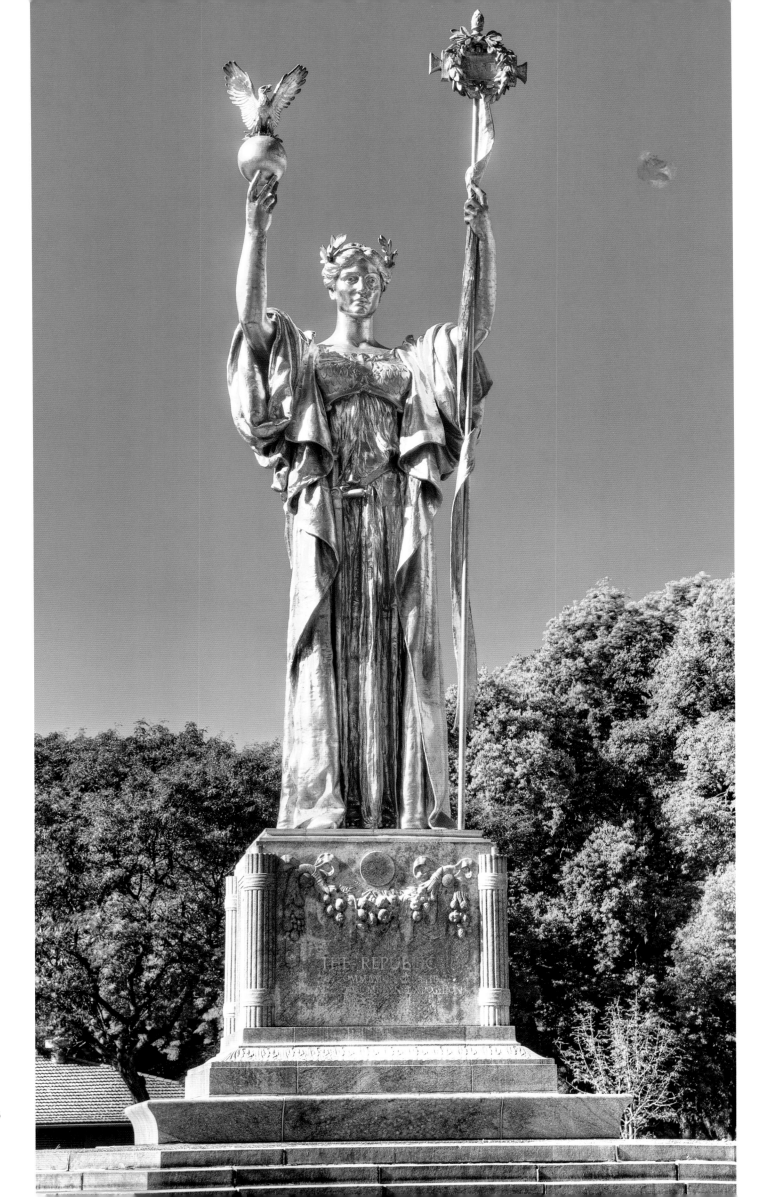

# THE REPUBLIC *by* DANIEL CHESTER FRENCH

### GILDED BRONZE | INSTALLED 1918 | JACKSON PARK

Chicago won a worldwide competition to host the 1893 World's Columbian Exposition, designed to celebrate the 400th anniversary of Christopher Columbus's arrival in what would become America. It was an amazing accomplishment for a city that had almost burned to the ground in 1871. The fairgrounds extended from Cottage Grove Avenue to Lake Michigan and from 56th Street to 67th Street and included what is now Jackson Park, Washington Park, and the Midway Plaisance. Daniel H. Burnham presided over architectural planning and Augustus Saint-Gaudens over sculptural selections. Many of America's leading architects and sculptors participated. It was Burnham's decision to paint almost all the exposition buildings white, in part to create reflective surfaces for colored electric lights at night—thus the name "The White City." The exposition opened May 1, 1893 and was scheduled to close October 1893 but because of the assassination of Chicago mayor Carter Harrison, Sr. it closed quietly a few days later with flags at halfmast.

Few of the fair buildings survived past 1893 as their construction was temporary in nature and a fire consumed many of them. The Palace of Fine Arts did survive and initially housed the Field Museum of Natural History. The building was reconstructed as the Chicago Museum of Science and Industry. One of the most impressive statues at the fair was French's *The Republic,* sixty-five feet tall, but it too was fabricated of staff and consumed by fire. The gilded bronze facsimile in Jackson Park was based on the original using a twelve-foot plaster model that did survive. It stands twenty-four feet tall on the site of the fair's administration building. Its installation celebrated the 25th anniversary of the fair and the Centennial of Illinois statehood.

Daniel Chester French (1850–1931), one of the most prolific and acclaimed of American sculptors of the late 19th and early 20th centuries, is best known for his Lincoln in the Lincoln Memorial, Washington, D.C., 1920. His sculpture *Memory is* at Graceland Cemetery.

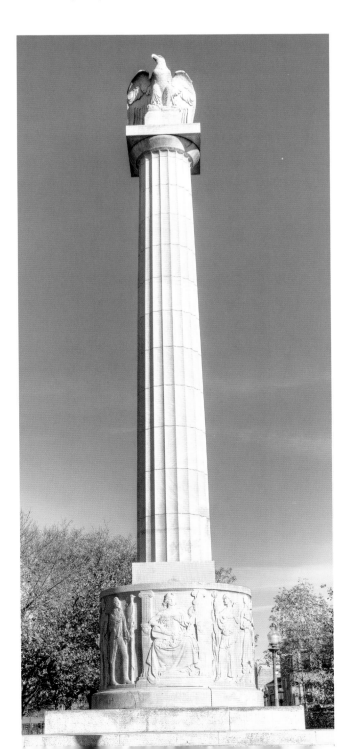

# ILLINOIS CENTENNIAL MEMORIAL COLUMN
## *by* HENRY BACON
## *and* EVELYN BEATRICE LONGMAN
### MARBLE | INSTALLED 1918 | LOGAN SQUARE

This monument was designed to commemorate the 100th anniversary of Illinois statehood. A single Doric column seventy feet tall was designed by Henry Bacon (1866–1924) and topped with an eagle sculpted by Evelyn Beatrice Longman (1874–1954) in reference to the flag of Illinois. On the base are reliefs depicting Native Americans, explorers, farmers, and laborers, also sculpted by Longman.

Henry Bacon is famous for designing the Lincoln Memorial in Washington, D.C. Other Chicacgo works by Bacon are the Marshall Field monument at Graceland Cemetery and the pedestal for *Statue of the Republic.*

Evelyn Beatrice Longman attended classes at the School of the Art Institute of Chicago taught by Lorado Taft and later worked in the studio of Daniel Chester French.

## CHICAGO RISING FROM THE LAKE
### *by* MILTON HORN
BRONZE | INSTALLED 1954 |
COLUMBUS DRIVE BRIDGE

Weighing more than three tons, this sculpture is twelve by fourteen feet. Chicago is represented by a female figure rising from a lake, which is symbolized by waves at the bottom of the sculpture. The sheaf of wheat and bull represent the role of Chicago as a grain trading center and its past role as a meat provider with its large stockyards. It was originally installed at 11 West Wacker Drive.

The prolific Russian-born sculptor Milton Horn (1906–1995) emigrated to the United States with his parents in 1913 and maintained a studio in Chicago. *Temple Har Zion, Hymn to Water, the Spirit of Jewish Philanthropy,* and *Merchandise Mart Hall of Fame* are among his other works.

C
H
I
C
A
G
O

## CONTENTS

CHICAGO

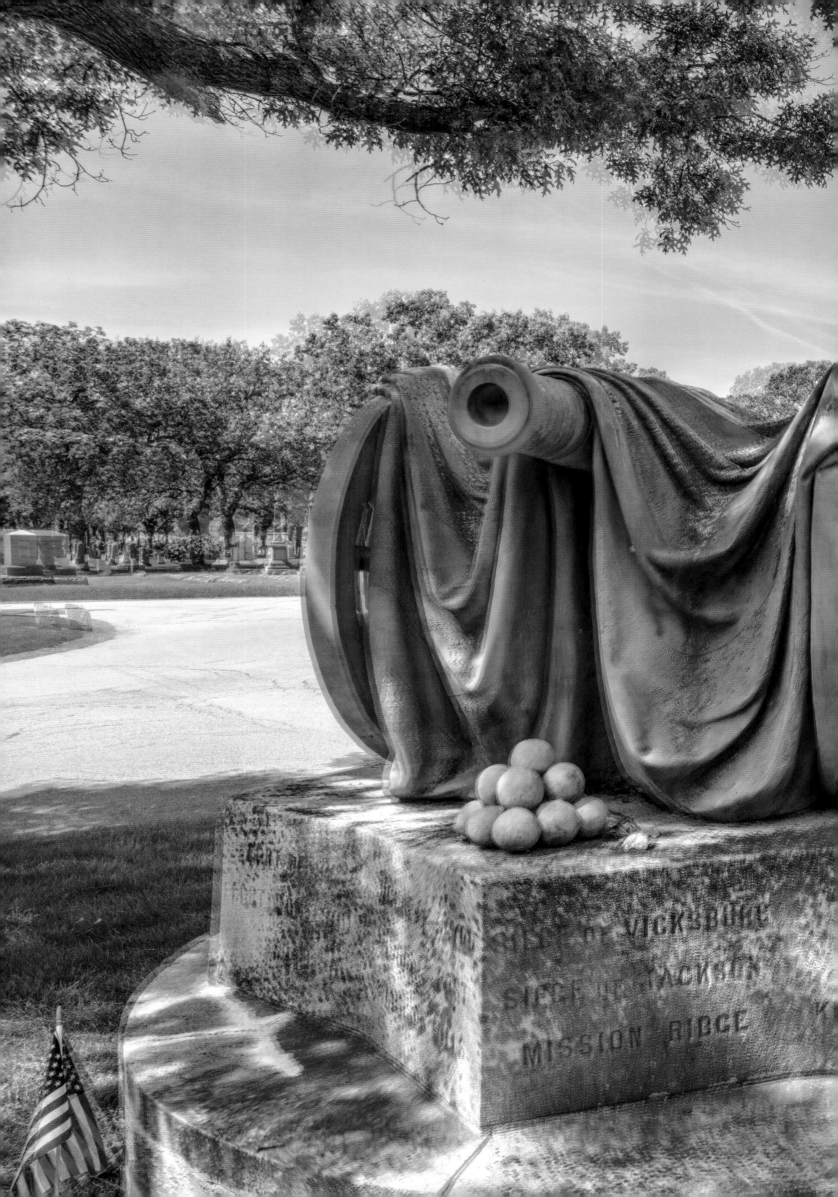

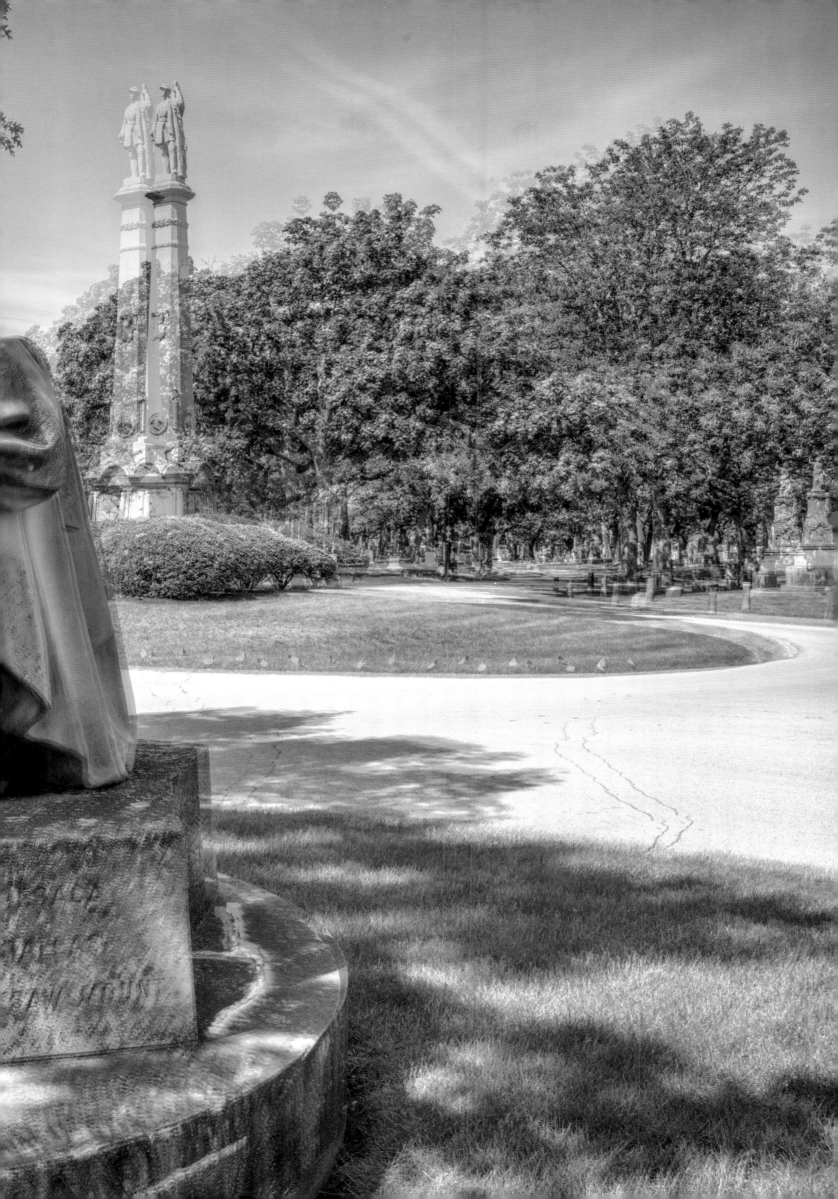

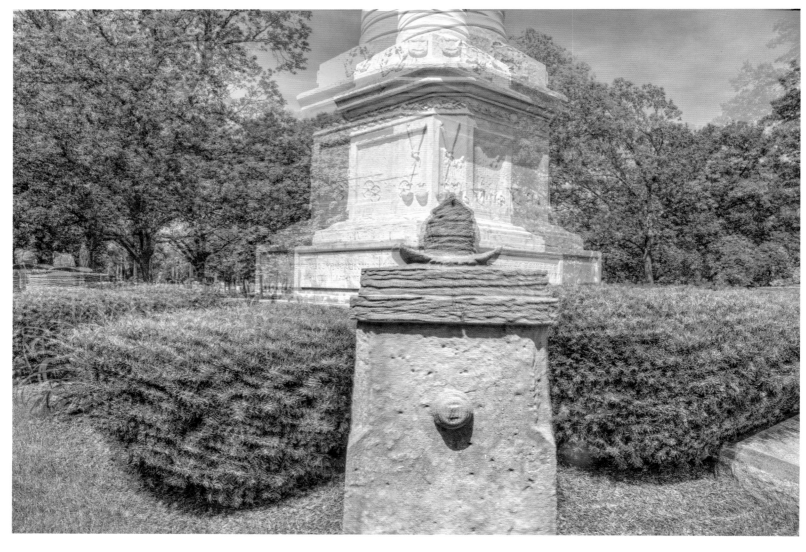

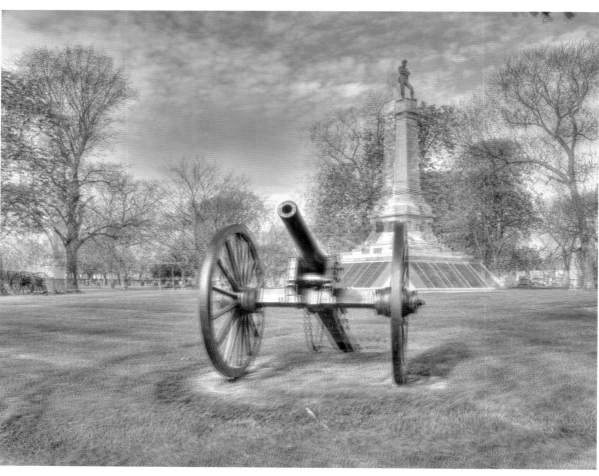

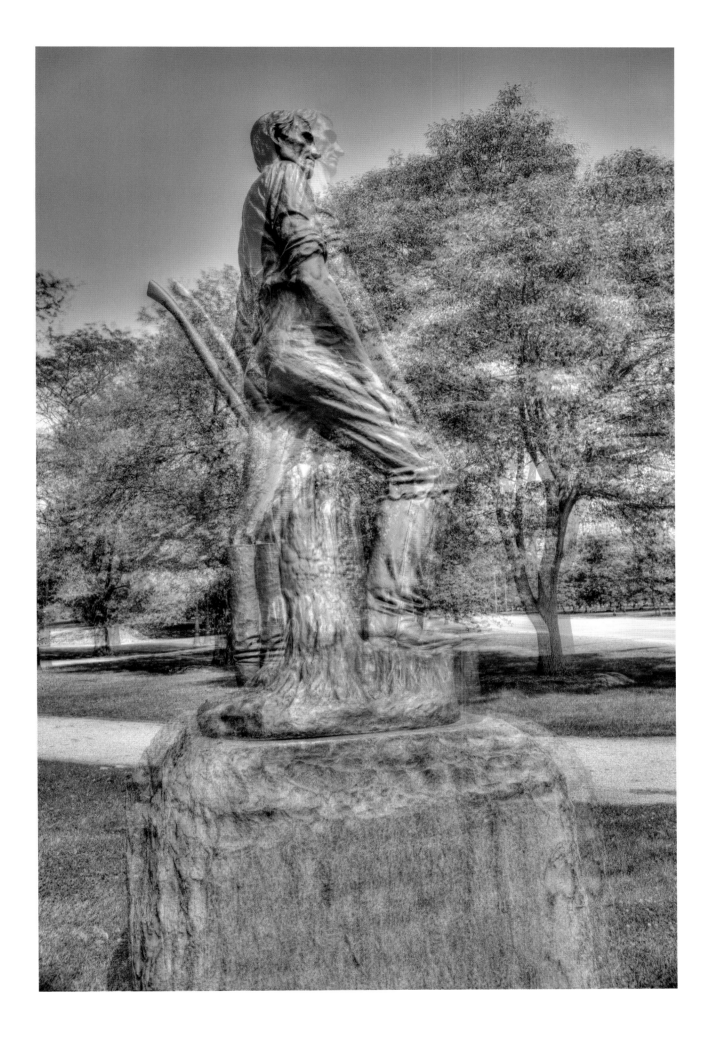

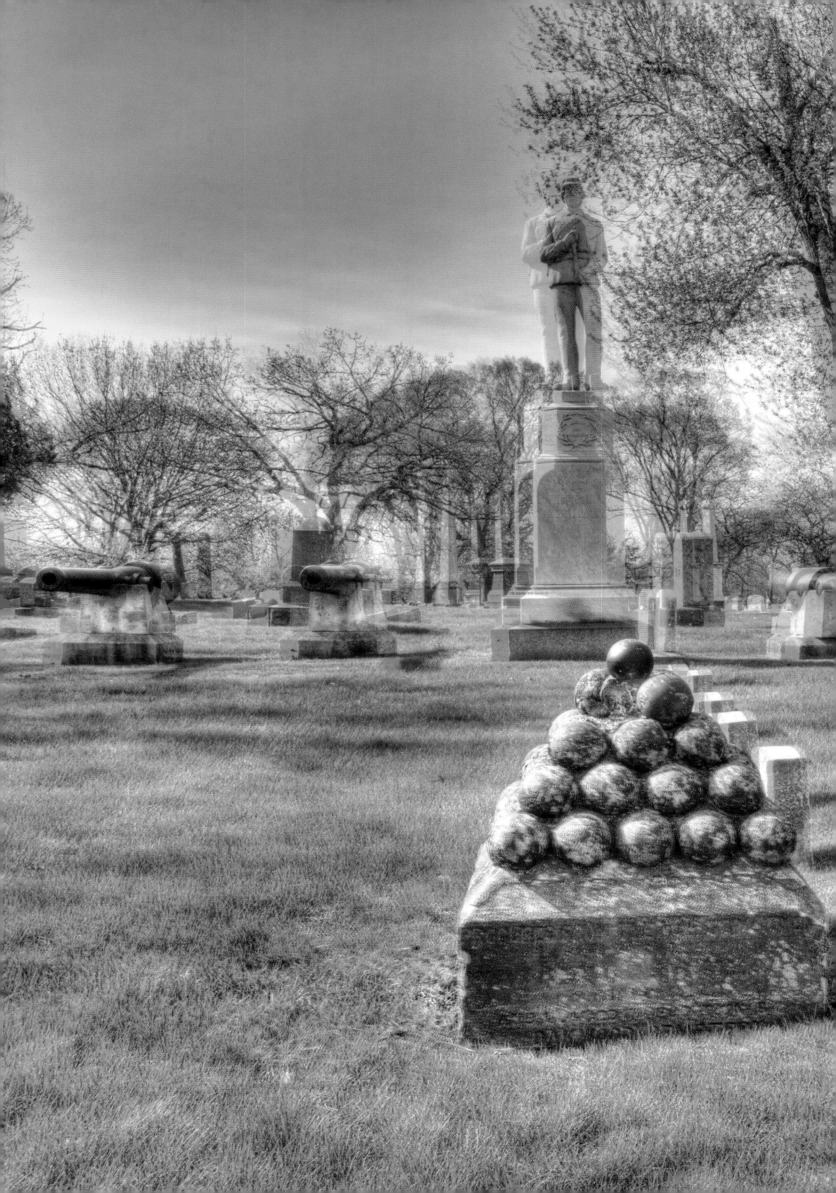

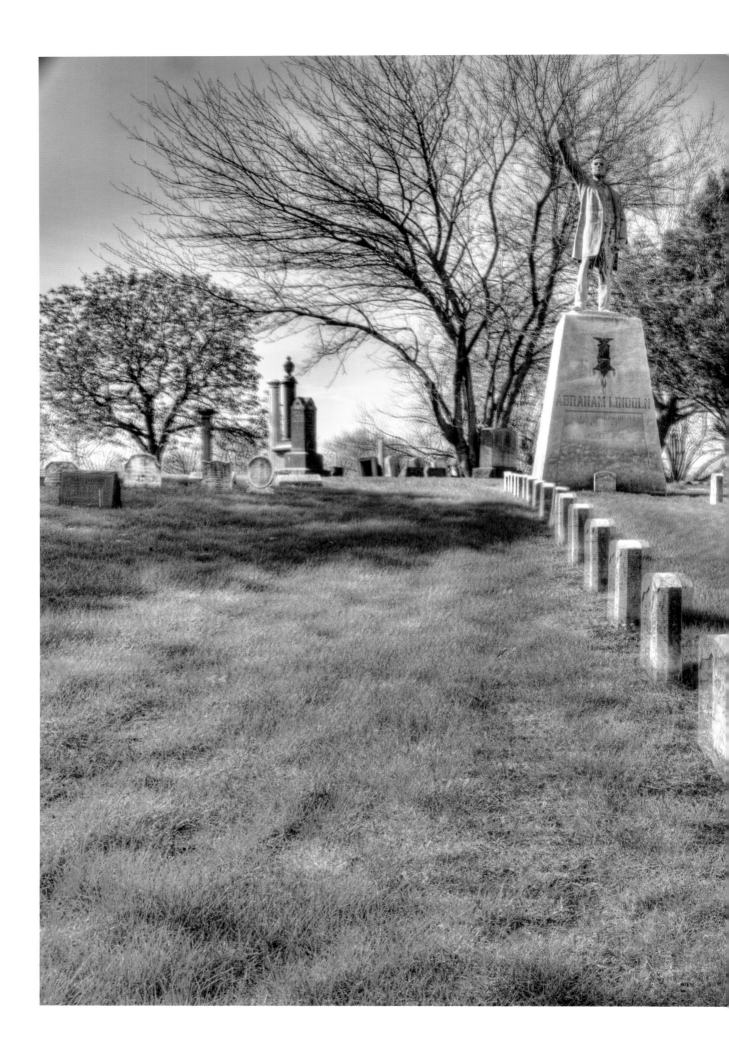

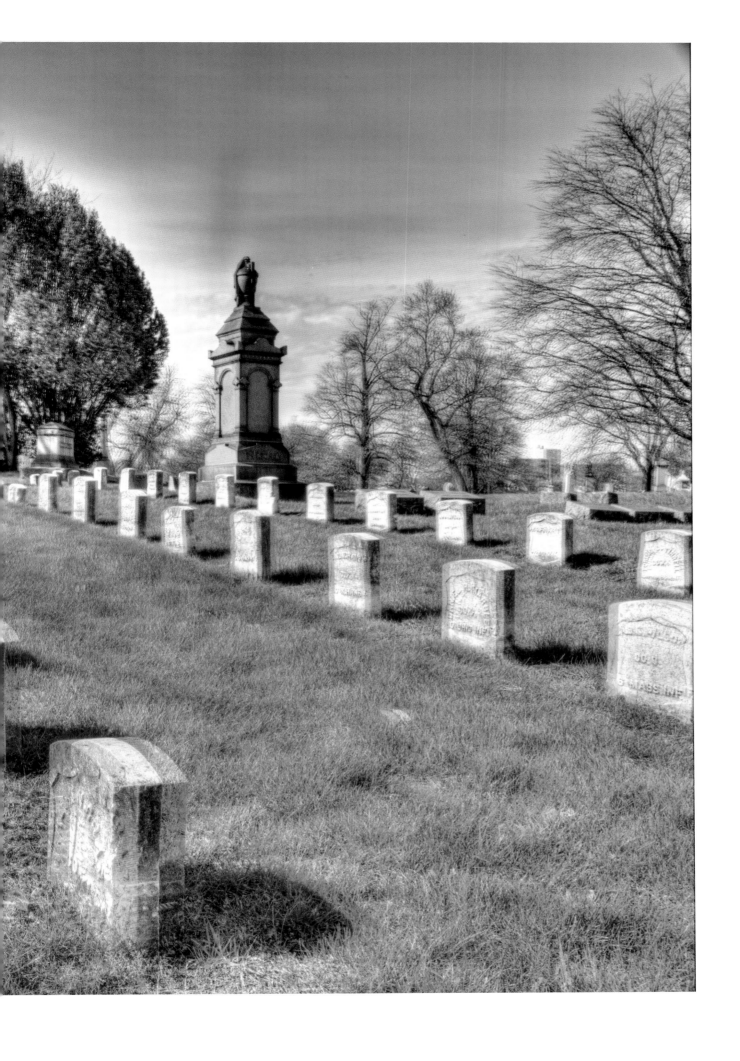

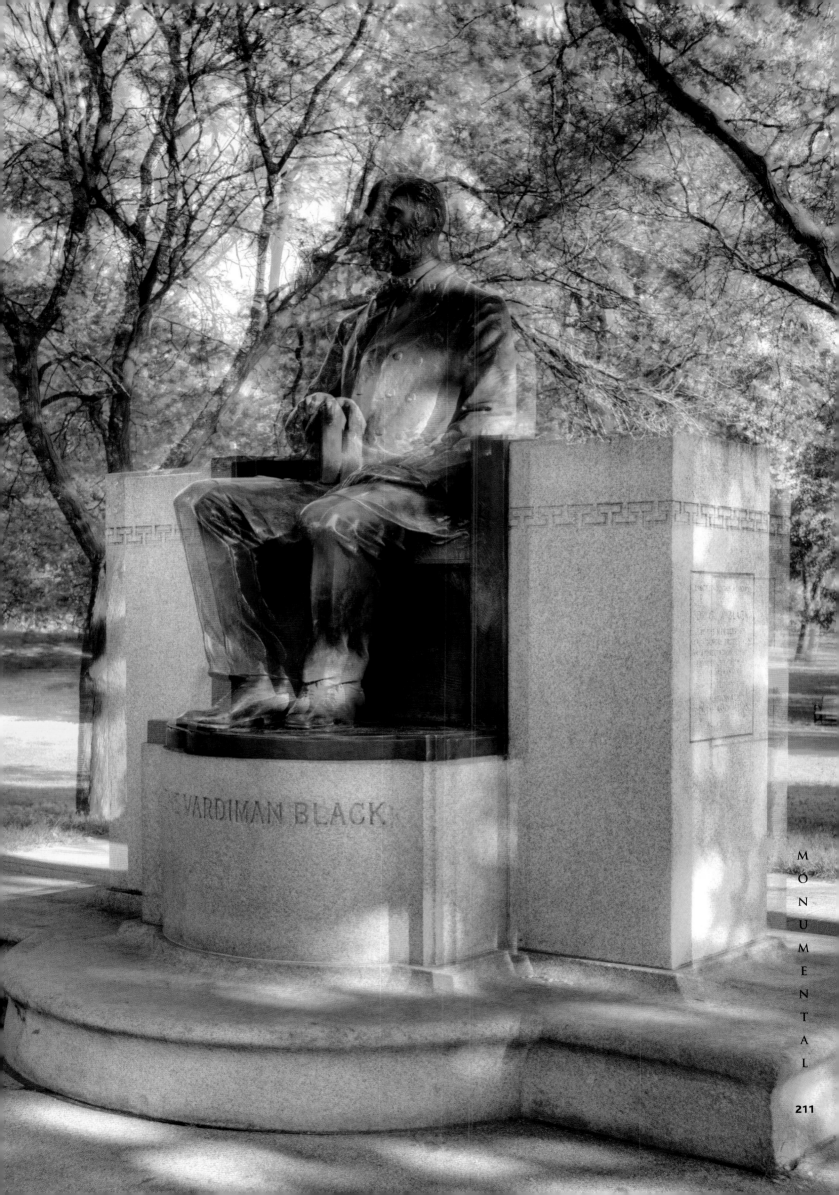

VARDIMAN BLACK.

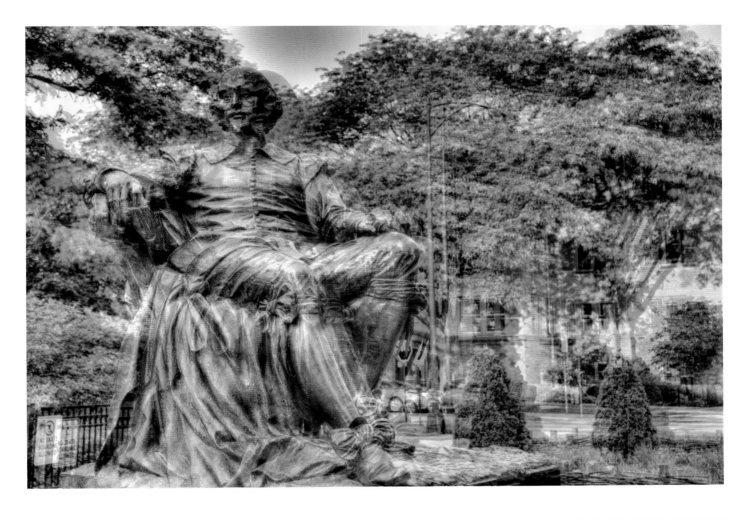

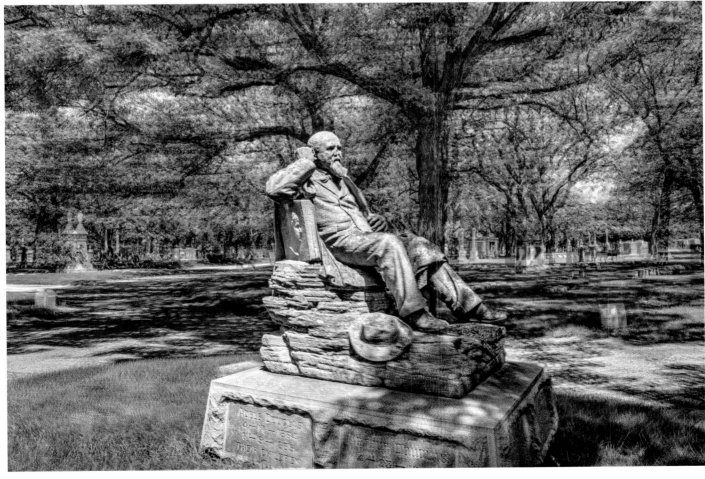

# ACKNOWLEDGMENTS

*Many thanks to my wife* **SUSANNE**, for helping me evaluate the quality of my images and for putting up with my many absences when on photo shooting missions, researching, and text writing.

**TIM SAMUELSON**, Cultural Historian, City of Chicago, who provided valuable information on the Lincoln bust,

**RUSSELL LEWIS**, Executive Vice President and Chief Historian, Chicago History Museum, who was willing to review all our text to assure its historical accuracy, thus making a very significant contribution,

**THOMAS CONNORS**, journalist and writer, who applied his skills wherever needed,

**JOHN RABIAS**, Photoshop expert and an instructor at the School of the Art Institute in Chicago, who reviewed and modified images without altering their integrity, often by removing unwanted light poles and hanging electric wires,

**JEN FREEHILL** of Photocraft in Boulder, Colorado, who did a magnificent job of final image touch-up,

and **CAROL HARALSON** of Sedona, Arizona, award-winning book designer and text editor, who made great sense of hundreds of monument images and many pages of material and created from them a beautiful book.

Books consulted: *A Guide to Chicago's Public Sculpture.* Ira J. Bach and Mary Lackritz Gray (The University of Chicago Press, 1983); *Chicago Sculpture.* James L. Reidy (University of Illinois Press, 1981); *Monumental Chicago.* Donald G.Krehl, 2011; *Chicago's Monuments, Markers, and Memorials;* John Graf and Steve Skorpad (Arcadia Publishing, 2002); *Chicago Figural Sculpture, A Chronological Portrait 1871-1923.* Gregory H. Jenkins, 2009.

**LESLEY WALLERSTEIN,** intellectual property attorney *extraordinaire,* reviewed the images and text and filed for all necessary permissions. Cited also with the reprinted materials, they are:
**Page 5:** "Chicago," from CHICAGO POEMS by Carl Sandburg. (Copyright 1916 by Houghton Mifflin Harcourt Publishing Company and renewed 1944 by Carl Sandburg. Reprinted by permission of Houghton Mifflin Harcourt Publishing Company. All rights reserved;
**Page 84:** The "I have a Dream Speech," reprinted by arrangement with The Heirs to the Estate of Martin Luther King Jr., c/o Writers House as agent for the proprietor New York, NY); **Page 137:** "The Eastland" from BILLY SUNDAY AND OTHER POEMS by Carl Sandburg. Copyright © 1993 by Maurice C. Greenbaum and Frank M. Parker as Trustees of the Carl Sandburg Family Trust. Reprinted by permission of Houghton Mifflin Harcourt Publishing Company. All rights reserved; **Page 180:** The Art Institute of Chicago Lions: Edward Kemeys, American, 1843-1907, Lions (a pair), 1893, bronze with green patina, 261.7 x 114.2 x 287 cm (103 x 45 x 113 in.), Gift of Mrs. Henry Field, 1893. 1a-b, The Art Institute of Chicago. The lion sculptures at Museum's Michigan Avenue entrance, accession #1893.1a-b (the "Lions"), are registered trademarks of the Art Institute of Chicago.

Author proceeds from sale of *Chicago Unleashed* will be donated to two Chicago-based not-for-profit service agencies:

**Chicago Lighthouse,** which is committed to providing the highest quality educational, clinical, vocational, and rehabilitation services for children, youth, and adults who are blind or visually impaired, including deaf-blind and multi-disabled. For over 100 years, the Lighthouse has been a national trendsetter in offering far-reaching programs that have opened the doors of opportunity for people who are blind or visually impaired.

**Access Living,** established in 1980 as a change agent committed to fostering an inclusive society that enables Chicagoans with disabilities to live fully engaged and self-directed lives. Nationally recognized as a leading force in the disability advocacy community, Access Living challenges stereotypes, protects civil rights, and champions social reform.

The Delahanty Family

Honoring the Career of
Sergeant
Gwana R Anthony

ee W. Gorell Sr.

In Memory of

Honoring
Edward
Mary
Ile

The Biebel Family

In Honor of All of
Fallen Officers
We Carry Their M
1061 Tactical

emory of
estigator
Waszkiewicz
#7650

In Memory of
Marie Olkiewicz

Honoring the Career of
John Baranowski

Vice Control
Section
2006

In Memory of
My Dear Grandmother
Ethel M DeSalvo

In Memory of
Lieutenant
Nicholas Juric

Bill Olszewski
Wayne Olszewski

In Memory of
My Brother
Jerome A. Drell JR.

In Memory of
Sergeant
Thomas J. Corcoran

In Memory of
Patrolman
atrick J. Lally #277
cired 1937 Died 1943

In Memory of
My Father
Jerome A. Drell

The
Chester and
Staniec

all your
milee

CPD's Loss
CFD's Gain

Honoring the Career of
John Patrick Finnegan
Star # 10891

Honoring the Career of
John Joseph O'Leary
Star #15559
Great Friend & Mentor

Honoring the Career
Detective
John F. Solecki
1962-1997

Honoring the Career of
Police Officer
Donald G Egan
CPD

Edward C Koop
35 Years of Se

Patro